The Best American
Travel Writing 2002

GUEST EDITORS OF
THE BEST AMERICAN TRAVEL WRITING

2000 BILL BRYSON
2001 PAUL THEROUX
2002 FRANCES MAYES

The Best American Travel Writing 2002

Edited and with an Introduction
by **Frances Mayes**

Jason Wilson, Series Editor

HOUGHTON MIFFLIN COMPANY

BOSTON · NEW YORK 2002

Visit our Web site: www.houghtonmifflinbooks.com.

ISSN 1530-1516
ISBN 0-618-11879-9
ISBN 0-618-11880-2 (pbk.)

Printed in the United States of America

DOC 10 9 8 7 6 5 4 3 2 1

Contents

Contents

Foreword

I traveled to Helsinki for the first time several Novembers ago. It probably won't surprise anyone when I report that Helsinki in November was brutally cold with a wind that whipped across the half-frozen harbor, that the sun didn't rise until midmorning and quickly set by early afternoon, or that it snowed part of every day.

I wandered around the city's snowy, quiet streets without purpose, following signs I could not read. I haggled with a Russian fur vendor over a muskrat hat in the market square. I drank coffee while sitting on boxes inside a tent near the fish vendors. I whiled away a dark afternoon at a tiny table in Café Engel, looking out across the stark Senate Square, warmed by sun lamps that the *barista* told me had been set up to counteract "the winter blahs." I ate reindeer served with cloudberries and lingonberries, dropped *markkas* into the cup of a blind accordion player, and listened to people ice-skating in the park across the street as I lay in my hotel bed.

The trip seems rather uneventful in the retelling, I know. And it surprises me a little to say that this trip has become a meaningful part of my personal history — more than I ever could have imagined when I bought my plane ticket. The reason has as much, or more, to do with context as with the destination.

If you remember back to the mid- to late 1990s, you may recall those years as the zenith of America's sudden, red-hot love affair with gourmet coffee and its accouterments. It also happened to be

the zenith for a certain genre of niche, connoisseur magazine. During those years, I wrote for — and later improbably became the editor of — an attractively designed magazine called *Coffee Journal,* which covered what it termed the "coffee and tea lifestyle." The magazine dutifully tasted and compared coffee roasts, reviewed the newest espresso machines and grinders, provided biscotti recipes, and profiled cafés all over the world. Travel was a major part of this so-called coffee and tea lifestyle, and I wrote stories about visiting coffee farms in Nicaragua and Haiti, as well as an article entitled "The Best Coffeehouses Coast to Coast." By the time I took the reins, the magazine's demise was imminent. America's love affair with gourmet coffee had cooled considerably.

Following an argument with the publisher over whether our next issue's cover would be a photo of a coffee mug with doughnuts or simply a photo of a solitary coffee mug, I decided to assign myself a travel story on the coffeehouse culture of Helsinki. The clever *Coffee Journal* angle for this travel article, I am embarrassed to admit, would go as follows: A widely circulated statistic asserted that nine cups of coffee was what the average Finn drank each day, the highest per capita consumption in the world. Taking that bit of information as my cue, I would sit in Helsinki's finest cafés, drink nine cups of coffee each day just like the Finns, make notes on the interiors of cafés and those sitting in cafés, and soak up just enough local color on which to hang an itinerary our readers could clip out and follow. It was basically the type of story one writes for a connoisseur magazine that has long ago exhausted its niche. Come to think of it, it's exactly the type of thin, slave-to-the-angle story I read in abundance over the course of the year while searching for quality travel stories for this anthology. I might add that it's the type of story that rarely, if ever, gets selected.

Well, I made my Finnair reservations, and two days later *Coffee Journal* ceased publication. I was now unemployed, but since it was November and flights were as cheap as they would ever be, I decided to fly to Helsinki anyway. Free of artifice or gimmick or even the need to do any particular sightseeing at all, I chose to wander in the cold and do just about nothing that would be of interest to the average travel editor.

I met a number of Finns who were tremendously amused that I had come to visit their city in November, a month that the Finns consider to be the worst and most unpopular time of year. So

amused was one man, a journalist, that he wrote a story about my visit and published it in the *Helsingin Sanomat,* the nation's largest daily newspaper, under the headline "Silence of November as a Souvenir." The journalist quoted me as saying, "I enjoyed the silence when walking the streets." Instead of my writing a travel story, one was written about me.

That newspaper clipping in its original Finnish hangs on my bulletin board. When I look at the article, it does indeed make me think of the strange, silent beauty of Helsinki's streets that I enjoyed, and of the snow-coated gargoyles and statues, including the two giant stone men who hold ball-shaped lights in front of the railway station. But soon enough, I find myself thinking of being unemployed, of how worried I was that I had made bad decisions, of loneliness and melancholy, and of how callow and absurd my thinking often tends to be. Now that some time has passed, I find that Helsinki also marks the end of things — things such as the end of my twenties, and in many ways the end of the 1990s too.

"I found that what I remembered, what seemed to transcend topic, and what affected me were not only essays with a grounded sense of place, but ones written in a highly personal voice," writes Frances Mayes in explanation of why she has chosen the twenty-six pieces that make up this year's anthology.

I couldn't agree with her more. We all know it's impossible to separate honest personal experience from the place at hand. Life happens even when we're in a new place, far away from home. That's why it always baffles me when writers and magazine editors try to pretend otherwise.

My friend Maggie recently showed me a postcard she'd received from her seventy-year-old mother-in-law, sent from Colonial Williamsburg. The photo was a typical scene of docents in period costume riding in a horse-drawn carriage. The caption on the back read, "A gentle mist and autumn shades of yellow, orange, and red provide the backdrop for this splendid carriage that conveys passengers around Palace Green." Pretty banal stuff. But then I looked at the hand-scrawled personal note:

Dear D — s,
 We have had light rain — no carriage ride this year. Edgar and I have played tourist and enjoyed the history and each other's company.

Dad has gotten herpes zoster back (10 years since) and in his ears?!!!!
Went to a "doc in the box" for treatment. Better already.
Driving home today.
 Love,
 Grandmother

While I felt sorry and chagrined for Edgar, Maggie roared with laughter at the thought of her prim and proper mother-in-law scribbling this note. Clearly this postcard, and this otherwise straightforward trip to Williamsburg, had already become part of her family's comic shared history.

Some other friends, Dave and Andrea, just returned from a trip to Vietnam, where they went to adopt a beautiful four-month-old girl. I watched their travel videos, with some great scenes capturing the hustle and bustle of Saigon, including some fabulous footage of Dave getting a haircut by a street barber as deafening motorbikes careen by. Of course, everything else on the video is overwhelmed by the dramatic footage shot inside the Saigon orphanage, where expectant parents from the United States wait for Vietnamese nurses to bring out their babies. This was a human moment that certainly transcended the destination. Even in amateur format, the expressions and reactions of these parents were riveting to watch. That moment defined Dave and Andrea's trip to Vietnam, and no one else's. How different is their trip from that of the fifty-year-old war veteran who revisits the jungle where his buddies were killed thirty years ago? How different is the Vietnam experience of a twenty-two-year-old backpacker just out of college, who has never been outside the United States before?

The travel writing one finds in magazines too often suffers from a reluctance to transcend the topic at hand, a reluctance toward digression of any kind. I realize that some of this is the result of space concerns, but it is still unfortunate. Anyone who reads travel classics such Gerald Brenan's *South from Granada* or Robert Byron's *The Road to Oxiana* or D. H. Lawrence's *Sea and Sardinia* or Graham Greene's *The Lawless Roads* knows that digression is a part of all great travel writing. In many ways, the digressions are the story.

The stories collected here are fiercely personal. How does tragedy turn a simple walk home in Manhattan into a meditation on how much New York matters, and how much we have to lose? Read Adam Gopnik's "The City and the Pillars" within these pages to

find out. What personal ghosts turn a pleasurable summer getaway to Rome into a haunting reminder of what's eternal? Read André Aciman's memoir "Roman Hours." What turns an octogenarian grandfather's annual winter retreat to Acapulco into a lesson on how to live the good life? Devin Friedman will share that wisdom. How does a famous chef's trip home to Cambodia to cook dinner for his family turn into a bittersweet tale of reconciling the past? Molly O'Neill's skillful hand will show you in "Home for Dinner." Whose sensibility turns a flight delay into one of the funniest essays you will read all year? David Sedaris's, of course.

All the writers whose work you will read in this anthology share the ability to transcend their chosen destinations, to understand that a trip's context — whether personal or political — is as important as the trip itself, and they all deliver a compelling and beautiful narrative.

The stories included in this anthology are selected from among hundreds of stories in hundreds of diverse publications — from mainstream and specialty magazines to Sunday newspaper travel sections to literary journals to in-flight magazines. My eyes are far from perfect, but I have done my best to be fair and representative, and in my opinion the one hundred best travel stories from the year 2001 were forwarded to Frances Mayes, who made the final selections.

And so with this publication, I begin anew by reading the hundreds of stories published in 2002. I am once again asking editors and writers to submit the best of whatever it is they define as "travel writing." These submissions must be nonfiction, published in the United States during the 2002 calendar year. They must not be reprints or excerpts from published books. They must include the author's name, date of publication, and publication name, and must be tearsheets, the complete publication, or a clear photocopy of the piece as it originally appeared. I must receive all submissions by January 30, 2003, in order to ensure full consideration for the next collection. Further, publications that want to make certain their contributions will be considered for the next edition should make sure to include this anthology on their subscription list. Submissions or subscriptions should be sent to Jason Wilson, *The Best American Travel Writing*, P.O. Box 260, Haddonfield, N.J. 08033.

It was an honor to work with Frances Mayes, whose well-docu-

mented life in Tuscany I have deeply envied for some time. I enormously appreciate her efforts to pull this collection together on the heels of finishing her first novel. I would also like to thank Samantha Pinto for her assistance on this year's anthology, as well as Deanne Urmy, Melissa Grella, and Liz Duvall, among others at Houghton Mifflin. But of course the writers included here deserve the greatest praise. *The Best American Travel Writing* is dedicated, as always, to them.

JASON WILSON

Introduction

Monarch butterflies are camping in the eucalyptus trees around my house, a California pause in their long yearly migration. Sitting at the kitchen table reading essays for this book, I look up and see them flickering among the leaves, showing their orange wings to the sun. I wonder — is travel a natural instinct? Birds ride updrafts across continents; turtles are born knowing how to swim from Africa to Brazil; wildebeest herds thunder across the veldt, on their way somewhere. Chaucer's storytellers felt the spring sap rise in their veins, sending them out on pilgrimages to seek the holy blessèd martyr. Today, late February, the crabapple trees in full frisson, I'm longing to air out my carry-on bag, search for my passport, and take the first thing smoking on the runway for I know not where. Maybe some primitive push in the genes makes humans light out for the territories, makes us long, from time to time, for anywhere, anywhere other than where we are.

When I graduated from high school, I was given a set of leather luggage by my mother. It was smoky blue leather with my initials stamped clearly in silver, FEM. A large, a medium, and a round bag, all lined in quilted satin. I was ready to go. Where was I going? Only to college in Virginia, eight hundred miles from home. That was my first encounter, all on my own, with a new geography. As a teenager, I had traveled with my mother — to Washington and New York and to see the battlefield at Gettysburg. My father always said, *"Packing and Unpacking.* If we had a family crest, we should carve

Packing and Unpacking in Latin across the top." We loved to *go*. Not
that we went very far. From our house in southern Georgia, when I
was a child, we traveled to St. Simons and Sea Island, two of the
Golden Isles of Georgia; to Atlanta, Daytona Beach, Fernandina
Beach; sometimes as far as Highlands, North Carolina. Although
she never considered Europe or Hawaii or even California — *there
be beasties* — my mother was restless. Occasionally my parents went
to New York. After my father died, my mother tried a few Carib-
bean cruises, where she hoped to meet someone glamorous who
would rescue her from the boredom of life in a small town. Instead
she would come home with stories of ladies from Upstate New York
being pelted with tomatoes by angry natives in Barbados, of dining
with a Canadian gentleman who excused himself shortly before the
check arrived, and of sharing a stateroom with an old friend who
had nightmares and called out, "My virtue, my virtue," in the night.

These, I suppose, were the first travel stories I ever heard. We
were bees in amber in that small town. Within its one-mile parame-
ter, we lived in a world unto itself. When I came across Thoreau's
wry remark about having "travelled much in Concord," I knew ex-
actly what he meant.

Besides my brief excursions away from my hometown, books
gave me the idea of travel. In our town we didn't have much to en-
tertain us, but we did have a Carnegie library. I methodically read
my way across the shelves, with the librarian occasionally calling my
mother to report that I was reading unsuitable books. I must admit
that I devoured Frank Yerby's stories of octoroons and plantations,
and all writers who oozed the Deep South mythos. But what I came
to recognize as *a sense of place* I happened upon in D. H. Lawrence,
Dostoyevsky, Yeats, Elizabeth Bowen, Henry James. *Other worlds,* I
realized, *whole other worlds are out there.*

By the time I went to college, I was ready to bolt. Ever since then,
there has not been a time when I was not planning a trip. Unlike
my mother's preparations, which involved wrapping tissue paper
around a great deal of pastel linen and packing a huge suitcase, my
preparations merely raise my usual bedside stack of books to the
teeter point. The pretrip is almost as much of a pleasure as the ac-
tual trip. Half of my suitcase is taken up by books and maps. And on
returning home there are more books to read, because I encoun-
tered unexpected places, paintings, foods, people, and customs.
What delicious study.

Because for me reading and travel have a natural symbiosis, reading the essays for *The Best American Travel Writing 2002* has been a joy. Every few weeks over the rainy California winter, series editor Jason Wilson sent me bundles of photocopied articles from an enormous range of publications. Since he had selected them, I found them all good. I read them with my morning cappuccino, in the bathtub, in bed, and even creeping up Highway 101 in rush-hour traffic. (Please don't tell the highway patrol that I read and drive at the same time.)

Early in the process I began to wonder what exactly qualified as travel writing. I am immediately drawn to the incongruous qualities of spontaneity and reflection. I like to read about journeys when the traveler is charged or changed by the place, when the traveler is moved from one psychic space to another during the course of the trip. Some of the strong pieces seemed to veer away from travel and fall more comfortably into the category of investigative journalism, with a topic or situation more than a place as a focus. I reluctantly put those aside. As my yes, no, and maybe stacks drifted back and forth across my desk, gradually I found that what I remembered, what seemed to transcend topic, and what affected me were not only essays with a grounded sense of place, but ones written in a highly personal voice. Keats wrote a short poem, "This Living Hand," in which he implores the future reader to remember the vital, living hand that wrote the poem. The essays collected here mostly display that quality of immediate touch.

A late phenomenon, travel writing in America is blossoming. As a reader, I've always loved the genre. I was astounded, about fifteen years ago, to walk into a London bookstore and see an entire wall of travel narratives. The biggest shock came from discovering the Victorian ladies, such as Lucy Duff Gordon (*Letters from Egypt*), Margaret Fountaine (*Love Among the Butterflies*), and Mary Kingsley (*Travels in West Africa*), who set out for Africa with tea sets and butterfly nets, lifting their long skirts over mud holes. From Florence Nightingale cruising down the Nile to Freya Stark trekking across South Arabia's Incense Road in the thirties, these traveling women, usually "in possession of a modest private income," captivated me. I loved, too, Eric Newby, the marvelously eccentric Sitwells, Patrick Leigh Fermor, and Lawrence Durrell.

The English may be the most intrepid travelers who ever pushed off from a shore, but from now on, I think the Americans will equal

them. Our lineage, after all, includes Francis Parkman, William Bartram, M.F.K. Fisher, Jack Kerouac, Washington Irving, John Steinbeck, Henry Miller, and my old friend Thoreau. All of them would be astounded at the liveliness of American travel writing today. In unprecedented numbers, people are traveling. Everywhere I go I meet people who keep to the motto *Packing and Unpacking*.

Since the publication of my three memoirs about living in Italy, I have received hundreds of letters describing travels. Some have drawings or photos, or a sprig of lavender or a red poppy tucked into the envelope. Written from foreign café tables or from back home, these letters are often moving. With the removal of a few coffee stains, many could be published. Travel magazines, Sunday papers, and a dizzying number of Web sites advertise adventure travel, house rentals, study trips, cruises, painting trips. There are now fantastic cruises and walks and courses. Forget the tour group pouring out of a bus into a parking lot and trudging off behind someone with a flag. There are specialized trips out there, magical opportunities for seeing and learning. I am going off this spring on a boat that sails around the whole boot of Italy, beginning in Naples, docking at small ports, and ending in Venice. What a dream.

I've never read anything about the enormous privilege of travel. Those of us who can contemplate where we would like to go on vacation are plain lucky. Turkey this year? A llama trek across the Cascades, skiing in Banff, the sacred return to Pawley's Island for August, scuba diving in Virgin Gorda? What a miracle! Although in 2001 Americans were paralyzed by terrorism, all indications right now are that they are gaining confidence in new airport security, are refusing to be intimidated, and are picking up again and going to most of the places they want to go. Let's hope this confidence can hold and grow. Still, ugly new barriers have been erected. For as long as I can remember, I've wanted to go to Egypt. I'd finally planned to go this year, but an English friend, who was hissed at and shoved, convinced me not to attempt the trip. I'm waiting.

As a people we have been too insular, too content, too ignorant. If any good comes out of the terrorist attacks, it's bound to be that we look with more comprehension and benevolence toward other ways of being in the world. The travel boom of the recent past works toward that, too. When you travel, if you are open to experience, you cannot help but be changed by the validity of what you

see. A quirky American traveler, Mark Twain, noted that "travel is fatal to prejudice, bigotry, and narrow-mindedness." What you expect from a trip sometimes doesn't happen; what you take with you sometimes must be jettisoned. It is an odd, sometimes uncomfortable sensation to feel your expectations breaking off and floating away as you encounter the real place. The great gift is that your perception expands, as your love expands when a new baby comes to the family.

Many travelers will write about their trips, whether in e-mail journals with photos to all their friends or in magazine essays or in books. I'm ready to read all of them. The current variety of travel writing is a delight. My sisters and several friends send me clippings from their local papers. I like the magazine column where someone writes in about the disappointment of construction noise in paradise and the ombudsman wields the power of the magazine to make the guilty hotel owner offer a free week. I even like the page in the Sunday *San Francisco Chronicle* where people write short letters saying what restaurant they enjoyed or what B&B they stayed in up the coast.

I love the books best, the delicious narratives that make you know what it would be like to live in Spain or Mexico or to open a *taverna* in Greece. In an extended piece of writing, time enters. The reader and writer have time to understand how place has had its way. When we put ourselves down in a foreign place for a period of time, we begin to change, like it or not. We begin to see how the people who live there were shaped by the place, even as we feel ourselves being shaped. I've found, by living in a small Italian hill town for part of every year, that the learning curve never inscribes its downward side of the bell — it keeps rising. "I had a farm in Africa," Isak Dinesen wrote. Everything follows from that. By the power of her writing, *Out of Africa* became a classic long before Meryl Streep imprinted her moody beauty over the visage of the bony, haggard Dane. Some other classics of place are being reissued, such as Ann Cornelisen's *Women of the Shadows* and *Torregreca*. Bravo! More is better. *Other worlds, whole other worlds are out there.*

Unfortunately for writers who like to publish in periodicals, many magazines have shortened articles to conform to some idea they have of the readers' attention span, or to save money. I'd prefer fewer but more developed articles to sound-bite sentences.

Some magazines require of their writers a formulaic progression or a mind-set. One where I published an article insisted that I identify the exact location in the first paragraph, including the exact number of miles from a known place. This axed my opening. Once I wrote an article for a magazine published by a credit card company. I included a description of a bus trip, a mention of poverty. Cut, cut, cut, the editor wrote back. She crossed out the bus section with a big X. "The cardholders do not ride buses," she scrawled in the margin. Too many rules and red pencils, of course, lead to the erasure of the individual passionate and observing voice. We're left with mere practicality instead. I may jot some of the what, where, when, and how from such an article into a notebook, but I will not reread it.

I *will* reread Jim Harrison's "Soul Food" for the delight in his use of language, André Aciman's "Roman Hours" for his grasp of the workings of memory and place, and Thomas Swick's "Stolen Blessings" for his perception of how travel changed after the destruction of the World Trade Center on September 11. I'm partial to the personal quest, a guarantee of idiosyncrasy. In "Sovereigns of the Sky," Stephen Bodio travels to Mongolia to pursue his interest in falconry. Toni Mirosevich's "Lambs of God and the New Math" is a contemporary version of the archetypal pilgrimage tale. Kira Salak in "Making Rain" and Kate Hennessy in "Slow Flying Stones," distant descendants of those long-skirted Victorians, set out on adventurous quests to discover why they are on quests.

I loved finding essays that rip the rug out from under my expectations. It is a pleasure to take a trip to Israel ("Zion's Vital Signs") with P. J. O'Rourke. Who would expect to smile when reading about Israel these days? O'Rourke gently reminds us that there's more to the country than the latest explosion. Humor's edge sharpens when someone finds a laugh where no one else would look for one. Flights and airport delays might seem the last target for a funny essay, but David Sedaris ("The Man Upstairs") jumps right in.

These and all the other essays published here heighten my appreciation for the liveliness of travel writing we're able to enjoy in American publishing venues. "Much have I traveled in the realms of gold," Keats also wrote. The gold referred to gilt-edged books. Although this volume lacks gilt, it offers instant premier status in

the realms-of-gold department. These writers cover many latitudes and longitudes, physically and metaphorically. They know, as John Steinbeck said, that we do not take a trip; a trip takes us. Not one essay is irksome. Some travel writers *can* become serious to the point of lapsing into good ol' American puritanism. Travel writing is not about pleasure, some of them insist. You must be slapping fleas, hunkering down in the hold of a rusty ferry, or confronting the last leper colony on earth. What nonsense! *I have traveled much in Concord.* Good travel writing can be as much about having a good time as about eating grubs and chasing drug lords. (For me, it's dangerous enough to live in an American city.) I think it is indisputably harder to write well about happiness than it is to write about travail. As these essays reveal, travel is for learning, for fun, for escape, for personal quests, for challenge, for exploration, for opening the imagination to other lives and languages.

In *The Best American Travel Writing 2002,* "travel" is an adjective. "Writing" is the most vital word in the title. There are as many reasons to travel as there are travelers. For a writer interested in place, the subject can be any dot on the map. One goes to a war zone, one takes a wildflower walk, one experiences a gun at the temple, one trails a foot off a sailboat in aquamarine waters. Only the writing will reveal who traveled furthest.

FRANCES MAYES

The Best American
Travel Writing 2002

The Best American
Travel Writing 2002

ANDRÉ ACIMAN

Roman Hours

FROM *Condé Nast Traveler*

TODAY, AGAIN, I STARED at the small knife on my desk. I had purchased it months ago on the Campo de' Fiori, just before buying bread rolls and heading down the Via della Corda to find a quiet spot on the Piazza Farnese, where I sat on a stone ledge and made prosciutto and Bel Paese sandwiches. On the way to the Palazzo Farnese, I found a street fountain and rinsed a bunch of muscatel grapes I had bought from a *fruttivendolo*. I was leaning forward to cleanse the new knife as well, and to douse my face while I was at it, when it occurred to me that this, of all my days in Rome, was perhaps the one I would like most to remember, and that on this cheap knife — which I had originally planned to discard as soon as I was finished using it but had now decided to take back with me — was inscribed something of the warm, intimate feeling that settles around noon on typically clear Roman summer days. It came rushing to me in the form of a word — one word only, but the best possible word because it captured the weather, the city, and the mood on this most temperate day in June and, hence, of the year: serenity. Italians use the word *sereno* to describe the weather, the sky, the sea, a person. It means tranquil, clear, fair, calm.

And this is how I like to feel in Rome, and how the city feels when its languid ocher walls beam in the midday sun. When overbrimming old fountains dare you to dunk your hands in and splash your face and rest awhile before resuming your walk through yet narrower twisting lanes along the Campo Marzio in the *centro storico* (historic center) of Rome.

This warren of old alleys goes back many centuries, and here, sinister brawls, vendettas, and killings were as common in the Renaissance as the artists, con artists, and other swaggerers who populated these streets. Today, these lanes with tilting buildings that have learned to lean on each other like Siamese twins exude a smell of slate, clay, and old dank limestone; wood glue and resin drift from artisans' shops, attesting to the timeless presence of workshops in the area. Otherwise, the streets are dead past midday. Except for bells, an occasional hammer, the sound of a lathe, or an electric saw that is no sooner heard than it's instantly silenced, the only sound you'll hear on the Vicolo del Polverone or the Piazza Quercia is the occasional clatter of plates ringing from many homes, suggesting that lunch is about to be served in all of Italy.

A few more steps into the Largo della Moretta, and suddenly you begin to make out the cool scent of roasted coffee emanating from hidden sanctuaries along the way. These havens — like tiny pilgrimage stations, or like the numerous churches to which men on the run, from Cellini to *Tosca*'s Angelotti, rushed to seek asylum — each have their old legend. Caffè Rosati, Caffè Canova, Caffè Greco, Caffè Sant'Eustachio, Antico Caffè della Pace — small oases where blinding light and dark interiors go well together, the way hot coffee and lemon ice go well together, the way only Mediterraneans seek the shade and wait out the sun they love so much.

There is a magic to these summer hours that is as timeless as the tiny rituals we invent around them each day. Here are mine. Strolling in the dry heat and suddenly rediscovering the little-known Vicolo Montevecchio, where a huge off-white *ombrellone* suddenly sprouts, spelling food and wine. Wasting yet another bottle of sparkling water by washing a hand unavoidably made sticky with food purchased on the fly. Baring both feet by the Turtle Fountain in the Piazza Mattei, the empty square basking in the ocher glory of its adjoining buildings, and when no one's looking, letting them soak awhile in a pool of water so peaceful and translucent that not even the quietest beach on the quietest day could rival it.

Getting lost — the welcome sense that you are still unable to find your way in this maze of side streets — is something one never wishes to unlearn, because it means one's visit here is still very young. The rule is quite simple: Scorn maps. They never show all of Renaissance Rome anyway; they merely stand between you and the

city. Stray instead. Enforced errancy and mild disconcertment are the best guide. Rome must swim before your eyes. You'll drift and wander and suddenly land, without knowing how, at the Piazza Navona, or the Campo de' Fiori, Sant'Andrea della Valle, the Pantheon, the Piazza di Spagna, or the Piazza del Popolo, with its stunning *tricorno* fanning out in three directions: the Via del Babuino, the Via del Corso, and the Via di Ripetta. "Could this be the Trevi Fountain?" you wonder, half fascinated by your internal compass, which knew all along where you were headed and which, in retrospect, gives you a sort of proprietary claim on the piazza, the way a prince may think he alone is entitled to marry a particular debutante simply because he was the first to spot her at court. How we discover beauty is not incidental to it; it prefigures it. The accident that brings us to the things we worship says as much about them as it does about us. What I want is not just to see the Turtle Fountain but to stumble upon the Turtle Fountain inadvertently.

This protean city is all about drifting and straying, and the shortest distance between two points is never a straight line but a figure eight. Just as Rome is not about one path, or about one past, but an accumulation of pasts: You encounter Gogol, Ovid, Piranesi, Ingres, Caesar, and Goethe on one walk; on another, Caravaggio and Casanova, Freud and Fellini, Montaigne and Mussolini, James and Joyce; and on yet another, Wagner, Michelangelo, Rossini, Keats, and Tasso. And you'll realize one more thing that nobody tells you: Despite all these names, masonries, and landmarks, despite untold layers of stucco and plaster and paint slapped over the centuries on everything you see here, despite the fact that so many figures from one past keep surfacing in another, or that so many buildings are grafted onto generations of older buildings, what ultimately matters here are the incidentals, the small elusive pleasures of the senses — water, coffee, citrus, food, sunlight, voices, the touch of warm marble, glances stolen on the sly, and faces, the most beautiful in the world.

And this, without question, is the most beautiful city on earth, just as it is the most serene. Not only is the weather and everything around us serene, but we ourselves become serene. Serenity is the feeling of being one with the world, of having nothing to wish for, of lacking for nothing. Of being, as almost never happens elsewhere, entirely in the present. This, after all, is the most pagan city

in the world; it is consumed by the present. The greatest sites and monuments, Rome tells us, mean nothing unless they stimulate and accommodate the body; unless, that is, we can eat, drink, and lounge among them. Beauty always gives pleasure, but in Rome, beauty is born of pleasure.

Twice a day, we come back to the Antico Caffè della Pace, off the Piazza Navona. The *caffè* is a few steps away from the Hotel Raphaël (a luxurious place whose roof garden offers an unimpeded view of the Campo Marzio). At the *caffè*, dashing would-be artists, models, drifters, and high-end wannabes sip coffee, read the paper, or congregate, which they do in greater numbers as the day wears on. I like to come here very early in the morning, when the scent of parched earth lingers upon the city, announcing warm weather and blinding glare toward noon. I like to be the first to sit down here, before the Romans have left their homes, because if I hate feeling that those who live here or were born after I'd left Rome, years ago, have come to know my city better than I ever will, then being here before they're ready to face their own streets gives me some consolation. While I retain the privileged status of a tourist who doesn't have to go to work, I can easily pretend — an illusion sanctioned by jet lag — that I've never left Rome at all but just happened to wake up very early in the morning.

By evening, the jittery *caffè* crowd spills over into the street. Nearly everyone holds a *telefonino* in their hand, because they expect it to ring at any moment but also because it's part of the dress code, a descendant of the privileged dagger that conferred instant status at the unavoidable street brawl. One of these twenty- to thirty-year-olds sits at a table, staring attentively into his *telefonino* as though inspecting his features in a pocket mirror. Watching the flower of Rome, I see how easy it is to reconcile its cult of the *figura* with the beauty that abounds on a Baroque square such as the Piazza Navona. There will always remain something disturbingly enticing about this shady clientele. This, after all, is the universe of Cellini and Caravaggio. They lived, ate, brawled, loved, plotted, and dueled scarcely a few blocks away. Yet from some unknown cranny in their debauched and squalid lives, they gave the world the best it is ever likely to see. Here, as well, lived the ruthless Borgia pope Alexander VI, whose children Lucrezia Borgia and Cesare Borgia are notorious to history. A few steps away, and a

hundred years later, Giordano Bruno was brought to the Campo de' Fiori, stripped naked, and burned at the stake. Scarcely a few months earlier, an event had taken place that shook Rome as probably nothing had since the martyring of the early Christians: the brutal decapitation of the beautiful young Beatrice Cenci by order of the pope himself

We may never become Roman, and yet it takes no more than a few hours for the spell to kick in. We become different. Our gaze starts to linger; we're less fussy over space; voices become more interesting; smiles are over-the-counter affairs. We begin to see beauty everywhere. We find it at Le Bateleur, a charming rundown antiques and curios shop on the Via di San Simone, off the Via dei Coronari, where we find stunning French watercolors. Or at Ai Monasteri, which sells products made in Italian monasteries and where I found a delicious spiced grappa, the best Amaro, and the sweetest honey I've ever known. Or at the Ferramenta alla Chiesa Nuova, seemingly a hardware store but actually a nob, door handle, and ancient keys gallery where people walk in bearing precious antique door hinges they despair of ever finding a match for, only to have the owner produce a look-alike on the spot.

The city is beautiful in such unpredictable ways. The dirty ocher walls (fast disappearing under new coats that restore their original yellow, peach, pink, lilac) are beautiful. And why not? Ocher is the closest stone will ever come to flesh; it is the color of clay, and from clay God made flesh. The figs we're about to eat under the sun are beautiful. The worn-out pavement along the Via dei Cappellari is, however humble and streaked with dirt, beautiful. The clarinetist who wends his way toward the sunless Vicolo delle Grotte, wailing a Bellini aria, plays beautifully. The Church of Santa Barbara, overlooking Largo dei Librari, couldn't offer a more accurate slice of a Roman *tableau vivant,* complete with ice-cream vendor, sleeping dog, Harley-Davidson, canvas *ombrelloni,* and men chatting in gallant fashion outside a small haberdashery where someone is playing a mandolin rendition of "Core 'ngrato," a Neapolitan song, while a lady wearing a series of Felliniesque white voiles cuts across my field of vision. This sixty-year-old aristocratic eccentric is, it takes me a second to realize, speeding on a mountain bike, barefoot, with an air of unflappable *sprezzatura.*

What wouldn't I give never to lose Rome. I worry, on leaving, that like a cowered Cinderella returning to her stepmother's service, I'll slip back into my day-to-day life far sooner than I thought possible. It's not just the beauty that I'll miss. I'll miss, too, the way this city gets under my skin and, for a while, makes me its own, or the way I take pleasure for granted. It's a feeling I wear with greater confidence every day. I know it is a borrowed feeling — it's Rome's, not mine. I know it will go dead as soon as I leave the Roman light behind.

This worry doesn't intrude on anything; it simply hovers, like a needless safety warning to someone who's been granted immortality for a week. It was there when I purchased the ham, the rolls, the knife. Or when I saw the Caravaggios in San Luigi dei Francesi; or went to see Raphael's sibyls in Santa Maria della Pace but found the door closed, and was just as pleased to admire its rounded colonnade instead. Could any of these timeless things really disappear from my life? And where do they go when I'm not there to stare at them? What happens to life when we're not there to live it?

I first arrived in Rome as a refugee in 1965. Mourning my life in Alexandria, and determined never to like Rome, I eventually surrendered to the city, and for three magical years the Campo Marzio was the place I came closest to ever loving. I grew to love Italian and Dante, and here, as nowhere else on earth, I even chose the exact building where I'd make my home someday.

Years ago, just where the Campo is split by the ostentatious nineteenth-century thoroughfare, the Corso Vittorio Emanuele II, I would start on one of two favorite walks. As soon as the school bus had crossed the river from Vatican City, I'd ask the driver to drop me at Largo Tassoni — rather than bring me all the way to Stazione Termini, from where I'd have to take public transportation for another forty minutes before reaching our shabby apartment in a working-class neighborhood past Alberone. From Largo Tassoni, either I would head south to the Via Giulia and then the Campo de' Fiori, ambling for about two hours before finally going home, or I'd head north.

I liked nothing better than to lose my way in a labyrinth of tiny, shady, furtive, ocher-hued *vicoli*, which I hoped would one day, by dint of being strayed in, finally debouch into an enchanted little

square where I'd encounter some still higher order of beauty. What I wished above all things was to amble freely about the streets of the Campo Marzio and to find whatever I wished to find there freely, whether it was the true image of this city, or something in me, or a likeness of myself in the things and people I saw, or a new home to replace the one I'd lost as a refugee.

Roaming about these streets past dark had more to do with me and my secret wishes than it did with the city. It allowed me to recast my fantasies each time, because this is also how we try to find ourselves — by hits and misses and mistaken turns. Dowsing around the Campo Marzio like a prospector was simply my way of belonging to this area and of claiming it by virtue of passing over it many, many times, the way dogs do when they mark their corners. In the aimlessness of my afternoon walks, I was charting a Rome of my own devising, a Rome I wanted to make sure did exist, because the one awaiting me at home was not the Rome I wanted. On the twilit lanes of a Renaissance Rome that stood between me and ancient Rome just as it stood between me and the modern world, I could pretend that any minute now, and without knowing how, I would rise out of one circle of time and, walking down a little lane lined by the mansions of the Campo Marzio, look through windows I had gotten to know quite well, ring a buzzer downstairs, and through the intercom hear someone's voice tell me that I was, once again, late for supper.

Then one afternoon, a miracle occurred. During a walk past the Piazza Campitelli, I spotted a sign on a door: AFFITASI ("to let"). Unable to resist, I walked into the building and spoke to the *portinaia,* saying that my family might be interested in renting the apartment. When told the price, I maintained a straight face. That evening, I immediately announced to my mother that we had to move and would she please drop everything the following afternoon and meet me after school to visit a new apartment. She did not have to worry about not speaking Italian; I would do all the talking. When she reminded me that we were poor now and relied on the kindness of relatives, I concocted an argument to persuade her that since the amount we paid a mean uncle each month for our current hole in the wall was so absurdly bloated, why not find a better place altogether? To this day I do not know why my mother

decided to play along. We agreed that if we couldn't persuade the *portinaia* to lower her price, my mother would make a face to suggest subdued disapproval.

I would never have believed that so rundown a facade on the Campo Marzio could house so sumptuous and majestic an apartment. As we entered the empty, high-ceilinged flat, our cautious, timid footsteps began to produce such loutish echoes on the squeaking parquet floor that I wished to squelch each one, as though they were escaped insects we had brought with us from Alberone that would give away our imposture. I looked around, looked at Mother. It must have dawned on both of us that we didn't even have enough money to buy a kitchen table for this place, let alone four chairs to go around it. And yet, as I peeked at the old rooms, this, I already knew, was the Rome I loved: thoroughly lavish and baroque, like a heroic opera by George Frideric Handel. The *portinaia*'s daughter was following me with her eyes. I tried to look calm, and glanced at the ceiling as though inspecting it expertly, effortlessly. I slipped into another room. The bedrooms were too large. And there were four of them. I instantly picked mine. I looked out the window and spotted the familiar street. I opened the French windows and stepped out onto a balcony, its tiles bathed in the fading light of the setting sun. I leaned against the banister. *To live here.*

The people in the building across the street were watching television. Someone was walking a dog on the cobbled side street. Two large glass streetlights hanging from both walls of an adjoining corner house had started to cast a pale orange glow upon its walls. I imagined my mother sending me to buy milk downstairs, my dream scooter I'd park in the courtyard.

My mother had come well-dressed that day, probably to impress the *portinaia*. But her tailor-made suit, which had been touched up recently, seemed dated, and she looked older, nervous. She played the part terribly, pretending there was something bothering her that she couldn't quite put her finger on, and finally assuming the disappointed air we had rehearsed together when it became clear that she and the *portinaia* could not agree on the rent.

"*Anche a me dispiace, Signore* — I too am sorry," said the *portinaia*'s daughter. What I took with me that day was not just the regret in her dark, darting eyes as she escorted us downstairs, but the pro-

found sorrow with which, as if for good measure, she had thrown in an unexpected bonus that stayed with me the rest of my life: *"Signore."* I had just turned fifteen.

I have often wondered what became of that apartment. After our visit, I never dared pass it again and crafted elaborate detours to avoid running into the *portinaia* or her daughter. Years later, back from the States with long hair and a beard, I made my next visit. What surprised me most was not that the Campo Marzio was riddled with high-end boutiques, but that someone had taken down the AFFITASI sign and never put it up again. The apartment had not waited.

And yet the building I never lived in is the only place I revisit each time I come back to Rome, just as the Rome that haunts me still is the one I fabricated on my afternoon walks. Today, the building is no longer drab ocher but peach pink. It too has gone to the other side, and, like the girl with the blackamoor eyes, is most likely trying to stay young, the expert touch of a beautician's hand filling in those spots that have always humanized Roman stone and made the passage of time here the painless, tiny miracle that it is. At fifteen, I visited the life I wished to lead and the home I was going to make my own someday. Now, I was visiting the life I had dreamed of living.

Fortunately, the present, like the noonday sun here, always intrudes upon the past. Only seconds after I come to a stop before the building, a budding indifference takes hold of me and I am hastening to start on one of those much-awaited long walks I already know won't end before sundown. I am thinking of ocher and water and fresh figs and the good, simple foods I'll have for lunch. I am thinking of my large seventh-story balcony at the Hotel de Russie, looking over the twin domes of Santa Maria di Montesanto and Santa Maria dei Miracoli, off the Piazza del Popolo. This is what I've always wished to do in Rome. Not visit anything, not even remember anything, but just sit, and from my perch, with the Pincio behind, scope the entire city lying before me under the serene, spellbinding light of a Roman afternoon.

I am to go out tonight with old friends to a restaurant called Vecchia Roma on the Piazza Campitelli. On our way, I know we'll walk past my secret corner in the Campo Marzio — I always make

sure we take that route — where I'll throw a last, furtive look up at this apartment by the evening light. An unreal spell always descends upon Rome at night, and the large *lampadari* on these empty, interconnecting streets beam with the light of small altars and icons in dark churches. You can hear your own footsteps, even though your feet don't seem to touch the ground but almost hover above the gleaming slate pavements, covering distances that make the span of years seem trivial. Along the way, as the streets grow progressively darker and emptier and spookier, I'll let everyone walk ahead of me, be alone awhile. I like to imagine the ghost of Leopardi, of Henri Beyle (known to the world as Stendhal), of Beatrice Cenci, of Anna Magnani, rising by the deserted corner, each one always willing to stop and greet me, like characters in Dante who have wandered up to the surface and are eager to mingle before ebbing back into the night. It is the Frenchman I'm closest to. He alone understands why these streets and the apartment up above are so important to me; he understands that coming back to places adds an annual ring and is the most accurate way of measuring time. He too kept coming back here. He smiles and adds that he's doing so still, reminding me that just because one's gone doesn't mean one loves this city any less, or that one stops fussing with time here once time stops everywhere else. This, after all, is the Eternal City. One never leaves. One can, if one wishes, choose one's ghost spot now. I know where mine is.

SCOTT ANDERSON

Below Canal Street

FROM *Esquire*

IT IS AN ODD THING, probably not what one would predict or re-member afterward, but when a person encounters true horror, the body's first response almost always occurs in the hands. With women, the hands tend to immediately come up to cover the mouth or press the cheeks. Among men, they tend to form a stee-ple over the nose and mouth or to clutch tightly onto the sides of the head. It is as if, in this moment of utter incomprehension and helplessness, the hands are trying to give comfort.

I'm not sure where I first noticed this. It might have been in Bel-fast in 1989, when a large car bomb went off downtown and the people around me didn't know which way to run as glass rained down around us. Or it might have been before that, in Beirut in 1983 or in Sri Lanka in 1987, but it does seem to be a universal reflex, this thing with the hands. I saw it again at 9:59 on the morn-ing of September 11 in New York City.

At that moment, I was standing on the roof of an apartment building in the East Village, watching the billows of white smoke pouring off the upper floors of the World Trade Center towers, perhaps two miles away. On the surrounding rooftops were scores, maybe hundreds, of other onlookers. At 9:59, there appeared to be a sudden bulging outward around the midpoint of Tower Two, a quick glittering of either fire or the morning sun reflecting off dis-lodged windows, and then Tower Two started straight down with a speed that seemed to defy gravity. On the rooftops all around me, men gripped their heads, women their faces. Just down from me, a man in his late thirties with a long ponytail and tattooed fore-

arms began screaming, "No, no!" then dropped to his knees and wrapped his arms tightly over his chest. I remember looking at him with a mix of pity and envy — pity for his pain but envy because he was the first among us to find his voice, the first to move from shock to despair, and this seemed the healthiest reaction to have. I was still just standing there, mute, numb, clutching my head.

Over the past eighteen years, I've been to a dozen-odd war zones around the world. Usually, I went as a journalist, with all the detachment and comparative immunity that implies. Of course, there were times when both detachment and immunity fell away, when I witnessed things that affected me deeply, or I found myself in harm's way, but in all these places, I was, first and foremost, an outsider; what was happening fundamentally did not involve me, it was not my war. Nor could I ever reasonably claim to be shocked by what I saw; after all, I had gone there for the very purpose of seeing it. All that ended, as it did for millions of other New Yorkers, on the morning of September 11. For the first time, I had not gone to war, but war had come to me — and with as little warning as it comes to most — and if a lot of it felt very familiar, a lot of it didn't at all.

After Tower One collapsed at 10:28, I left the apartment rooftop. Like everyone else in the city, I didn't know what to do, I just knew that I needed to do something, and maybe if I began to walk I would discover it. I started south, toward the plume of white smoke and dust in the sky.

The five lanes of First Avenue were virtually empty save for an occasional racing ambulance or police car, but along the sidewalks came a flood of people heading north. There was a hush to them, hardly anyone speaking, and here and there in the crowd was someone caked in fine beige powder. I don't think any of them knew where they were going, either, just away from the ugly cloud, further into the warmth and sunlight of this beautiful late-summer morning.

Walking against the current, I spotted a middle-aged businessman approaching at a brisk pace, weaving and overtaking "traffic" the way New Yorkers do on sidewalks. He was dressed in an expensive suit and clutched a fine leather briefcase, but it was as if he'd been dipped in buckwheat flour from head to toe, and the briskness of his walk was causing little spumes of dust to fly off him with each step. As we passed, he gave me a quick, slightly annoyed

glance, as if to say, "What the hell are you looking at?" He obviously had been close when the towers came down, had undoubtedly sprinted for his life, and had done so in such blind terror that it never occurred to him to drop the briefcase. Now, a half hour and two miles away, he was still pumped up, still moving on the adrenaline that might give out on the next block or might carry him all the way to wherever he imagined he was headed.

In war, the fabric of society — the rules and laws and customs that are lived by — frays in direct proportion to one's nearness to the battlefield. In most wars, this fraying occurs over a distance of provinces or valleys or mountain ranges, but in New York on September 11 it was happening over the space of a few city blocks. By 11:00, the authorities were trying to establish a security perimeter at Canal Street, a demarcation line between civilization and madness that civilians would not be allowed past. The problem was, the police detailed to this task were just as lost and stunned as the rest of us; their authority had deserted them. A policeman stopped me, ordered me back. I nodded at him and continued on, and he simply turned to try his luck with someone else. Once past this line, authority had little to do with rank or uniforms; in the peculiar kind of meritocracy that takes over in a place of chaos, leadership now fell to anyone with the surety or charisma to seize it.

I first saw this at a forward triage unit being set up in the lobby of the Department of Health building near City Hall, where a black woman in her mid-thirties in a white coat was in command of people twice her age. Perhaps she was a doctor, perhaps a nurse, but her authority stemmed from her calm, her ability to focus on each person who came before her and to give them orders. It didn't matter if the commands she gave were impossible to fulfill, it was the certainty with which she gave them that made the rest of us trust her; in our collective impotence, we were all just looking for someone to tell us what to do.

I helped unload boxes of medical supplies coming off trucks, stacked them along the walls of the lobby. It felt good to do this, like I was being useful, and I was spurred on by a man somewhere in the crowd who repeatedly shouted, "Come on, people, we have to get organized. They're going to be coming in any minute now." Except they didn't come in. No one came in. No one was coming out anymore from the awful cloud a few blocks away, and we were

all just there — doctors, nurses, grunts like me — stacking boxes, erecting eyewash kits, making neat little arrays of gauze bandages and syringes and antiseptic wash, because it was only by staying busy that our minds could detach from the enormity of what had happened, could let us believe we were doing something to help.

After a time, I wandered outside. Another set of wooden barricades had been set out on the far side of the street, and as I walked toward them, a policewoman called out to me: "Sir, you're not allowed past there."

"Okay," I called back, and continued on. She was not a cop anymore; she knew it and I knew it, and if I'd had the presence of the woman in the Health Department lobby, I could have told the cop to go across the street and start counting paper cups and she would have done it.

I walked a little ways down a deserted side street, and, finally, out of the gloom came two women caked in dust. One was middle-aged and white, the other elderly and black with tightly braided hair, limping. I couldn't tell if they were friends or coworkers or simply found each other on the way out, but they were very protective of each other, the white woman hovering close as the other settled into a chair on the sidewalk. I asked if there was anything I could do for them; they thanked me and said they were fine.

"I was at my desk on the ninety-first floor," the white woman said. "I think the plane must have hit right above us, maybe on ninety-three or ninety-four. They told us to leave."

She told of her long descent down the stairwell of Tower One, how after a few flights she felt a second shudder, softer than the first, and figured this must have been from the other plane hitting Tower Two. She related all this in a flat, matter-of-fact voice, but her face was trembling, her knees unsteady.

"When I got outside, I saw people jumping. I didn't know they were people at first. I thought maybe it was just different things falling, you know? Maybe bits of the building or chairs or lamps. I really didn't know. Even now, I'm not sure that's what I saw, that maybe it wasn't people. Have you heard anything about people jumping?"

Her eyes were desperate and terribly sad, and they searched my face for a clue. I'd seen that look many times before — after car bombings or artillery attacks, on the faces of mothers looking for

lost sons — and it seemed that her mind was trying to erase what her eyes had seen, that with the right words at this fragile moment, the memory might be erased altogether.

"No," I told her. "I haven't heard anything about that. There's a lot of wild rumors flying around, but I haven't heard that one."

This seemed to calm her, and I asked if she'd like me to find her a chair.

"No, thank you," she said, wiping at her cheek with shaking fingers. "I just want to stand for a while, wait for the others."

I stayed with them, and we all gazed down the side street from which they had emerged, from which any other survivors coming this way would probably emerge. After a time, a lone figure appeared. She was a very pretty Hispanic woman in her mid-twenties, and she seemed oblivious to the fact that she had lost her shoes and was leaving behind drops of blood with each step. Just about the only way to reach someone in severe shock is to look directly into their eyes and talk softly, but this woman only stared straight ahead, so as she passed, I leaned close and whispered that she was bleeding, that there was a medical unit just ahead. She continued on without any indication she'd heard me.

We waited awhile longer, the two ladies and I, but no one else came down the street, and, finally, the white woman turned to her friend. "Well," she said, with that exaggerated exhalation that usually suggests impatience or that it's time to get motivated, "are you ready?"

The black woman nodded and got to her feet, and the two went off together down the sidewalk. I was sorry to see them go, because even just standing beside them in their vigil, I felt I was doing something. With them gone, I had no purpose again.

I came upon a large crowd gathered in Foley Square, in front of the New York Supreme Court building. Groups were being organized and corralled into little pens delineated with yellow police tape. It appeared most people were there to donate blood, their blood type marked in big black letters on their arms or T-shirts, and one young man moved about shouting in a hoarse voice, "O-negatives, we urgently need O-negatives." Except there was no one around to actually take blood, no vehicles to take anyone to a place where it might be done. It was organization for organization's sake, a plan of action being devised in the absence of either plan or ac-

tion. But if it was absurd, it was also inspiring; what I was seeing was the very first steps toward rebuilding an ordered society in a corner of Manhattan where it had suddenly vanished, and it was being done with black Magic Markers and yellow police tape by the natural leaders among us.

At one corner of the park, search-and-rescue volunteers were being divided into various groups, and I joined the one consisting of current and former members of the military. I chose the group both because I figured it would be among the first to go in and because I was drawn to its self-appointed leader: an athletic, bespectacled man in his late thirties with a crew cut and a bullhorn. Through the hot afternoon, he put us through our paces, ordering us to "form up" in columns or "fall out," to "rehydrate" ourselves, to "listen up, and listen good" to whatever new bits of information he had gleaned from somewhere. "Stay loose, men, and stay focused," our "commander" exhorted us. "There's a lot of desperate people in there, and they're counting on us."

"We kept running over body parts," the fireman whispered. He was staring into my eyes with a pleading look, as if seeking forgiveness. "I mean, the ash was so thick, you'd see things in the street, but you couldn't tell what they were until you ran over them. I mean, what the fuck were we supposed to do?"

I nodded, patted him on the shoulder, and when I did, he let out a single sharp sob, almost like a hiccup. I looked past him at the 150 or so other firemen resting in a tunnel nearby.

At about four o'clock, I and the rest of the "military team" had been bused over to the west side of Manhattan, just above the ruins. We had assumed we were about to go in, but instead we'd been told that another high-rise building was about to collapse and were ordered back toward the West Side Highway. In our retreat, we'd come upon the firemen in the tunnel.

I'd heard many rumors over the course of that day — that the Capitol had been hit, that another hijacked plane was shot down over the Hudson River — but a recurrent one held that a huge number of New York City firefighters were dead or missing; as I passed the firemen, I studied their faces for some clue as to its validity. I couldn't detect a pattern. At some tables they were talking, even laughing at some shared story, while at the next table over they were sleeping or simply staring into space.

One day in Chechnya, I'd come upon a group of Russian soldiers stranded on a remote firebase. The night before, they'd been attacked by the rebels, had taken a number of casualties, but now, in the false calm of day, they were scattered over the ground, some sound asleep, others crying, others contentedly playing cards or listening to music. It occurred to me then how in moments of emotional collapse, we simply mimic those around us — if you sit next to a laugher, you laugh, next to a crier, you cry, that if you get enough shell-shocked people together in one place, you won't discern any pattern at all.

On the West Side Highway, we linked up with some of the other search-and-rescue teams waiting to go in and huddled around to wait some more. The sun set over the river, and for a while, maybe a half hour, there was a stunning gold tinge to the sky and the buildings around us. Up the highway stretched a line of emergency vehicles and knots of waiting firemen and medics and police as far as the eye could see, and, as hard as it was for us to accept — and it was very, very hard — I think it began to dawn on all of us volunteers that if they were not going into the ruins and flames, neither were we.

At about midnight, I finally gave up hope and began the long walk north toward the perimeter line and the "normal" city that lay beyond. I remember that I passed a man walking his dog. For a fleeting instant, I felt an absolute rage at the sight, but the very next instant, I felt my eyes well up for reasons I wouldn't have been able to explain. I decided to keep to the quieter, less-peopled streets as I made my way home.

The following evening, I reached the edge of the disaster site, not as a "deputized" search-and-rescue volunteer but as a mere onlooker. A measure of official authority had been established by then, but only a measure; by cutting through the back streets below the Brooklyn Bridge, I charted a path past the police barricades and emerged onto Broadway at the corner of Ann Street. Across the street, the graves of St. Paul's were covered in ash and scattered papers, and along the wall next to me was an enormous pile of crudely made wood stretchers. Yesterday, one of the construction teams had gone off to make stretchers, and here they sat, unused, never to be used, gathering ash from the fires that still burned.

Walking south on Broadway, I came to the corner of Liberty

Street, just a block from where the World Trade towers had once stood. It was, of course, a bizarre scene, made more so by the ghostly glow of stage lights that illuminated the workers scrambling over the ruins. Enormous sections of the Tower Two facade jutted up at odd angles, and as shovels dug at the pile, little bursts of flame appeared beneath. I stood on the corner and watched for a time, but what I eventually began to notice were all the shoes scattered in the street before me. There were ladies' pumps, men's dress shoes, high heels, but they all looked much the same, twisted and mangled by either their owner's flight or the wheels of emergency vehicles, all half sunken in the ash-mud that coated everything here.

I can recall only one other time that I've ever written about shoes. It was in a book I wrote with my brother, an oral history of five wars taking place around the world. In the epilogue I had tried to sum up what war now meant to me, and the image that came to me was of a young man, a lotus-blossom seller I had met in Sri Lanka, sitting in his hut and holding up a pair of small green shoes. Two years earlier, guerrillas had suddenly appeared at the Buddhist shrine where he sold his flowers and started shooting anyone not quick enough to get out of their way — and that included the man's five-year-old son. The boy had lost four inches of his left leg, and that was now compensated for by a four-inch heel on his left shoe.

"And I suppose for me that is war," were the last words I'd written in the book, "that for a variety of reasons, all of which sound good, men shoot the children of lotus-blossom sellers and leave behind them little green shoes."

And now here I was again, not in Sri Lanka or Chechnya, but on the corner of Broadway and Liberty Street in downtown Manhattan, looking at the shoes that war leaves behind, and all at once, in this place I had tried so hard to reach, I didn't want to stay any longer, I didn't ever want to see it again.

On the night of Thursday, September 13, a dramatic thunderstorm approached New York from the northwest. It had been sixty hours since the attacks, and the people of the city were slowly emerging from their shock, their emotions settling down into anger and sadness. Throughout the city that day, impromptu memorials

had been erected, little altars of flowers and cards and candles wherever enough people decided to place them. What had also blossomed were a million small posters, photographs of those still missing, appeals from their families for any information on their whereabouts; they reminded me of so many other posters and families that I'd seen around the world — in Bosnia, in Guatemala — holding on to the memory of those who had vanished, refusing to relinquish hope that they might miraculously return. On that day, no one had been found alive at the World Trade Center.

At about one o'clock on Friday morning, the storm finally reached Manhattan. There had been times in the past when, coming back from a war zone, it had taken me time to get used to such storms, when I couldn't get out of my head how much the roar of thunder can sound like artillery or a collapsing building, how much the flash of lightning can look like something exploding in the distance. If it is possible to be simultaneously comforted and saddened by a thought — and, believe me, any crazy combination of emotions is possible in New York after September 11 — then I was comforted and saddened right then, knowing that across my city were hundreds of thousands of other people just like me, unable to sleep, unable to fully believe that what was passing over us was nothing more than a late-summer storm.

STEPHEN BODIO

Sovereigns of the Sky

FROM *The Atlantic Monthly*

IF YOU LOOK at photographs of the people of Central Asia, sooner or later you'll see a man with a bird. I have one such picture in a book published in 1930; another, a transparency, has the Russian space shuttle in the background. The man is a Kazakh or a Kyrgyz tribesman; usually he is mounted and wears a fur hat. But the real constant is the bird — a female golden eagle (in Russian, a *berkut*). She stands on her handler's right arm, her head level with his. Her hard-knuckled talons are as large as human hands. Her great eyes may stare unemotionally into the camera or they may be covered by a leather hood.

As a falconer and a writer about human-animal relations, I've always been interested in the Kazakh and Kyrgyz eaglers, the *berkutchi,* whose practices may offer the clearest window onto how people and birds first learned to hunt together. The renowned naturalist and bird artist Roger Tory Peterson once wrote that man emerged from the mists of history with a peregrine falcon perched on his fist. It's a nice image, but it contains the wrong bird. Game hawking specifically with peregrines — a stylized drama in which a small, finicky bird flies over a highly trained dog, "stooping," or diving, at any game bird the dog flushes — has been practiced for only a few centuries, and purely as recreation. Whatever game reaches the table is symbolic, a sign of a successful outing rather than necessary provender.

Falconers can be found in a wide range of cultures today; they may be working-class Englishmen, Turkish peasants, or Arab billionaires. But backtracking along the various trails of the sport, one

finds that they all converge on a single location: the Altai Mountains of Central Asia, ancestral home of the Turkic-speaking peoples. The Crusaders brought falconry practices back from the Arabs, who had learned them from the Turks; the Japanese learned from the Koreans, who had learned from the Chinese, who had learned from tribes "north of the waste." In the high valleys of the Altai, where present-day Siberia, Mongolia, and Kazakhstan come together, herders started hunting with eagles about six thousand years ago. When I began to pursue my interest in hunting with birds of prey, nearly forty years ago, I soon came across old tales of eagles that brought down large food animals, such as gazelles and deer, and protected their owners' herds against predators, including foxes and even wolves. I knew of nothing like this elsewhere in the world. Over the years the more I stared at the pictures from Central Asia, the more I wondered, Could the traditional practices of the *berkutchi* really have survived decades of forced settlement and collectivization?

In 1995 an old friend, the photographer David Edwards, went trekking in western Mongolia and returned with tales of people "from history, from legend, from myth." He spoke of Mongol sheep feasts, Tsataan who rode reindeer and lived in tepees, Kazakhs who wintered in adobe houses and hunted with eagles. Edwards said that the Kazakhs were hospitable and had eagles in every village. He knew a young Kazakh entrepreneur, Canat, who had learned English in the Soviet army and was willing to guide me. I was ready to go.

Some weeks later I stood blinking in a Mongolian courtyard in the blazing sun of a February morning. The night before, Canat and I had rattled into the village of Bayaan Nuur, in the northwestern province of Bayaan Olgii Aimag, in a Russian jeep. The village was near the home of Canat's mother-in-law, where we were staying, and Canat knew of a master eagler there. The eagler was a shepherd and potato farmer named Suleiman. His eagle, a two-year-old, dozed atop a tractor tire. She was nearly three feet from head to tail, thick and broad-shouldered, black-bodied and touched with gold on her neck. She wore a black-leather hood like those I had seen in the photos (eaglers generally keep their birds hooded except when they are flying, so that the birds will stay calm). Her bill

was charcoal-colored and gracefully curved; her feet shone like yellow stone. Pale fluff fanned out over the white bases of her tail feathers. Braided leashes connected heavy sheepskin anklets on her legs to the hub of the wheel. In the bright desert light she glowed like a dark sun, as elegant as a living thing can be.

Suleiman ushered us inside, to a brilliant-blue room. In it was another eagle, on a roughly carved tripod. A slender young man entered, carrying the first eagle on his right arm and a similar perch under his left. Canat explained that this was Suleiman's apprentice, Bakyt, who owned the second eagle, and that they were going to give the birds a drink. A child brought in a teapot and some lump sugar, decanting the tea into a drinking bowl and sweetening it while Canat translated. "Suleiman says that it is end of season. He has not flown eagles for two weeks. But tea and sugar give them energy, so they will be hungry and fly." Suleiman put one end of a length of rubber tubing into his mouth, like the end of a hookah, and made a joke ("He says it is the exhaust pipe"). He put the other end into the drinking bowl, sucked up some tea, and then emptied it into the first eagle's mouth. He repeated the process. The bird shook her head but otherwise remained still. "Now he will take the eagle's hood off," Canat said. "She will vomit fat if she has any." Indeed, after a moment the eagle gagged, brought up a little tea, shook her head again, and wiped her beak on the perch. She then "roused," shaking down all her feathers, and looked alertly about, as though a morning caffeine dose and purge were the most normal thing in the world. The other bird got a similar dosing, and we were ready to go.

Back out in the courtyard we found a bustling scene of organized chaos, with elements that spanned many centuries. A camel was signaled to kneel so that its rider could mount. Horses stood waiting as Suleiman gave brisk orders. Hunters slung rifles and shotguns over their shoulders, single-shot twelve-gauge Baikals. Siassi, our driver, fired up our jeep and popped in a cassette; wild Kazakh music with the rhythm of a galloping horse rang out loudly from the speakers. Suleiman motioned toward a ridge about a mile away: we would climb the rocks and sit on top while Suleiman's younger brothers beat the plain below for game. He, Bakyt, and the other riders set off.

A few minutes later we pulled up at the foot of the ridge. Sulei-

man gestured grandly from the back of his little white stallion, pointing his crop at the crest. "He says he will ride to the top," Canat told me. Astonishingly, Suleiman and Bakyt pointed their horses uphill and trotted straight up the rocks, carrying the eagles on their fists. Canat and I followed more cautiously on foot, holding on to the scant vegetation to keep from falling.

The view from the top was enormous. Red plains flattened out nearly as far as the eye could see. Snowy mountains, the high Altai, fringed the southern horizon; the black peaks in the province of Uvs reared up past the Hovds Gol (Blood River), to the east. Suleiman and Bakyt sat companionably with their eagles on the two highest boulders. Canat and I settled down nearby.

And for the next two hours nothing happened. The hunters sat with a hunter's calm, which soon flowed into me. Canat talked quietly, quizzing me, for example, about the meanings and etymology of the English word "flush": "Is it the same word? Rabbit flushed. Suleiman's son flush rabbit. We flush *toilet?*" But mostly we sat and watched.

Suddenly a hare popped out of the thin desert scrub below, well away from any beater. Suleiman unhooded his bird and pointed her toward the running speck. She lowered her head and stared, bobbed her head, stared again, shifted her feet, lifted her tail, and deposited a small amount of liquid droppings to lighten her load. She launched — and flew thirty feet to a rock spire below. She leaned forward, watched intently for a moment, and then sat upright. She looked back at Suleiman, fluffed her feathers, roused and relaxed, and began to pipe plaintively in his direction.

No falconer needed a translation for those actions: Sorry, too much work. Suleiman hiked down to retrieve his eagle and climbed back up to his horse. The hare was gone and the hunt was over, at least for the day.

Suleiman, Canat, and I made our way down, leaving the eagles on the summit under Bakyt's eye. When we reached the foot of the ridge, Suleiman produced a half-frozen hare on a cord from his bag. Birds, especially heavy ones like eagles, will readily fly at a lure for an easy reward even when they are not eager to hunt. He swung the lure until his bird launched herself, and then he dragged it along the sand, screaming like a dying rabbit. The eagle skidded into the lure, feet forward and crest up. Still screaming, Suleiman

dragged her a few feet to simulate a fight and then dropped the cord. The eagle began gobbling morsels of the rabbit.

After a moment Suleiman beckoned to Bakyt and began to pull on the eagle-encumbered lure, resuming the dying-rabbit scream and stabbing his gloved hand toward the ridge. As Suleiman's eagle bristled, I saw a speck enlarging against the clear blue sky: Bakyt's bird, coming in. She circled uneasily and then landed lightly beside the lure. To my surprise, the first eagle moved over, and they began to feed side by side. Suleiman grabbed my hand and pulled me in, encouraging me to stroke the birds, to fold an outstretched wing, finally to hood them. They were more docile than any birds I had ever worked with — even the sweet-natured peregrines I had reared from ten-day-old fluffballs.

That evening, as I talked with Suleiman over shallow bowls of vodka, the reason for the eagles' tameness became apparent: Kazakhs literally live with their birds, conducting daily activities in their presence, eating and even sleeping with them in the room. Western falconers, in contrast, keep their birds in separate houses, where they are alone most of the time. The training methods Suleiman described were straightforward and simple, involving none of the elaborate technology — for example, tiny tail-mounted radio transmitters to keep track of wandering birds — that Western falconers employ. An eagle is fed sitting on the fist or the lure from the moment she is taken from the nest or trapped. Once she learns that she has nothing to fear from her owner and that she is rewarded when she comes back, she is ready to hunt. Instinct has given her all the skills she needs for that.

Suleiman liked to hunt foxes rather than hares or other small game, and he said that a good bird should take forty in a season — a haul that represents a significant amount of income for her owner. (Fox skins are worth the equivalent of $30 or $40 each.) "So you train eagles because it is practical?" I said to tease him, knowing there was far more to it. "Not just practical," Suleiman said. "Because it is very traditional, and the most interesting thing I know. I am sixty, and still I am learning."

Finally I asked about his bird's refusal to go after the live hare. Suleiman reminded me that it was very late in the hunting season. His sheep had begun to drop their lambs, and he no longer had

time to hunt, so his bird was out of condition, both physically and mentally. The same was true of Bakyt's bird. Suleiman had dosed them with caffeine and flown them more to be polite to a guest than in expectation of success. In addition, the eagles were beginning their annual molt, during which they cannot be flown. He thought that most of the other eaglers in the area had already stopped flying their birds. To see a successful hunt I would have to come back.

Last fall I returned to Mongolia, accompanied by my wife, Libby. Canat and I had kept in touch over the years, and he agreed to serve as my guide again. This time he suggested that we hunt with his cousin Manai, a fierce-faced expert eagler who lives about twenty miles south of Olgii City.

As it happened, on our first day in Olgii City we ran into Manai in the bazaar. He was wearing a fox-fur hat made from one of his eagle's catches. He had buzzed into town for supplies on the quintessential Kazakh vehicle, a Russian motorcycle. After gathering our own provisions, we piled into Canat's battered Russian van and followed Manai into the tangle of dirt tracks that crisscross the mile-wide plain beneath the Altai. We followed one of the tracks up into the mountains and over a pass at nine thousand feet. Then we turned onto an even more rudimentary road for the climb to Manai's winter cabin, a thousand feet higher.

The cabin sat in a narrow valley framed from above by brown hills and dominated by the angular, white-clad mass of a still higher peak. Flocks of choughs and hill pigeons swirled in the deep-azure sky, and herds of yaks and horses grazed below. Manai's sons, aged eleven and fourteen, were out hunting with his eagle, a bird he had worked with for two years. When they arrived, the older son dismounted and tossed the eagle to the ground, where she shook down her feathers and stood placidly as he patted her head, much as one would pat a spaniel's. The eagle had gone after but missed a wolf on the volcanic ridge that formed the south wall of the valley. Manai declared that we would hunt there the following day.

We returned the next morning and met up with Manai and a neighbor of his on the ridge. Manai suggested that Canat and Libby drive along the base of the cliff, in order to see the flight in relative comfort, while he and his neighbor rode the ridge, carry-

ing their eagles on their fists. I was to scramble along the side of the slope in order to block any attempts of prey to flee downhill.

A half hour later, sweating and wheezing in my effort to keep up with the horsemen above and the van below, I saw Manai's eagle spring from his glove and start to climb. She unfurled her wings and slid sideways until she caught an updraft from the plain below. Instantly, barely moving her wings, she was carried up. When she reached a height of about two hundred feet, she turned back toward us and plummeted. Below her a fawn-colored corsac fox was cascading down the rocky ledges like a furry waterfall. The fox dodged, and the eagle missed, but she recovered, spread her wings, soared up fifty feet, and stooped again. This time there was no escape. The eagle slammed into the fox, raising a cloud of dust and snow that dissipated immediately in the wind. Her wings were spread in a black cloak, her head and crest raised like a dragon's. Suddenly lifeless, in the clutch of her talons, the fox was a compelling token of the most magnificent flight I have ever seen.

Back home, I sorted through the objects I had collected during my trips. They seemed like artifacts retrieved with a time machine: an old hood — a gift from Manai — that had belonged to an eagle who had killed a wolf and later been killed by one, a brand-new hood from Suleiman, a fox pelt. The *berkutchi*'s traditions had survived Stalinism, Russian jeeps, and video games, but I worried about new threats. Canat had told me that ecotourists and trekking expeditions were beginning to discover the Kazakhs. On my wall hangs a photo that gives cause for optimism: caught in a golden beam of afternoon light, Manai strums a *domboro* — a Kazakh two-string guitar — and serenades his eagle with a song he has composed for her.

WILLIAM BOOTH

Throw Junior from the Car

FROM *The Washington Post Magazine*

SINCE MY FATHER'S DEATH a few years back, my wife and I have begun to take an annual trip with my mother. All I can say is, you have not lived until you have driven with your mother through traffic circles in Rome. Traveling with your mom is a transforming experience. In my case, it transforms me into the Cruise Director.

"Relax," says my wife. "Have a nice cold beer."

"Or a nice cup of tea?" my mother pips, sitting on the couch, her bags — a collection of suitcases and mysterious paper sacks — neatly packed. I have been loading tackle boxes and birding binoculars and expedition quantities of emergency lubricants into the car and nattering on about mileage and schedules and dinner reservations. It is, like, three in the afternoon, and we have already had lunch twice and we are still not on the road from Los Angeles for our first destination in what I had planned as a relaxing but educational and tightly scripted trip up the central coast of California. I would show my mother a good time, and I did not care if it killed her.

I do not know why I feel this compulsion to show my mother a good time. With no help from me, she has in her early seventies become quite the accomplished traveler.

I remember a recent telephone conversation, which went something like this: "Sweetheart, I'm sorry I missed your birthday. Did you get my postcard?"

She thinks she mailed it from Helsinki, or maybe Fez? She goes to places like that now, on "cruises."

"We didn't get into the Royal Ballet," she confessed. "But we saw

some very nice folk dancing, with army men, I believe. And we did do the Hermitage."

"Wait a second. You were in Russia?"

The Cruise Director has never been to Russia. I crammed the last of the crap into the car and stomped on the gas.

When I was a kid, our family vacations were like home movies on fast forward, the film jumpy, the colors cartoony, a blur of motel swimming pools viewed with longing from the backseat of a hurtling Dodge Dart.

For most of the year, my father was a relatively sedentary company man, a real Clark Kent. But for two weeks in August, he was the Roadrunner. The man enjoyed crossing state lines.

The motel had not been built that could hold Pop longer than one night. My family could do a week at the shore in about eight hours.

"Nice beach," Dad would sigh in his Bermuda shorts. "Now back in the car."

A more observant child might have suspected his parents were on the lam. My mother was always making sandwiches, so we could keep moving. Years later, when I think about it, I realize that my parents (both only children, both the children of immigrants) had never really been on American-style family vacations themselves, so they didn't know what they were doing, American family vacation-wise. They were making it up as they went along.

I went to Europe for the first time with a backpack and $2,000 in traveler's checks in order to, I am ashamed to admit now, "find myself." My father always thought that was hilarious. "Maybe you could find yourself," he would say, "by mowing the lawn." For his first trip to Europe, he was handed a rifle, loaded onto a troopship, and sent to crush the Nazis.

So Mom and I are making new home movies in our heads, on these Togetherness Travels, driving past the dross of Malibu, and then breaking free north of L.A., onto the openness of the Oxnard Plain, through agricultural fields of cucumber and kale, the big sprinklers making rainbows; through dry hills of brown grass and diseased live oaks; through the microclimates of the central coast, first cold and heavy as a wet sweater, then blistering hot, sweating in a wet T-shirt contest; along the dunes, through the vineyards of zinfandel; past hippie enclaves and bobcat roadkill; past missile

sites and mission sites. And all along the way, my mom is sitting in the backseat, serene, and only rarely does she ask, Are we there yet?, and what have we done but play the musical chairs of life, me the Cruise Director, mother begging for a bathroom break. "Nice beach," I sigh. "Now back in the car."

"Would you like a cookie?"

There are things about the B&B experience that I find disturbing. Bedrooms with names, like "the Thistle," and doors without deadbolts. Strange people sharing your tub. And the phones. Why is it that there aren't any? What, exactly, are they afraid of? Everything that an adult with a credit card wants from a lodging — the twenty-four-hour prawn cocktails, the minibar with its platoon of Absolut vodka soldiers ready to give their lives, the freewheeling cable ("movie titles will not appear on your bill"), the glorious vaultlike anonymity of it all? A B&B is antimatter to all that.

And so, naturally, we find ourselves checking into one in Cambria, which the guidebook describes, quite nicely, as "a town that has spent too much time looking in the mirror." Total Tweeville.

Innkeeper John is wiping his apron and welcoming us to his dollhouse. The first thing to hit you is the reek of cinnamon and apples. You cannot turn around in a B&B without bumping into bowls of potpourri. Why is that? What smells are they hiding? John introduces us to his white poodle. "I was just baking," he says, but then, just so I don't get the wrong idea, he takes my hand and squeezes really hard. Did I mention the dog's name is Brittany? Ouch. His grip is a vise.

My mom loves the place. "No," she says, "I don't find this creepy at all. It is very, very nice. You did good."

We went out for dinner at Robin's and sat outside in the cool night air, warmed by braziers. We ate papery fillets of herby salmon and drank grassy Riesling from the local vineyards. When we returned to the B&B, my mom stopped in the parking lot and looked up.

"The stars," she whispered. "Have you ever seen so many stars?" I had a desire to hold her hand.

In the morning, I brace myself for breakfast. My mother is already seated, telling John stories about me. My mother's narratives are Tolstoyan. You need a cheat sheet to keep track of the characters.

John reappears with the breakfast. It is, I kid you not, stuffed French toast. Recipe adapted from Martha Stewart, natch. The toast thing is dense. The innkeeper is prattling on about it: a hand of bananas, loaves of bread, a quart of butter, a vat of cream cheese, a cask of syrup. Etc. John actually watches us eat it. "I promise," he says, "if you finish that, you won't be able to eat lunch." The sadistic bastard. Like that was a good thing.

Did I mention this particular B&B has a lot of teddy bears, which seem to watch you, closely, with their unblinking glass eyes? It is in keeping with a general theme, I believe, of the B&B as infantilizing simulacrum, Little Red Riding Hood, without the Big Bad Wolf.

Naturally, my mother buys a bear. Teddy is dressed in a pinafore, with a hat, cocked at a jaunty angle. We place her/him/it? on the dashboard.

What I really want to see is a super weaner. That is what they call elephant seal pups that have stolen milk from lactating females that are not their mothers and have reached enormous size, as if they had been fed a diet of nothing but stuffed French toast.

On November 25, 1990, a miraculous event transpired in a small cove just south of the Piedras Blancas lighthouse. A dozen pioneering elephant seals hauled themselves onto the sand and reclaimed their ancestral home. Amazing, because elephant seals were assumed to have gone extinct sometime in the 1880s, hunted to oblivion by shore whalers and sealers, bludgeoned to death or shot at point-blank range, and then rendered into lamp oil.

And yet — a tiny hidden population of a few dozen animals survived on an island off Baja Mexico, and now they are back, protected. Hundreds of thousands of them live in the Pacific Ocean, and about eight thousand elephant seals flop like spring breakers onto the beaches of Piedras Blancas to mate, birth, nurse, and molt each year.

The alpha bull males, which preside over harems and are covered in ugly purple scars, can grow to sixteen feet in length and more than five thousand pounds of glistening, rippling blubber. The biggest ones are known as "beachmasters." The idea of watching my mother watch one of these bad boys wade into his harem was irresistible. Payback, perhaps, for the time she took me to see *The Way We Were* hours after I had reached puberty, and the ex-

treme psychological damage done as we watched Robert Redford and Barbra Streisand get intimate, and as — I am not making this up — my mother actually reached over and . . . covered my eyes.

We pulled into the shoreside gravel lot, grabbed the bird glasses, and went looking for sex-crazed beachmasters.

"What is that?" my wife asks, and we stop to listen to one of the most disgusting sounds in the natural world, an elephant seal breathing. It is a thing you never forget: a harumphing, phlegmatic, burping, farting, snarfling grunt, like a monster grandfather hocking up a gigantic salty hairball.

"Oh, my," my mother says, clearly impressed, and the Cruise Director thinks: Bingo.

Hundreds of seals are splayed across the beach today, giant browny-gray-pink slugs, the super weaners and their beachmaster dads.

We buttonhole one of the volunteer docents from the Friends of the Elephant Seal group, a trim, sunny, attractive gent, and begin to ask extremely detailed questions about the mating rituals of oversize seals. Actually, I ask the detailed questions. There is something about the sound of the word "proboscis." Alas, the seals were not mating. They were molting. Big difference.

My mother shoots me a look that hovers between pride and embarrassment. Oh, gentle reader, if I could bottle that look. My mom and Mister Docent ignore me and begin to chat about her home in Florida, the Gulf shore breezes, the Kremlinology of condo politics, and manatees. A shared moment.

Back in the car, I look into the rearview mirror and ask my mother whether she found Mister Docent at all suitable as a possible second husband.

"You just keep your eyes on the road," my mother says, squinting. But is that a girlish blush? I know that in addition to her volunteer duties at the public library, she is a closeted devotee of the romance novel genre, the bodice-rippers she peels through with titles like *The Overripe Heather.*

"You're not my son," Mom says.

"I am a super weaner!" I say.

My wife snorts: "You got that right."

Looming like a swirling black hole of indescribable supermagnetism on the central coast of California is the fabled Hearst Cas-

tle. You cannot resist its power, try as you might. The Cruise Director called the toll-free line, said, Yes, master, I have a credit card, and made reservations for three on the "Experience Tour."

We board a bus at the Visitor Center and, at thrilling high speeds, ascend the twisting five miles from coast to rocky aerie (the Enchanted Hill) where the newspaper mogul William Randolph Hearst built his monster mansion by the sea. At the steps leading to the Neptune Pool, our group is met by the Tour Guide, our no-funny-business hostess, and her loyal assistant, the Tour Drover, whose job it is to herd stragglers.

The Tour Guide begins by telling us that despite what informed people may think, Hearst did not go around the world with "a checkbook and a crowbar," removing Roman temple facades, Gothic tapestries, French caskets made of rock crystal, and Florentine coats of arms. No, the Chief bought through catalogues, from auctions. He was that rare gazillionaire of taste and intelligence, we are told.

Which is interesting, because the castle stands as a monument to an egomaniacal, compulsively acquisitive, bullying control freak who ran an empire of newspapers and magazines and thought he should be president of the United States. The Hearst Castle is the man, and property and publisher combine to produce a wonderful, over-the-top amusement park. Hearst was an American Original.

Consider his instructions to Julia Morgan, his architect. The main house, the Chief instructed, should stand like a cathedral at the center of an Italian hill town, but done in a style he described as "Japo-Swisso." There are Art Deco bathrooms and Roman fountains and Egyptian sculptures and Spanish hacienda tiles and a Venetian pool and a medieval dining hall (called the Refectory), complete with bottles of yellow mustard as condiment.

But the Tour Guide is reverent, a pious hagiographer. "Imagine," she says, sotto voce, to the group herded into the Assembly Room, "there is Clark Gable talking with Mary Pickford, and over at the piano, Harpo Marx is playing, and Charlie Chaplin is sitting down to cards."

Imagine, the horror. David Nasaw, in his fine work *The Chief: The Life of William Randolph Hearst,* describes a weekend at the castle. Guests are invited/summoned/imported from Hollywood, includ-

ing not only the stars but Hearst's favorite hacks. Imagine: Bobby DeNiro and Britney Spears forced to spend the weekend with Joan Rivers and the staff from the E! channel.

The actor David Niven, in his autobiography, recalled that W.R. had three cardinal rules: "'No drunkenness,' 'No bad language or off-color jokes,' and, above all, 'No sexual intercourse between unmarried couples.' This last was a strange piece of puritanism from a man living openly with his mistress, but it was rigorously enforced."

The Tour Guide does not dish. But my mother enjoys the castle. Mom is, after all, the Sun Region Representative of the Embroiderers Guild of America, and the woman appreciates fine needlework when she sees it on sixteenth-century tapestries of classical hunting scenes. But she is not bowled over.

As she reminds me later, the Hearst Castle is "very nice," with "a stunning view" and "a beautiful pool." But "it's their job," my mother says, "to make it all sound more glamorous than it really was." My mom is no fool.

Twisting and turning, Teddy's head snapping left then right on the dashboard, we wind our way up Highway 1 to El Sur Grande, the Big South, a terrain of steep mountains crumbling into gulping surf, so woolly and wild even the Spanish conquistadors gave it a pass. There were a few rancheros, the first pioneering gringos, then the beatniks and hippies.

Big Sur today lives on in a kind of suspended animation, tended by caretakers. Because of its splendid isolation, and its accessibility to L.A. and the Bay Area, Big Sur has become a refuge for the rich, who don't actually live here; they just own all the houses. Tourists still flock to the cliff-side Nepenthe, for the great sunsets, bad food, and "Astrology Nights," but the cool daddy-os playing bongos are long gone, replaced by twenty-something dot-commers with goatees. Hunter Thompson doesn't soak in the hot tubs at Esalen anymore. Henry Miller moved to Los Angeles and died in peace. The guy at the gas station is still listening to Canned Heat, but the Mexican cooks sleep in their vans. The real California Casual.

A room today in the Tree House (featuring "a window seat and writing desk") at the ecotouristic Post Ranch Inn will set you back $655 a night, that's how rugged it is. Big Sur will soothe your soul, and the masseuse will rub away the kinks, if you have the dough.

We spent our evenings at the more modest Glen Oaks Motel, which prefers payment in cash, upfront.

We wound down to Pfeiffer Beach, where slobbering happy dogs ran without their leashes, and we walked along the sand, the water as cold as a fresh martini. Big Sur is a nostalgia trip now, but the ocean is still here, and its surge against the rocky haystacks fills your ears like a heartbeat.

We meandered in the redwood forests. My mother had never seen such big old trees. The slanted, gemstone light; the hush of duff beneath your feet. Visitors have said it before, and my mom said it again, which does not make it less so: "It's like a cathedral," she said. Holy space.

My mother's maiden name is Gokemeier, and she is the daughter of August and Elsie, Lutherans who immigrated to America from Germany as adults. August came first, on seaman's papers, and he jumped ship to become an illegal alien, something my mother tends to gloss over. It was all sorted out later with the INS and everybody became real Americans.

August was a waiter in New York City, and later a fishmonger, who prospered during the forties, despite his heavy accent and previous military service in World War I for the kaiser, because of wartime rationing and because of, even better, the Catholics, who had to eat fish on Fridays. On my mother's twelfth birthday, August gave her a bicycle, and it was only later that she was made to understand that the bicycle would be used by her to deliver flounders.

So, naturally, my mother fell in love and married a Catholic, my Irish-American father, and she converted, and today is a devout member of the Church of the Incarnation. One of its Irish priests, Father Joe, who looks like Mel Gibson, buried my pop and has been a great comfort.

During our coastal cruise, we visited three of the twenty-one missions erected by the Catholic church with the collusion of the Spanish crown to lay claim to and control California and its indigenous population. On the drive home, we stopped at Mission San Miguel Arcangel, perhaps my favorite.

The mission church, more than two hundred years old, is made of adobe brick and lime, and still shows, in faded Mother Mary blues and sunflower yellows, the original frescoes painted in the

nave. It is hot as hell, but the parking lot and street are filling rapidly with cars. It appears that a choral group from Los Angeles has come to sing Gregorian chants, to raise money for the restoration of the church, which is still occupied by Franciscans who serve the local community. The Cruise Director slips a crisp twenty into the tip jar.

The plainsong, the tonality and rhythm of the chant, is so old and sublime, like music as time travel. You imagine the smell of the barefoot Salinan Indians, clothed in ugly rough sacks, kneeling on the hard stone.

We wander out into the church cemetery, a sunbaked courtyard of hard white dirt and a few struggling oleanders. The tombstones have been vandalized. It does not look like anyone really gives a damn. A plaque informs visitors that the first Indian was christened on July 25, 1797, the day of the church's founding, and was buried here a year later. In the next few years, the sign informs us coyly, others followed him, interred here and in "adjoining plots." Mission records record 2,249 Indian deaths.

We look around. The dead — from disease, from starvation, from melancholy? — must have been buried in mass graves, like cordwood. No stone marks their resting places. The sad truth is that the romantic Spanish missions were death camps for the California Indians, not that anybody tending the memories of these romantic sites is ever going to tell you that, but it's true.

Later, we were talking, and my mother suggested that the Spanish priests probably weren't bad people, they just did something bad. That's my mom, always looking for the good.

I want to travel with her for years and years and years.

Postcards from the Fair

FROM *The Oxford American*

IT'S HOT. A haze of heat and dust floats over the road, a rolling two-lane through the red hills out of Philadelphia, Mississippi. It's July, ten in the morning. The usual not-much around every corner, BOILED PEANUTS and trailer houses and the kind of country house that seems a little too fancy for its size, scaled-down Taras behind brick walls. Nobody's out, no tractors or cows or pulp trucks. You feel the heat through the window, like touching the glass of an oven door, and it feels like everybody's been driven inside or driven away.

Then you come around the last corner and in front of you is a bustling city, cars and cops and horse trailers and little bright-colored houses jammed up all along one side of the road. Welcome to the Neshoba County Fair, the world's oldest and largest campground fair.

And what exactly is a campground fair? At first, 109 years ago, it meant families tenting out on the grounds, then, later, building small dirt-floored shacks to stay in for the week. Today there are around six hundred of these cabins, individually owned. Families gather, friends assemble (the sleeping quarters upstairs in some of the cabins resemble old-style Pullman cars, with tiers of curtained bunks), everybody gets a cold beverage out of the cooler, and then several things start to happen.

You want to see some real redneck stuff, just stick around. (Horse-racing fan, on his way out)

What happens is: Over the course of the last couple of horse

races, people start to gather at the gates, holding their chairs. It's a long afternoon of racing, and by the end, it's half past four or five o'clock on a hot, red-dust afternoon in the Mississippi hills. Everybody's in tank tops and shorts, clutching a Styrofoam cup of something in one hand and a chair — or two, or four — in the other. The chairs are ordinary aluminum-and-plastic-webbing jobs in every shade of plaid the Taiwanese can devise. Some of the men have several chairs already bound together arm-to-arm with duct tape. The security men, all in black, self-important and sweltering, stand at the gates talking into their radios. There are four gates, and each one has fifty or more people milling around behind it. The water truck makes one last pass, as does the tractor with the chain thing dragging along behind it to smooth the track.

Then the track announcer shouts *Go!* into the microphone, and everybody jumps, and the gates open.

It's pell-mell, ridiculous; grown men and women elbowing teenagers out of the way, little kids lost at the edge of the scuffle, and everybody diving for the best real estate, the track directly in front of the grandstand, where the night's show will be. You dive in, unfold, stake your ground, and try to hold it for your buddies while other chairs unfold around you, sweaty people jamming into your space, hustling their rows of chairs together and then starting to tape them up while you still can't see your buddy, and then it's over. Two or three hundred chairs sit in nice even rows, and the rest of us wonder exactly what happened and how it happened so quickly.

And if that night's show isn't really worth it — if halfway through the 38 Special concert, for instance, a third of the hard-fought chairs are empty — it doesn't matter. It's the race that matters, the good spot.

It used to be a lot better, fights and everything, but now they've cleaned it all up. (Overheard)

Brisket with bacon, smoked brisket, ribs, chicken, ham, and lima beans, green beans with bacon, cauliflower casserole with cheese, potato casserole with cheese, unidentified casserole with cheese and a potato-chip crust, deviled eggs, egg salad sandwiches, the table piled high with food for fifty, and fifty people there to help eat it, friends and family and lucky strangers — like us! — invited in off the Square or connected by some thin thread of a connection,

the friend of a cousin of a friend of the cook's, but that seems to be enough, everybody's invited, and there's food for everybody: coleslaw, Jell-O salad, banana pudding with vanilla wafers, banana pudding with whipped cream, cold Cokes, cold beer (one word: colbeer), Sam's Club spring water, cold tea, hot coffee.

There was Grandma on the front porch, her oxygen hose in one hand and a cigarette in the other. (Overheard)

When was the last time you heard of a cakewalk? But here it is, alive and well. The cakes — sugar and pink and caramel — sit off to the side while eighty-six adults and sixty children shuffle around a circle of numbers to the Steve Miller Band's *Greatest Hits.* When the music stops, a number is called, and whoever is standing on that number gets a cake. Simple — except for the business of buying the tickets and collecting the tickets and standing in line while somebody figures out where the tickets got to, and then moving the whole line to the other side of the building so that everybody can stand in the shade, and then waiting around for another fifteen minutes trying to figure out where the tickets got off to and all of this before the cakewalk even starts, and the cakewalk takes forever. But everybody's enjoying themselves. The children get a kick out of watching their mothers shuffle around in a circle, making mistakes, clumsy. It's not like this is difficult, but they make a mess out of it anyway, and this is the fun of it. If this were an efficient cakewalk, it would be no fun at all.

You want to know what goes on at the fair, you've got to know what goes on in the front of the house and what goes on in the back of the house. (Overheard)

The fair: It's not one thing, it's several dozen different things happening all in the same place, a family reunion here, a six-day drunk there, a chance to watch the ponies or to fire up the Southern Pride stainless steel trailerized barbecue pit and cook a half dozen turkeys. Politicians come for the politics, teenagers come because their parents make them (but they end up having fun anyway). All this has grown up organically over time, plenty of time. The fair was officially organized in 1891; the horse racing started in 1894; the politicians started up in 1896; and the beautiful old oaks in Founders Square — the central heartbeat of the fair — were planted in 1898.

What everybody has in common, though, is that everybody stays. All the cabins are organized into neighborhoods, and everybody knows their neighborhood — Happy Hollow, Beverly Hills, Founders Square, Neon Alley — suits them better than any of the others would.

The average fair cabin is two stories tall with porches on both floors, the doors open on the bottom so that passersby can see in. The old ones are fan-driven, louvered, and ventilated, but some of the new ones are air-conditioned. A resident of Beverly Hills scandalized himself by building a three-story fair cabin with carpeting and a chandelier, but nearly all the rest have a ramshackle look, as if they had gotten there by accident and were only sticking around for a minute. The paint jobs are as bright and playful as children's party decorations; one of the most vivid belongs to a Florida Gators fan who painted his house orange and his porch blue and then had his kids dip their feet in yellow paint and walk around on the blue porch. The Ole Miss and Mississippi State colors are the most popular, the Rebel and the Bulldog fighting for prominence, as are the Stars and Stripes versus the Stars and Bars. (The CSA seemed to be winning last year's battle.) Airplanes, pinwheels, fireworks, even some accomplished Impressionist views of fairgoers can be seen on the walls of some cabin or another. And this disarray is maintained by some careful rules about what can and can't be built. My favorite of the "House and Ground Rules" (1996) says: "Materials that are imitations of other materials, such as aluminum siding, vinyl siding, plastic coated wood products, and patterned plywood, shall be discouraged."

(Much of this rulebook seems to have been written by an elderly person in a bad mood. "It is a privilege to have car permits," says Rule 16. "They are for entering the fairground and parking — NOT FOR RIDING AROUND." And Rule 7 states: "DURING THE OFF-SEASON, ALL LOUD NOISES AND AMPLIFIED MUSIC MUST END AT MIDNIGHT. Parties continuing after midnight must be conducted in an orderly and quiet manner, without amplified music.")

The cabins, anyway, are grouped together in rows, the rows facing each other across a sawdust-covered alley fifteen or twenty feet wide. The cars are restricted to the backs of the houses so that the alley becomes an extended outdoor living room. This is where you want to walk, down the shady, quiet lanes between the porches, say-

ing hello or waving to the people out on their rockers and swings. In the daytime, spindly trees shade the ground, and children play in the shade, many of them with their cabin numbers written on their arms in permanent marker so they can be returned if lost, hungry, or wet. At night the party lights all come on, icicle lights and Japanese lanterns, chili-pepper lights and Bud bottles, flamingos and Elvises, and then the real work of the fair starts in earnest: visiting, sitting, rocking.

"I was one of eight children," the Honorable David Chandler says. "Daddy was a pulpwood driver, and Mama worked at the factory. I got a job at the steel mill at night and started college in the daytime."

At first it isn't crazy clear what this has to do with his candidacy for appellate court judge, District 1. But as the morning wears on, I discover that by some strange coincidence all the other candidates have strong working-class roots, too. Not only that, but they all have a sincere religious faith, a loving family, and a good work ethic. They may not be the smartest or the slickest, but they promise that they will be the hardest-working judge (senator, congressman, commissioner of public service) that Mississippi has ever seen.

The crowd is listless, attempting to cool themselves off with the souvenir fans that the candidates' helpers are handing out. When the bus from East Central Community College pulls up and the cheerleaders get off in red spangly outfits, right behind the stage, it's impossible to keep your attention on the speaker. But this is an off year; when the statewide races come around every four years, the house is packed, the TV cameras lined up, and the reporters with their notebooks ready. Ronald Reagan kicked off his 1980 campaign here, an event that I saw picture after picture of, hanging in different cabins like photographs of JFK in an Irish village. And Michael Dukakis spoke here, an event that I find impossible to imagine. But this is an off year. Nothing's happening, not till horse racing, or at least till lunch.

(A persistent rumor went the rounds that George W. Bush was supposed to show — had even, according to one source, rented out a floor of the nearby Choctaw casino for a fundraiser — but backed out at the last minute, thinking that Philadelphia, Mississippi, might be sending the wrong message. This is as close as any-

body got to talking about the history of the place. I didn't ask, they didn't say — but it was clear, talking about Bush, that they felt the sting.)

"My favorite color is baby blue, my favorite food is dirty rice, and my hobbies include cheerleading, playing softball, singing, and talking on the phone with my friends," says contestant number five, and a little sigh of approval whispers through the grandstand. One breath of cynicism would stop the pageant in its tracks, would turn these beauty queens back into what they really are: small-town high school girls in glittery dresses, girls who don't really know how to walk. I don't see the magic myself. The backdrop doesn't look as starry and glamorous as it's supposed to; it looks like Christmas tree lights and cardboard and wrapping paper stapled onto the stage. And the singing! "I Wonder If God Cries"! But this isn't meant for me; I'll sneak out now and leave the pageant to those who love it — and they do, they love it, the beautiful girls up there in the lights . . .

> Q: *Is the talent show still going on?*
> A: *That's what they call it.* (Overheard)

I saw that trotting horse, and I thought: That's it, that's what I want to do, um-hm. (Robert Chambliss, owner and trainer of Proud Lizz)

The betting technique favored by the experts here is to take a set of cards with the same number of horses in the race — ace through seven for a seven-horse race — pick a card, and that's your horse. Everybody bets their horse, and the winner takes all.

Either that or you can take the racing program and cut it up into little strips and fold the strips and put them into a hat and pick your horse that way, but it's a lot more work. You have to bet for yourself here — there's no parimutuel window, no tote board, no racing form. There's no money in this, not for the track and not for the trainers. People race here not for the money but because they want to beat each other.

Where you want to be is up on the balcony of one of the cabins that line the back of the racetrack, up in the shade of the big trees with a cold glass of something and a fan blowing on your neck. These cabins are so close, you can hear the jockeys talking to their

horses as they pass, hear the crack of the whip on the horse's back, see the white sweat, feel the speed and power. This is harness racing mostly — although there are a couple of thoroughbred and quarter horse races at the end of the day — and these races are fought with an excess of daring and drive, wheel-to-wheel, that's completely out of proportion to the stakes.

After a while of this, though, you may start to feel left out. It's certainly pleasant up on the balcony, a comfortable way to spend the afternoon, but you may want to get closer to the action — and you can.

I spent my fair afternoons in the shade of a pair of tall pines, down along the rail, down at the gate where the stables open up onto the track. All the noise and color are here: the drivers in nylon silks spattered with red mud that looks like blood, the rearing horses, the stable hands and helpers and wives with picnic lunches. The serious betters are down here, too, with shirt pockets full of twenty-dollar bills, checking the horses on their exercise rounds, checking the jockeys. "I'll take the four horse against the field!" yells a white guy with a midperiod George Jones haircut. "Two to one! I'll take the four horse two to one! Four to one!"

He's still shouting as the horses round the far turn and the crowd at the rail starts to liven up. "Come on!" somebody shouts — a trainer, a friend of the jockey's, somebody — "Come on, man, get him off that rail! Let him run!" It's all good-natured, but everybody wants to win, and you can see which horse is ahead by which group is the most tense — not yelling but tense, muttering, clutching the programs — because it's a long race, and it's not over yet. "Ain't nobody going to beat my horse!" a great, tall black man in a cowboy hat yells, watching them stream out of the last curve and pound for the finish. "Ain't nobody!"

It's an interesting crowd, the trainers: black people with a little bit of money, from the looks of the Lincolns and the cowboy Cadillacs parked around some of the stables, diesel pickups towing eight-horse trailers. Most of the operations are not so fancy, but still — there's hardly gas money in this style of racing, without the betting windows. Once in a while they might raise a colt with real promise and send him racing up North, but mostly this is just for the love of it. "Just a bunch of black guys trying to build it up," says Johnny Tillman, leaning on his pickup. His son Jamaica has just

ridden the last race they'll run this year, and they didn't win any of them. But they'll be back.

Say you're sixteen, somebody's cousin, stuck at the fair for a week, and you don't know anybody you're not related to. Maybe you're from Mobile or Meridian or Bay Minette. Maybe you start off thinking this is a drag.

About ten o'clock on the first night you're there, though, you realize that this is not a drag — that this is, in fact, arguably the best place to be sixteen on the face of the planet. There is beer, for one thing. The whole fairgrounds is awash in beer, and nobody's paying all that much attention, and, besides, nobody can really tell what's in that giant Mississippi State plastic mug you're toting around, not till you start to wobble and yell. There are girls, too, girls on vacation — not like back home, under the watchful eyes of everybody. There's wiggle room at the fair. There's lots of out-of-the-way places and lots of darkness around the edges, and nobody is really keeping track of you because there's nowhere to go, really, no cars to wreck or restaurants to get kicked out of. You're on your own, with girls and beer. King of the world.

So what you do is show off, a little drunk and braggadocio, try to win a four-foot fuzzy puppy for some girl you just met. You buy a light stick, Day-Glo green, to prop in the corner of your mouth; you buy one for the girl, too, and then you try to talk her onto the Zipper or the Kamikaze or the Viking Boat. In the end you settle for the Tilt-A-Whirl, and then you end up riding the Zipper anyway with your cousin, and you succeed in not throwing up, although all of your change and your cigarette lighter come raining down when your cousin flips you upside down. You buy the girl a glow-in-the-dark blue drink and win her a goldfish in a little plastic tank.

And afterward, if you didn't get too drunk, you might end up down at the Square for some late-night dancing, some awful local band that's good enough to keep you up till two, two in the morning, and nobody's minding you, and nobody's keeping score, and that girl you just met is still carrying that goldfish around, and there's all that soft, inviting darkness all around the edges of the light . . .

Or maybe not. Maybe your cousin found a bottle of gin. Maybe you wind up on somebody's porch, and you can't move, and you

can't talk, and you feel like the whole world is going away from you, the girl, the goldfish, the ten thousand whirling flashing lights of the midway. It doesn't matter; there's always tomorrow. It doesn't matter, but it doesn't help the feeling: It's all going on, and you're missing it. It's all going on. The best place to be sixteen.

It's just like the way I've always imagined Hell: It's hot, I'm thirsty, and everybody I know is here. (A first-time visitor wearing long pants and a sport coat)

Everybody stays, and everybody comes back. Clayton Kilgore has been fairgoing since childhood; retired from J. C. Penney after a career that took him to every corner of the United States, he makes the pilgrimage every year from Alabama to Neshoba County. His daughters come from North Carolina and Georgia with the children, and they spend a family week at the fair — the "orderly and quiet" party that the rulebook mentions. This little temporary village in the middle of nowhere has insinuated itself into family life, a place where "what we do" shades invisibly into "who we are." With its slow pace and old-fashioned recreations, the Neshoba County Fair seems like a thing out of the past. But it isn't the past, not yet, not till it's gone — and it's going strong, thanks.

ROD DAVIS

A Rio Runs Through It

FROM *The San Antonio Express-News*

1. The Tip of Texas

THE TWO *mexicanos* had come about halfway across the hidden
sandbar at the mouth of the Rio Grande to throw their nets, and I
was stripping off my jeans and T-shirt as fast as I could to get out
and meet them. To their backs the Gulf of Mexico broke so loudly
that hailing was a waste of breath. I'd heard of the submerged pas-
sage at Boca Chica but hadn't figured on finding it, since few peo-
ple ever venture out to this isolated and hurricane-scoured place
that marks the southern end of the historian Paul Horgan's "great
river," and of Texas, and of the United States. And marked the start
of a personal sojourn along the 1,250-mile length of a *frontera* that
defines two countries and yet is neither. The Texas-Mexico border:
volatile, porous, violent, corrupt, greedy, beautiful, seductive, as
distinct from its linked nations as the husk of a coconut from the
meat inside.

On the Mexican side, maybe a hundred yards away, a few chil-
dren sought relief in black inner tubes safely upstream from the
turbulence that churned at the meeting of the river and the sea.
Their mothers and fathers sat on the banks next to Styrofoam cool-
ers, pole-fishing for supper. I was the sole delegate on the U.S. side,
and a poor one at that, hastily clad in dirty running shorts and
making for the swelling tide.

The present and the past seemed inseparable here. Directly
south of me once stood the Mexican port of Bagdad, boomtown
cotton outlet for the Confederacy. On my side had been Clarks-

ville. Both were wiped away by the hurricane of 1867. Not far inland, U.S. forces under Zachary Taylor provoked an attack by Mexican troops in 1846, giving President Polk the Tonkin Gulf pretext of his day. Thus began the land-grab war that resulted in the humiliation of Mexico, the jailing of Henry David Thoreau, and the imposition and often violent enforcement of a U.S. border today, here to San Diego, that was once Mexico all the way up to Utah. To my west, toward Brownsville, thick tropical foliage once covered the banks of what Spanish explorers had originally named Rio de las Palmas.

In this century, dams and cities and farms far upstream have depleted the Rio Grande so ruthlessly that the Gulf tides rush in, turning the mouth to salt, the land from here to Brownsville morphed into something Rome might have visited upon Carthage. It is estimated that 98 percent of the river's original natural habitat has been destroyed. The gray-brown waters are so full of DDT, PCBs, sewage, and industrial metals such as mercury, arsenic, and copper that a cleanup will cost at least $8 billion over ten years, if it ever happens. This section, below Laredo and Nuevo Laredo, cities that, like many along the border, draw their drinking water from the river, is the most toxic of all.

There is worse. Sometime this spring, the unprecedented upstream siphoning, combined with runoff and severe clogging from opportunistic hydrilla and water hyacinths, so depleted the "great river" that it couldn't reach its mouth. The lagoons and estuaries along its side to Boca Chica from Brownsville lay arid and sunbaked.

On Memorial Day weekend, the river fell at least one hundred yards short of the Gulf. The city of Matamoros, across from Brownsville, has begun suspending water services. Upstream releases from Falcon Lake, seven days' flow from the west and itself forty-four feet below normal and getting lower, could theoretically raise the level, and dredging might get the river to the culmination of its 1,900-mile search for an outlet. And it could rain torrents. But at least for now, you could walk across what I was about to wade first in 1997 and recently thought to try again. If the river's reach can no longer exceed its grasp — an unspeakable violation — at least I can bear witness to the memory of the generations who knew things to be otherwise.

Ironically, on that day when the imperiled waters ran their natural course, they nearly drowned me. The sandbar was hard to follow and I stepped off into an undertow pulling me slowly but unmistakably into the Gulf. When I broke free, and found footing in a shallow stretch, I was so elated to be alive I tore off my gym trunks and splashed around like a baptismal mutant. Then I realized I had company on the American side. A white pickup with Texas plates had pulled up about twenty yards down from my jeep. A Latino man and woman and several children spilled out, unloading fishing tackle, ice chests, and plastic floats. The gym shorts went back on.

If my new neighbors had seen me, or cared, they didn't show it, so I walked on over and said hello. We spoke in the half Spanish, half English that is the vernacular. They were from Brownsville, taking the afternoon off. I asked the man if he was worried about eating fish from such a polluted river. He said he never thought about it. Seeing me dripping wet, fresh from said river, added what we both realized was authority to his indifference and he went about his preparations.

This time, I saw no one fishing on either side. Only the receding figure of another *mexicano,* this one walking back across the silt and sand to "his" country from "mine," after being dropped off halfway across my vanished sandbar by the U.S. Border Patrol.

As borders go, Texas-Mexico is the edge of edges. At its centerpoint, Laredo has produced the busiest land port in the country. Not so far away, Starr County remains the poorest county in the state. Terrell County is one of the most sparsely inhabited, only .5 people per square mile and a total population of 1,081, down 23 percent from a decade ago. Of the state's four fastest-growing areas, three — Brownsville–Harlingen–San Benito, McAllen-Mission-Edinburg, and Laredo — are on the border. In the Big Bend, the river cuts through the sierra to mark the boundary of a stark and bewitching (and, ironically, polluted) national park that is also a gateway for some of the biggest drug-smuggling operations in the hemisphere. El Paso, Texan in name only, is slowly being swallowed by its twin, Ciudad Juárez, a grim and violent poster child to multinational capitalism.

Almost everywhere along the border zone, 90 to 95 percent of

the local population is of Mexican descent. For the better part of two centuries, U.S. fears of and prejudices toward this population have pitched *la frontera* into wars, violence, and world-class population dislocations. The manifestation of that anxiety, both nationalistic and racist, today can be found in the frustrating pseudo-wars against illegal immigrants and drugs, the complex combination of which may make this the most dangerous era of all. You can sense it all along the border, and you can see it day and night in the sheer blanketing of the region with an unprecedented array of armed agents, from Border Patrol to DEA to Marines to giant Air Force surveillance blimps.

Undocumented immigrants, drug smugglers, resident aliens, American citizens — it's so mixed up that anyone at any time is subject to search within twenty-five miles of the river. The Border Patrol runs checkpoints on the highways farther north than that. By the time I got to El Paso, I would variously hear this southern rim of the United States described, without tones of hyperbole, as "the DMZ," "the West Bank," "Somalia," "a police state," and "a Constitution-free zone." It is also politically expendable. This spring, the Texas Legislature voted against sending even a paltry $250 million "Marshall Plan" aid package to help with the region's economic development, and the governor vetoed a health insurance package.

I went to the border because the border is the future.

Downtown Brownsville was just a few blocks away, but in the vacant field where Manny Figueroa slammed the white Ford Explorer to a hard stop and jumped out, we were in mesquite and brush so thick we might as well have been in the backcountry. Less than two minutes ago, Figueroa and Frank Rodriguez, then both senior Border Patrol agents, had been routinely cruising the streets of this southernmost city in Texas, when Rodriguez spotted two men coming up a small residential street not far from the city's hard-bitten central district. It was easy to make the pair for undocumented immigrants: they clutched bulging plastic grocery bags, were walking northward in the "stagger" formation, one a little ahead of the other for better lookout, but most of all they turned south and ran.

Figueroa, a handsome ex-Marine who had just earned his supervisor's gold bars (he has since transferred to El Cajon, California),

turned the truck fast and gunned toward the place he knew the men would be heading, an overgrown field that provided heavy cover and wasn't far from the tall reeds at the river. Speeding through a west side barrio of modest houses, we almost cut them off at a concrete drainage culvert, but they got to the field. Rodriguez, a tough and savvy forty-year-old (since promoted to field operations supervisor), had grown up in the city and could do this in his sleep. He jumped out and loped up the culvert. "Hang on," said Figueroa, and gunned it along a jolting trail surrounding a mesquite thicket till he came to the place where he thought he had the men in a pincer.

Cutting for sign, as agents call tracking, he followed beat-down grass high as my head and footprints in strips of sandy soil. At several places the mesquite opened to clearings littered with plastic bags, tin cans, cast-off gallon water jugs, shards of clothing so torn even the desperately poor, who buy *ropa usada* by the pound, can't wear them. We passed a freshly squashed can of ranch-style beans. "Probably ran over their lunch," he said.

I was trying to keep switches of scrub from slapping my face when I heard Figueroa call out in Spanish. "Who are you? Where are you going? Where are you from?" He indicated some high weeds, and although I heard voices, at first I saw nothing. Then a leg moved; I could see two meek figures lying close to the ground. Rodriguez came up from the rear. Busted.

The men, both small, thin, dark-skinned, dressed in old T-shirts and soiled jeans — so *mojado* they never had a chance — got up almost obediently, without struggle, accepting their innings in the Big Game. They'd just been shopping, one of them said, and were on their way back to Matamoros. Their bags held white bread, canned vegetables and beans, a gallon jug of milk. The milk was the lie. "That's what puzzled me. In this heat you'd have to drink it right away," Rodriguez said. "It's more likely they were just going to hide out here and move north after it gets dark."

Figueroa called one of the collection vans that spends its days taking undocumented immigrants back to the fortresslike central office on the expressway for processing and return to Matamoros. Of course the crossers come right back, if they're not robbed, raped, or murdered by the violent parasites who feed off their plight, until they make it to San Antonio, or Chicago, or Seattle.

Wherever they can make a living, send money orders home to Mexico each payday. That is what they have done since the United States invited "guest workers" here through the bracero program in 1942 and then tried kicking them all out during "Operation Wetback" in 1954. And so on today. They come because chicken costs $2.50 per pound in Matamoros and the minimum wage is $4 per day. They can make $4 in less than an hour in the United States and buy chicken for 85 cents per pound. They come because they are good at math.

To stop them, the Border Patrol, *la migra,* runs its trucks day and night. It runs foot patrols. It runs bike patrols. It uses high-tech motion sensors at high-volume crossings. It uses airplanes and helicopters. Farther west it uses fences. For a time in El Paso, it stationed agents every four hundred yards. Along the entire U.S.-Mexico border, this country is deploying about ten thousand agents on a budget of about $1.4 billion. It caught 1.6 million people last year. This year, officials think there will be fewer arrests. Of course, no one knows how many people aren't caught, and stay; guesses range from 6 million to 9 million now living in the United States without legal immigrant status.

Is all this working? In Brownsville there are places the river is so narrow you can wade across and not get your trousers wet. Steep banks covered with mesquite, reeds, and grass offer camouflage and shade. On the far side of those banks, any hour of the day, you can see Mexicans, men, women, and children, alone or in groups, sitting patiently, waiting. They gather right under the Gateway Bridge downtown, they come in through the golf course, they carry each other piggyback, they float where it's deep. They follow livestock trails under the moon.

After lunch at a Tex-Mex café, the officers were back in the truck, patrolling a levee. So why not just stop the charade? I suggested. Open the borders. Rodriguez turned in his seat to look at me, hard. His badge bore a black band in memory of an agent who had fallen to his death off a cliff while patrolling in El Cajon. "We do that," Rodriguez said to me, "and the next day Matamoros will move across the river to Brownsville. The border will keep heading north. Is that what you want?" Figueroa stopped the truck and picked up his binoculars to study three teenagers making their way down a well-worn path on the opposite bank. "Can you imagine the life?" he said, almost to himself.

That afternoon we got an "officer down" call. An agent was trying to break up a riverside robbery of three undocumented immigrants by two others. In doing so, he'd been bitten badly, the worst injury in the age of AIDS, hepatitis-A, and other contagious diseases. When we arrived, his face betrayed more than the pain of the teeth marks. Nothing for it but to sweat out the blood test.

Across the river, three black SUVs and pickups were parked on the bank. They belonged to Grupo Ebano, an elite Mexican border police unit with a reputation. They watched a little longer, then left.

2. The Lower Rio Grande Valley

The real business of the Rio Grande Valley, or the Lower Valley, or more commonly just "the Valley," which stretches from Brownsville to Mission, reaching north to Harlingen, is agriculture: cotton, cantaloupes, onions, milo, sugarcane, watermelons, tomatoes, sorghum, cabbages, citrus. It's a rich list with good soil and, thanks to the Rio Grande, ample water. Flat as the Netherlands, cut through with irrigation canals, dikes, and levees like Asian rice paddies, the Valley has fed America for decades, always better than itself. The high points on the skyline are storage silos and church steeples.

The biggest one of those is the national shrine to La Virgen de San Juan del Valle, in the town of the same name, along four-lane U.S. 83 in Hidalgo County, home of one of the largest concentrations of campesinos in the country and, not coincidentally, the state's largest vegetable crop. The Virgin of San Juan, like Mexico's patron saint, the Virgin of Guadalupe, bears more than religious significance. Both are manifestations of the Virgin Mary, but both are political symbols, too.

In this area, the politics are about struggle and survival. In 1970, something about the shrine so troubled a pilot that he kamikazied his private plane into it, destroying all but the stone tower, which still stands. Damages exceeded $1.5 million. The diocese rebuilt the shrine as a spare and modernist basilica, dedicated in 1980 amid a multiblock church complex as large as some border villages, with a school, housing for the elderly, and social services. More than 20,000 visitors a week come to the shrine to light votive candles, fill their water jugs from the spigots of a holy fountain, and pray for relief.

The one and only campesino organizing center in Texas, or any-where in the Southwest outside Southern California, is also in San Juan, just down César Chavez Road, a busy strip renamed despite vigorous protests from the Valley's other migrants, the Anglo "snowbirds" who come down each winter and fill RV parks and hookup sites. In the early 1980s, the Valley had two unions: the United Farm Workers and a more radical breakaway, the Texas Farm Workers Union. But as a "right-to-work" state, Texas doesn't like unions, and it doesn't like people who do. Of about 250,000 campesinos in the Valley, no more than 3,000 to 5,000 are orga-nized.

That doesn't mean the area is placid. In the center's main meet-ing hall, a modest space filled with folding tables and metal chairs, the walls are emblazoned with bold murals in the revolutionary Mexican style depicting workers in decades of *huelgas* and *luchas*. Perhaps the most historic fight was the melon strike of 1966, which started in the Valley, spread spontaneously, and culminated in a march on Austin, famously snubbed by Governor John Connally. A watershed event in the growth of the state's Chicano movement, the strike of '66 radicalized the baby boom generation of Mexican-Americans.

But decades of severe repression by state police, Texas Rangers, county sheriffs, and the Austin-based government, aided in no small part by the selective use of undocumented Mexican workers to glut the American labor pool, have altered at least the short-term goals and tactics of the union, which now concentrates on le-gal and social services, education, and voter turnout.

As a focal point of the community, the union hall can be one of the busiest places in San Juan. But in the spring or summer, it is of-ten empty. The campesinos are away, following on the migrant path that reaches north into Canada. The idea is to make enough in the spring and summer to get back by September and get the children in school. The idea of school is that the children won't have to remain migrants.

It is an area with mind-numbing problems — paramilitary occupa-tion, drugs, diseases such as cholera, TB, and rabies and severe birth defects thought to be caused by the chemical sewer that is the river. And poverty — two of the lowest-ranking metropolitan

areas in the United States, based on 1999 statistics, were in the Valley: Brownsville and McAllen. Two more were on the border: Laredo and El Paso (the fifth is Las Cruces, New Mexico). There is scant health insurance or coverage for the poor; this year Hidalgo County said it was forced to stop seeing all new indigent patients, and in May, Governor Rick Perry vetoed a plan to help provide new insurance.

It's a hard-knock life times ten, and you'd expect the Valley to be somber and depressing. The contrary is more the case. The pull of land and blood in the Valley is legendary, and there are few Mexican-American families in Texas, if not the nation, in which someone doesn't have an uncle or cousin, brother or grandmother, who lives in one of the string of towns that run together from Brownsville to Mission, or who has worked the fields, and who then in turn has relatives across the river.

Anglos feel the draw, too. In La Feria, a sunburned farmer named Ed Bauer works the same land his father did, and his three sons are doing the same. At San Benito, a second-generation German Lutheran from South Dakota named Roy Kosel, at seventy-two, is still growing citrus and raising cattle more than thirty years after moving to the Valley for his health, marrying a Mexican-American, and raising a family, some of whom also have stayed. In Mercedes, an ex–New Mexico rancher, Trainor Evans, has made a go of a small boot company, Rios of Mercedes, and opened a shoe manufacturing plant across the river in Las Flores.

I liked seeing that optimism and perseverance in the Valley. In a place of great hardship, there is always something more. There must be, or nothing would remain. The essence of the Tejano life in the Valley is that it has endured, and in that endurance is a strength that will easily outlast this century. From what I had heard of the Valley, and what I would see for myself, an unexpected liking began to color my perception. Not rosy — you can't be rosy about the Third World — but a balance. An ability to perceive the importance of the endurance.

If the future of America is the turn toward what the linguist and social critic Noam Chomsky has called the national security state — already well in place right here, right now — the future lies also in a stubborn resilience among the Mexican-American people that matches anything that ever came from the cradle of New England.

And that is precisely what I had been seeking by setting out to explore the border. A secret is to be found in the choices people make about where they settle.

I began to discern this one.

It was gradual. Cruising a palm-lined street in Brownsville after a late-afternoon shower; gouging my forehead on the jeep door while watching a young woman in a cotton dress and high heels straight out of a ZZ Top video filling up a Cadillac at a gas station; walking back across the bridge from Matamoros at night, aware of the violence and dangers but also of the stars overhead; the coolness of the evening; the unquantifiable faith of the people.

And sudden. South of La Feria, passing a small rural cemetery in a field under big shade trees. Every marker was adorned with bright, fresh-cut flowers. Every soul that was buried had another one tending to it. It is like that in cemetery after cemetery in the Valley. I got it: This is a place in which the people take the long view. In the long view, the Rio Grande is just a river. Families endure; the land provides. Thomas Wolfe would have written something else if he'd grown up in the Valley. People come home all the time.

The Valley is hot and flat, its freeways are congested day and night, and in many ways it is a war zone, but it is also a Hemingway's Cuba that might have been. Cheap, full of energy, sensuality, youth. Noble crusades if you have such a bent. The people are friendly, the food good, the women graceful. The light is legendary. The winters are warm, and the summers aren't really any worse than anywhere else in Texas and definitely better than Miami. And Mexico is just across the river.

"Some of my friends said to me, 'You've got your Harvard degree, why come back to the Valley?'" the artist-entrepreneur Noe Hinojosa Jr. told me one day over lunch near downtown McAllen. "I say, 'Isn't it obvious? Everything is to be done here. The whole time I was in Cambridge I always knew I was going to come back.'" He did just that after college and founded *The Mesquite Review,* now a general interest bimonthly, and the Millennium Bookstore Café, where, until it closed a year ago, you could hear live music, get a good sandwich, a decent chess game, and maybe pick up a painting, a music poster, or a comic book. Noe and his wife, Joicie, an

Anglo who also grew up in the Valley, now live in Weslaco with their young son and daughter and are looking into other business projects. They will stay.

Frank Bailey felt the same way and, although he had not been reared in the Valley, he had come "back" to it as surely as if he had been born there. This came to me as we were sitting on wooden barstools on a cracked sidewalk outside a narrow café in Las Flores, Mexico, the last unspoiled border town, Frank said, drinking Carta Blancas and becoming insistent, even strident, that it was impossible to imagine living anywhere else. I never have stopped thinking that.

The sky was just losing its scarlet and the shops were mostly closed, although people were still moving to and fro finishing up the day's business. Across the street someone had built a balcony on the second floor of an apartment and a few people were gathering, as they do in the French Quarter, to observe and unwind. The third floor of the building was unfinished, marked by metal rods poking out of concrete. In Mexico, people build when they have money and stop when the money is gone. Devaluations and corruption make saving useless. Or people from Mexico take their money across the border to buy and invest. Thus, the real estate boom in some areas.

Frank, though, wanted to buy a café in Las Flores. A chef, former food columnist for *Texas Monthly*, and a former expat in Paris, he had been lured back to the Valley in the nineties to start the Rio Grande Grill, a smart continental restaurant in Weslaco. He had done his research. He was well aware that the border was different, that the Valley was a Secret River Kingdom. That without Mexico, Texas is just Oklahoma. That a makeshift sidewalk café in Las Flores isn't all that different from one on the Left Bank.

In effect, Frank is an expat again. He lives near Progreso, about as close to the river as you can get without falling in. Close, also, to the railhead used by Al Capone to ferry Chicagoans to Valley speakeasies during Prohibition. Not unlike the government-created drug gangsters of today, Capone liked the area so much he bought a place here for his mama.

Almost every night, Frank goes over to Las Flores the way Frasier went to Cheers, inventing his own café society, one cantina at a

time. I joined him one evening, driving to the bridge along a U.S.-side levee in the coolness, windows open, Mexican radio louder even than the birds and insects. When we got to the bridge I turned right, paid the toll, and we were in a foreign country. "It's the closest bar to my house," Frank explained. We parked at Arturo's. To call Frank a regular would be an understatement. Sunday mornings he drives over for coffee and *machacado con huevos* and reads the Reynosa paper, because he doesn't like the Valley's papers.

We found ourselves in a small dance hall, called, I believe, The Opera, sharing a table with a thirtyish working man well into his Dos Equis. A conjunto quartet worked the room, the *bajo sexto* and accordion lending a dreamy timelessness. Couples were dancing, and the room was so crowded that a group of three women, workers at a maquiladora, also squeezed in at the table. I wanted to stay forever, and I could see that Frank, who would never tell you he's also the brother of U.S. Senator Kay Bailey Hutchison of Texas, already had.

"I'm glad you could spend time in my world," he said, sincere beyond the beers, and we waxed on, and I thought about the writer Ambrose Bierce ("The Old Gringo" in the novel by Carlos Fuentes) just turning south at El Paso and never coming back. Then the bar manager gestured to the guitar player and the conjunto group began backing out the door. The younger crowd was coming in, and somebody plugged in the jukebox.

3. Cities Along the Plains

Beyond the Valley, the semitropical greenhouse merges into mostly underpopulated rolling plains. West of the rain line that helps sustain farming, the land devolves into long stretches of chaparral punctuated by a few small towns in counties with populations that wouldn't fill a Texas League ballpark. But you can feel the Valley pushing outward.

Felix Alaniz III — whose father, the affable Felix Jr., runs Felix's Meats, a barbecue and grocery in La Joya — for a time drove from his home in Palmsville, known mostly for being a "snowbird" enclave, to Edinburg, where he and his former wife attended Pan American University, and back to La Joya. Five days a week. Three

days he also went into McAllen to work out at a gym. That figures to a hundred-mile circuit; in two years he put seventy thousand miles on his truck. He's been doing that for years. If you can find a used pickup along the border with low mileage, buy it.

Just west of La Joya, which is in poverty-ridden Hidalgo County, you enter Starr County, the poorest of all 254 counties in Texas. Circumstances here are outright desperate. It is a place of collapsed dreams and parched hope. Clapboard shacks, rusted-out cars, and rib-thin mongrels lie back in the brush as though nightmares seen through a dim haze, or congregate in shared misery along blacktop or gravel roads visited only by *la migra,* preachers, and mail carriers.

All along the border, on both sides, in the squatter communities known as *colonias,* conditions are often as bad. Following a lace of dusty back roads east of Rio Grande City one afternoon, trying without luck to follow an oil-lease road down to the river, I happened upon a small community of decrepit houses. Through the torn screen of one bedroom window I glimpsed an old man, shirtless, panting in the heat like a dog. It is not an image that easily goes away; it is one I wish the governor and every member of the Texas Legislature who voted down aid for the border this past session could witness in person.

Other places in this part of the border seem preserved as if in amber. You can take a road just past La Joya down to the river at Los Ebanos, named after the indigenous shade tree, and find the last hand-drawn ferry on the Rio Grande. When you cross from one brushy, tree-lined bank to the other, three vehicles at a time, it doesn't surprise you to see horses waiting on the other side to come back over. If ten cars are in line ahead of you, you'll wait an hour to embark, but somehow it doesn't matter.

Rio Grande City, Starr County's biggest town, bristles with activity. Not all is good. The city has an off-and-on reputation as a drug conduit, and its streets, fast-food stands, and discount-store parking lots are saturated with Border Patrol, Customs, and DEA vehicles. Nor is it uncommon to see expensive new sports cars and lavish homes that seem about as subtle and incongruous amid the poverty as tiger sharks in the desert. But there's something about the place: the older section, north of the highway and up the terraced hills, mixes the historic and the ramshackle; the downtown section

features the old LaBorde House, a favorite B&B among those who travel the region.

To the west lies Roma, the historic settlement perched on a bluff over the river, its old quarter, used as a movie for the film *Viva Zapata,* stubbornly immune to change. But like Rio Grande City, Roma is a strange, almost haunting, city full of the border's contradictions. A busy retail strip down on the highway seems almost unconnected to the old buildings on the hill, and men of questionable occupation use the same streets as hard-working mothers and fathers. From just behind the old Roma City Hall, you can look down at the river to Ciudad Miguel Alemán and watch children from the Mexican side swim in inner tubes. Sometimes they or their friends come all the way across.

I was driving through on the main street in late May when five teenagers burst out of an alley along the busy highway storefronts and ran directly in front of me, heedless of being hit, wild looks in their eyes. They ran as a group and disappeared into the back streets on the other side. They did not appear to be the after-school science club. They appeared to be hunted.

Then there is Laredo.

Revisionist border geography: Rio Grande City is the border. Roma is the border. Eagle Pass, farther on, and Del Rio, last stop before the Big Bend, are the border. Even Big Bend is the border. But Laredo is not the border. Laredo is a toll booth for $85 billion in goods passing through its bridges annually. In 1851, it was the first official port of entry on the U.S.-Mexico border. Today it is the busiest, a traffic jam for NAFTA's $656 billion yearly transcontinental juggernaut and a shopping spree for Mexico.

Day after day, tractor-trailer rigs and bobtails tie themselves up for five miles at a time, bumper to mudflap, waiting, fumes blanketing the heavy and humid air and settling on the river, to get through to the customs bridges. No other town in Texas has so prospered from the "free trade" legislation of 1994 or been so contorted by it. But Laredo — "more connected up and down I-35," as one observer told me, "than to the other towns on the border" — has unhinged itself from its kin on *la frontera* in a way that is jolting even to its longtime residents.

It may not even be a U.S. city anymore. More than 70 percent of its retail sales are to Mexicans, says the Chamber of Commerce, and a behemoth Wal-Mart, an exit away from one of the biggest

H-E-B grocery stores in Texas, caters heavily to Mexican and Mexican-American shoppers. Downtown seems entirely designed for people coming across the river to take things back — nice things. And with 95 percent of the city Mexican-American or Mexican, it's rare to be spoken to in English as the first option, and sometimes there are no options.

"You come in here a white boy and you're going to become Mexican pretty quickly or you're not gonna get a job," said a laughing Alberto Luera, former secretary of La Raza Unida party that briefly terrified Texas Democrats in the early 1970s. "Laredo is the most Mexican city in Texas, if not the entire country. It has always been a center of activism and has produced a lot of Chicano leaders. We don't know how to bow our heads to white people. We have roots going back five, six, ten generations. And there's a steady influx of culture which is continually generating support to the whole idea of being connected to Mexico. We're really the people whites are afraid of. We've been born here. Full-blooded and enfranchised."

Luera, whose thick mustache, spectacles, and preference for T-shirts mark him as clearly different from the middle- and upper-class Mexican-Americans who turned conservative, works with the nonprofit Centro de Servicios Sociales Aztlan, an immigration counseling center in the same east side barrio in which he grew up. He doesn't wonder if the borders should be open or closed, because he thinks the issue is moot. People come over because they have to. "Mexico is extremely poor," he said. "There is no 'trickle down' of anything." Besides that, he says, neither U.S. employers nor Mexican politicians have any interest in bottling up the flow.

I could never get my bearings in Laredo. It's laid out simply enough, but old landmarks, such as the Plaza Hotel, have become banks; familiar cafés are Laundromats; an easy walk to the bridge from La Posada, the new hotel of choice, is like crossing Times Square, only more crowded. Northward, urban growth pushes out into a suburbia that could be mistaken for San Antonio north of Loop 410. But this is what happens. This is not where you go so you can cross over to Nuevo Laredo and have a Ramos gin fizz at the Cadillac Bar, which became the El Dorado. It is a place where you go to make money as fast as you can and the devil take the hindmost. It is ephemeral in the extreme. So maybe I was wrong about Laredo. Maybe it *is* the border.

*

The proof is a negative one, demonstrable a few hours to the south, off Mexico Highway 2, at the bottom of Falcon Lake. These days you can drive down, not dive. What Spanish colonists founded in 1750, and the U.S. Army Corps of Engineers flooded in 1952, a retreat of the waters resurrected. I visited Guerrero Viejo as I headed out of the Valley heading west, and for a while its connection to Laredo didn't occur to me. But I had been stuck in the present. The cities are linked inseparably, in the only place they can be, where the future has drowned the past.

Engineers knew all along that Falcon Lake, the first of two major reservoirs to control flooding and the historic tendency of the Rio Grande to shift its bed, would inundate Guerrero, so the residents were "relocated." Some stayed in Mexico, but many moved to Texas, settling from near the oilfield town of Zapata all the way to Laredo. But droughts came and the engineers made adjustments and the lake level fell. Guerrero Viejo, so named to distinguish it from Nuevo Guerrero, the dusty roadside eyesore that replaced it, has literally risen from the depths. Its eerie shell protrudes from the northern end of the reservoir like some desecrated Atlantis.

The skies had darkened the afternoon I made my way down the steadily descending and barely passable eight-mile dirt lane, one of the worst of many bad roads I'd taken deliberately or by accident trying to hew as close to the river as possible without getting shot for crossing private land or tailed because my mud-coated jeep looked like a smuggler's vehicle. A deep subsurface crater seemed an ominous place to seek refuge, and I didn't feel any better coming into the village and spotting two tarantulas so large I thought they were turtles. Then discolored sandstone ruins began to appear among what had once been orderly streets and blocks but now seemed a labyrinth of rubble, gnarled trees, and opportunistic grasses. On one side stood the shell of the Iglesia de Nuestra Señora del Refugio, the town's eighteenth-century Franciscan church, overlooking what had once been a plaza.

I half expected a character from *Pedro Paramo*, Juan Rulfo's magical realism classic, to appear in the dusty streets. As if on cue, one did. The old woman wore a loose orange smock and hurried along a flock of thirty to forty goats with her stave. She was the only person I'd seen, except the toothless gatekeeper five miles back whom I was going to have to tip to get out. I pulled the jeep next to a ruin,

caught up to the woman, and asked if she wasn't afraid to live there. She shook her head. Later I found out her name was Julia. The woman who told me, Maria Eugenia Guerra, commutes to Laredo from her family ranch at San Ygnacio, near Zapata, to publish the vibrant monthly *LareDOS*. That's when it hit me. Everyone on the border is connected to everyone else: now, in the past, alive, dead. Laredo, the city of no determinate future, is the living sarcophagus for Guerrero Viejo, the city of a disappeared past.

After Laredo, border-hugging U.S. 83 shifts away from the river, skirting the huge ranches that mark the countryside almost all the way westward to the New Mexico border. Dirt and gravel roads crisscross the ranch country, and I tried following them many times so I could stay as close to the physical border as possible, but frequently I was rebuffed. Sometimes the heavily rutted washboards just went nowhere or stopped at a dry streambed, but more often I encountered the South Texas stop sign: a padlocked gate with a NO TRESPASSING sign. Strictly speaking, this was illegal, but over the years ranchers began to assume the "unimproved" roads were their own and treated them as such. It was never wise to argue the point and mortally foolish to actually cut a lock and go through a gate.

I pushed about forty miles on an austere, four-wheel-drive road through the deep chaparral, which, by the map, went all the way to Del Rio, but in reality was abruptly blocked off by a gate. I had to turn around and drive back to the outskirts of Laredo, where the clerk at a busy truck stop matter-of-factly told me what I'd just spent two hours finding out: The map was right, but you couldn't get through anyway.

Thwarted by private property and natural terrain, I took U.S. 83 northward to Carrizo Springs, where it merges with U.S. 277, which leads back to the border to link Eagle Pass and Del Rio, the last sizable towns before the sparsely populated high country of the trans-Pecos. Somewhat rivalrous, the cities are little alike: Eagle Pass, where John Sayles's *Lone Star* was filmed, is small, poor, and more than 95 percent Hispanic, while Del Rio is of moderate size, comparatively prosperous, and about 30 percent Anglo.

Del Rio has abundant natural springs, Laughlin Air Force Base, a direct highway to San Antonio, Amistad Lake for tourists, a Border

Patrol sector headquarters, a decent winery with its own vineyards, and good schools. It has the grave of Judge Roy Bean, easy access to the notorious pleasures of Ciudad Acuña, and a secure place in broadcast history as the home of the late Dr. John Brinkley. Brinkley, a.k.a. the "goat gland doctor," had an Acuña-based 500,000-watt radio station, XER, which was the most powerful in North America in the 1930s, and its successors launched the career of Wolfman Jack.

Del Rio also has one of the most distinctive Mexican-American communities along the border, San Felipe, until recent years segregated by law and/or fact from the Anglo parts of Del Rio. But with its trees and churches and murals, it is the most beautiful part. So strong run the feelings of community that San Felipe's "ex" association of students who went to the district's school before it was merged with Del Rio boasts a membership of some of the city's most important businesspeople, educators, and residents.

What Del Rio doesn't have is the Lucky Eagle Casino. It doesn't have the Kickapoo.

Following the lead of other Indian tribes in the United States, the once wretchedly poor Texas Kickapoo, who for years lived under the international bridge to Piedras Negras, used 123 acres they had been given south of town to tap the apparently endless yearning for quick cash. Theorizing that the state lottery is the legal equivalent of gambling, the Kickapoo, like the Tigua in El Paso, who operate the only other casino in Texas, went into business despite pending lawsuits. The Lucky Eagle Casino opened August 1996 in what looks like an industrial warehouse makeover and almost is, fitted together from truck trailers hollowed out and joined together like Lego blocks. At one edge of the reservation, it's close enough to the river to invite clandestine crossings and is therefore cruised frequently by the ubiquitous *la migra*.

As casinos go, the Lucky Eagle is a far cry from Vegas, or even Biloxi. It's a moderately sinful social club for people who would otherwise be playing church bingo or betting on football on TV. And who have few other outlets. The parking lot is generally filled with sedans, vans, and pickup trucks from the surrounding ranch lands, or from Del Rio or Laredo, and about as many bear plates from the Mexican states of Coahuila, Nuevo León, or Chihuahua. The dress is jeans and gimme caps, not tuxes and slinky low-cuts.

There's a nook for beer, burgers, and nachos. There are hundreds of bingo tables, almost that many "pull-tab" slot machines, black-jack rims, and a glass-enclosed room for some serious poker play-ing. There's also a caged cash booth that dispenses lottery-type slips instead of coins to finesse the licensing laws.

You could feel the envy of the rest of the town. The casino, which has plans to build on-site hotels and other additions, employs hun-dreds from the area and makes millions. It's the only really big game in the area, which otherwise relies on agriculture and the oil industry. The literal reversal of fortune has caused some uneasi-ness, and occasional hostility, between the tribe and the mostly Mexican-American population. But in this case, the change is one that seems likely to stay. The influx of suckers who think they'll hit it big is unlikely to stop. I took a seat at one of the bingo tables and played cards totaling five dollars. I won one dollar. Anyone but gamblers can do the math.

After Del Rio, the country thins out even more than ever, and the spartan beauty that seems to transfix Texans intensifies. Ami-stad Lake is low, but it is full of fishermen, Jet Skiers, and weekend speedboat freaks. The Pecos River, which provides water to the lake, as does the Rio Grande and Devil's River, cuts through a gorge that catches your breath with its sudden visual power. Except the river below you so far has dwindled to a trickle. Apart from all the other assaults on the rivers of the Southwest, it is dry out here. I pressed on, hoping to make Sanderson, the old railroad repair de-pot, in all-but-humanless Terrell County, home now to scarcely a thousand souls, by lunch. But I had to turn in at Langtry.

Judge Roy Bean is buried in Del Rio but he famously held court here at the Jersey Lily, and despite his utterly subjective rule of "law," the state, thinking of revenues, has built a tourist center in the old crook's honor. But forget Bean; the center has a superb bo-tanical habitat containing examples of just about all the flora — cactus, maguey, beargrass, cenizo, palo verde, and more — that survive in the region's harsh environment.

Last time I was in Langtry, I spent hours trying to track down the owner of two rusty Morris Minors, the tiny, long-out-of-production English cars, sitting next to a makeshift shack on a rocky hillside. I wanted to ask the obvious question — "Why?" But I never found the man I sought. This time the cars were gone, but I encountered

another mystery. On the highway, I had passed a man pedaling a bike up a steep hill, and now he wheeled into the center. He was from Argentina and was on his way to Alaska, a journey he calculated would take at least eighteen months. He was in his twenties, lean, sunbaked, his hair in dreadlocks below his cap. *"Hace calor,"* he observed of the 101-degree temperature. I nodded. I asked the obvious question.

"It is to help" — he struggled for the words — "bring more peace and love to the continent."

"That would be good," I said.

4. The Trans-Pecos

"When I come out here I feel like the rest of the world is kind of on the other side of the mountains," Butch Hancock was telling me. We were leaning against a hitching post on the porch at sunset outside the Starlight Theater, the evening gathering spot for the two hundred or so pilgrims from progress in the past two decades who've repopulated the old Terlingua ghost town at the western edge of Big Bend National Park.

Thick clouds over the Chisos Mountains, backdrop to the seemingly boundless acres of creosote, mesquite, lechugilla, and yucca and a thousand other kinds of plants in the Chihuahuan Desert in front of us, flashed with lightning and then sparkled with rainbows. I have seen these rainbows several times; for some reason it rains when I pass through the Big Bend. Maybe the spectral arcs across the buttes and canyons and arroyos are sending me a message: Stay.

It's easy to become transfixed by natural beauty here, to feel that you're separated from the world and its ills here, because in many ways you are. The closest big city, El Paso, is five hours away. Even the old ranch-country cluster of Marfa, Marathon, Alpine, and Fort Davis are two hours or more to the north. The Spanish called the region *despoblado,* or unpeopled, and the increasingly inverse proportion of people to land begins west of Del Rio. The head count falls all the way to .5 people per square mile in Terrell County, where the distressed Rio Grande, now at levels too low in many spots for rafting, culminates its "big bend," the hundred-mile diversion around the mountains that started west of Candelaria and south of Van Horn.

Anyone who hasn't been to Terlingua, or nearby Lajitas, since Jerry Jeff Walker released "¡Viva Terlingua!" in the 1970s or when Ted Kaczynski's younger brother, David, lived there in the 1980s, is in for bruised nostalgia. Terlingua isn't exactly a metroplex, but unlike the old days it now has electricity, running water, and a consolidated high school at Study Butte. The chili cook-off, once favored by culinary cultists, is now just as likely to be overrun by beer-swilling bubbas who, as one resident put it, "think that if you're out here you can do anything you want." Lajitas, bought by the Houston magnate Walter Mischer Sr. in the late 1970s and auctioned to Austin's telecom tyro Steve Smith in February 2000 for $3.95 million, is being transformed into what Smith hopes will be a corporate-friendly desert playland, not the money drain it was for its previous visionary. On the planning board: a new hotel, a new golf course, an airstrip, and updates to the faux Old West main street that supplanted its onetime simple trading post. Given the location — perched between Big Bend National Park and Big Bend River Ranch State Park — development is probably inevitable.

But the Big Bend still can feed the soul like few places on earth, and it is filled with good people and small-town closeness. Early one morning along the dusty riverbank between Lajitas and Paso Lajitas, Mexico, I managed to lock myself out of the jeep. In no time, a construction foreman named Bob was driving me around in his pickup looking for someone with a Slim Jim, which actually wouldn't do the trick, and then after making the rounds of various Lajitas shops, a maintenance man referred me to Carlton Hall, who just happened to have driven over for the day to work. He was the only African-American anywhere in the vicinity, as he quickly pointed out. He had come down to the Big Bend area from Detroit in 1972, "following the Buffalo Soldiers," and stayed. Lucky for me, since he was also a locksmith. He worked in the heat and dust for more than an hour and asked twenty-five dollars. I gave him forty. There are people like that all over the place out here. Not all are that way. But enough are.

Even with the slight trendiness of the place, and the early signs of Major Tourist Destination, the Big Bend and Terlingua in particular remain more than getaways for weary urbanites. It is a nexus for free spirits, mavericks, recluses, and artists. It is still a place where Butch, a Lubbock-reared musician with a repertoire of hit songs for

friends such as Joe Ely and Jimmie Dale Gilmore, could move from Austin in the mid-nineties, park his Airstream trailer on a hillside, and sleep outside under the stars every night. "You ask me why I moved here?" Butch grinned that night four years ago, opening his arms to the natural amphitheater of the storm-draped Chisos. "This. This is it. This is the first place I've ever missed when I'm away." He missed it so much that he has now moved his family there and is building a small home in the ghost town, doing most of the work himself. For insulation in the walls, he's using crushed cans — a desert renaissance man with the conscience of an environmentalist and a fearless enthusiasm for life that seems rare. Except here.

Butch also is known for juggling projects, and one was a novel about a man who could live only in the present. We tried to figure out how to do that, but my thoughts that evening drifted to something I'd felt repeatedly on my journey — a kind of unstopping of time, as Kurt Vonnegut might have called it, or a timelessness, as the Zen masters would say, in which I saw places as they had been as well as what they were in that moment. Sounded crazy until I heard what Butch was working on. Then it made more sense.

Indeed, the more I saw of the thin line of nationality spinning out through the ludicrously artificial border with Mexico, then and now, the present offered an insufficient perspective. Time seeped over and sewed up everything; borders are but bores — a drone of dates, legends, and latitudes in history classes. And yet in the present, the borders are condensations of all that a country is, was, and will be. So I had started on a route that truly was chimerical; not just the boundary between nations, but between reality and illusion itself.

The Starlight's owner, Angie Dean; the veteran river guide Betty Moore — just two of the strong, independent women who have taken to Terlingua in the last two decades — and some of the town regulars joined us on the porch to watch the lightning show. That's what you do in the Big Bend. You watch nature. All the time. You can't help it. Off toward a high mesa across the river, near Boquillas, someone had started a bonfire. A strange, jumpy man in a scraggly beard that everyone seemed to give wide berth walked up to the railing and explained that the fire was an annual ritual of a regional drug smuggler. From the same direction we could hear

the sharp crack of AK-47 rounds, and what looked like the paths of tracers. It was nearly the Fourth of July.

I knew what Butch meant, and the spell of the trans-Pecos is strong. But all of us knew then, and even more so now, that the world wasn't really on the other side of the mountains. Start with the pollution, both in the water and, lately, in the air, blown in from Mexican coal-fired utility plants to the southeast. This year, the National Parks Conservation Association put the Big Bend on its list of the country's ten most endangered parks. On the worst days, even if there were lightning, it could only be seen through a maze of particulates.

And there is the constant policing. On the morning Carlton worked to pry open my door, the foothills across the river were lined with dozens and dozens of Mexican men wondering if they dared risk coming across to work at the miniboom in Lajitas. They normally would have already crossed, but early that morning, agents from the Border Patrol's Alpine sector had swooped down in their SUVs and vans and arrested about fourteen people. All would be driven back north nearly two hours to Alpine for processing, then back down to the border again to be released at Presidio, another hour to the west, a task likely to take most of the day. And mean nothing, since everyone knew the men would be back the next day for work.

There also was the arrest April 29 and subsequent detaining in Ojinaga, Mexico, of the Presidio grocer Jesus Manuel Herrera, or "Junie," on charges of the murder of the Mexican journalist José Luis Ortega Mata. Ortega had been writing stories about the drug trade, but Herrera somehow was fingered for the crime based on an "eyewitness" account. Herrera and his supporters say it's a crooked frame-up and want him released. Meanwhile the entire area is filled with protests and bad cross-border feelings.

If at the bottom of all this there is indeed something about corruption and drugs, it will not be surprising, because most of all what belies the idea that the Big Bend is any kind of sanctuary is the War on Drugs and its almost uncountable disruptive effects. And none of the effects compare to what happened May 20, 1997, near the farming town of Redford, east of Presidio on scenic Texas 170. That was the day Ezequiel Hernandez Jr., an eighteen-year-old

high school student tending a herd of goats, made history when he was ambushed by a team of Marine snipers. When he slowly bled to death, he became the first civilian death attributed to U.S. military forces on an antidrug mission since the War on Drugs started, and more specifically since the 1989 creation of Joint Task Force 6 at Fort Bliss in El Paso. Whether he will be the last remains to be seen. The oppressive truth about the trans-Pecos, from its arbitrary searches and arrests to the sheer abundance of firepower and empowerment of warlords on both sides, is that it is like a powder keg waiting to go off. A University of Texas sociologist, Timothy Dunn, in the influential book *The Militarization of the U.S.-Mexico Border,* argues that the area's warlike nature can be traced to application of the Pentagon's LIC — for low-intensity conflict — doctrine.

Developed during the Reagan years and applied in wars in El Salvador, Nicaragua, and Grenada, LIC is an extension of the counterinsurgency warfare ops of the Kennedy administration. Plenty of violence is involved, but not as much as in a "high-intensity" conflict, such as Vietnam or the Persian Gulf War. The chief characteristic of an LIC is that U.S. military forces play a limited or advisory role with local police. The secret Marine surveillance team that killed Hernandez had been invited into the area by the sector chief of the Marfa Border Patrol. They were part of a fifty-six-member platoon from Camp Pendleton in California brought in to watch for drug smuggling for two weeks. Nobody in Redford even knew they were there.

The Marines involved, young Hispanics themselves, were subsequently absolved of their actions by military courts. It was ruled that they were acting within their parameters and could plausibly have thought Hernandez was smuggling drugs or shooting at them, or both. The commander at Camp Pendleton, General Carlton Fulford, went so far as to say the shooting was justified. I was in Redford shortly after the incident, and went to look at the site and to talk to those left behind.

"I can't hold the Marines too responsible," said Father Mel LaFollette, a maverick Episcopal priest with a Yale Divinity School degree who moved to Redford in 1984 and helped lead community protests over the slaying. "Their heads have been filled with . . . [ideas] that we're the enemy. The real point is that they shouldn't be here."

Father Mel took me to the place up on the creosote-covered hill where Hernandez had been slain. "A lot of people think Junior was out in the mountains," the priest said as we drove over. "He was practically in town." We parked near an abandoned well where Hernandez had fallen. Out there, among the scrub, the three Marines, wearing camouflage gillie suits, had been hiding when one of them, Corporal Clemente Banuelos, fired a round from his M-16.

It was a clear shot, 135 yards, to the well, perhaps 100 yards from the town's Baptist church. Hit through the side, Hernandez crumpled. For reasons that were never made clear, he was not given first aid, and died before U.S. Border Patrol agents reached him twenty minutes later.

The Marines said Hernandez fired his .22-caliber rifle in their direction, twice. Father Mel pointed out, though, that the angle of the wound indicated the boy had been facing away from the patrol. The people who knew Hernandez say that he always took his rifle, a vintage piece belonging to his grandfather, to shoot at snakes, or rabbits. Even the Border Patrol had encountered the boy tending his goats with the weapon. "None of us believe he ever saw them," Father Mel said.

"Stand here," the priest told me. With one arm he described an arc from the well toward the town. "From here you can see where Junior was standing when he was killed, where the killers were hiding, the house where Junior's family lives, the church where his body was laid out, and the cemetery he's buried in."

In 1998, the boy's family settled a wrongful death suit with the U.S. government for $1.9 million. In 1999, the conjunto artist Santiago Jimenez Jr. recorded the *corrido* "La Trajedia en Redford: La Muerte de Ezequiel Hernandez" (The Tragedy in Redford: The Death of Ezequiel Hernandez). This June, I drove through Redford again. Just before reaching the town, elation from the vistas of the steep and winding roadway down from the mountain gorges out of Lajitas gave way to a knot in my stomach. I realized I was coming back to the little unpaved road that turned up to the well. Except that the yellow crime-scene tape was long gone, the killing ground looked almost unchanged. A simple cross with Junior's name, draped with artificial flowers, had been affixed to the well. If it had eyes, it could, as Father Mel said, see the church off to the

left. Directly to the west: a field of headstones, the grave of a teen-
ager.

5. The Chinati and Sierra Vieja: Remote No More

Because of the Chinati and Sierra Vieja ranges, you can't follow the
river closely from the Big Bend to El Paso, but you can get as far as
Candelaria before Ranch Road 170, the last state-maintained road,
runs itself out. A footbridge at that tiny end-of-the-line hamlet
makes it a fair but doable walk on a rutted farm lane between
drought-dry fields into San Antonio del Bravo, Mexico. You can
drive a little farther west on rough dirt and gravel lanes, but you
still can't traverse the mountains. You have to double back.

One option is to return to Presidio, a flat, hellishly hot agricul-
tural center and gateway to Ojinaga, Pancho Villa's old haunt.
From there you take U.S. 67 north up to Marfa — a route that may
become another NAFTA truck conduit between Mexico and the
United States — and pick up U.S. 90 westward. Then past the
slightly sci-fi presence of the Air Force tethered aerostat spy bal-
loon at Valentine, and on to Sierra Blanca, a quiet foothills town
that, at least for now, has blocked attempts to bury nuclear waste in
the nearby scrub plains.

A better way, unless it's raining hard or icy in this northern part
of the Chihuahuan Desert, is the Pinto Canyon road. Coming back
from Candelaria, you turn north at Ruidosa. The graded roadway is
unpaved, but most vehicles probably can take it. Not only does the
route cut through classic trans-Pecos ridges and valleys, it links up
with Ranch Road 2810 about thirty-two miles before Marfa.

This is one of the immortal two-lanes, sweeping through rolling,
well-tended ranch land. If you're like me, the only traffic you'll
meet is mule deer hopping the fences and running alongside you.
Sort of. After all, this is the border. Just before I got to Marfa, a Bor-
der Patrol SUV parked at a ranch gate decided I needed to be fol-
lowed and tailed me closely all the way into town.

No matter how you get to Marfa, once you make it to Interstate
10, next stop is El Paso. But my map showed a possible alternate
trail, starting just south of Sierra Blanca and slicing through Quit-
man Pass, from the mountains of the same name. On the south
side of the pass, the trail seemed to intersect the beginning of

Ranch Road 192 toward El Paso and thus resume the state road system that had stopped at Candelaria. Unlike the Pinto Canyon road, Quitman Pass promised to be trouble, but it was the most direct way back to the river and would keep me off the interstate. So I took off. At the time, I was driving a V-8 four-wheeler with a statue of the Virgin of Guadalupe glued on the dashboard and plenty of water in the back.

I guessed correctly at a couple of dusty, signless forks as the pass road devolved into little more than ruts from previous vehicles, which I reasoned were probably DEA or Border Patrol, meaning the road wouldn't dead-end because it was essential to the drug war. Two deep streambeds almost stopped me, but I pulled enough traction and didn't tip over. When I finally crested a rocky plateau and saw a comparatively easy dirt path winding down to the green irrigated fields along the river I stopped the jeep and got out as if I'd been trapped under the sea. I realized the pain in my crabbed-up fingers was from gripping the steering wheel so tightly.

Although such was not my intent, the Quitman Pass route might also have served as one of numerous ways around the permanent Border Patrol checkpoint on I-10 near Sierra Blanca, where anyone on the eastbound side can be stopped and searched for any reason whatsoever. Had I wanted to elude *la migra,* I could have just reversed my route and gone north instead of south, although one always runs the risk that a patrol car or helicopter might be working the area. But such is life on the border.

For my part, I had from the start decided never to provoke the small army of occupation in the border zone. I was as polite to the uniforms as possible, no matter how many times they went through my luggage or book boxes, no matter how many times they didn't believe I hadn't bought anything in Mexico, no matter how many times my license plates were scanned by the computers.

And I gave the guards the benefit — even Will Rogers would turn paranoid checking thousands of cars a day. When a bored and officious customs officer confiscated the sack of prize grapefruit Roy Kosel had given me back at San Benito and dumped it in the trash, practically daring me to object, I chalked it up to the vagaries of international travel. Only once did I worry: the afternoon I was returning to Presidio from Ojinaga, and U.S. Customs closed the

bridge gates behind me, trapping me and ten other cars amid a phalanx of agents and drug-sniffing German shepherds. Me and ten other cars and the blonde in the seat next to me.

Mimi Webb-Miller had come with me from Terlingua to show me Ojinaga, where her ex-boyfriend had lived. "Ex" as in dead. In 1986, Mexican federal police using U.S. helicopters had bottled up Pablo Acosta, once the drug kingpin of northern Mexico, at the village of Santa Elena, just across the Rio Grande from Big Bend National Park. They shot the town to hell and him with it. Mimi, an art dealer, entrepreneur, and a niece of the late Senator John Tower, was one of the women who showed up to claim Acosta's body.

Two customs agents moved down my side of the line with questions and dogs. Then they did it again. I may not have mentioned that Mimi had also dated the former head of the U.S. Customs antinarcotics unit at Presidio. At the same time she saw Acosta. She liked them both so much she introduced them to each other at her Mexican spread, Rancho El Milagro, between Paso Lajitas and San Carlos.

I figured someone had recognized Mimi either on crossing into Mexico or while dining at one of the late Pablo's favorite restaurants. All kinds of knowing looks as we walked around. I have to admit it was a rush. For a few years after Acosta's slaying, she had gone into federal protection, fearing retaliation in the turf wars that followed.

But she loves the Big Bend and moved back, fixing up a flagstone miner's shack in Terlingua, commuting to her TV commercial casting business in Los Angeles. She maintains active business interests in Mexico and hopes to open a small hotel in Paso Lajitas soon, although she'll have to compete with the juggernaut of Austin's Steve Smith.

Mimi thought the gate sealing was just a coincidence, that customs officials had received a tip that someone was moving something across and were just searching everyone.

She was probably right. I had no drugs or contraband, not even any fresh fruit anymore, and they let us through without incident. Who knows? No one ever tells you why you've been stopped, why you've been released, and it's not a good idea to ask. Along the border today, you get used to that being normal.

*

Earlier in the week, while still based in the Big Bend, I spent a night not far from Ojinaga-Presidio at a place that could not have been more tied to the Southwest's great ranching past, nor more overwhelmed by its paramilitary present and future. The Chambers ranch was a grueling ten-mile, two-hour drive up rugged mountain flanks overlooking Candelaria. It's so wearing that when Johnnye Chambers, the matriarch of the family, and her daughter, Theresa, whose grit and beauty inspired some to call her "the queen of the trans-Pecos," taught in the one-room schoolhouse, they spent weeknights in town rather than face the tire-eating and teeth-rattling trip into the rimrock each day.

Now the Candelaria school is closed, its passing noted by a poignant, sun-bleached sign near an abandoned church: "Give us this day our daily school." Johnnye, now retired, lives in Ruidosa; Theresa has moved to Presidio, teaching there. Boyd Chambers, seventy-six, still works the ranch he leases with help from his son, John.

To me, the Chamberses were and are the stuff of John Ford movies, people of great courage and tenacity who worked hard in a hard land and mostly wanted to be left alone.

But being left alone is not the way of the border. I was at the ranch for a day and night and saw two B-1 bombers passing five hundred feet overhead on routine training flights from Holloman Air Force Base near Alamagordo, New Mexico. Twice as many as I'd ever seen in person in my life. At ground level, the Army Corps of Engineers has graded and scraped the main ranch road, as it has at ranches throughout the state, to make better routes for troops and government agents. The Marines for a time tried to build a road to make access to the region easier, but gave up and have decamped, leaving behind a Quonset hut.

As with the population of any DMZ, the intrusions of war have grown ever more personal. For years, the Chambers family was stalked, stopped, or intimidated by government agents — once while Johnnye and Theresa were taking Christmas packages to the children of San Antonio del Bravo, the village across the river from Candelaria. Boyd is pretty sure some of his cattle were shot from helicopters.

In the early nineties, another son, Robert Chambers, handsome and charismatic, was convicted, along with Presidio County's sher-

iff, Rick Thompson, for moving horse trailers full of cocaine across the river. They went deep into federal prison. Robert's world is trying to get a cell that's smoke-free and wondering how things will be when he's released, in seven years or so.

It could be that the Chamberses are on permanent surveillance, since rumors persist that Robert stashed drug money somewhere and might come back for it.

And it's easy to be judgmental about Robert — whom, I may not have mentioned, Mimi Webb-Miller also once dated. But he grew up in a war zone, adopted the macho and often sadistic ways of the region, learned the meaning of its perverted economy. The writer Richard West recalls the first time he met the tall, blond young man, now a graying inmate: "He drove up in a pickup truck, wearing only blue jeans, shirtless so you could see his muscles. But mostly what I remember was that he had a puma chained to the truck bed." Robert spoke Spanish like a Mexican and knew the country across the river as well as his own. He didn't have to drift into the drug mafia, but it was there, and he was there.

Theresa avoided discussing her brother as we forded the Rio Grande — technically an illegal crossing since there's no customs port — in her old pickup one afternoon at the same spot just west of Candelaria where the bust had gone down. We were taking supplies across to her wonderful little *posada,* Casa de los Santos. The road into the village along the Mexican side was even more tortuous than the one we had negotiated on the Texas side, and badly cleft where occasional floods had eaten away the packed dirt. Usually it was easier to drive supplies up to the footbridge in Candelaria, carry them across, and put them in another truck to take into San Antonio del Bravo. But sometimes this was the only way.

As much as for axle-breaking drops, Theresa kept looking through the cracked windshield for Mexican soldiers garrisoned in the area. The foliage was thick in spots and offered easy cover to the military or anyone else. She had been stopped often, at gunpoint. But she didn't scare anymore. None of them did.

"The Border Patrol drove up here one time and told me since I was within twenty-five miles of the border they can come in my house when they want to," Boyd had told me up at the old ranch house — a real one, simple, functional, not one of those weekend

affectations of the wealthy. He had been taking a break from the noon heat while Johnnye cooked pan-roasted chicken and plump water biscuits for lunch. "I told them that's not in the Constitution. It's not right. They can't have different laws for people on the border."

Johnnye walked over to refill my glass of sweet tea. "I was down in Guatemala one time," she said, "and some soldiers came out of the jungle and stopped us. One of the people in the group with me asked if I was afraid. I said, 'No, I'm from Presidio County. We can be stopped anytime.'"

6. El Paso, America

The westering Texas border ends at El Paso not unlike it begins in the Valley, its long, meandering middle stoppered up with a semi-isolated city-state bearing the brunt of international upheaval. The difference is that the Valley has accepted its changed role and demographics, and El Paso is still working on it.

Coming out of the mountains of the trans-Pecos, you begin to approach perhaps the most distinctive of Texas cities at what here is called its own "Lower Valley," the stretch of historic Spanish mission and market towns, now poor to lower-middle-class communities or barrios — San Elizario, Socorro, and Ysleta — that hug the river. Most of the way from Quitman Pass the land is heavily diked and canalized, surrealistically verdant and lush with cash crops. Scattered everywhere is the mishmash of substandard *colonias* poor workers have built and hang on to with great determination. The reason is simple. Living in a *colonia* is better than paying rent to live in a dilapidated apartment or nowhere at all. Politicians and professional advocates who occasionally seek to close the *colonias* sometimes forget the power of this Hobson's choice.

The northeast side of El Paso is a mix of barrios, middle-class suburbs, retail strips, the airport, and military bases, the largest of which is Fort Bliss, where the drug war's controversial Joint Task Force 6 was created. The city then wraps itself around the Franklin Mountains, known for a tram and scenic views, to the prosperous and mall-friendly west side, home to the University of Texas–El Paso and most of the city's Anglo population, now shrunk to perhaps one third of the three-quarter million residents.

To the south are the dry, brown hills of much-maligned Ciudad Juárez, aglow each evening in yellowish electricity. More than 2 million souls, mostly drawn from the horrendous poverty of the interior, often find themselves in even worse straits — cardboard boxes or streets serving as home in a city polluted and pressed in just about every way possible. Juárez and Tijuana have the highest concentration of the U.S.-Mexico border's estimated 3,500 maquiladoras, the manufacturing plants created in 1965 through binational agreement that pay a fraction of the U.S. minimum wage. That gives more jobs to Mexicans, but effectively stifles industrial development in El Paso and elsewhere on the American side. Replete with drug mobsters, Juárez is also the murder capital of Mexico. As with about one third of Mexican border cities, there is no public sewer system. Except the river.

The tired, the poor, and the huddled masses are pretty much massing right here. Feelings of nationality, even between Mexican-Americans and Mexicans, seem to run higher than anywhere else along the border. In 1993, Mexico raised a flag the size of Montana over its Chamizal territory, a little patch of land ceded by the United States after a shift in the riverbed. You can see the flag from miles away, a giant flapping source of pride not coincidentally an up-yours to the offspring of Uncle Sam. Every Fourth of July, El Paso gets payback. A local bank traditionally drapes lights in the shape of the American flag along the side of its multistory downtown headquarters. The two symbols duel in the night, one waving, one electrified; textile and technology, them and us. You don't know whether to salute or laugh.

Some people don't like to go to Juárez these days, given its penchant for violence, but plenty still do anyway. My visit started indirectly, with a dinner with Malcolm McGregor, the flamboyant attorney whose clients include the reclusive author Cormac McCarthy, at the Camino Real Hotel in the heart of downtown El Paso. Next to the convention center and bus station, and a short walk from the international bridge, the Camino Real is the meeting place of choice in the city. As if in proof, someone tapped me on the shoulder just as dessert arrived. I turned to see Butch Hancock. He'd driven over from Terlingua for a birthday party for Terry Allen, the eccentric and underrated Lubbock songwriter and artist. A couple dozen of Allen's friends, mostly artists and musicians such as Butch

and the blues guitarist Charlie Sexton, were whooping it up in the hotel's bar, and next thing I knew we were walking across the bridge to have dinner at Nuevo Martino in Juárez. It was a good time, but I wanted to get back out into the streets and slipped away early.

Despite a steady drizzle, Juárez Avenue was spiked curb to corner with swarms of people and an edgy ambience of latent anything goes.

Everyone seemed dramatically young. More than half the population in Mexico is younger than twenty-five, and the border reflects that. Short-haired soldiers from Fort Bliss jostled past me on the way back from the red-light district or en route to the endless string of bars. El Paso teenagers escaping Texas drinking laws hooted down the sidewalks whacked on tequila shots. Mexican counterparts spilled out of discos as though from a strip in L.A. Cars streamed through, honking, radios blaring. Sometimes I couldn't move forward the sidewalk was so jammed.

Returning, I stopped halfway along the bridge to look down at the water. But the wire barricades made it impossible to see, and if you didn't keep moving, the beggars and hustlers would give you no peace. Back in the States, the customs agent wanted to know where I'd been and if I was a citizen. "Yes," I said. He looked at me a very long fifteen seconds and couldn't leave it at that. "Of what country?" I gave him the answer we both knew to be true and then walked up to the lower end of El Paso Street. It had been taken over by the homeless — men, women, and children — stretching out on the sidewalks and in the doorways to sleep. I got to the hotel and stopped at the bar for a nightcap, but something unpleasant had settled in my mind and I went up to my room, sat awhile staring out the tenth-floor window at the sweep of the two cities, and finally fell asleep.

At five-forty-five the next morning I met Malcolm for chorizo tacos at his favorite breakfast spot, a Whataburger on the far west side. A burly, white-haired Renaissance man known not only for his law practice and his stints as a state legislator, but for his living room. It's an airplane hangar: two biplanes on the floor, another suspended from the ceiling. What he flies is the two-seat Super Cub. After he pushed it out and gassed it up, no small feat for an older

man, we taxied down the runway that lies in the middle of the Cielo
Dorado estates, just across the New Mexico state line. All the resi-
dents have private planes, though usually not parked behind the
TV. Some of the residents aren't there anymore. On the way back
to his house from breakfast, McGregor had pointed out several
homes in the estate which had been confiscated by the DEA or
whose owners had been arrested for smuggling.

"It's hard to know where it starts and stops," he said. He's han-
dled drug cases but doesn't like to anymore. He doesn't even want
to talk about it much. "In federal court these days," he said without
smiling, "about all you can do is plead guilty and inform on all your
friends."

From the air, the division between El Paso and Juárez is stark and
evident. "There's the First World," McGregor said through the
headset, pointing to an enclave of six-figure homes with tennis
courts and swimming pools below us. Then we banked toward the
drab-looking foothills of Juárez. "And there's the Third."

The encroachment seems unstoppable. "It's like being on the
backside of a monster dam. The country with one of the highest
birthrates in the world, just waiting to jump over. That's what got
Sylvestre Reyes elected [as a U.S. congressman], you know. When
he was head of the Border Patrol here he set up Border Patrol cars
every four hundred yards." Malcolm turned back northwest, to-
ward the United States. "Periodically you can see it [the fear] like a
bamboo wall going up. The Mexican Revolution got 'em all excited
over here. Dope has got 'em excited again."

Like many border residents, Anglo or Mexican-American, and
maybe like the government itself, McGregor doesn't know what to
do about the changes he thinks really began to affect the city in the
mid-fifties and now make it a place he sometimes barely recog-
nizes. "What should we do? Open borders completely or become
Fortress America?" The plane made a slow turn near the statue of
Christ atop Sierra del Cristo Rey's peak, which marks the intersec-
tion of Juárez, El Paso, and New Mexico. Until the Mexican War
split the border in two, everything functioned as El Paso del Norte,
one city.

Not far below, near the Anapra sector of Juárez, I could see the
slow grade on the railroad tracks said to be favored by train rob-
bers. Everywhere I looked along the concrete channels that held

the river as it passed between the cities were high fences topped with barbed wire. From the backseat, I pressed my microphone button with my delayed answer. "I don't know," I said.

I was pretty sure he'd heard that before.

I am in El Paso and I have just had enchiladas verdes at the L & J Café, "the old place by the graveyard." I am driving crosstown back to the Mission Trail in the Lower Valley to visit the historic presidio chapel at San Elizario, so pristine amid streets so aching with poverty. But I am not here, really.

In my mind I'm back in the Big Bend, a few years ago, pushing my jeep through the quicksand-like lava-silt, steep-banked streambeds, hairpin turns, and axle-swallowing ruts of the treacherous fifty-one-mile River Road, which traces the southern curve of the national park. In the passenger seat is Betty Moore, a raft guide and old friend from Austin, well known for her monitoring of peregrine falcons and the open-air bathtub outside her self-improved miner's shack. She had, with only moderate arm-twisting, agreed to join me for what everyone in Terlingua but me knew was a nasty, brutish four-hour trek, albeit a great way to see the Chihuahuan Desert floor.

The outside temperature fluctuated between 113 and 120, and a few forays into that outback-style heat, plus the general ride through hell, made us thirsty. The closest place was Santa Elena.

Fortunately the old *chalupero* was still working, and he rowed his aluminum skiff, or *chalupa,* across, angling hard upstream until the swift current vectored him down to the American side, landing at just the right spot. He took us across, then sat under a shade tree and returned to a six-pack of Tecate. Betty and I walked up the steep dirt bank to the small town where Pablo Acosta had been shot a decade ago.

Maria Elena's Café was open, so we sat at a metal folding table under a string of multicolored lights on a screen porch and had a couple of *cervezas,* practicing Spanish on the young waitress.

When we returned to the river, the *chalupero* was feeling no pain. On the way back, I asked him how old he was. *"Soy viejo,"* he beamed. He was sixty-four.

I reached over and touched his arm, which was as thick as my leg. *"Pero muy fuerte,"* I said. On the other hand, I had all my teeth.

I told him I was *viejo*, too, but not as *viejo* as he was, and both of us were more *viejo* than Betty, and we argued about who was *más viejo*. At the other side he pulled up the skiff and boarded his oars and asked for four dollars.

I knew that was high and said so, but he shrugged, because, of course, there was nothing he could do about these things. I was nearly out of cash but began counting out what I had into his palm, coins and all, until we came up with what seemed like five dollars.

Then we counted it again, English and Spanish, maybe even Latin, until we were laughing too much to care. No doubt he got one over on me, but if I'd had fifty dollars I probably would have given it to him. I think he had the best job on the border. He made it go away.

MICHAEL FINKEL

Thirteen Ways of Looking at a Void

FROM *National Geographic Adventure*

"HELL," says Mousaka. He raises a forefinger and circles it in the air, to indicate that he is referring to the whole of the void. I am sitting on Mousaka's lap. Mousaka is sitting on Osiman's lap. Osiman is sitting on someone else's lap. And so on — everyone sitting on another's lap. We are on a truck, crossing the void. The truck looks like a dump truck, though it doesn't dump. It is twenty feet long and six feet wide, diesel-powered, painted white. One hundred and ninety passengers are aboard, tossed atop one another like a pile of laundry. People are on the roof of the cab, and straddling the rail of the bed, and pressed into the bed itself. There is no room for carry-on bags; water jugs and other belongings must be tied to the truck's rail and hung over the sides. Fistfights have broken out over half an inch of contested space. Beyond the truck, the void encompasses 154,440 square miles, at last count, and is virtually uninhabited.

Like many of the people on board, Mousaka makes his living by harvesting crops — oranges or potatoes or dates. His facial scars, patterned like whiskers, indicate that he is a member of the Hausa culture, from southern Niger. Mousaka has two wives and four children and no way to provide for them, except to get on a truck. Also on the truck are Tuareg and Songhai and Zerma and Fulani and Kanuri and Wodaabe. Everyone is headed to Libya, where the drought that has gripped much of North Africa has been less severe and there are still crops to pick. Libya has become the new promised land. Mousaka plans to stay through the harvest season, January to July, and then return to his family. To get to Libya from the south, though, one must first cross the void.

The void is the giant sand sea at the center of the Sahara. It covers half of Niger and some of Algeria and a little of Libya and a corner of Chad. On maps of the Sahara, it is labeled, in large, spaced letters, "Ténéré" — a term taken from the Tuareg language that means "nothing" or "emptiness" or "void." The Ténéré is Earth at its least hospitable, a chunk of the planet gone dead. Even the word itself, "Ténéré," looks vaguely ominous, barbed as it is with accents. In the heart of the void there is not a scrap of shade nor a bead of water nor a blade of grass. Most parts, even bacteria can't survive.

The void is freezing by night and scorching by day and wind-scoured always. Its center is as flat and featureless as the head of a drum. There is not so much as a large rock. Mousaka has been crossing the void for four days; he has at least a week to go. Except for prayer breaks, the truck does not stop. Since entering the void, Mousaka has hardly slept, or eaten, or drunk. He has no shoes, no sunglasses, no blanket. His ears are plugged with sand. His clothing is tattered. His feet are swollen. This morning, I asked him what comes to mind when he thinks about the void. For two weeks now, as I've been crossing the Sahara myself, using all manner of transportation, I have asked this question to almost every person I've met. When the truck rides over a bump and everybody is jounced, elbows colliding with sternums, heads hammering heads, Mousaka leans forward and tells me his answer again. "The desert is disgusting," he says, in French. "The desert is hell." Then he spits over the side of the truck, and spits again, trying to rid himself of the sand that has collected in his mouth.

"Faith," says Monique. "The Ténéré gives me faith." Monique has been crossing and recrossing the void for four weeks. We've met at the small market in the Algerian town of Djanet, at the northern hem of the Ténéré. Monique is here with her travel partners, re-supplying. She's Swiss, though she's lived in the United States for a good part of her life. Her group is traversing the void in a convoy of Pinzgauers — six-wheel-drive, moon-rover-looking vehicles, made in Austria, that are apparently undaunted by even the softest of sands.

Monique is in her early seventies. A few years ago, not long after her husband passed away, she fulfilled a lifelong fantasy and visited the Sahara. The desert changed her. She witnessed sunrises that

turned the sand the color of lipstick. She saw starfish-shaped dunes, miles across, whose curving forms left her breathless with wonder. She heard the fizzy hum known as the singing of the sands. She reveled in the silence and the openness. She slept outside. She let the wind braid her hair and the sand sit under her fingernails and the sun bake her skin. She shared meals with desert nomads. She learned that not every place on Earth is crowded and greed-filled and tamed. She stayed three months. Now she's back for another extended visit.

Her story is not unusual. Tourism in the Ténéré is suddenly popular. Outfitters in Paris and London and Geneva and Berlin are chartering flights to the edge of the void and then arranging for vehicles that will take you to the middle. Look at the map, the brochures say: You're going to the heart of the Sahara, to the famous Ténéré. Doesn't the word itself, exotic with accents, roll off the tongue like a tiny poem?

Many of the tourists are on spiritual quests. They live hectic lives, and they want a nice dose of nothing — and there is nothing more nothing than the void. The void is so blank that a point-and-shoot camera will often refuse to work, the auto-focus finding nothing to focus on. This is good. By offering nothing, I've been told, the void tacitly accepts everything. Whatever you want to find seems to be there. Not long after I met Monique, I spoke with another American. Her name is Beth. She had been in the Ténéré for two and a half weeks, and she told me that the point of her trip was to feel the wind in her face. After a fortnight of wind, Beth came to a profound decision. She said she now realized what her life was missing. She said that the moment she returned home she was quitting her Internet job and opening up her own business. She said she was going to bake apple pies.

"Money," says Ahmed. "Money, money, money, money, money." Ahmed has no money. But he does have a plan. His plan is to meet every plane that lands in his hometown of Agadez, in central Niger, one of the hubs of Ténéré tourism. During the cooler months, and when the runway is not too potholed, a flight arrives in Agadez as often as once a week. When my plane landed, from Paris, Ahmed was there. The flight was packed with French vacationers, but all of them had planned their trips with European full-service agencies.

No one needed to hire a freelance guide. This is why Ahmed is stuck talking with me.

Ahmed speaks French and English and German and Arabic and Hausa and Toubou, as well as his mother tongue, the Tuareg language called Tamashek. He's twenty-seven years old. He has typical Tuareg hair, jet black and wild with curls, and a habit of glancing every so often at his wrist, like a busy executive, which is a tic he must have picked up from tourists, for Ahmed does not own a watch, and, he tells me, he never has. He says he's learned all these languages because he doesn't want to get on a truck to Libya. He tells me he can help tourists rent quality Land Cruisers, and he can cook for them — his specialty is tagela, a bread that is baked in the sand — and he can guide them across the void without a worry of getting lost. Tourism, he says, is the only way to make money in the void.

Inside his shirt pocket, Ahmed keeps a brochure that was once attached to a bottle of shampoo. The brochure features photos of very pretty models, white women with perfect hair and polished teeth, and Ahmed has opened and closed the brochure so many times that it is as brittle and wrinkled as an old dollar bill. "When I have money," he says, "I will have women like this."

"But," I point out, "the plane landed, and you didn't get a client."

"Maybe next week," he says.

"So how will you make money this week?"

"I just told you all about me," he says. "Doesn't that deserve a tip?"

"Salt," says Choukou. He tips his chin to the south, toward a place called Bilma, in eastern Niger, where he's going to gather salt. Choukou is on his camel. He's sitting cross-legged, his head wrapped loosely in a long white cloth, his body shrouded in a billowy tan robe, and there is an air about him of exquisite levity — a mood he always seems to project when he is atop his camel. Often, he breaks into song, a warbling chant in the Toubou tongue, a language whose syllables are as rounded as river stones. I am riding another of his camels, a blue-eyed female that emits the sort of noises that make me think of calling a plumber. A half dozen other camels are following us, riderless. We are crossing the void.

Choukou is a Toubou, a member of one of the last seminomadic peoples to live along the edges of the void. At its periphery, the void is not particularly voidlike; it's surrounded on three sides by craggy mountains — the Massif de l'Aïr, the Ahaggar, the Plateau du Djado, the Tibesti — and, to the south, the Lake Chad Basin. Choukou can ride his camel sitting frontward or backward or side-saddle or standing, and he can command his camel, never raising his voice above a whisper, to squat down or rise up or spin in circles. His knife is strapped high on his right arm; his goatskin, filled with water, is hooked to his saddle; a few dried dates are in the breast pocket of his robe, along with a pouch of tobacco and some scraps of rolling paper. He is sitting on his blanket. This is all he has with him. It has been said that a Toubou can live for three days on a single date: the first day on its skin, the second on its fruit, the third on its pit. My guess is that this is truer than you might imagine. In two days of difficult travel with Choukou, I saw him eat one meal.

If you ask Choukou how old he is, he'll say he doesn't know. He's willing to guess (twenty, he supposes), but he can't say for sure. It doesn't matter. His sense of time is not divided into years or seasons or months. It's divided into directions. Either he is headed to Bilma, to gather salt, or he is headed away from Bilma, to sell his salt. It has been this way for the Toubous for two thousand years. No one has yet discovered a more economical method of transporting salt across the void — engines and sand are an unhappy mix — and so camels are still in use. Camels can survive two weeks between water stops and then, in a single prolonged drink, can down twenty-five gallons of water, none of which happens to be stored in the hump. When Choukou arrives at the salt mines of Bilma, he will load each of his camels with six fifty-pound pillars of salt, then join with other Toubous to form a caravan — a hundred or more camels striding single file across the sands — and set out for Agadez. In the best of conditions, the trek can take nearly a month.

Choukou occasionally encounters tourists, and he sometimes sees the overloaded trucks, but he is only mildly curious. He does not have to seek solace from a hectic life. He has no need to pick crops in Libya. He travels with the minimum he requires to survive, and he knows that if even one well along the route has suddenly run dry — it happens — then he will probably die. He knows that there are bandits in the void and sandstorms in the void. He is not

married. A good wife, he tells me, costs five camels, and he can't yet afford one. If he makes it to Agadez, he will sell his salt and then immediately start back to Bilma. He navigates by the dunes and the colors of the soil and the direction of the wind. He can study a set of camel tracks and determine which breed of camel left them, and therefore the tribe to which they belong, and how many days old the tracks are, and how heavy a load the camels are carrying, and how many animals are in the caravan. He was born in the void, and he has never left the void. This is perhaps why he looks at me oddly when I ask him what comes to mind when he contemplates his homeland. I ask him the question, and his face becomes passive. He mentions salt, but then he is quiet for a few seconds. "I really don't think about the void," he says.

"Cameras," says Mustafa. "Also videos and watches and Walkmans and jewelry and GPS units." Mustafa has an M-16 rifle slung over his shoulder. He is trying to sell me the items he has taken from other tourists. I am at a police checkpoint in the tiny outpost of Chirfa, along the northeastern border of the void. I've hired a desert taxi — a daredevil driver and a beater Land Cruiser — to take me to Algeria. Now we've been stopped.

Mustafa is fat. He is fat, and he is wearing a police uniform. This is a bad combination. In the void, only the wealthy are fat. Police in Niger do not make enough money to become wealthy; a fat police officer is therefore a corrupt police officer. And a corrupt officer inevitably means trouble. When I refuse to even look at his wares, Mustafa becomes angry. He asks to see my travel documents. The void is a fascinating place — there exist, at once, both no rules and strict rules. To cross the void legally, you are supposed to carry very specific travel documents, and I actually have them. But the documents are open to interpretation. You must, for example, list your exact route of travel. It is difficult to do this when you are crossing an expanse of sand that has no real roads. So of course Mustafa finds a mistake.

"It is easy to correct," he says. "You just have to return to Agadez." Agadez is a four-day drive in the opposite direction. "Or I can correct it here," he adds. "Just give me your GPS unit." He does not even bother to pretend that it isn't a bribe. Mustafa is the leader of this outpost, the dictator of a thousand square miles of desert. There is no one to appeal to.

"I don't have a GPS unit," I say.

"Then your watch."

"No," I say.

"A payment will do."

"No," I say.

"Fine," he says. Then he says nothing. He folds his arms and rests them on the shelf formed by his belly. He stands there for a long time. The driver turns off the car. We wait. Mustafa has all day, all week, all month, all year. He has no schedule. He has no meetings. If we try to drive away, he will shoot us. It is a losing battle.

I hand him a sheaf of Central African francs, and we continue on.

"Beer," says Grace. "Beer and women." Grace is maybe thirty-five years old and wears a dress brilliant with yellow sunflowers. She has a theory: Crossing the void, she insists, seeing all that nothing, she posits, produces within a man a certain kind of emptiness. It is her divine duty, she's decided, to fill that emptiness. And so Grace has opened a bar in Dirkou. A bar and brothel.

Dirkou is an unusual town. It's in Niger, at the northeastern rim of the Ténéré, built in what is known as a wadi — an ancient river-bed, now dry, but where water exists not too far below the surface, reachable by digging wells. The underground water allows date palms to grow in Dirkou. Whether you are traveling by truck, camel, or 4x4, it is nearly impossible to cross the void without stopping in Dirkou for fuel or provisions or water or emptiness-filling.

Apparently, it is popular to inform newcomers to Dirkou that they are now as close as they can get to the end of the earth. My first hour in town, I was told this five or six times; it must be a sort of civic slogan. This proves only that a visit to the end of the earth should not be on one's to-do list. Dirkou is possibly the most un-redeeming place I have ever visited, Los Angeles included. The town is essentially one large bus station, except that it lacks electricity, plumbing, television, newspapers, and telephones. Locals say that it has not rained here in more than two years. The streets are heavy with beggars and con artists and thieves and migrants and drifters and soldiers and prostitutes. Almost everyone is male, except the prostitutes. The place is literally a dump: When you want to throw something away, you just toss it in the street.

Grace's emptiness theory has a certain truth. I arrived in Dirkou

after riding on the Libya-bound truck for three days. Of the 190 passengers, 186 were male. Those with a bit of money went straight to Grace's bar. The bar was like every structure in Dirkou: mud walls, palm-frond roof, sand floors. I sat at a scrap-wood table, on a milk-crate chair. A battery-powered radio emitted 90 percent static and 10 percent Arabic music from a station in Chad. I drank a Niger beer, which had been stored in the shade and was, by Saharan standards, cold. I drank two more.

My emptiness, it seems, was not as profound as those of my truck mates. In the Ténéré, there exists the odd but pervasive belief that alcohol hydrates you — and not only hydrates you but hydrates you more efficiently than water. Some people on the truck did not drink at all the last day of the trip, for they knew Grace's bar was approaching. Many of these same men were soon passed out in the back of the bar. There is also the belief that a man cannot catch AIDS from a prostitute so long as she is less than eighteen years old.

One other item that Dirkou lacks is bathrooms. After eating a bit of camel sausage and drinking my fourth beer, I ask Grace where the bathroom is. She tells me it is in the street. I explain, delicately, that I'm hoping to produce a different sort of waste. She says it doesn't matter, the bathroom is in the street. I walk out of the bar, seeking a private spot, and in the process I witness three men doing what I am planning to do. This explains much about the unfortunate odor that permeates Dirkou.

"Spirits," says Wordigou. He is sitting on a blanket and holding his supper bowl, which at one time was a sardine tin. His face is illuminated by a kerosene lamp. Wordigou has joined us for dinner, some rice and a bit of mutton. He is a cousin of Choukou's, the young salt trader who told me that he does not think about the void. Choukou allowed me to join his camel trek for two days, and now, in the middle of our journey, we have stopped for the evening at a Toubou encampment. Wordigou lives in the camp, which consists of a handful of dome-shaped grass huts, two dozen camels, an extended family of Toubous, and a herd of goats. In the hut I've been lent for the night, a cassette tape is displayed on the wall as a sort of curious knickknack. Certainly there is no tape player in the camp. Here, the chief form of entertainment is the same as it is almost everywhere in the void — talking. Wordigou, who guesses that he is

a little less than thirty years old, leads the mealtime discussion. He is a sharp and insightful conversationalist. The topic is religion. The Toubous are nominally Muslim, but most, including Wordigou, have combined Islam with traditional animist beliefs.

"The desert," says Wordigou, "is filled with spirits. I talk with them all the time. They tell me things. They tell me news. Some spirits you see, and some you don't see, and some are nice, and some are not nice, and some pretend to be nice but really aren't. I ask the nice ones to send me strong camels. And also to lead me to hidden treasures."

Wordigou catches my eye, and he knows immediately that I do not share his beliefs. Still, he is magnanimous. "Even if you do not see my spirits," he says, "you must see someone's. Everyone does. How else could Christianity and Judaism and Islam all have begun in the very same desert?"

"Work," says Bilit. "It ties me to the desert." Bilit is the driver of the overloaded truck that is headed to Libya. He has stopped his vehicle, climbed out of the front seat, and genuflected in the direction of Mecca. Sand is stuck to his forehead. The passengers who've gotten off are piling aboard. Only their turbans can be seen through the swirling sand. Everyone wears a turban in the void — it protects against sun and wind and provides the wearer with a degree of anonymity, which can be valuable if one is attempting a dubiously legal maneuver, like sneaking into Libya. Turbans are about the only splashes of color in the desert. They come in a handful of bold, basic hues, like gumballs. Bilit's is green. I ask him how far we have to go.

"Two days," says Bilit. *"Inshallah,"* he adds — God willing. He says it again: *"Inshallah."* This is, by far, the void's most utilized expression, the oral equivalent of punctuation. God willing. It emphasizes the daunting fact that, no matter the degree of one's preparation, traveling the void always involves relinquishing control. Bilit has driven this route — Agadez to Dirkou, four hundred miles of void — for eight years. When conditions allow, he drives twenty to twenty-two hours a day. Where the sand is firm, Bilit can drive as fast as fifteen miles an hour. Where it is soft, the passengers have to get out and push. Everywhere, the engine sounds as though it is continually trying to clear its throat.

His route is one of the busiest in the Ténéré — sometimes he sees three or even four other vehicles a day. This means that Bilit doesn't need to rely on compass bearings or star readings to determine if he is headed in the correct direction. There are actually other tire tracks in the sand to follow. Not all tracks, however, are reliable. A "road" in the Ténéré can be twenty miles wide, with tracks braiding about one another where the drivers detoured around signs of softness, seeking firmer sand. Inexperienced drivers have followed braided tracks and ended up confounding themselves. In a place with a blank horizon, it is impossible to tell if you're headed in a gradual arc or going straight. Drivers have followed bad braids until they've run out of gas.

Worse is when there are no tracks at all. This happens after every major sandstorm, when the swirling sands return the void to blankness, shaken clean like an Etch-A-Sketch. A sandstorm occurs, on average, about once a week. During a storm, Bilit stops the truck. Sometimes he'll be stopped for two days. Sometimes three. The passengers, of course, must suffer through it; they are too crowded to move. The trucks are so crowded because the more people aboard, the more money the truck's owner makes. The void is a place where crude economics rule. Comfort is rarely a consideration.

One time, Bilit did not stop in a sandstorm. He got lost. Getting lost in the void is a frightening situation. Even with a compass and the stars, you can easily be off by half a degree and bypass an entire town. Bilit managed to find his way. But recently, on the same route, a truck was severely lost. There are few rescue services in the Ténéré, and by the time an army vehicle located the truck, only eight people were alive. Thirty-six corpses were discovered, all victims of dehydration. The rest of the passengers — six at least, and possibly many more — were likely buried beneath the sands and have never been found.

"War," says Tombu. Where I see dunes, Tombu sees bunkers. Tombu is a soldier, a former leader of the Tuaregs during the armed rebellion that erupted in Niger in 1990. Warring is in his blood. For more than three thousand years, until the French overran North Africa in the late 1800s, the Tuaregs were known as the bandits of the Ténéré, robbing camel caravans as they headed across the void.

The fighting that began in 1990, however, was over civil rights. Many Tuaregs felt like second-class citizens in Niger — it was the majority Hausas and other ethnic groups, they claimed, who were given all the good jobs, the government positions, the college scholarships. And so these Tuaregs decided to try to gain autonomy over their homeland, which is essentially the whole of the Ténéré. They were fighting for an Independent Republic of the Void. Hundreds of people were killed before a compromise was reached in 1995: The Tuaregs would be treated with greater respect, and in return they would agree to drop their fight for independence. Though isolated skirmishes continued until 1998, the void is quiet, at least for now. This is a main reason why there has been a sudden upswing in tourism.

Tombu is no longer a fighter; he now drives a desert taxi, though he drives like a soldier, which is to say as recklessly as possible. I have hired him to take me north, through the center of the void, into Algeria — a four-day drive. We were together when the police officer forced me to pay him a bribe. During rest stops, Tombu draws diagrams in the sand, showing me how he attacked a post high in the Massif de l'Aïr and how he ambushed a convoy of jeeps in the open void. "But now there is peace," he says. He looks disappointed. I ask him if anything has changed for the Tuaregs.

"No," he says. "Except that we have given up our guns." He looks even more disappointed. "But," he adds, visibly brightening, "it will be very easy to get them back."

"Speed," says Joel. He has just pulled his motorbike up to the place I've rented in Dirkou, a furnitureless, sand-floored room for a dollar a night. Joel is in the desert for one primary reason: to go fast. He is here for two months, from Israel, to ride his motorbike, a red-and-white Yamaha, and the void is his playground. Speed and the void have a storied relationship; each winter for thirteen years, the famous Paris-to-Dakar rally cut through the Ténéré — a few hundred foreigners in roadsters and pickup trucks and motorbikes tearing hell-bent across the sand. The race was rerouted in 1997, but its wrecks are still on display, each one visible from miles away, the vehicles' paint scoured by the windblown sand and the steel baked to a smooth chocolate brown.

Joel reveres the Paris-to-Dakar. He talks about sand the way skiers talk about snow — in a language unintelligible to outsiders. Sand,

it turns out, is not merely sand. There are *chotts* and *regs* and *oueds* and *ergs* and *barchans* and *feche-feche* and *gassis* and *bull dust*. The sand around Dirkou, Joel tells me, is just about perfect. "Would you like to borrow my bike?" he asks.

I would. I snap on his helmet and straddle the seat and set out across the sand. The world before me is an absolute plane, nothing at all, and I throttle the bike and soon I'm in fifth and the engine is screaming and sand is tornadoing about. I know, on some level, that I'm going fast and that it's dangerous, but the feeling is absent of fear. The dimensions are so skewed it's more like skydiving — I've committed myself, and now I'm hurtling through space, and there is nothing that can hurt me. It's euphoric, a pure sense of motion and G-force and lawlessness, and I want more, of course, so I pull on the throttle and the world is a blur and the horizon is empty, and it is here, it is right now, that I suddenly realize what I need to do. And I do it. I shut my eyes. I pinch them shut, and the bike bullets on, and I override my panic because I know that there's nothing to hit, not a thing in my way, and soon, with my eyes closed, I find that my head has gone silent and I have discovered a crystalline form of freedom.

"Death," says Kevin. "I think about dying." Kevin is not alone. Everyone who crosses the void, whether tourist or Toubou or truck passenger, is witness to the Ténéré's ruthlessness. There are the bones, for example — so many bones that a good way to navigate the void is to follow the skeletons, which are scattered beside every main route like cairns on a hiking trail. They're mostly goat bones. Goats are common freight in the Ténéré, and there are always a couple of animals that do not survive the crossing. Dead goats are tossed off the trucks. In the center of the void, the carcasses become sun-dried and leathery, like mummies. At the edges of the void, where jackals roam, the bones are picked clean and sun-bleached white as alabaster. Some of the skeletons are of camels; a couple are human. People die every year in the Ténéré, but few travelers have experienced such deaths as directly as Kevin.

Kevin is also on the Libya-bound truck, crossing with the crop pickers, though he is different from most other passengers. He has no interest in picking crops. He wants to play soccer. He's a midfielder, seeking a spot with a professional team in either Libya or

Tunisia. Kevin was born in South Africa, under apartheid, then later fled to Senegal, where he lived in a refugee camp. His voice is warm and calm, and his eyes, peering through a pair of metal-framed glasses, register the sort of deep-seated thoughtfulness one might look for in a physician or religious leader. Whenever a fight breaks out on the truck, he assumes the role of mediator, gently persuading both parties to compromise on the level of uncomfortableness. He tells me that he would like to study philosophy and that he has been inspired by the writings of Thomas Jefferson. He says that his favorite musician is Phil Collins. "When I listen to his music," he says, "it makes me cry." I tell him, deadpan, that it makes me cry, too. This is Kevin's second attempt at reaching the soccer fields across the sands. The first trip, a year previous, ended in disaster.

He was riding with his friend Silman in a dilapidated Land Cruiser in the northern part of the void. Both of them dreamed of playing soccer. There were six other passengers in the car and a driver, and for safety they were following another Land Cruiser, creating a shortcut across the Ténéré. The car Kevin and Silman were in broke down. There was no room in the second Land Cruiser, so only the driver of the first car squeezed in. He told his passengers to wait. He said he'd go to the nearest town, a day's drive away, and then return with another car.

After three days, there was still no sign of the driver. Water was running low. It was the middle of summer. Temperatures in the void often reach 115 degrees Fahrenheit and have gone as high as 130 degrees. The sky turns white with heat; the sand shimmers and appears molten. Kevin and Silman decided they would rather walk than wait. The other six passengers decided to remain with the broken vehicle. Kevin and Silman set out across the desert, following the tracks of the second Land Cruiser. Merely sitting in the shade in the Sahara, a person can produce two gallons of sweat per day. Walking, Kevin and Silman probably produced twice that amount. They carried what water they had, but there was no way they could replace a quarter of the loss.

Humans are adaptable creatures, but finely calibrated. Even a gallon loss — about 5 percent of one's body fluid — results in dizziness and headache and circulatory problems. Saliva glands dry up. Speech is garbled. Kevin and Silman reached this state in less

than a day. At a two-gallon deficit, walking is nearly impossible. The tongue swells, vision and hearing are diminished, and one's urine is the color of dark rust. It is difficult to form cogent thoughts. Recovery is not possible without medical assistance. People who approach this state often take desperate measures. Urine is the first thing to be drunk. Kevin and Silman did this. "You would've done it, too," Kevin tells me. People who have waited by stranded cars have drunk gasoline and radiator fluid and battery acid. There have been instances in which people dying of thirst have killed others and drunk their blood.

Kevin and Silman managed to walk for three days. Then Silman collapsed. Kevin pushed on alone, crawling at times. The next day, the driver returned. He came upon Kevin, who at this point was scarcely conscious. The driver had no explanation for his weeklong delay. He gave Kevin water, and they rushed to find Silman. It was too late. Silman was dead. They returned to the broken Land Cruiser. Nobody was there. Evidently, the other passengers had also tried to walk. Their footprints had been covered by blowing sand. After hours of searching, there was no trace of anyone else. Kevin was the only survivor.

"History," says Hamoud. Hamoud is an old man — though "old" is a relative term in Niger, where the life expectancy is forty-one. I have hired a desert taxi to take me to a place called Djado, in eastern Niger, where Hamoud works as a guide. Djado is, by far, the nicest city I have seen in the Ténéré. It is built on a small hill beside an oasis thick with date palms and looks a bit like a wattle-and-daub version of Mont-St.-Michel. The homes, unlike any others I've seen in the void, are multistoried, spacious, and cool. Thought has been given to the architecture; walls are elliptical, and turrets have been built to provide views of the surrounding desert. There is not a scrap of garbage.

One problem: Nobody lives in Djado. The city is several thousand years old and has been abandoned for more than two centuries. At one time, there may have been a half million people living along Djado's oasis. Now it is part of a national reserve and off-limits to development. A handful of families are clustered in mud shanties a couple of miles away, hoping to earn a few dollars from the trickle of tourists.

Nobody knows exactly why Djado was deserted; the final blows

were most likely a malaria epidemic and the changing patterns of trade routes. But Hamoud suggests that the city's decline was initiated by a dramatic shift in the climate. Ten thousand years ago, the Sahara was green. Giraffes and elephants and hippos roamed the land. Crocodiles lived in the rivers. On cliffs not far from Djado, ancient paintings depict an elaborate society of cattle herders and fishermen and bow hunters. Around 4000 B.C., the weather began to change. The game animals left. The rivers dried. One of the last completed cliff paintings is of a cow that appears to be weeping, perhaps symbolic of the prevailing mood. When Djado was at its prime, its oasis may have covered dozens of square miles. Now there is little more than a stagnant pond. Hamoud says that he found walking through Djado to be "mesmerizing" and "thrilling" and "magnificent" and "beautiful." I do not tell him this, but my overwhelming feeling is of sadness. In the void, it seems clear, people's lives were better a millennium ago than they are today.

"Destiny," says Akly. He shrugs his shoulders in a way designed to imply that he could care less, but his words have already belied his gesture. Akly does care, but he is powerless to do anything — and maybe this, in truth, is what his shrug is attempting to express. Akly is a Tuareg, a native of Agadez who was educated in Paris. He has returned to Niger, with his French wife, to run a small guest house. Agadez is a poor city in a poor nation beset by a brutal desert. It is not a place to foster optimism.

Akly is worried about the Sahara. He is concerned about its expansion. Most scientific evidence appears to show that the Sahara is on the march. In three decades, the desert has advanced more than sixty miles to the south, devouring grasslands and crops, drying up wells, creating refugees. The Sahara is expanding north, too, piling up at the foothills of the Atlas Mountains, as if preparing to ambush the Mediterranean.

Desertification is a force as powerful as plate tectonics. If the Sahara wants to grow, it will grow. Akly says he has witnessed, just in his lifetime, profound changes. He believes that the desert's growth is due both to the Sahara's own forces and to human influences. "We cut down all the trees," he says, "and put a hole in the ozone. The earth is warming. There are too many people. But what can we do? Everyone needs to eat, everyone wants a family." He shrugs again, that same shrug.

"It has gotten harder and harder to live here," he says. "I am glad that you are here to see how hard it is. I hope you can get accustomed to it."

I shake my head no and point to the sweat beading my face, and to the heat rash that has pimpled my neck, and to the blotches of sunburn that have left dead skin flaking off my nose and cheeks and arms.

"I think you'd better get used to it," Akly says. "I think everyone should get used to it. Because one day, maybe not that far away, all of the deserts are going to grow. They are going to grow like the Sahara is growing. And then everyone is going to live in the void."

DEVIN FRIEDMAN

Forty Years in Acapulco

FROM *Men's Journal*

YOU WAKE in your dim hotel room to a day just like yesterday and exactly like tomorrow. That's the idea, anyway: that every day down here be identical. Namely, sunny, with low humidity and temperatures hovering in the low nineties. This is what people work their whole lives for, and it's more than you could have expected. You, a schnook from Poland who came over on the boat in 1920. But these are the facts of life if you're Mort Friedman, known to some as Mort the Sport, to others as the Window King of Cleveland, my eighty-nine-year-old grandfather. One full month in Acapulco, Mexico, every February for the last forty years. You tell everyone: This is the life, baby.

Wearing only your drawers, you make your way to the window and throw open the drapes of room 1233 at Acapulco's Continental Plaza Hotel. And there it is, nearly blinding you: paradise. The high blue sky, the beach, the deck with its cul-de-sacs of chairs. And right in the middle, the epicenter of paradise, the Plaza pool, a glowing aqua moat that smells wonderfully of chlorine even from here on the twelfth floor. The best goddamn pool in Acapoca (that's how you say it). They've got fancier hotels up the coast, newer and more expensive. But nobody has a pool like this, boy. The thought provides no small measure of reassurance, the first in a day spring-loaded with reassuring things.

Your eighty-six-year-old girlfriend, Toby Fishman, is asleep in the other bed, and you stop on the way to the bathroom and watch her chest rise and fall, rise and fall. One day, twenty years ago, you woke, dressed, and nearly left for work before you realized your

wife's (my grandmother's) chest was not making this motion. Stroke. Never knew what hit her, boy. But Toby Fishman is, thank God, alive and well. Not that you wake her. She doesn't like to be talked to before ten o'clock.

You open the closet and survey your stacks of bathing ensembles. Thirty pairs of swim trunks with matching tops, each of them brand-new. This, in the logic of Mort Friedman's Essential Guidelines for Living, could be called *Rule No. 17: You wear a bathing suit once and then retire it forever.* Like you told your son (my father) a few months ago, you've always been an A in fashion. Him? C minus.

You slip on a Nautica suit with matching Nautica T-shirt. Then you select from among your shoes, five pairs, all white. *Rule No. 14: White is the appropriate color for resort-season footwear.* You've got your white loafers, your white sandals, two pairs of white-and-tan saddle shoes, and a pair of unblemished white Adidas tennis sneakers that you pluck from the tree and slip on, sockless.

Dressed, you begin to assemble the necessary pool paraphernalia in the airline tote you take down every day. Toby rouses in the half-light and trudges into the bathroom to put on her face. She applies the foundation, the blush, the lipstick, the three spangly rings, and the heart-shaped necklace cast of platinum and coated in diamonds. At five minutes to ten, you are ready to exit the hotel room and begin your (if you account for thirty-nine years at twenty-eight days, plus, what, ten leap years, plus the fourteen days of this, your fortieth year, you arrive at . . .) 1,116th day of the good life.

Down at the northwest corner of the pool, Adam, the pool boy, is setting out the towels and lining up the chaise longues for you and the rest of the crew, the dozen or so friends who hold court at the best goddamn pool in Acapoca. At one point, you were one of the young ones. Now you're the oldest guy in the joint. The elder statesman, the ranking member of the pool committee. But to look at you, you're doing pretty good for eighty-nine. Still drive yourself to work every day (you're a general contractor now), still pick up Toby, your girlfriend of nineteen years (what's the point of getting married when everything's perfect the way it is?), for dinner, still come down here to Mexico for a whole month every year. When people hear how old you are, they all say the same thing: Hey, Sport, what's your secret? How do you do it? And chief among the people who want to know your secret is me, your grandson.

The bearer of your genes. I have asked you frequently. But you usually shrug, look away (to the left, specifically), and pat your belly. You're not overly verbal.

The only thing you allow has a palliative, rejuvenating effect on you is the yearly pilgrimage to Acapulco. I was in Acapulco once before, about seven years ago, on an ill-fated attempt at college spring break. I stayed at a hotel called, yes, the Copacabana. The highlights of the trip were: (1) getting robbed on the beach; (2) getting slapped by a *chica* at a discotheque; and (3) watching a kid known only as Brick jump from his third-floor balcony into the hotel pool and break his right hip to the applause of the hotel population. Acapulco itself seemed in a protracted state of decline. The old Hollywood-era hotels appeared to have been evacuated, and the new hotels looked like either prisons or beached cruise ships. Having been there, I am no closer to explaining why you return at the same time each year like a Galápagos tortoise preparing to spawn. You're not much help on this account: shrug, look left, pat belly. It occurs to me that, unlike the members of my generation, you do not possess the capacity to find each and every one of your actions endlessly fascinating and worthy of discourse. You do not see yourself as the star of a perpetually filming movie called *My Life*. While this is, in general, one of the reasons it's refreshing to hang out with you, it can become difficult to know exactly who you are, to understand your not insignificant powers of longevity and happiness.

And now that I am down here recording your behavior like a lab scientist, I have become intimately familiar with the discrete set of rules for living to which you hew religiously. You wake at nine-thirty; you put on a brand-new bathing ensemble; you wear only white shoes. You fly down on American Airlines on the same date every year; you stay at the same hotel, in the same room, probably sleep on the same mattress (you have been given a "key for life" to room 1233). Before you leave home, you sever all ties, as if you were going off to war or prison. Don't send me letters, you tell my father before boarding the jetliner. Don't call me if the hot-water heater bursts. Someone dies, don't tell me until I get back. That's the essential setup. After that, as far as secrets go, you start by telling me this: *Rule No. 36: Breakfast is at ten.*

*

Your table is over by the patio door, next to the decaying piñata. Just like every day, Sol and Charlotte are waiting for you with fresh, hot coffee and a couple of sweet rolls. They are a handsome couple. Sol looks like a regal old seal, with his shiny head and silver mustache and bright white uppers. Charlotte has short, stiff, perfect blond hair and wears a flowing pool gown patterned with geometric colors. They both have tans so deep they can only be the product of forty years in the Mexican sun. There's something wonderful about being among people not of the SPF generation, people who are, as they call themselves, real sun worshipers.

As you and Toby approach the table, Sol rises. He is wearing one of those Cuban shirts he likes, open all the way down the front. From within protrudes his magnificent round belly. Sol grabs you by the face with his two big hands and kisses you firmly on the cheek. You seize up a second, look left. Your hands make little fists. In the past, this would have been the entirety of your reaction to this kind of behavior. But these displays of affection have become kind of amusing to you now, though you're still a little awkward about initiating them.

You say, These are the Masers. From Chicago. They've been coming down here for forty years.

Sol: That's right.

Mort: Sol runs the biggest goddamn Chevy dealership in America.

Sol: In the world!

Mort: And that's Charlotte, the wife, there.

Sol: Found her fifty-seven years ago. Thank my lucky stars every day.

Charlotte: You better!

Breakfast proceeds apace. The waiters, the busboys, even the omelet guy, know you by name. *Buenos días, Señor Friedman,* they say. *Buenadia,* you say back. Grease their palms with a dollar or two so they take care of you. You bring a Wet Ones canister stuffed with singles down on the plane with you for this purpose. *Rule No. 26: You take care of them, they take care of you.*

You order yourself an omelet, real hot. You have always ordered by temperature, and the temperature is invariably *real hot.* The waiter has no idea what you're saying, but neither of you gives much of a shit, and you seem happy with your eggs. *Rule No. 13:*

Asking for what you want is even more important than getting what you want. You've known all these hotel guys forever. José, the waiter, you met when he was twenty; now he's fifty, with a little belly of his own and a slight wheeze as he pours your coffee. But the two of you bring a deep familiarity to your relationship, even an unspoken affection, which is the way you like your affection.

Today is Valentine's Day, a big deal down here. Partly because it's the birthday of Irv Gelden, the patron saint of the Continental Plaza. Irv has been a mythical figure in my family from the time I was a young boy. Irv is rich beyond our wildest dreams. He holds parties, very high-class affairs. Thousands of dollars of lox, you would say, hundred-dollar trays of salami, corned beef, anything you could ever want, which they bring down from California. *Rule No. 12: You measure a party by the cost of its meats.*

Sol: Gelden happens to be the largest purveyor of meats in the state of California.

Mort: How many butchers he got working for him? A hundred, hundred twenty-five?

Sol: He does all the beef for McDonald's and Burger King on the West Coast. That's a lot of beef, boy.

Mort: The man is a millionaire.

Sol: The man happens to be a multi-, multi-, *multi*millionaire.

But there will be no birthday party this year. A few days ago, Gelden's wife was moving through one of their penthouse suites (Sol: Big as a house) when her high-heeled shoe caught on something (Sol: A doorway, it was) and she fell and broke her hip. Cost them $24,000 to send her home on a private airplane (Sol: Five hundred alone just to send the golf clubs). You say, Can you imagine what would happen if you were just a regular schnook who doesn't have $24,000? You don't want to go to a hospital down here. They're like dungeons, honest to God.

There's a discussion about death. This is to be expected. When I asked who would be in Acapulco this year, you responded, Whoever's still alive. You and Toby and the Masers start to name the people who are no longer here. It's a formidable list. The whole Cleveland Jewish mafia you came with at first, all of them are gone now. You tell me that two people even died when they were already down here. Honest to God. Did you know you have to pay to have the body shipped back? Thousands of dollars it costs you.

There's no sadness to this discussion. The stuff (death) is too goddamned familiar to you to be all spooky and horrific like it is to me. Still, Toby sees it's time to change the subject, and she tells the story of the monkey.

Toby: Used to be this, what do you call it, chimpanzee at one particular restaurant. You'd take your picture with it.

Sol: They had a cheetah, too.

Toby: Well, this chimpanzee, he put my sunglasses on. And they took the picture.

You add, This was the best damn picture you ever saw. Everyone who sees it says so. You got the monkey with the glasses, and I'm laughing so hard. You could make a postcard out of it.

But inevitably the conversation boomerangs.

You say, This was nineteen years ago. Of course, the monkey's dead now.

At ten-thirty, Toby goes upstairs to the room, and you go for your walk on the beach. After the morning workout, you stop at the hotel's outdoor showers, cool yourself off, and head up to the pool, where the *real* hard work gets done. At eleven, you make your entrance. Everyone's there, right down the line. What ensues is not unlike the ceremonial greeting executives get at the office: Good morning, Mort, says Mrs. Weinstock from Michigan. Good morning, you say. Dr. Ruff, a Canadian, waves. Workin' hard, Dr. Ruff, you say, or hardly workin'? He replies, The latter, Mr. Friedman, the latter. Roberta from Jersey says, How's the leg today, Mort? You say, I had a rough one yesterday, baby. But I take a pill. Knock on wood it'll be okay. Roberta says, Don't put weight on it, Mort. Mrs. Weinstock says, Stretch it like this. You see Charlotte and say, Hey, what are you doing? And Charlotte says, A whole lotta nothin'. Just like I like.

The pool is doughnut-shaped. You used to quote how many gallons it holds. (I can't remember the number now, and neither can you.) There are portions of the deck that are crumbling, and the groundskeepers can barely keep the vegetation from encroaching on it, so bounteous are the sunlight and soil down here. You unload the airline tote onto your chair: Vaseline Intensive Care lotion for the skin, Chap Stick for the lips, a box of Kleenex for the nose, a Dennis Lehane book for the brain, and, to claim your territory, you throw the MORT and TOBY signs at the feet of your chairs.

Everyone on the pool committee is of a certain age. Still ambula-
tory, still full of good cheer. But no longer, maybe, ambitious. All of
the men are possessed of great, Sol-like bellies, which they carry
around with pride. It's my opinion that the bellies are the product
of (1) the psychology born of living through the Great Depression
that says, Let's celebrate being well fed; and (2) an overall gravita-
tional settling of the organs (even the nipples are somewhere at the
bottom of the rib cage). *Rule No. 21: Any shame of physical appearance
is ridiculous.*

A pervasive feeling of acceptance vibrates among the members
of the pool committee. I think you can kind of feel it. You love one
another not because of wit or riches (though Irv Gelden is one rich
son of a bitch) but because you've known one another for years, be-
cause in a world where people with whom you've shared history are
dropping like flies, the pool committee is no small thing. *Rule No.
9: Breathing is nine tenths of friendship.* Perhaps it is this notion of
unqualified acceptance that allows you to drop almost immediately
to sleep. I watch you. All around, books are read, Valentine's hearts
are eaten, the decades-old quest for a burpless cucumber is dis-
cussed. Important stuff.

Toby talks about what she thought of you before she met you: I
didn't want to speak to him. He scared me! He always looked like
he was in pain! Walking like this! Or like this! Everyone laughs.
Charlotte says, You're the perfect couple. You should never get
married. This exchange you've heard before. You sleep on, your
face dappled with sun. You missed a patch shaving, on your lip, and
there are some wispy white hairs. Your left foot twitches, maybe
some kind of dream-triggered response. All around you, the deck is
covered in greenery. Things growing at accelerated, tropical rates.
As you sleep, I think you can almost feel everything growing, mov-
ing to erase the hotel and return the whole goddamn place to jun-
gle.

Around three-forty-five, Sol comes over for a talk. You know, he
says, Acapulco ain't what it used to be. There is consensus on this.
When you first came, in 1962, there was a little panache to the
place. The same high rollers who hit Vegas had villas in the hills.
You spent nineteen of the swingingest, most joyous years of your
marriage to my grandmother Selma down here with the pool com-
mittee. In 1962, you and Selma stood *this* far away from Mr. Kis-

singer, honest to God. One February, you even whiled away the hours with none other than Mr. Michael Landon. The committee used to hold big parties at night. Fifteen parties a year. Fella name of Terry would bring down floor shows from Vegas. It was a real extravaganza, boy. Of course, he's dead now, Terry.

But we love it, Sol says. You say, Yes sir. Sol says, We come here now for the weather and the people. Beautiful people, like Mort and Toby. We'll stick it out.

At four o'clock, everyone gets up and begins preparations for the trip back to their rooms to watch another perfect sunset from their balconies. Before they take leave of the pool, though, the committee stands at the fence that lets out to the beach. You all stand there quietly, and Lester from Jersey says, You don't get weather like this in Aruba, you know.

This is one subject of which the whole committee never tires: the perfection of the Acapulco weather. Its dependability, its essential invariability. The place may be going to hell in a handbasket, but you cannot argue weather. There is the frequent incantation of the place names whose weather isn't as perfect as Acapulco's.

Weinstock: You don't get this in Florida, not in Texas, not in wherever the hell you go in Europe.

Brown: We've gone on cruises to every island in the South Pacific. This is better.

Sol: Bimini, Bermuda. In all the years we've been here, we got caught in the rain *once*. And one night it was foggy. Remember that? There was supposed to be a party down at the cabanas. But other than that . . .

And he shrugs his shoulders.

Toby says, With weather like this, time stands still. Is it yesterday? Is it tomorrow? Who cares!

Your secret, really, is the schedule. Every moment must be accounted for. I think you don't want any unscheduled cracks into which despair and uncertainty can creep. It's the same when you're at home. You eat dinner at the same place every Saturday night, take a schvitz at the club every Sunday, eat breakfast at the local deli every weekday morning and then drive yourself to work. This is what you brought to my life: inflexibility. And there's no overstating how much good that's done me. What with my parents engaged

in multiple divorces, ex-hippie carousing, and a general ecology of uncertainty, inflexibility was practically a forbidden vice. Every Monday, my father and I would have dinner with you, three bachelors exactly thirty years apart. There were no excuses for missing a date. *Rule No. 3: No matter what, do not vary the routine.* Do not stop driving to work, regardless of eyesight or response time. Do not skip a February in Mexico, even if they have hospitals like dungeons. You want to live? It's an act of willful regularity.

At day's end, you take me upstairs to your room. You show me all the stuff you get special. See that fan, you say. I bet you don't have a fan in your room.

In fact, I don't. You also have a bouquet of flowers and a rolling clothing rack that no one else gets (and probably no one else needs). *Rule No. 24: Stay someplace where you're not just a regular schnook.* You, Toby, and I discuss the ritual of packing. You begin packing six months before coming down. You keep four or five suitcases open in your special packing room. (When you live alone in a big house, you can afford the luxury of a packing room.) The suitcases are opened sometime in August. They remain open for additions, subtractions, tinkerings, fresh tubes of toothpaste, and new bathing ensembles until a week before departure, when they are sealed, not to be reopened.

Mort: I make a list this long, what I gotta bring down.

Toby: And he still forgets something every year. I knew you forgot that shirt, Mort.

Mort: I got it down to a science. Four suitcases and one carry-on.

Toby: Last year, he forgot a shoehorn.

Mort: I check the suitcases at the curb.

Toby: I gave him a butter knife to use. Instead of a shoehorn. I know how to make do.

Mort: You want something to drink? I'll order you up a Sprite. You like Sprite. They don't have 7-Up.

Toby: Now he packs a shoehorn, first thing.

You have created a six-month task that takes up a decent amount of time almost every day. *Rule No. 2,* and it's a primary rule, is: *You must always have something you are actively looking forward to, so that hope is scheduled into your life.* But there's a corollary to this rule that's even more important.

After we look through the suitcases, we order up some ice cream.

Back in Cleveland, your grocery shopping has been refined to a single class of food: snacks. Boxes of mint-chocolate-chip ice cream are stacked in the freezer, and flat-bottomed cake cones are out on the counter; you still dip ice cream skillfully and with a flourish. Boxes of the Nabisco fancy-cookie assortment line the cupboards, along with nuts of various shapes and provenances: smoked almonds and roasted cashews and honey-coated peanuts. On your refrigerator there's a little magnet that says on it NOSH! NOSH! NOSH! (The Friedmans are noshers from way back. One can locate us at any party by heading directly to the hors d'oeuvres table.) The ice cream in Mexico, you say, is particularly good. You like strawberry. When it arrives at room 1233, we unwrap our plastic serving cups silently. You take your wooden spoon and scrape up a bite, looking not unlike a little boy in terms of concentration and facial expression. You then eat the stuff with near-pornographic pleasure. This is *Rule No. 1*, the most important of Mort Friedman's secrets to life: *You must have the capacity to find pleasure in the same things, again and again.* Each ice cream cup, each trip to Acapulco, each dip in the pool is actually better, more peculiarly enjoyable, than the last. In your younger days, my family called this stubbornness, rigidity, sometimes (we were so analytical) fear. But now it looks a lot like enlightenment.

LAURENCE GONZALES

Beyond the End of the Road

FROM *National Geographic Adventure*

WE CAME into that land from the rich rolling green fields of the Midwest. The smell of cut hay and fresh manure drifted up through the vents as Jonas and I took long turns flying an airplane whose interior was so tight that sometimes it felt as if we were reclining side by side in dual coffins.

Over Nebraska, the land grew severe and a harder emptiness beckoned. Though we were still on its farthest edge, we could feel the whirling vortex of those vast spaces. Higher and higher we climbed into skies marked only by the smoke from range fires, until the last few scratchings of man were overblown by dust or overgrown by sage. Finally, we could see nothing man-made from horizon to horizon.

Look at any road map. It will show the entire United States, like a sad old bear, snared in a reinforced concrete net of interstate highways. But as you draw your finger out west to the 120th Meridian, there's one spot at the 42nd Parallel where it looks as if the bear could get a whole paw through. I-84 veers up toward Portland and I-80 dives toward San Francisco, leaving a great swath seemingly untouched. It was there that we had our compass set: the last empty place in the lower forty-eight.

Though we felt increasingly lost, coming into Nevada's Great Basin upon a desolation so complete that neither eye nor airplane could measure it, we were intent on becoming more lost still. And on our second day out, we spotted our portal to Nowhere.

From fifty miles, the first few white patches were so bright that we thought they must be water. Then we dove down to investigate and saw what appeared to be dry lakes.

We surveyed several small lakebeds and selected one in the Black Rock Desert between Jungo and Sulphur, Nevada. It was about nine miles long and clear of obstacles except for a double row of greasewood bushes cutting across it at an angle. Again and again we flew over, inspecting carefully. If the surface was sand or loose dust, we'd bury our wheels going ninety, the plane would flip end over end, and . . . well, that would be bad.

I've worked on and off with my companion on this expedition, the photographer Jonas Dovydenas, for years, and by now we don't need to say much when we're working. I know what he's going to do and mostly I know why, and sometimes I even know what he's thinking. On our third pass, we were both thinking the same thing: What can we see that will transform a deadly sinkhole into a hard, dry landing place?

Jonas skimmed low over the lake — very low now — and slowed down to minimize the blur, while I craned my neck to look. There was only one sign that we'd bet our lives on.

Neither of us discussed what we both knew: that since at least the big bang, Nature has been trying to make circles, as she did with Earth and moon and stars. But being infinitely patient, she had lost out to impetuous Weather, which dried circles into quick and dirty approximations and made hexagons instead.

"Hexagonal cracks," I said.

He put the gear down and dropped the flaps, and as the airplane settled, we felt the wheels touch a surface that was as smooth and hard as concrete. We both let out our breath as the plane rolled toward the line of head-high bushes.

It was a hot and windy afternoon as we tossed our gear out. We stood alone on alkali hardpack flat as a spirit level, bright as snow. And suddenly we were both seized by laughter: We'd done it. We had set down in the middle of Nowhere, right in the heart of America. Estimated population density: .04 persons per square mile, counting me and Jonas and our fifty square miles of lakebed. And beyond the lake, more saltbush, sage, and cheatgrass. No rules, no fences — we were as free as we were going to get in this life.

As I set to work making camp, Jonas took the plane back up to shoot a few photos. I watched him taxi far down the lakebed and then make the takeoff run toward me, dragging a huge column of dust behind him. He took off right over me, then pulled hard into the sky and rocked his wings good-bye.

Then I was really alone. One bag of water, six beers in fast-melting ice, a few provisions. As the clatter of his engine faded into the dry gulches to the north, a consuming silence fell. The vast dome of the sky seemed to settle down upon the earth like a bell jar, and I felt like a speck of gristle inside it. I had wanted to be alone in the last empty place in America, and now I had only one thought: Be careful what you wish for.

I had a hard time finding even a single rock, but I located a small one, which I used to drive stakes to hold our tarp. It was like trying to pound nails into iron, every strike making a hollow *tink!*

Sunset brought out the dust devils as I scanned the sky, calculating in my mind how much fuel Jonas had left. At last I heard a faint buzzing and saw a tiny dot on the ridge. Jonas roared overhead, not ten feet off the ground, then popped up, rolled the plane triumphantly, and settled in a plume of white dust.

We sat on the tarp with a cooler between us. The light faded and the wind picked up, animating the oddly shaped bushes into almost human forms. As the last streaks of light withdrew behind the mountains, a smothering darkness closed around the *playa.*

I walked out onto that featureless tableland to view our campsite from afar. The wind made our fire roar like a smelter and drove orange cinders dancing across the dry lake, leaping and vaulting in wild arcs. A trio of silent falling stars lit up the purple sky. Holes in the clouds sent spotlights down across the *playa* and made a death's-head of the moon until it breached the wall of cloud, luring mountains out of dark. The desert glowed all night with an eerie chemical light.

At dawn, the moon was a pale chip off the dry lakebed; walking beneath it, I cast a shadow to the distant hills.

We found an old abandoned campsite with a threadbare parachute for shelter and two La-Z-Boy armchairs. Archaeologists find arrowheads. We found weathered military cartridge casings. If you wanted to express yourself with a machine gun or settle a grudge, here was the ideal spot, where only you and your gods were in on the deal.

On the way back to the plane, we stumbled upon a shrunken boot, the toe curled up, filled with mud dried to concrete. But where was the man? The horse? The other boot? It put me in mind of grisly deeds this land must have seen.

The land looks so simple, flat and white, like a canvas on which

nothing has ever been painted. At first you think you get it. But the wise Elmore Leonard once advised looking closer: There's a mile of wire in a screen door.

Susan Boswell, the president of Cartographic Technologies in Brattleboro, Vermont, once set out to find the spot farthest from any publicly maintained road. It turned out to be the Thorofare Ranger Station in the southeast corner of Yellowstone. And the distance was twenty miles.

On the other hand, Jonas and I would spend ten days visiting places that are a good deal farther from what your average SUV-driving suburbanite would call a "publicly maintained road." There are roads there, yes, like there are tracks on Mars. We drove some of them, too, and nearly destroyed our 4x4. A lot depends on how you define your terms.

I asked Lynn Nardella, an archaeologist with the Bureau of Land Management (BLM), how the agency maintains those roads. He laughed. "We maintain them by driving them."

"How often?"

He shrugged. "Whenever."

At the time of the conversation, we were near Massacre Lake, Nevada, grinding along a boulder-strewn track in low four-wheel drive to view evidence — in the form of Native American petroglyphs — that this part of the world wasn't always so empty. Our speed: about a quarter mile per hour, the better to avoid high-centering his truck on a rock. We had two other vehicles following us, because that's how they do it: If the road kills two, there is still one left; you don't want to try walking out.

"Are you maintaining this road now?" Jonas asked.

"Of course," Nardella said with a smirk.

If you want to get technical about Nowhere, the region surrounding the Black Rock Desert — covering the northwestern corner of Nevada (but pouring over into California and southern Oregon) — amounts to some 17,700 square miles without a single highway. And to the immediate north and east of the region are the Alvord and Owyhee deserts, the centers of similarly vast tracts of nothing. You may see lines on the maps, indicating roads, but don't expect many to be paved or kept up. In 1992, a young California couple with a baby made that mistake just east of Massacre Lake.

They nearly died when they became stranded for a week in a snow-storm and had to hole up in a cave.

Most lands in that area are publicly owned and therefore generally restricted from permanent habitation. The federal government alone owns 83 percent of Nevada, 53 percent of Oregon, and 63 percent of Idaho. The combined holdings of the Departments of the Interior and Agriculture amount to more than a million square miles — a third of the U.S. — and most of it is west of the 100th Meridian.

As for population density, Humboldt County, Nevada, which contains the Black Rock Desert, is home to 1.9 people per square mile — a number skewed by the fact that nearly half of the county's population lives in Winnemucca, in the south.

On the other hand, I asked Nardella what the population density was in the area around Massacre Lake, and he gave me an odd look. "Zero," he said, then had a thought: "Oh, there's that one guy who bought a place just east, so if you count him, it's one."

So the 30,000 square miles (roughly speaking) that we set out to investigate — an area about the size of Maine — ought to satisfy even the most crazed misanthropes, some of whom we met on our hopscotch from Elko, Nevada, to Burns, Oregon, and from the Owyhee Canyon to the Black Rock Desert.

Our FAA charts showed an airstrip in Owyhee, Nevada, on the eastern fringe of our target. Unfortunately, we found this, like the "maintained road," to be more myth than reality. After our night on the lakebed, we dragged in over the Owyhee airstrip, low on fuel, to find a crooked, badger-holed, dried-mud gash in the earth, overgrown with saltbush, hopsage, and greasewood — not something we wanted to hit going eighty. We crept back to Elko, watching the gauges dip into the red and singing, "Oh, bury me not on the lone prairie."

But then, the idea was, after all, to go to the last real wild place, not where some bureaucrat says we should go. We love Bob Marshall and Frank Church and all those guys with wildernesses named after them. But those places have trail maps. They have hiking thoroughfares with signs. Eager rangers. Set campsites. Happy tourists.

No. We wanted a place where no one told anyone what to do, where it was just us and whoever else was crazy enough to be there.

*

Back in Elko that first night, we walked into a tavern to find three cowboys with drooping mustaches drinking at the bar. They were covered with dust and wore battered boots, dirty jeans, and beaver cowboy hats curled back by the weather.

As we came in, the biggest one stopped in midsentence to size me up with steady red eyes. He said, to my face, "Well, it ain't got no cowboy hat and it ain't got no mustache. What is it?"

Jonas was dressed somewhat like they were (minus the beaver), but I was wearing flip-flops, a T-shirt, and swimming trunks. I was tired and thirsty and in some dim, distant way aware that we might be about to get into our first fistfight in a real cowboy bar.

The big guy was standing. The other two were sitting, and one was smiling and clocking me in a way that's both inviting and menacing, because you don't yet know what you're being invited to.

I walked up to the big one, close enough to smell his breath, and stuck my hand out. I said my name. He laughed and grabbed my hand and offered me a drink.

"Aw, he's all right," he said. "He's just a Messikan." Which was half right, my mother being a Mosher with a bunch of O'Sullivans falling out of her family tree.

The third man had not looked up from the contemplation of his beer. His name, we learned, was Michael, and he made it plain that he didn't like to be called Mikey, which was what the big guy kept calling him.

Mikey was a one-legged bull rider who had done well on the rodeo circuit until a bull fell on him and doctors took his leg off below the knee. He reached down and rapped on it. Now he fed cowboys from his chuck wagon. He gave me his recipe for biscuits and flapjacks, which he made from the same batter.

A few beers later, Mikey loosened up enough to lift his hat to show us twenty new stitches in his freshly shaved pink scalp. It hurt just looking at it. Early that morning, someone had knocked on his motel-room door and laid into him with a baseball bat.

"At's all right," Mikey said, his eyes cold. "I'll find out who it was and fix him."

Everywhere we went out there, we encountered the same sense of justice — the single boot on the dry lakebed — coexisting alongside a courtly diplomacy. No one tells anyone what to do except the man who pays the wages, and he doesn't have to, because

everybody understands what's expected. No two ranches are run by the same method, in fact, since no one tells anyone how to do anything and no one asks. Even seemingly insignificant things, such as the latches on the ranchland gates, are handmade, each one unique; it is out of such details that a life is made, and nowhere have I seen lives assembled with such singular care and precision.

So when a man came to Elko for a few days of relaxation, he already understood all the rules he needed to know. As for the diplomacy, the people were polite because they assumed that you were either carrying a gun or could quickly locate one. Even the Sav-On drugstore in Elko sells handguns, rifles, and carloads of ammo. And if someone decided, by whatever mad logic, that he had to lay into you with a Louisville Slugger, well, all right, but it was understood that no one would question it when wild justice came at last to settle up.

Late that night found me listening to Mikey's tales from when he was a sniper in Vietnam. I would not have wanted to be the other fellow.

The following day we would rent a big 4x4 so that we could go beyond even the worst vanishing tracks. We weren't going for any other reason than to be there. You couldn't call this recreation, where you take your snowboards or kayaks, your big rafts or bicycles, where wilderness becomes a larger playing field for a game with a name. Each time someone asked me what I was doing, I balked, unable to say what I'd always been able to say before: I'm going to hike Copper Canyon. I'm going to canoe the Brule River. I'm going to learn to surf in Kauai.

No, none of that certainty was here. We were wandering, lost, in a wild place that had no name and that didn't invite much in the way of recreation, either. Stiff, standoffish, luminous, harsh, ghastly, and beautiful by turns, the land received us but never quite accepted us. As days went on, speaking strictly for myself, I began to wonder if perhaps I had traveled there as my Irish ancestors had, those monks who went, in the words of Barry Lopez, "in search of *Terra Repromissionis Sanctorum,* the blessed landscape where one stepped over that dark abyss that separated what was profane from what was holy."

Let me first address the profane, where we began our next day's journey: At the Hertz counter in Elko, we stood waiting for the clerk to get off the phone. "We had a report of you throwing rocks at it," she was saying in a not unpleasant voice. "People at the café saw you throwing rocks at it. And now it's got six hundred dollars in damage." Pause. "Well, how would you like to pay for that?" It seemed that even the good folks at Hertz understood Mikey's brand of justice. You threw some rocks, and that's just fine. But how would you like to pay for that? (The implication being: You *are* going to pay.)

Elko is a heck of a fun town if you're there for the justice, or the great Northeastern Nevada Museum, or if you'd like to drink and gamble. You can even visit an old-fashioned brothel, where you sit at a timeless mahogany bar while the madam makes you a drink, then rings a dinner bell to alert the ladies, as they are delicately called. At Mona's, right around the corner from the Stockmen's Hotel, two women emerged like prizefighters at the sound of the bell. We told them we were there for purely journalistic reasons. What we were learning, it seemed, was that the profane is never far from the holy.

The next day, we drove the 4x4 as far up the eastern edge of our province as it would go and then got out and walked, navigating overland by sun angle. We had spotted the road from the air, and it had looked passable, given the right vehicle. It led over a hump in the mountains and down toward a little ranch, the Keddy. Jonas had visited here twenty-five years before while taking photographs that were eventually published in 1987 in his book *Nevada, a Journey.*

We crossed a shattered lava dome, immense fields of jagged red stones, signatures of the monumental forces here, of the reality that this landscape was ultimately a sea of rock in turmoil.

Passing through alkali and pumice flats, we climbed up volcanic ravines, which cut my gloves or came out in big slabs as I reached for handholds. At each high vantage, we found eagle droppings bleaching the rocks. And yet nothing grew here but a few burned-over sage. So where did the eagles find their prey?

As we topped the next rise, the aroma — and the answer — drifted up to us: Wherever you pour water on the stone, life explodes in a mystifying profusion. We descended out of that dead

world of dust and rock to a slow-moving brook, rich with sedges and reeds and grasses, watercress and ferns, fairy rings of flowers in pink and yellow and purple. Iridescent dragonflies buzzed among reeds of biblical antiquity. Sign of fox, cat, rabbit: eagle prey. Fish swam in the waters. Fish!

Jonas and I scrambled back to retrieve the truck and inched it through the rubble to ford the stream. We pushed on until we came to a dirt track, which we followed through low hills. Around a bend, we found a cabin, a few tents set up around it, with a dog tied to one.

We entered the cabin and stood before a cold sandstone wall, which was carved with names and dates going back for decades. Jonas pointed out the name Howard Hughes with the date 1970. The owner of the Keddy, a man apparently not given to exaggeration, had told Jonas that Hughes used to stay there. I gave Jonas a skeptical look. Anyone could have carved it. He reached up and took a crudely framed photo down from above the door. It showed a tall, rough-looking man in a full beard — a cowboy, I guessed — standing in the gate through which we'd passed to reach the cabin. "Look again," he said. I did. Scrawled across the photo was a signature: Howard Hughes.

As we left, we saw a blue canopy half a mile away against the side of a cliff. We hiked over and found a group of archaeologists. They'd been drawn to the area because it had been well populated until perhaps a thousand years ago. They worked in the hot sun, sifting the dirt that seemed hammered into every pore of their grinning faces. Kelly McGuire, an owner of Far Western Anthropological Research Group, had brought along his nine-year-old daughter, Chloe, who was asleep with her head on a folding table in the shade of the blue canopy. One of his archaeologists, a very pregnant Kim Carpenter, showed us a perfect arrowhead, which someone had chipped out of green translucent stone thousands of years ago.

In the Great Basin, it seemed, all that was left were artifacts and the scientists who chased them. A few days later, we viewed the area's archaeology from the other side of the state. We crossed Surprise Valley to Massacre Lake with Lynn Nardella and other BLM archaeologists to view what they called "a mile-long art gallery." The nearly impassable (but "publicly maintained") road wound

through crested wheat, where feral horses ranged free, and terminated in a stand of ancient junipers.

There we hiked a boulder-strewn wash to a crumbling rock rim thirty feet high. Chipped into the brown rock, one after another, were pictures of the world those people had seen or imagined. Some showed the looping course of rivers in the valley below. One depicted a huge fish hanging head down, as if freshly caught. Obviously, the land once had plentiful game and water and vast fields of grasses to provide a wild harvest of grain.

We found one of their grinding stones wedged into a crack in the wall. It was no different from the stone I'd seen my great-grandmother use to grind corn for tortillas when I was four or five. We also found one of their chiseling tools, which they had used to etch the petroglyphs. Those tools had been cached there, perhaps thousands of years ago, to await the tribe's return. One day they didn't come back.

Another image was striking because it was so unlike the others. It showed a quarter moon in opposition to a bright sunlike figure. There were hash marks beneath, as if someone had been counting. According to the archaeologists, Chinese astronomers described a supernova that was visible in full daylight in A.D. 1054. It could have been seen from the spot where we were standing, and a quarter moon would have been out when it had appeared. The hash marks ticked along at regular intervals beneath the image and then stopped abruptly. I counted them. There were twenty-three.

"How many days was the supernova visible?" I asked.

"Twenty-three," one of the archaeologists told me.

We climbed the reef and found more recent evidence of man. A bronze disk had been cemented into a rock near the precipice. It was inscribed WALLACE L. GRISWOLD, and beneath "1918–1982." An archaeologist named Penni Carmosino picked up a fragment that I assumed was a porous white rock. "This is part of a human skull," she said. She picked up a black bit and said, "This is cinder, see?" Cinder that had been Wallace. She looked out over the valley and said, "Someone cremated him and put his ashes here. Wallace must have loved this place."

We hiked back over ground strewn with evidence of arrow points, chipped-off bits of obsidian called bifaces. Obsidian doesn't form in that area, so someone had to have brought it there. As the

sun reached a certain low angle, the whole land lit up from re-
flections of the broken volcanic glass. We could see it glittering all
the way to the horizon. It was eerie, because it so clearly demon-
strated how teeming and busy the place had been. That hypnotic
light, which comes but once a day, and mostly when not a single liv-
ing soul is there to bear witness to it, now gave form to the last lumi-
nescent bones of the people who had lived there.

Because we had an airplane that could go 150 miles per hour with-
out even trying, we were able to see in two weeks literally the entire
thirty thousand square miles that had caught our interest on the
charts. And while there were a couple of big gold mines, which
looked as if great inverted pyramids had fallen from the sky and
sunk their stair-stepped impressions into the sides of mountains,
there was little else except a few ranches in the bottoms and a few
circles of green where someone had poured water onto the stone
to grow alfalfa. Meeting people was rare, though not for lack of
trying.

One day, we achieved one of our goals: to be lost on a summit
road somewhere. We had a GPS, which was not much use without
the airplane, and I had lost track of where we were while motoring
through northeastern Nevada to the music of Hank Williams and
Patsy Cline. We went veering along a sheer drop above a tumbling
series of gullies and chasms. Pale green valleys fell away to the hori-
zon's last sawtooth peaks, which seemed to chew up the sky in the
misty gray distance.

Jonas and I left the road on a track that faded into far sage,
grinding overland along time-blasted ruts. The two-track gulched
out in stony dry washes a yard deep and clamored up rock-strewn
reaches until the last traces were lost in grass. We drove on, up and
up the hill, until we were stopped by heaps of stones at a place
where the land dropped straight down several hundred feet on ei-
ther side.

We walked the rest of the way to the promontory, from which we
could see all around, and found our bearings in sheer, ragged red
walls streaked with yellow, where scree slopes descended to a slow-
moving, late-summer river. I recognized the canyon that wound
away to the west; Jonas and I had flown the same route a few days
earlier, not twenty feet above the boulder on which I now sat. The

wind struck a different note on each bush, making the land cry out in dissonant harmonies.

Heading down, we found an empty ranch of rusted tin buildings in dry yellow hills of grass and hopsage. We gingerly climbed barbed wire and crossed among weathered corrals to a bunkhouse in back. Beside it, a white porcelain bathtub had been sunk into the ground. Cold water, dribbling from an iron pipe, overflowed the rim at ground level.

I lifted the steel automobile leaf spring that held the bunkhouse door shut. In the kitchen were two stoves: wood and gas. Red-checked oilcloths covered the tables. Two bedrooms with spring steel beds. A sixties-era aqua-green rotary-dial telephone on a wooden stand.

"Pick up the phone," Jonas suggested.

Putting it to my ear, I heard a dial tone.

Signs of man were plentiful: bone, bullet, telephone. But few and strange were the men.

As we descended through aspen, a stately buck kept pace, then bounded into the woods. The road narrowed as we crossed a cliff-side, which was topped by mysterious animal shapes in stone, as if aspiring gods had auditioned here for the job of Creator. Our camp was in an aromatic forest along an ice-cold river above the old mining town of Jarbidge. The sun flared in purple shadows through the pines. The air at seven thousand feet couldn't hold its heat. We huddled near a fire of fallen branches and dead saplings.

In the morning, we headed up-canyon, watching the snowmelt dash over brown stones, pausing under the totems and spires of a cratered red rock wall, and crossing into a terrain of broad, rolling hills. Here we saw a small motorized vehicle bouncing overland. At last: human beings.

Half a mile later, we found two small girls climbing off the ATV beside a cabin. Giggling, they hurried away and disappeared inside. Utter silence. High sun. Low moon. Yellow grass.

A thin man, perhaps seventy, emerged, wearing a sleeveless undershirt, a baseball cap, and jeans. His name, he told us, was Frank Bogue. His son-in-law, Danny Betancourt, followed him, along with the little girls, who jumped back on the ATV, stifling laughter, and roared off, buckjumping through the brush.

We learned that Frank had worked his whole life in an Elko hardware store that he didn't even own, dreaming of his own log cabin.

"I read everything there was about building a log cabin," he told us. "A month after my sixty-fifth birthday, I told them good-bye and never went back." A dozen years earlier, he'd found his thirty acres in that river valley, which had been a migration route for Stone Age peoples who fished and followed game and the fruiting of native grains through the seasons.

Frank and Danny had cleared land and planted trees and set pipe and built the cabin — and a very nice job they did, too. A pumping system turned the garden green, and the wood was all split and stacked for winter. But in due time, the work was done and all the racket stopped. There must have been an epiphany of dread and awe as the colossal, almost willful, tranquillity of that place descended upon them.

As we stood talking, I bent down to pick up something shiny. It was a .50-caliber machine-gun cartridge. I commented that Frank must be pretty serious about hunting, and he laughed. "No, we just shoot it at that hillside." And I thought: Noise. Yes. What else could fill a space that size?

"You see those bowling balls?" he asked.

Thirty yards away by the outhouse was a pile of them. It turns out that a bowling ball has the same diameter as the inside of a large oxygen cylinder. They had cut the top off one such tank and drilled a hole in the bottom for a shotgun-shell primer. They charged the bore with three ounces of powder, and they had a big answer to the big silence: a bowling ball mortar.

"See that clearing over there?" Yellow grass with small black dots on it. "Those are bowling balls."

Oh, the novelty had worn off that, too, but then someone came up with the idea of drilling extra holes in the balls to make them whistle in flight. "And we also stick a railroad flare in 'em so you can see 'em at night."

On the ride back, Jonas idly mused that it would be cool to have one of those mortars. "You know," he said, "I've probably got enough room on my farm . . ."

Our last day but one, we took off under a pale quarter moon, skimming low over the first colorless ridgeline and dipping down into a shadowed coulee. Giant owls loomed out of the darkness and went veering past the plane as we hammered on into the lifting dawn.

By the time we had crossed the low mountains from Nevada into

Oregon, morning had begun to break. The desert sky was streaked with pink above a landscape of flint and bister.

Twenty minutes later, I dove the plane down into the Owyhee Canyon and leveled off about two hundred feet below the rim. We were going about 175 miles per hour down through that serpentine excavation, edging between jagged turrets of volcanic rock. It was daylight above, but down here it was still cool and dark, as a rust-red rock face loomed ahead.

It appeared that the canyon simply ended there. Every instinct told me to climb, to get out, but I held on, waiting for a glimpse of daylight. I was confident that the canyon would open and that I could make the turn. For one thing, I was betting on the cutting power of time and water. For another, I was betting on the Falco I was flying, which Jonas had spent five and a half years building with his own hands. It would hold together, no matter how hard I flew it.

Neither of us said a word as we waited, my hand steady on the stick, to see if it was a right turn or a left turn or no turn at all.

We passed an invisible point where we understood that we carried too much momentum through too short a distance to turn back or climb away. The only way out was through. So we waited and waited some more, as the monolith seemed to take on human form. I began to see the dimples in its flesh.

Then, at last, the rock wall parted like a curtain. I threw the stick hard to the left, standing on the rudder and slamming the plane into a knife-edge turn, one wing up and one wing down. We drifted through the turn and snapped out level in another section of the gorge. I grinned over at Jonas, remembering at last to breathe.

"Cheated the devil again," he said.

I pushed the nose, accelerating deeper into the shade of ragged rimrock. The green swath made by the river's ropy course slipped beneath us in a blur as we neared the redline at 240 miles per hour. The music of that rocket violin moved through me to stir my hand, and we popped up, vertical. Blue sky filled the bubble canopy as the canyon reappeared over my shoulder. We rolled and pivoted: straight down for a shot of the startling lush arroyo.

"I got it," Jonas said, taking the controls and diving back into the canyon. I let go and put my hands in my lap as we dropped like a hawk folding its wings, headlong through castles of rust and stone,

groves of ancient juniper and white-bark aspen. Clouds skated on mirror-blue pools of water. Kindred shrikes and herons dipped and dove around us. Coves of trees released mule deer to drink at the edge of the river. There was such a profusion of life there, and yet just on the other side of that lava wall was one of the emptiest deserts in the United States.

We leveled off, face-to-face with another rock wall. No more peekaboo turns; this was the end of the line.

A growing tightness in my chest told me that we'd never clear the rim in time. Then I felt the pull, the heavy G, as the wings loaded up and we took a huge gulp of blue sky. Shadows fell away like bolts of satin. We emerged into sunlight.

We flew west across the Oregon flatlands toward smoky Steens Mountain and landed on a remote strip of gravel. Our GPS read: "No Destination."

We shut down the engine and stepped down from the cockpit. Silence but for the whistling wind. Nothing but sagebrush in every direction. I knelt to examine the composition of the gravel as Jonas and I discussed the possibility of blowing a tire or not getting out of there for some other reason.

We took out the binoculars and glassed Steens Mountain. There on the highest ridge, a spindly antenna. A repeater. I powered up the cell phone and called home. "Guess where I am," I said to my daughter, Amelia.

"Nowhere?"

Then Jonas called his wife, Betsy, his daughter, Elena, and his son, John. So as austere and remote and difficult to reach as that place is, we'd just had a family reunion there. A few days earlier, we'd flown the Black Rock Desert and found several hundred blue Porta Potties for the 24,000 people who would attend the annual Orwellian hippie rave that is the Burning Man Festival. The last empty place was dwindling fast.

We departed the gravel strip and made a few more passes through the canyon. Heading back, I tilted a wing along the Owyhee River and spied a white hat far below, drawing a long train of dust behind. The cowboy on horseback was moving steadily, leading hundreds of cattle, while other cowboys kicked zigzag patterns in and out, scouting the stragglers on the drive north.

I was reminded of something Ed Abbey once wrote. He had run

into a hard-rock prospector out there and asked him why he loved the desert. "Them other so-and-sos don't," the old man said.

Our last day, Jonas and I drove the northern reaches to look for those cowboys. We spent the day groping across impossible landscapes and had nearly given up when we saw a great amoeba of dust, shot through with late sun, rising in the distance.

We found the Mori brothers teaching their sons calf roping. The calves came thundering out of a chute, the men and boys hard behind them on horseback, lariats whirling in the air. They communicated not in whoops and hollers but in whistles and muted syllables. I saw nothing they did with hands or feet that could have explained their complex maneuvers: Man and horse were one. Ropes from two directions caught head and back legs with an accuracy that was scarcely believable.

After roping half a dozen calves, they were done, and Sam Mori, who with his brother owned three thousand deeded acres, rode over to the fence and sat his horse. He had a weathered face burned black by the sun and was covered from head to toe in dust. (When he told me his name, I at first thought he'd said Samurai. It would have been perfect.)

Mori wore white cotton gloves and worried a frayed rope over the saddle horn as he spoke. He talked of the particular differences among types of rope. He preferred a nylon-poly blend, but straight nylon was springier. But, he concluded, "It's about identical to golf clubs. It's whatever you like."

A moment before, he had been galloping in hard pursuit, raising a plume of dust. The lasso had shot out from his hand like a harpoon as the calf's head snapped around and its body hit the hardpack with a concussion that Jonas and I could feel twenty yards away through the soles of our boots. As I watched his hands gather up the rope and loop it precisely, I marveled that such violent work could take such a delicate touch, such finesse.

There are no indigenous people. They all come from somewhere and eventually go. But if they stay in one place long enough, another world will come and determine to displace them. The Indians came from Asia. The cowboys came from Europe. And now America's shifting paradigms — environmental, economic, cultural — may force them out.

I asked Sam how that struggle was going for him, and he squinted up through the dust, and a bemused smile creased the corners of his mouth and eyes. Like the land, his aspect was both inviting and faintly menacing. He said, "The less pretty the ground is, the easier it is to manage." By which he meant that while environmentalists were still blinded by a dazzling beauty elsewhere, he might just make a stand here for a bit longer.

Then he invited us to come out for the branding in the spring. And he touched the brim of his hat and rode off, quite literally, into the setting sun.

ADAM GOPNIK

The City and the Pillars

FROM *The New Yorker*

ON THE MORNING of the day they did it, the city was as beautiful as it had ever been. Central Park had never seemed so gleaming and luxuriant — the leaves just beginning to fall, and the light on the leaves left on the trees somehow making them at once golden and bright green. A birdwatcher in the Ramble made a list of the birds he saw there, from the northern flicker and the red-eyed vireo to the rose-breasted grosbeak and the Baltimore oriole. "Quite a few migrants around today," he noted happily.

In some schools, it was the first day, and children went off as they do on the first day, with the certainty that, this year, we will have fun again. The protective bubble that for the past decade or so had settled over the city, with a bubble's transparency and bright highlights, still seemed to be in place above us. We always knew that that bubble would burst, but we imagined it bursting as bubbles do: no one will be hurt, we thought, or they will be hurt only as people are hurt when bubbles burst, a little soap in your mouth. It seemed safely in place for another day as the children walked to school. The stockbroker fathers delivered — no, inserted — their kids into school as they always do, racing downtown, their cell phones already at work, like cartoons waiting for their usual morning caption: "Exasperated at 8 A.M."

A little while later, a writer who happened to be downtown saw a flock of pigeons rise, high and fast, and thought, Why are the pigeons rising? It was only seconds before he realized that the pigeons had felt the wave of the concussion before he heard the sound. In the same way, the shock wave hit us before the sound, the

image before our understanding. For the lucky ones, the day from then on was spent in a strange, calm, and soul-emptying back and forth between the impossible images on television and the usual things on the street.

Around noon, a lot of people crowded around a lamppost on Madison, right underneath a poster announcing the Wayne Thiebaud show at the Whitney: all those cakes, as if to signal the impotence of our abundance. The impotence of our abundance! In the uptown supermarkets, people began to shop. It was a hoarding instinct, of course, though oddly not brought on by any sense of panic; certainly no one on television or radio was suggesting that people needed to hoard. Yet people had the instinct to do it, and, in any case, in New York the instinct to hoard quickly seemed to shade over into the instinct to consume, shop for anything, shop because it might be a comfort. One woman emerged from a Gristede's on Lexington with a bottle of olive oil and said, "I had to get *something*." Mostly people bought water — bottled water, French and Italian — and many people, waiting in the long lines, had Armageddon baskets: the Manhattan version, carts filled with steaks, Häagen-Dazs, and butter. Many of the carts held the goods of the bubble decade, hothouse goods: flavored balsamics and cappellini and arugula. There was no logic to it, as one man pointed out in that testy, superior, patient tone: "If trucks can't get through, the Army will take over and give everybody K rations or some crazy thing; if they do, this won't matter." Someone asked him what was he doing uptown? He had been down there, got out before the building collapsed, and walked up.

People seemed not so much to suspend the rituals of normalcy as to carry on with them in a kind of bemusement — as though to reject the image on the screen, as though to say, That's there, we're here, they're not here yet, *it's* not here yet. "Everything turns away quite leisurely from the disaster," Auden wrote, about a painting of Icarus falling from the sky; now we know why they turned away — they saw the boy falling from the sky, sure enough, but they did not know what to do about it. If we do the things we know how to do, New Yorkers thought, then what has happened will matter less.

The streets and parks were thinned of people, but New York is so dense — an experiment in density, really, as Venice is an experiment in water — that the thinning just produced the normal den-

sity of Philadelphia or Baltimore. It added to the odd calm. "You
wouldn't put it in a book," a young man with an accent said to a girl
in the park, and then he added, "Do you like to ski?" Giorgio
Armani was in the park — Giorgio Armani? Yes, right behind the
Metropolitan Museum, with his entourage, beautiful Italian boys
and girls in tight white T-shirts. *"Cinema,"* he kept saying, his hands
moving back and forth like an accordion player's. *"Cinema."*

Even urban geography is destiny, and New York, a long thin island,
cuts downtown off from uptown, west side off from east. (And a
kind of moral miniaturization is always at work, as we try uncon-
sciously to seal ourselves from the disaster: people in Europe say
"America attacked" and people in America say "New York attacked"
and people in New York think, Downtown attacked.) For the finan-
cial community, this was the Somme; it was impossible not to know
someone inside that building, or thrown from it. Whole compa-
nies, tiny civilizations, an entire Zip Code vanished. Yet those of us
outside that world, hovering in midtown, were connected to the
people dying in the towers only by New York's uniquely straight
lines of sight — you looked right down Fifth Avenue and saw that
strange, still neat package of white smoke.

The city has never been so clearly, so surreally, sectioned as it be-
came on Wednesday and Thursday. From uptown all the way down
to Fourteenth Street, life is almost entirely normal — fewer cars,
perhaps, one note quieter on the street, but children and moms
and hot-dog vendors on nearly every corner. In the flower district,
the wholesalers unpack autumn branches from the boxes they ar-
rived in this morning. "That came over the bridge?" someone asks,
surprised at the thought of a truck driver waiting patiently for
hours just to bring in blossoming autumn branches. The vendor
nods.

At Fourteenth Street, one suddenly enters the zone of the miss-
ing, of mourning not yet acknowledged. It is, in a way, almost help-
ful to walk in that strange new village, since the concussion wave of
fear that has been sucking us in since Tuesday is replaced with an
outward ripple of grief and need, something human to hold on
to. The stanchions and walls are plastered with homemade color-
Xerox posters, smiling snapshots above, a text below, searching for
the missing: "Roger Mark Rasweiler. Missing. One WTC, 100th

floor." "We Need Your Help: Giovanna 'Gennie' Gambale." "We're Looking for Kevin M. Williams, 104th Fl. WTC." "Have You Seen Him? Robert 'Bob' Dewitt." "Ed Feldman — Call Ross." "Millan Rustillo — Missing WTC." Every lost face is smiling, caught at Disney World or Miami Beach, on vacation. Every poster lovingly notes the missing person's height and weight to the last ounce and inch. "Clown tattoo on right shoulder," one says. On two different posters there is an apologetic note along with the holiday snap: "Was Not Wearing Sunglasses on Tuesday."

Those are the ones who've gone missing. On television, the reporters keep talking about the World Trade Center as a powerful symbol of American financial power. And yet it was, in large part, the back office of Wall Street. As Eric Darton showed in his fine social history of the towers, they were less a symbol of America's financial might than a symbol of the Port Authority's old inferiority complex. It was not the citadel of capitalism but, according to the real order of things in the capitalist world, just a come-on — a desperate scheme dreamed up in the late fifties to bring businesses back downtown. In later years, of course, downtown New York became the center of world trade, for reasons that basically had nothing to do with the World Trade Center, so that now Morgan Stanley and Cantor Fitzgerald were there, but for a long time it was also a big state office building, where you went to get a document stamped or a license renewed. No one loved it save children, who took to it because it was iconically so simple, so tall and two. When a child tried to draw New York, he would draw the simplest available icons: two rectangles and an airplane going by them.

Near Washington Square, the streets empty out, and the square itself is beautiful again. "I saw it coming," a bicycle messenger says. "I thought it was going to take off the top of that building." He points to the little Venetian-style campanile on Washington Square South. The Village seems like a village. In a restaurant on Washington Place at ten-thirty, the sous-chefs are quietly prepping for lunch, with the chairs still on all the tables and the front door open and unguarded. "We're going to try and do dinner today," one of the chefs says. A grown woman rides a scooter down the middle of LaGuardia Place. Several café owners, or workers, go through the familiar act of hosing down the sidewalk. With the light pall of

smoke hanging over everything, this everyday job becomes some-
how cheering, cleansing. If you enter one of the open cafés and or-
der a meal, the familiar dialogue — "And a green salad with that."
"You mean a side salad?" "Yeah, that'd be fine . . . What kind of
dressing do you have?" — feels reassuring, too, another calming
routine.

Houston Street is the dividing line, the place where the world be-
gins to end. In SoHo, there is almost no one on the street. No one
is allowed on the streets except residents, and they are hidden in
their lofts. Nothing is visible, except the cloud of white smoke and
soot that blows from the dense stillness below Canal. An art critic
and a museum curator watched the explosions from right here.
"It was a sound like two trucks crashing on Canal, no louder than
that, than something coming by terribly fast, and the building was
struck," the critic said. "I thought, This is it, mate, the nuclear at-
tack, I'm going to die. I was peaceful about it, though. But then the
flame subsided, and then the building fell." The critic and the cu-
rator watched it fall together. Decades had passed in that neighbor-
hood where people insisted that now everything was spectacle,
nothing had meaning. Now there was a spectacle, and it *meant*.

The smell, which fills the empty streets of SoHo from Houston to
Canal, blew uptown on Wednesday night, and is not entirely horri-
ble from a reasonable distance — almost like the smell of smoked
mozzarella, a smell of the bubble time. Closer in, it becomes acrid,
and unbreathable. The white particulate smoke seems to wreathe
the empty streets — to wrap right around them. The authorities
call this the "frozen zone." In the "Narrative of A. Gordon Pym,"
spookiest and most cryptic of Poe's writings, a man approaches the
extremity of existence, the pole beneath the Southern Pole. "The
whole ashy material fell now continually around us," he records in
his diary, "and in vast quantities. The range of vapor to the south-
ward had arisen prodigiously in the horizon, and began to assume
more distinctness of form. I can liken it to nothing but a limitless
cataract, rolling silently into the sea from some immense and far-
distant rampart in the heaven. The gigantic curtain ranged along
the whole extent of the southern horizon. It emitted no sound."
Poe, whose house around here was torn down not long ago, is a re-
alist now.

*

More than any other city, New York exists at once as a city of symbols and associations, literary and artistic, and as a city of real things. This is an emotional truth, of course — New York is a city of wacky dreams and of disillusioning realities. But it is also a plain, straightforward architectural truth, a visual truth, a material truth. The city looks one way from a distance, a skyline full of symbols, inviting pilgrims and Visigoths, and another way up close, a city full of people. The Empire State and Chrysler buildings exist as symbols of thirties materialism and as abstract ideas of skyscrapers and as big dowdy office buildings — a sign and then a thing and then a sign and then a thing and then a sign, going back and forth all the time. (It is possible to transact business in the Empire State Building, and only then nudge yourself and think, Oh, yeah, this is the Empire State Building.) The World Trade Center existed both as a thrilling double exclamation point at the end of the island and as a rotten place to have to go and get your card stamped, your registration renewed.

The pleasure of living in New York has always been the pleasure of living in both cities at once: the symbolic city of symbolic statements (this is big, I am rich, get me) and the everyday city of necessities, MetroCards and coffee shops and long waits and longer trudges. On the afternoon of that day, the symbolic city, the city that the men in the planes had attacked, seemed much less important than the real city, where the people in the towers lived. The bubble is gone, but the city beneath — naked now in a new way, not startling but vulnerable — seemed somehow to increase in our affection, our allegiance. On the day they did it, New Yorkers walked the streets without, really, any sense of "purpose" or "pride" but with the kind of tender necessary patriotism that lies in just persisting.

New York, E. B. White wrote in 1949, holds a steady, irresistible charm for perverted dreamers of destruction, because it seems so impossible. "The intimation of mortality is part of New York now," he went on to write, "in the sound of jets overhead." We have heard the jets now, and we will probably never be able to regard the city with quite the same exasperated, ironic affection we had for it before. Yet on the evening of the day, one couldn't walk through Central Park, or down Seventh Avenue, or across an empty but hardly sinister Times Square — past the light on the trees, or the kids on

their scooters, or the people sitting worried in the outdoor restaurants with menus, frowning, as New Yorkers always do, as though they had never seen a menu before — without feeling a surprising rush of devotion to the actual New York, Our Lady of the Subways, New York as it is. It is the symbolic city that draws us here, and the real city that keeps us. It seems hard but important to believe that that city will go on, because we now know what it would be like to lose it, and it feels like losing life itself.

JIM HARRISON

Soul Food

FROM *Men's Journal*

"WHAT DOES IT MEAN, anyway, to be an animal in human cloth-
ing?" asked the novelist Barbara Kingsolver. This question has dis-
turbed me a great deal in the past few years, especially during late
nights and early mornings when the ticking of my biological clock
can resemble an air hammer due to natural fatigue or questionable
behavior. We're more likely to question the need for sleep or sex
than we are the obvious food, shelter, and clothing, and since no
one who reads this magazine is likely short on shelter and clothing,
the question of the human animal and food presents itself in dense
immensity. I'm not dismissing sex lightly, but it's after four in
the afternoon and I'm feeling decidedly nonmental pangs of hun-
ger. If you get a hard-on during dinner, you're either fourteen or
feeling the wandering hand of a partner, or you're inside of one
of those apocryphal stories where someone is under the table,
whether it's from the *Arabian Nights,* Boulevard Montparnasse, or
just off Sunset Strip.

There's an almost visible barrier to any deep thinking about
food. The first indication of the whisper of the word "food" and the
12 billion neurons and 32 billion synapses in our brains activate.
Am I hungry or not hungry? If I'm hungry, what do I want to eat?
And this may or may not depend on what's available. Adding to the
confusion is the idea that the 5 billion souls on earth have slightly
or radically different tastes, just as voices, features, even brains are
identifiably different. And what you wish to eat within the evolu-
tionary curve will depend on good and bad food memories, not to
speak of certain health and possibly ethical considerations. We are
memorably punished by truly bad food, and we tend to learn more

permanently from bad experiences than we do from the pleasure of the good.

As I sat in my small studio at the Hard Luck Ranch (actual name) in the early waning sun of a December afternoon, I was reminded of the irony that very good food can also be painful and unpleasant. The day before, my wife had laboriously made genuine boeuf bourgignon for a friend's birthday. Our kitchen in the casita down here on the Mexican border smelled like a bistro in Lyon. For some reason I ate far too much of this stew and also drank a great deal of red wine. I can't seem to learn from experience, other than momentarily until my "animal" appetite overwhelms my good sense, a trifling contest like a heavyweight fight that ends in seven seconds.

It was a rumbling, gaseous night. I had hurt an ankle again while quail hunting. Would my ankle be less susceptible to injury if I weighed less? Possibly. There are loud voices down at the creek crossing a hundred yards from the bedroom. Young men drinking beer, revving their battered Jeeps and Camaros and yelling, "Fuck you, you fucker! You fucking fucker, fuck you!" With my mild success in Hollywood I could have helped this dialogue despite the drum-hard belly bloat under the sheets. I awake at dawn sadder but not conclusively wiser, only to lose my setter, Rose, on a walk. Without a shotgun I'm not, in her view, a serious person. She returns in an hour or so and despite the exercise of the search my sore tummy settles for two tortillas and some beans for lunch.

Of course this is a setup. While writing late in the afternoon I envision my simple intended pasta with garlic, olive oil, and health-giving broccoli, but when I reach home I discover that my friend Abel Murrieta has dropped off ten pounds of elk. I love elk! It's better than venison, antelope, and bear, and every bit as good as moose. What better accompaniment to pasta with broccoli than a couple of ample pieces of elk steak sautéed in butter, medium rare? I eat two pieces while my wife eats only one. She says she is no longer hungry. What an extraordinary idea. Who needs to be hungry to eat?

Now it is nearly midnight, my mind clear and my stomach relatively docile. The moon is gently waxing over America, her collective gut packed with mostly trash, her skies electronically filled with the

croaking shitbirds of politics, masses of feathered ex–fraternity boys trying to get their hands in the national till.

I am preoccupied with something far more important: my food memories. Early in September I began a food journal that would include a driving trip to Montana to fish brown trout, the festive eating in northern Michigan during bird-hunting season, and a twenty-five-day book tour that would include cities as varied as Vancouver, British Columbia, and Oxford, Mississippi. With a fresh journal at the ready, I expected our great land to yield up nutritional secrets, though I was probably on a second bottle of Côtes du Rhône when this thought occurred.

Frankly, on driving trips from the heartland west we tend to think of anything we eat that is not outright bad as good. "At least I didn't puke afterward" dollars up as a good review.

The first night out, in a motel in Ladysmith (lovely name), Wisconsin, I began to lose heart. Perhaps this was only the honeymoon blues, but the file of American-food research spread on my desk was discouraging. Tacked onto the knotty-pine wall there was a print of a sad-eyed faux-Spanish donkey carrying a burden of red flowers. This donkey seemed to speak to me in the manner of childhood movies featuring Francis the talking mule. I swear the donkey's pink lips were moving and the voice was that of an Irish tenor: "You are an artist acclaimed by at least a handful of unnameable critics. Do not waste your talent describing in detail the plates of lukewarm dogshit that daily fuel the bodies of three hundred million of your fellow Americans. Spend your time on the pinnacles, not the suck holes. As Yeats said, 'What portion in the world can the artist have / Who has awakened from the common dream / But dissipation and despair?'"

Of course I disagreed. I'm a midwesterner who doesn't countenance voices from the nether void, but then how much can you say about the generic gravy that is trucked to thousands of restaurants in mighty plastic barrels? I had carefully noted on trips to supermarkets that the nearly invariable item in every cart was soda pop. Billions are spent on flavored sugar water for a low-rent sugar rush. If you get them hooked you've made a fortune. Whether it's dope or sugar. It's also arguable that fast food and butter are killing as many people as cigarettes. I like to make this argument in public with great authority because I smoke, I don't like butter, and fast food repels me.

Back to the song of the road. Other than a few staples, at one time in our country to a remarkable degree we ate what was indigenously available. It was a matter of geography, of culinary regionalism, also the hunting, fishing, and gathering in an area, and how much we grew in our gardens. In the nineteenth century it was only the high-end urban restaurants that offered exotica from other regions and continents. Now the situation is reversed, with only the high-end restaurants using fresh local produce, unfrozen prime meats, and free-range fowl. In our time this emphasis was pioneered by the renowned Alice Waters at Chez Panisse in Berkeley, and is well established in many places in New York such as the Gramercy Tavern and Craft, both under the chef Tom Colicchio.

On the second day out, passing through western Minnesota, I had a baked-ham luncheon special at a truck stop that perfectly illustrates the point. Like 95 percent of the ham we are served, this was ham in name only. Everywhere in the midwestern countryside there are pigs but, ironically, no ham remotely worthy of the name. It is simple dead pig's ass, artificially smoked, steamed, or boiled, strictly what they call "industrial food" in France, where it has also become prevalent.

It should be noted here that small pork producers are being victimized by the processors. When I'm driving Interstate 80 through Des Moines, Iowa, I avert my face in embarrassment as I pass the National Pork Producers Council building. Pork must be sold as pork, not "the other white meat." Pork fueled our westward movement! There are thousands of delicious ways to cook pork, but it is difficult now to find an acceptable piece of sausage, only tiny wafers and tubes of tasteless ground pork. You can find great sausage at the Cornhusker Hotel in Lincoln, Nebraska, or at the Carlyle Hotel in New York City, or in the specialty sausage restaurants like the Bob Evans chain in the Midwest. If you want to experience the grandeur of pork sausage, stop at the Powhatan Restaurant, just off Route 40 in Pocahontas, Illinois. If you want a first-rate pork chop, stop at Thunder Bay Grill in Davenport, Iowa. At the Powhatan Restaurant, though, I was swept back to my childhood like Proust and his silly cookie, back to butchering time, to the making of true pork sausage and the glorious flavor of home-smoked ham. Luckily I don't live next door or I'd get "swollen up," as farm folks used to say.

Naturally after my Minnesota luncheon ham I vowed never to eat again, but by sunset in Medora, North Dakota, I had a decent rib steak at the Iron Horse Saloon. There was the additional pleasure in the alarm of a lady at the next table when my new upper partial plate came out with my fork while I was chewing a gristly piece. She really bunched her undies. The flavor of the steak was fine and my heart gladdened. Later, while I was playing blackjack, the usual ditzy movie crew entered and I had the pleasure of being condescended to after asking innocent questions and concealing my own glorious screenwriter identity.

Oddly, outside of urban centers it is difficult to find a first-rate steak in the West, except in Nebraska and Kansas. I mean the kind of prime steak you get at Gibsons in Chicago, or Smith & Wollensky or Peter Luger in New York. The best porterhouse of my life was at the Peppermill in Valentine, Nebraska. Curiously, prime steak and sausage have become anathema to the colorful spandex crowd. I managed to get my cholesterol as low as 156 a few years ago without giving up steak or sausage, but then it's an advantage to dislike fast food, snack food, butter, and desserts. I also eat a lot of fish and game, which I catch and shoot. When people criticize me for these activities I say that I'm less evolved than they are, which makes us both feel good. The great poet Gary Snyder has noted the presumed virtue of people who keep their distance from the sources of their food. How few of them have ever embraced a piglet in their arms and reflected on the ancient cycle of predator and prey.

Food is not a problem in Livingston, Montana, where both our daughters, Jamie and Anna, live, and where I fly-fish for trout every September. I pre-order a half dozen (or more) cases of Côtes du Rhône from Kermit Lynch in Berkeley and make a sizable list for Zingerman's, the ne plus ultra of delicatessens, in Ann Arbor, Michigan. Why drive this far to go fishing if you're eating bad lunches on the riverbank? Our culture wishes to make us indiscriminate gobbling machines, and to avoid this requires advance vigilance of the sort some hearty souls devote to the stock market, a matter I gave up on over twenty years ago when my English gambling and Australian oil stocks proved worthless. If only this money had been spent on food and wine, say a few casks of Bordeaux, which I could be drinking at this moment.

Dinners at my daughter Jamie's are not diet numbers: lasagna with a Bolognese ragu of veal, pancetta, flank steak, Japanese eggplant, garlic, carrot, celery root; a 4-H brisket with tomatoes, cucumbers, and Italian green beans from her garden, after an appetizer of deep-fried pumpkin blossoms, also from the garden; a chicken fricassee with caper, lemon, egg yolk, and free-range Hutterite chicken; lobster and yellowtail with roasted vegetables and orzo; Harrington ham from Vermont and potato salad; a pasta with green tomatoes, onions, and pancetta; a party dish of roast locally raised beef and lamb, starting with some homemade ricotta. That sort of thing, day after day.

It suddenly occurred to me that the term "foodie" pisses me off. Why not eat well during a severely truncated life on earth, our short brutish passage? Not that our culture doesn't own a large number of food ninnies, especially in urban areas in the so-called haute cuisine area. Here food is often oversqueezed, as it were. I haven't lost my food adventurism, but I no longer wish to see chefs outdo one another at my expense in the name of experimentalism and that dread word "creativity," wherein newly minted dishes lose their connection with the earth that bore their ingredients. Of course something valid occasionally emerges, but others are welcome to be on the expensive receiving end of this hundred-to-one shot.

Cooking provides a fine binder for marriage and family and friendship, but the efforts can become fatiguing. Everyone gets tired and wants to be served. There can be a friendly camaraderie in the kitchen that easily dismisses marital and family quarrels, if only because hunger and the delight in good food are far more basic than quarrel issues like murder and infidelity. Livingston, Montana, is lucky that the famed artist Russell Chatham owns and runs a fine local restaurant. Several years ago it seemed ill advised to me for Chatham to split his attention from his painting, but he had the simple motive that there was nowhere locally for him to eat. Since Chatham is one of the best amateur cooks I know, and an old friend, I had to finally trust his impulse, though I'd guess it cost him about a million bucks. Chatham comes from the Alice Waters–Colicchio–Cindy Pawlcyn school of the freshest and finest ingredients, and part of the problem in Montana is the monthly FedEx bill, what with his fish coming from Charles Morgan in Destin,

Florida, and also Harry Yoshimura in Seattle, Wm. King in Naubin-way, Michigan, and Browne Trading Co. in Portland, Maine. Given the dough for the freight bill, everything is available nowadays, assuming you know what you're looking for.

While having a good lunch in a Japanese restaurant, Tanuki, in the Army base town of Sierra Vista, Arizona, I was full of light and dark food thoughts. As with sexuality, it is difficult to make a philosophical system about food. It is a matter of random pleasures that have a logical basis. Fast food is an integral part of a culture that demands speed so people can get at important things like making money and other understandable inanities. What's the point of making money if you don't even eat well, a basic principle for a decent life? And where is the American cuisine outside a dozen or so ethnic roots? It's hard to find except in the South, which is historically not a speed-intoxicated society, except in recent decades in southern cities. America's breadbasket is so vastly full the bottom has dropped out and we usually get a mess worthy of the floor. Not always, but very often.

I once wrote that I like recipes that are as fascinating as dirty pictures. As I get older I am finding more of these recipes, a matter of hormonal inevitability. And I have often thought my preoccupation with good food levels itself into an aesthetic matter, a more physiological response to something finely made in terms of art or craft. A great meal is similar to one of those rare paintings you'd like to live within for a while. Maybe painters and sculptors tend to eat better than writers do because their work is more visceral. Many writers are infantile and indiscriminate, and often when they cook they treat the most basic food compositions as culinary triumphs, perhaps because they're surprised it turned out to be more than modestly edible, the usual mistake of trying to be innovative with no training. For years — forty to be exact — I've been mystified why my wife is a far better cook than I am. Easy: I'm a writer.

The difference between a reasonably good amateur cook and a real chef is the difference between a Missouri tennis-club champ and Pete Sampras. If you have spent any time in a professional kitchen you are simply stunned by the deft capabilities of real chefs. Most fine home cooks would become weeping cretins by the third day within the demands of a professional kitchen, but

then this also adds a disturbing dimension. There are a number of fine cooking schools now, perhaps led by the Culinary Institute of America in Hyde Park, New York. Of late I have also noted that there are more and more faux fine restaurants led by chefs who are graduates of the cooking schools. Perhaps we should feel lucky these places exist, but the problem is similar to the ubiquitousness of an M.F.A. in writing. Solid basics can be taught, learned, but the true step up has always been a little ineffable, unreachable by sincerity and hard work, a matter of dimension, experience, resonance, a perfect palate, which is similar to perfect pitch. I have also noted that the best of these cooking-school graduates have spent apprenticeship time in France or Italy, but that most turn out "continental" attention-getters that lack harmony as a total meal.

The day of doom arrived and I was off to Vancouver to begin flacking two new books. During years I'm not publishing I limit myself to a single public appearance. This is a matter of claustrophobia and the fact that in literary society the carrot on the end of the stick isn't attractive enough to make you board planes, an experience that now makes my Greyhound bus days of the remote past look golden.

There's something essentially comic about book tours. A number of writers have noted that your persona, your ostensibly true personality, easily changes during travel. It's easy to slide back and forth between Ronnie the Rodeo Clown, the Dark Orphaned Prince, and the simply Pissed-Off Artist. Of course it's not proper to whine about success, but people do. I'm totally unsympathetic to those fungoid rock songs about the arduous life of the road, but then my eyes dampen when I recall what I feel like after signing eight hundred books in five hours. It's much more pleasant to be admired at a distance: kind letters and big checks, please. It's convenient to forget early-career appearances to which only a dozen readers showed up.

The real problem, too, is that you're not very hungry after these events. Despite the idea that the American motto "Clean your plate" was beaten into you, you couldn't quite do the job on two dozen pretty good restaurants. Added to the problem is that because of the food column you used to write, many chefs still think of you as a "top gun" and insist on showing you their best, and it's

only barely possible to do them justice on the day you don't perform your song and dance and signing. Another factor, however vague, is one of etiquette — to wit, you're not supposed to eat if someone is talking to you. If I had not broken this rule I would have lost twenty-five pounds in twenty-five days, certainly an unhealthy regimen when the supposed ideal diet, my own, is to lose a pound a year.

My trick this time out of the chutes was to avoid newspapers, television, and too much jangly coffee and booze, and to read lots of ancient Chinese poetry. And never play the sensitive, remote, tormented writer, which anyway is a difficult role, or you'll be looking for a plane to Paris by the end of the first event. Above all, lay the foundation of the day with pork products, giving yourself the stalwart power of the pig, which can withstand anything until butchering time.

Lucky for me and others, Vancouver is a fine walking town and they have delicious oysters, albeit large ones perfectly suited for oyster stew. Shakiness caused by violating the rule of small amounts of booze can be resolved with oyster stew at Rodney's Oyster House, a few beers and a nap, and a glass of Gigondas when you wake up and put on your dowdy suit of lights and hear the questionable sound of your jaw flapping. "Buy this book, or how can I afford Parmigiano-Reggiano on my bird dog's food? She likes it and won't eat Alpo." This is true.

Seattle is a problem because a friend, Peter Lewis, owns Campagne, unquestionably one of the best restaurants on the West Coast. Seattle has an abundance of fine restaurants, and when we weren't at Campagne we were at the Sea Garden for exquisite Chinese seafood, or the Harvest Vine for equally exquisite tapas. A great bonus for my Seattle rounds is the fact that Mario Batali, of New York fame, has a father, Armandino Batali, who has opened a lunch counter, Salumi, after thirty-one years of working at Boeing. You easily see where his son got his genius. I was fortified by testing a dozen of his homemade sausages, and also delicious oxtail stew, a pork-cheek stew, and pork cutlets fried with fresh sage. Add more than a little red wine and I was well suited to partially snooze through four hours of interviews and the making of a CD of my poetry.

Naturally my digestion was decrepit by the time I reached San Francisco, where I usually eat at Alice Waters's splendid Chez Panisse in Berkeley or at Bix's downtown. Years ago I was steamed in Berkeley because I couldn't find a place to have a simple shot and a beer before a reading, so this time I opted for a fine dinner at Bix's. In sophisticated California, taverns have disappeared along with cigarettes, accordions, straight razors, and living grace. By the second night we simply called in for pizzas at my favorite West Coast saloon, the Tosca.

After Denver, where I ate only a piece of fish while others gobbled splendid steaks at Morton's, I had a twenty-four-hour sleeping vacation at home in Michigan. Buddhist texts have taught me not to eat a big steak at midnight if you're getting up at 5 A.M. Strangely enough, at 3 A.M. at my fancy hotel, a man down the hall started bellowing, "Don't kill me!" over and over. I'm old enough to remember Kitty Genovese so I checked it out, but it was only a drunk quarreling with friends. The staff at the Monte Carlo apologized, but I admitted I had enjoyed the adrenaline of real-life drama compared with what I'd been doing for a couple of weeks. The problem was that my left ankle was bluish from tripping on a curb while avoiding a car hurtling toward me from my blind side the night before. This blind left eye kept me out of Vietnam, which might have ruined my appetite.

Ann Arbor was pretty good because it is the home of Zingerman's, where I had a massive brisket sandwich with horseradish sauce, and dinner was at the Earle, the single American restaurant I'm aware of with a large selection of Domaine Tempier Bandol, for reasons of temperament my favorite wine. And now I was headed south, a richer pasture than the rest of the country if you except food capitals like New York, San Francisco, and Seattle.

I often think of myself as a private detective of food whirling through the American night (and day), not only looking for the criminally ill prepared but in ceaseless search of the genuine. Under my trench coat is a bib, and instead of a gun and a knife, I carry toothpicks, Pepto-Bismol, and a reasonably fat wallet. For instance, in the Memphis airport waiting for my luggage and ride, I coolly noticed that there were many big, fat men, or what in the South they call "a tad burly." I'm not judgmental, because I know this por-

cine condition must be called "Christian fat." These men are devout and don't want to become lean, hungry Lotharios, so they favor virtuous overeating, a tactic practiced in many areas away from our cities, which fairly shimmer with dank lust. Sinless fat people are doubtless headed for heaven.

Oxford, Mississippi, was tough the first evening, with an elegant meal prepared by chef John Currence at the City Grocery that included a first-rate rabbit cassoulet, which didn't exactly calm my tummy because there were a half dozen other good courses, including a new kind of pork rollitini. The next day I was saved by the Ajax Diner on the square, a southern-soul-food restaurant that is always crowded, where I was soothed by five vegetable dishes: potato salad, black-eyed peas, butter beans with beef gravy, turnip greens with smoked pork, and, grudgingly, broccoli. And after my reading there was a marvelous crawfish étouffée and rice at a private home. I was almost well by Jackson, but then there was a stomach-searing anxiety attack from being admired and perhaps too many barbecued pork ribs the night before. Ribs and the act of chewing off bones is a harbinger of our Pleistocene past, a past I daily identify with in the woods, so it is easy to eat too much from what is simply an ancient pull of genes.

Whatever self-induced physical suffering I was undergoing, much of it allayed by the nostrum of French red wine of the first order, I was consoled by my continued reading of Su Tung-p'o, a Chinese poet of the twelfth century, who had a monstrously hard life, also consoled by wine, and lived without complaint. This book was better soul food for me than Janis Joplin's "Get It While You Can," my anthem for earlier in life, which, if continued, would have brought me up well short of my recent years. But even better than Chinese literature were the facts that I had only Raleigh-Durham and New York to go, and that I might get to pet my dog again before my system ruptured as if someone had dropped a case of dynamite down a manhole.

Raleigh-Durham passed as a dream, partly because I was staying at the guesthouse of a private home in a pleasant rural retirement colony where I even got to pet a Galloway cow (black with a white stripe around the middle). Charles Frazier, of *Cold Mountain* fame, did the introduction for my appearance and I recalled a story Judy Hottensen, the marketing vice-president of Grove Atlantic and my

frequent companion on tour, had told me about Frazier when she accompanied him on an endless trip. One pathetic, exhausted day, Frazier asked if they could eat at a restaurant where "they didn't serve portobellos." These big domestic fungi are as sure a sign of mediocrity as skinless, boneless chicken breasts.

The first evening in Durham, a chef named Warren Stephens at the Ferrington House Inn cooked me a fascinating bird referred to plainly in the menu as a "marsh hen." I decided to leave the mystery intact in the manner of an evening with a lovely woman for whom you don't have a last name or a phone number. The next evening at the Magnolia Grill I was replenished with oysters and andouille and in the morning was off to New York, troubled by the idea that one of my dinner partners at the Magnolia, Reynolds Price, though in a wheelchair from spinal cancer, demonstrated more grace and joy than any American writer I had ever met.

Writers from the hinterlands usually have a problematic relationship with New York City. They want to have either a crazed love affair with the city or a total divorce without having been married to her. I think of New York as female, and Chicago male. In recent years when traveling to New York, I always remind myself of what Dogen, a Japanese philosopher of the fourteenth century, advised: "No changing reality to suit the self." In other words, moment by moment, accept the raw meat on the floor, and don't waste any time on fantasies, expectations, and disappointments. The wilderness is the best God has done, and cities like Paris, Rome, and New York are the best man has come up with.

Besides, there's no end to what you can find to eat there. There's a tug at my heart and stomach when I pass through the Village, where I discovered garlic and red wine in the late fifties as an indigent explorer hitchhiking in from the northern Midwest. New York is the last singular place in America where the dimensions of food are truly great and the local varieties of fast food aren't an obscenity. As an instance, both Judy Hottensen and I were all played out at the idea of lunch, so we met one day at the Papaya King at Eighty-Sixth Street and Third Avenue for hot dogs, and the next day ate noodle soup with chopped duck and vegetables at the Family Noodle Restaurant in Chinatown, the kind of literary lunch I truly enjoy.

My first night in New York I habitually go to Elaine's for an im-

mense veal chop with garlic, and sautéed spinach with garlic, but they were closed for an election night party, so I opted for a palatable braised lamb shank at La Goulue, going to bed without unpalatable election television. The second night, after a Barnes & Noble performance, we went late to one of my top five favorites in New York, L'Acajou, where I had rabbit stew, but by then I was truly a frayed warbler and couldn't eat enough to produce the wonderful nightmares caused by indigestion.

The third night, at Mario Batali's Babbo, I had what was easily the best meal I have ever had in an American restaurant. Batali himself dined with us and walked me through the courses, all of which I at least sampled. *Antipasti:* spicy two-minute calamari; marinated fresh anchovies with roasted peppers and black lentils; warm lamb's-tongue vinaigrette with chanterelles, pecorino Toscano, and a three-minute egg; Babbo salumi with cipolle Modenese, celery root, and pear vinegar; testa with waxy potatoes and thyme vinaigrette; duck bresaola with Winesap marmellata. *Primi:* bucatini all'amatriciana with guanciale, hot pepper, and pecorino; goose-liver ravioli with balsamic vinegar and brown butter; beef-cheek ravioli with crushed squab liver and black truffles; spaghetti aglio e olio with red and black pepper; and tripe alla parmigiana. *Secondi:* barbecued squab with roasted-beet farrotto and porcini mustard; grilled quail with wilted chard, chanterelles, and saba; and finally, fennel-dusted sweetbreads with sweet-and-sour onions, duck bacon, and membrillo vinegar. There were a half dozen exquisite desserts, a few double magnums of Barolo, and the obligatory grappa.

This dinner was a mystical experience, and as such, you must yourself live through it to fully understand the mysticality, which was a little less apparent when I got up early for the airport the next morning in a driving rainstorm, with the usual flooded freeways.

My first day home I had a bowl of pea soup. Period. I was lost in thought and a bit puzzled by the thousands of cookbooks I had leafed through in my life, none of them containing skin pictures. There's a splendid Saveur cookbook called *Authentic American,* but looking through it, it occurred to me that as a food lunatic I had cooked many of the dishes but had been served only a few of them in American homes or restaurants, as if a grand tradition had been neglected until forgotten.

Maybe we're a bit too restless to largely work for the authentic or

genuine in our eating. Or too lazy, or simply not sufficiently inter-
ested. When I first envisioned this piece I planned to spend an en-
tire week eating fast food, but life is far too short for this degree of
squalor, and self-cruelty lacks attractive flavors. The French philos-
opher Foucault has some elaborate notions of the culture as a zoo.
The dominant ethic is Calvinist. We must eat to perform for our
masters. But then if you wish to slip through the bars of the zoo, all
of the ingredients are here if you take the time to learn how to use
them, or if you wish to look long and hard enough for someone
who knows how to cook. It's not a birthright in this country, the sil-
liest of our presumptions. It's an art, or at least a craft. And in the
interest of journalistic honesty, a suspect item, two years ago this
summer, on a long drive on a hot day, I ate a Whopper at Burger
King, then drove on down the street in Gaylord, Michigan, for a
second course of French fries at McDonald's. I didn't die.

KATE HENNESSY

Slow Flying Stones

FROM *DoubleTake*

IN THE FOURTH CENTURY, tens of thousands of men and women headed to the desert looking for religion; asceticism was breaking out everywhere. I could understand why as we drove south from Oujda, where we crossed into Algeria, and camped in Taghit at the edge of the Grand Erg Occidental, a sand dune larger than Ireland. I watched the sunrise over dunes that rose like mountains outside the door of my tent, and felt tension and unhappiness recede before sand so fine it flowed like water.

They say the shifting sands of the Sahara often shift themselves onto entire villages. People move out when the sand advances — bone-dry tidal waves often a thousand feet high that move foot by foot, as far as twenty yards in a year — and move back when it recedes. Land on the move in a country of nomads, land formed and ruled by the wind with ripples and eddies, whirls, crests, and troughs of an ocean marked by nothing but the wind and the faint trails of lizards, beetles, camel spiders, and larks.

The Sahara is 3 million square miles and growing. At its center in the Ahaggar Mountains are volcanic plugs and mountains of rock reaching 9,000 feet. These are surrounded by gravel plains larger than France and Italy combined, which in turn are bordered by the *erg*, or sand dunes. It is a world of sand, gravel, and rock shaped by water, sun, and wind. A world where, on the maps, *"eau potable"* and *"eau bonne"* are meticulously marked in the middle of blank expanses, and swallows fly across twice yearly on their way between Britain and South Africa, traveling 30,000 miles per year. It is a world where blind guides go by the smell of the sand, and the sand has been heard to speak in a low, penetrating boom.

The Sahara is deceptive, for you think you are seeing all there is, but the elements cover with their simplicity a secret life of the desert. It is a land where the animals lie buried under the sand and come out only at night. Horned vipers, poisonous and square-headed, hide under the sand waiting for prey. Large black scorpions hide under delicately perched granite boulders. The mouflon, or wild sheep, and addax, or antelope, seldom if ever drink water and are rarely seen. Seeds can wait for ten years for the perfect moment when they will germinate within three days after a rainfall and sow seeds ten days after that. Water hides, revealed sometimes by the presence of oleander bushes. The people hide, too. Moslem women completely cover themselves, leaving only one eye showing, and Tuareg men cover their faces with black or indigo veils. The granite boulders are a dull brown at midday but contain secret colors, turning orange in the late-afternoon sun and purple at twilight. There are hidden remnants of a secret past, three-thousand-year-old olive trees in the mountains, ancient cypresses fifty feet tall, rock carvings of elephants, giraffes, and zebras, and fossilized trees and fish bones.

After some days in the desert, you begin to feel the Sahara's secret life, for it forces you to look closely. Perhaps that is why the desert fathers and mothers came in droves. Sand, gravel, and sky, texture and color, took on an intensity I wouldn't have thought possible, and in my inspection I backed off from the self-inspection and self-consciousness that were in danger of suffocating me. The overwhelming immensity of the Sahara could sink you. Perhaps the reason the best Saharan guides are blind is that they aren't caught and unsettled by the immensity. There is no distraction of insignificance.

What sent me to Africa I'll never know. In 1989, I joined up with a British overland tour company whose glossy Mercedes-Benz truck matched their glossy brochure. We started in London with plans to reach Zimbabwe seven months later. The truck — that orange-and-white monstrosity that was our wheels, our pantry, our refuge — made it to Zimbabwe, as did most of the people on it. I did not, for I got lost along the way, deliberately so, and in the getting lost found my independence, but it was a hard, hard fight.

There were twenty-five of us: Brits, Aussies, an Irishman, a Dutchman, a Fijian, and me, the lone American. We left London and hurtled south past a blur of flat French farms and Spanish olive groves,

then rode the ferry across the Strait of Gibraltar to Ceuta, Morocco, where we slept on our first African soil. It didn't seem to want us; our tents were almost swept away in a torrential downpour.

After three weeks on the road, I knew I had made a terrible mistake. I felt trapped by that orange-and-white monster of a Mercedes-Benz truck, outfitted as it was to keep twenty-five people secure and in splendid comfort with Pink Floyd on the tape deck, cases of Marmite and canned cream-of-mushroom soup on the roof, and one long video of Africa playing across our windows. The atmosphere on the truck was claustrophobic and raucous. The air reeked of alcohol and volatile group dynamics. I spent my time daydreaming, sometimes eight or nine hours at a stretch.

Under the influence of the Sahara, we all quieted down, although this may have been due to the lack of alcohol. Nouas, the Algerian beer, was hard to find and not very good when we did find it. Even the truck's tape deck, which had been playing nonstop since London, quieted down. Camping night after night, the sun setting over purple mountains rising straight up from the gravel plains turning the scattered boulders a warm orange, reduced me to a state of pure pleasure. I was content with clean clothes, clean body, and a good spot to pitch the tent. Going for a pee meant squatting in the middle of nowhere with nothing to hide behind, but who cared? We played boccie in the shadow of timeless stucco walls. I saw seven-thousand-year-old rock carvings of elephants at Timimoun and wandered through the tamarisks and date palms and found a boy twenty feet up in the trees knocking dates to the ground. His mother gave me a handful so sweet and moist I was sure I'd never find such dates again, not even in Sahadi's on Atlantic Avenue in Brooklyn.

I spent every moment I could away from the truck, listening to the silence, watching the colors change, always feeling slightly on edge because of the scorpions, who like sleeping bags. Intolerance and impatience abated as I listened to the silence; I finally felt caught up in the adventure of crossing the Sahara, which, through its elemental abundance, began to bring me out of myself. In the Sahara, nothing is in your face. All space is given to you with nothing but seas of sand, followed by mountains of rock, and then there were no sand dunes or mountains at all, just a wide, unbroken expanse of blue sky, brown earth, and the line where they met.

Arab travelers called the Ahaggar Mountains the country of fear.

Riding in a rented Land Rover up to the hermitage of Charles de Foucauld at Assekrem, our driver, a young Tuareg dressed in a white head veil, stone-washed jeans, and a fake Rolex, called me Amereeka and drove so fast he left the other vehicles in the dust. This isn't easy in a region of Tuaregs with heavy feet on the gas pedal. Père Foucauld (the Brits in my group pronounced it "FUCK-all") had at one time been a surveyor-spy traveling through Morocco disguised as a rabbi and carrying a sextant and compass. He had come to the Ahaggar Mountains in 1906 to create a new model of a contemplative, religious life, and was killed ten years later in the revolt against the French. He died alone and left behind a hermitage and the world's best Tuareg-French dictionary. The hermitage was a fifteen-minute walk up a rise beyond a hotel that was nothing more than several empty concrete rooms without windows or beds. The chapel was one of a small cluster of small stone buildings that shared a spectacular view of volcanic plugs and jagged mountains of rock and rubble, basaltic lava that was left lying around like gravel piles for giants. In the chapel, a Little Brother of Jesus led vespers in French.

That night, after watching the sunset turn the mountains purple, we slept on the floor of a room carpeted wall-to-wall with snoring and rustling people. There was intermittent traffic to and from the loo, which was filthy, but the moon was so brilliant I didn't care. Kicked, cramped, and cold, I spent the wee hours of the night lying awake wondering why the monks were so tenacious. What were they doing here, these French Catholic mystics perched on top of a mountain in the middle of a country of Moslems and pastoral nomads? Chewing on this mystery, I missed the sunrise by ten minutes.

The only route from Bangassou to Kisangani — across the Ubangui River and through the forests of northern Zaire — is at a snail's pace, seven miles one day, ten the next. It's a good way to see every single flower, tree, and mud hole of the rainforest. The road was a river of mud, and the bridges a handful of uneven, rotting logs. We passed through tiny villages surrounded by banana trees and pockets of sweet-smelling white coffee blossoms.

"*Mbote,*" I called out as I walked ahead of the truck, smelling the whiff of independence.

The villagers smiled and waved. *"Merci,"* they replied. A few asked for cigarettes or a Bic pen.

We bartered glass and plastic containers for bananas, pine-apples, sweet potatoes, pumpkins, butternut squash, and eggs. (There wasn't much money left after crossing the border and deal-ing with its predictably rapacious border officials.)

The second night, near the border village of Ndu, women sang and danced outside our truck as Bob Marley played on the tape deck. The older women, who could have been either forty-some-thing or eighty (it was hard to tell), sat on stools in the light of the campfire, laughing at the younger women, who were dancing and singing. An old man shouted now and again. The only word I understood was "Mobutu." We had barely crossed into Zaire, and already Mobutu's name and face cropped up everywhere you turned.

"Hey!" we all shouted in reply, raising our fists.

I have no idea what praise we were giving to that wonder of won-ders, one of the wealthiest men in the world, leader of some of the poorest people in the world, but I shouted along anyway, just as en-ergetically and enthusiastically as the next guy.

Days of parasol trees and bamboo stands thirty feet high. I was in love with parasol trees and bamboo stands and the sound of the hyrax screaming in the night. I never saw a hyrax; no one sees them. They are shy. I still don't know what they look like. I've been told they are a rabbit-sized relation of the elephant, and that they can also live in the Sahara. Definitely a mythical creature with a nerve-racking cry in the dead of night.

We met a Red Cross worker who was riding a bicycle on his way to visit his parents. His village was twenty-five miles from his job, but he hadn't seen his family in six years.

Coffee and banana trees, young people with goiters, entire vil-lages of people with goiters, and small thatched houses in random clearings kept immaculate; not one speck of garbage to be seen.

"It's because of the snakes," our driver told me. I began to check for vipers before crawling into my sleeping bag; I hadn't yet recov-ered from my Saharan scorpion scares.

Days of digging the truck out of potholes the size of ponds, nav-igating across moss-covered log bridges, and nights of bush camp-ing in churchyards where the churches were simple thatched cano-

pies over log benches. There we sat huddled around a tiny shortwave radio, listening to news of the fall of the Berlin Wall. Times were changing, and we were stuck outside them. Off the clock in Zaire.

Zaire was my dream of Africa — the Africa I had wanted to imagine but couldn't yet. It wasn't the spectacular Africa of seas of flamingos and waves of wildebeests; of the Masai in full dress, greeting me from a good foot and a half above with a nicely clipped "Good morning"; or of the women of Lomé, Togo, who were dressed to kill, their hair small works of art. It was an Africa much harder to define. The road from Ndu to Kisangani is one of the greatest roads I've been on. It's a road for walking, a road for dreaming. I regained some of my peace of mind on that endless muck of a road, walking past liana vines and ferns and protected by the green, sun-speckled canopy above. You must look up in a rainforest; the eye is drawn to the canopy as compellingly as to a cathedral vault, to a higher world, inaccessible, unknown, and unexplored.

Day after day, mile after mile, of being God only knew where. The desert in Africa goes on for weeks, and the semidesert Sahel, too, and the rainforest. All of Africa goes on for a very long time. It was clearly marked on my Michelin map, of course, my pen mark moving steadily south, stars to indicate where we camped each night, but this was no real point of reference at all.

My days of canopied reverie ended abruptly in Buta, the first sizable town since Bangassou. In the only bar there, we partied hard, drinking them dry of Primus and Skol, the local beer, with our dancing and drunken idiocies after those long forest days and nights. It all deteriorated into streaks of nastiness from too much time spent together, group dynamics hitting a low point, hostility going wild in all directions, particularly toward Africa and the Africans.

Here I am again, I thought, and went to bed. The protection of the rainforest canopy was proving to be false.

We arrived in Kisangani, my city of hope, of dreams, of desires (this should amuse anyone who knows Kisangani), thirteen days and three hundred miles after crossing the Ubangui River. I sat in the bar of the Hotel Olympia, a large bottle of Primus in my hand. Providing cheap and plentiful beer, I had discovered, was the ex-

tent of Mobutu's social welfare policy. I found my bottle of Primus
extremely helpful as a waiter dug away at the jiggers in my toes. Jig-
gers are hideous. They look like a cross between a tick and a grub,
and I didn't like the idea of them living in my tender flesh. The
waiter was quite good at digging jiggers out from even the pinkest
of American toes, and he laughed when I hollered and tried to
yank my foot away. But I let the fellow continue, for there was a
story making the rounds among travelers, about a man, English,
they said, who had decided to wait and bring his jiggers back home
for his mates to see, only the jiggers stayed in his foot too long and
multiplied so wondrously he had to have his foot amputated. There
were quite a few cautionary tales like this floating about. No one
ever claimed to believe them . . . but I wanted those creatures out of
my toes, and fast.

Not bad beer, that Primus. Comes in a nice big bottle, too.

Sitting at the bar in the Hotel Olympia after more than three
months of shame as an overland truck traveler, the village of the
goiters was somehow the last straw, though little did the villagers
know it: I said to myself, "This is it. Off I go."

This was quite easy to say while drinking Primus in the shelter of
a hotel, but it would take another two weeks before I finally walked
free of the life of an overland truck traveler.

There was a select group of things to fear. Malaria. Being robbed
while in the middle of a malaria attack. Bilharzia, yellow fever, hep-
atitis, meningitis, dysentery, AIDS, insect bites gone septic, flies
that lay eggs under your skin if you don't iron your shirts. Damn, I
didn't bring my iron. I hadn't even come close to hearing all the
horror stories, some rumor, some true.

And then there was the language barrier. I didn't speak French,
which is the official language of Zaire, or Lingala, the language of
the army, or Swahili, which they spoke in the eastern mountains.
Obtaining food, rides, and shelter should be interesting, I thought.
I didn't even have a guidebook.

Could I cross that line from having it all taken care of to not hav-
ing a blessed thing done for me? I had traveled overseas quite a bit
before Africa — in Europe, the Soviet Union, India, and Nepal —
but I had never traveled alone. This tormented me. There were
things I was sure I wouldn't see unless I was on my own. There
would never be any sense that this journey was my journey and not

as thoroughly canned as the truck's vast supply of canned soups. This illusory notion of traveling through Africa, this delusion that I was understanding anything of what I was glimpsing through the truck windows, had to be punctured with a good dose of adrenaline, which only throwing myself out into the world alone would provide.

Of course, leave it to me to choose Zaire as the birthplace of my independence. Italy might have sufficed. Or Ireland, if I really wanted to live dangerously.

Three days later, the orange-and-white monster, my home for the past three months, left Kisangani without me. But I wasn't alone — yet; hoping to blur the line a bit, postponing independence slightly, I agreed to travel with Simon, an Englishman who spoke fluent French, which I felt would make up for any flaws in his character. We settled down to wait for the riverboat to Kinshasa.

Kisangani is a place where people wait. For what, I don't know, for the riverboat, for any ride out. It is hot, wet, overcast, isolated, surrounded by the bush, with streets of red mud and crumbling sidewalks and an evil history as an Arab slave depot and Belgian killing fields. The air was so oppressive that I rarely stepped out into the streets. No one else seemed to be moving, either. The markets were unsettling, full of smoked monkey hands and bowls of caterpillars, palm grubs, and other larvae, large, small, white, black, fresh or deep-fried. I stuck with manioc and peanut butter served on banana leaves.

I spent seven days in Kisangani, seven long days, but I never made it onto the riverboat, for by the fourth day Simon had begun to deteriorate, rotting like a fallen tree in the rainforest, sinking into the torpor of Kisangani and the poison of Primus. I woke up in the middle of the night to see him stark naked and pissing by the light of the moon into the corner of the room. He then climbed on top of the table and crouched there on all fours, being eaten alive by mosquitoes, too drunk to notice he hadn't quite made it back to his bed safely under the mosquito netting. It wasn't the first time he'd been this plastered. He'd been plastered for about three months straight, having begun this journey on the heels of a divorce — as good a reason as any, perhaps, to sell the house and head to Africa, but my sympathy had run dry.

"Forget it," I told him the next morning as he drank his third

cup of coffee and dug away at his bleeding mosquito bites. "I'm going east."

I joined up with Ena, an Irish lady I had met several weeks earlier in Bangui. For two days, we sat in the Hotel Olympia watching the only eastbound trucks pass through — more overland trucks that had taken on the feeling of termites crawling out of the bush and into the mud of Kisangani.

I had plenty of time to think in Kisangani. There are images that you can't get out of your mind, that are left to fester in the heavy heat — Henry Morton Stanley looking for fame, fortune, and a doomed Livingston; Conrad's Marlowe traveling up the Congo River; the tens of thousands of severed hands left by the Belgians. I thought about the three months I had spent in Africa so far. I had been treading on awfully thin ice, trying desperately to keep Africa at bay, trying to keep at a distance this sense of it perched on the edge of a chasm.

I come from poverty, I thought. I should know something of what I am seeing here, but I'm not. Who am I seeing, then? Myself, of course, reflected in the truck's window, Africa turning my gaze back upon myself.

Each of us hears and sees something different when we speak of poverty, depending upon which spot of wealth, or lack of it, we stand on. We all think we know poverty when we see it, those of us looking at it from our middle-class doorsteps, those of us who have been welfare recipients, those of us who find ourselves traveling through Africa and gazing at the lives of others who may or may not be poor. We don't know what we are looking at, for we are too far removed from the only signs we have been taught to recognize, and which in Africa are extraordinarily inadequate to the job. Split-level houses? Family minivans? Bob Marley tapes? Goiters? How confusing it can get when you are neither in Beverly Hills nor in a Sudanese refugee camp. I knew I wasn't seeing the whole truth, just as people did not see the whole truth when they looked at me as a child of poverty.

My childhood was in many ways a painful affair, so I avoided for years the memories and any attempt at understanding them. But Africa was sending me back.

My mother was a single mother of nine. A simple statement and

a minefield of memories. The story of my parents is a simple story of good, practicing Catholics making a bad marriage. As a child, primed to take things personally, I got caught by the physical manifestations of the poverty that resulted from my parents' separation. The most apparent sign, the one that showed us to the neighbors, the one that reflected back judgment and anger, was our house, our sad shambles of a house that had once been beautiful, now with its buckled and stained hardwood floors and peeling wallpaper that depicted elegant ladies in carriages, ghosts of a more successful and welcoming era. The house was a long, continuous New England farmhouse of white clapboard with peeling paint, surrounded by a yard gone amok with ragweed and burdock and a green Datsun rusting under the butternut tree. It was a home nestled in a lovely, bucolic valley, though. The only photo of the house I can bear to look at, even now, is a black-and-white shot taken from the hill behind it. All you can see is the flow of the roof from the main house to the ell and its three gables and on to the barn. From that distance and angle, there's no rot visible, no details of neglect, just a beautifully simple line that flows with the line of the hill and is framed by butternut and maple trees. I was saved by that valley and the hills around it; by August afternoons picking blackberries warmed by the sun; by dreaming in the hemlock and beech woods, listening to the velvet echoes of the wood thrush; by sitting in the apple tree near the spring well, reading *The Complete Sherlock Holmes* three times, in three consecutive Septembers when I could reach over my shoulder to pick a crisp, clean apple.

"Sad house, poor house," my mother would say. It was over a hundred years old; it deserved better. It burned down in 1979, when I was nineteen, and I was glad. It seemed the only way to cleanse it, to rid it of the years of neglect and abuse. It seemed the only way to cleanse my own feelings of shame.

You grasp on to these physical aspects of poverty because it is what the world sees of you and it is how the world judges you. But I quickly learned how twisted that world could be.

My parents separated when I was one and my oldest sister was sixteen. Neighbors told my mother to send some of us kids to foster homes.

"We'll take the older girls," they offered thoughtfully, "and why don't you sell your house."

What they meant was, Sell your house and move to where all the

other poor people live, like you're supposed to. My mother kept the house and kept us kids. How, then, can I continue to loathe our house? It kept us together and out of Westview, the local low-income housing project.

Our house was a nightmare, but it wasn't what sent me reeling into the world. The everyday details of growing up with little money seem unremarkable to me now. They are mere facts of life. Sure, I was mortified when visitors saw how we lived, but houses can be left behind. It's the unseen things that eat away at you, the real poverty I had inhaled for far too long, a slow intake of toxicity. Deep down I knew the fallacy of the judgment this house brought down on us. I knew I was something much more than this, but who would recognize it? Who could recognize this, taught as we are what poverty is — rusty cars, couches that sag, clothes that shout "donation!"?

My mother received less than two hundred dollars a month from Aid to Dependent Children. In the early years, she would on occasion pile us kids into the red Corvair or the green Volkswagen or whatever piece of junk she was currently driving, and head to the local ice cream stand. The neighbors complained furiously to the welfare office: "We don't want our tax money spent on ice cream for those kids." The harassment became so severe that my mother's caseworker commented, "You don't have very nice neighbors, do you?"

It took a toll on me as a child. One of my sisters recently discovered an undeveloped roll of film that contained photos of me when I was about eight. I looked at them without recognition. Who is that pale, sad-faced waif? Sweet, unkempt, and burdened. Was that really me? What was I burdened by? I wondered, knowing the answer before I'd finished the question. Poor children grow up intently watching their parents. I watched my mother bear the brunt of our poverty as she kept things together.

As a teenager, I didn't know how to envision a future and plan for it, how to take stock of my resources, and certainly not how to consider myself as my greatest resource. I didn't know that life requires constant self-evaluation; I didn't know I was a project worthy of the best investment. I had no sense that there were any strengths or skills to build upon, or even that there were ways to shore up weaknesses without despairing over them. Instead, I wandered about in confusion, knowing something had been given to me but

not having a clue how to pursue it, unable to discern what was worth struggling for, what details made me happy, or how to care for them. Poverty isn't supposed to have details, it isn't supposed to have value, and welfare brats certainly aren't supposed to be valuable. I felt my family's poverty was a statement of my self-worth. I felt it meant something much more than simple unfortunate circumstance; it was a reflection of what I deserved for being poor in value and in human potential, physically, intellectually, and emotionally.

In Africa, I paid good money to see the poverty others lived in, and I thought I could see it well, for I had grown up poor, but I was hiding behind my window, pretending either that I knew all about it or that I knew nothing about it. I was protected from all that I feared, but how, then, would I ever know what it was I had come to see? I needed to move beyond the careless cruelty of using other people's poverty as something to observe, as just another video to watch casually and without consequence; beyond traveling in a way that wasn't much more than following marks on a map and being rewarded with stamps in a passport; beyond a tawdry sort of exploration that easily slipped into exploitation. Replace a consonant and add a vowel, and there you are.

 I had been unable to move beyond the reflection of myself in that truck window, and Africa, home of us all, was flinging me back to my own beginnings. It had thrown my beliefs and private myths back in my face. The victim of poverty was now the woman of wealth, staring with those middle-class eyes at "the poor," and God, did I need to be saved. I had at the time no money in the bank, no couch at all, sagging or not; but as a stationery-store owner reminded me, "You had the money for the plane ticket, and you have the time to come to Africa." I had time, loads of time, precious time to spend in Africa, and thus I had wealth beyond compare. This wealth, though, was tricky. I could use it to remain behind the truck window, peering out, or I could lace up my Timberlands, adjust my backpack, check my malaria prophylactics, open my eyes, and, with the bruises of my own history of childhood poverty and the blessing of shame and the grace that came from it, step out of that truck and into the roads of Zaire, woman of wealth drawing upon the strength of an American poverty.

After seven days in Kisangani, I gave in to the inevitable, and, sick with frustration and heat, Ena and I arranged a lift to eastern Zaire on another overland truck. A bitter, bitter pill. It was smaller and poorer, the shoestring version of overland traveling with ten Australians who called every African they met Trevor.

I hated it and despised myself for not getting off and walking. I despised myself every single moment I held back from making the leap, but now I see it had to be done in these small stages, that this leap of courage required baby steps. Still, there is only so far you can go before you reach that last step, the one that makes all the difference in the world, the difference between standing on the edge of the cliff and jumping off it.

I made that step ten days later, on a busy intersection in Goma, when I jumped down from the truck with nothing but my backpack. I understood none of the local languages and had no guidebook, but I was happier than a pig in shit, even if breathless. I who went to New York City at age twenty and spent a painful year there before I felt at ease walking down Second Avenue in the East Village — now jumping out on that muddy, noisy, chaotic African intersection. Evolution at its zenith, my life hitting the summit of Mount Everest. All those long lines of Hennessys, Days, Batterhams, all coming to this — their child, Kate, free, alone, and unwashed in Goma, Zaire.

I had a revelation, or perhaps it was altitude sickness, in the sulfur mists rising from the hardened lava on top of Nyiragongo Crater. I was eleven thousand feet up, lying in a tin hut, my muscles collapsed from the climb, in the bitter cold, the first cold I'd felt in a long time. The wind was furiously worrying a loose piece of tin, which, accompanied by the rain hitting the roof, made a racket that kept me awake.

Africa was irrevocably changing my traveling ways. Sniveling fear was yielding to happy cluelessness and rampant idiocies. I became foolish and thickheaded, never knowing what to do or where to go or how to get there or how to ask, and was delighted to be so. Let me make a fool of myself daily; I shall be daily forgiven. Zaire freed me from bad traveling, a clear lesson in learning that what I had most feared, namely jumping out alone into Africa, was what I was coming to love.

I learned that as long as I was part of a large group, we all, travelers and locals, remained faceless to each other. Stepping off that truck gave a face to me and to those I met, which was all that I could hope for. There wasn't much more to it than a never-ending flow of strangers and the effort of navigating through the days without too many foolish mistakes and wrong turns, getting from one place to another, finding food and lodging. Being on the road is a daily lesson in asking for help, and a lesson in how to greet the world — *mbote, jambo,* hello, *bonjour.* It's a lesson in being a beginner every step of the way. It's never knowing where you are in any detail, with any certainty. Being on the road whittles away at everything you believe about yourself. Everything you have been applauded for and recognized for, falls away. On the road, no one has heard you sing "Hard Hearted Hannah" or knows about your 3.9 GPA at Yale or that you were the national woodcarving champion at the age of fifteen. No one knows your motivations or intentions. No one knows if you are a good person or not.

I had begun the journey as a spectator, sometimes with lucky moments of connection and peace of mind, but most often irritated, fearful, and judgmental. Traveling alone, I was still a spectator, wandering from town to town, watching people as they went about the real business of living — brief glimpses of lives I would never see again. It was much like a silent movie, and I heard very little for a while, still too far removed, even though I walked side by side or sat hip-to-hip with others in a *matatu,* I on my odd journey, they on their way home or to the market, for we were not on the same road by any stretch of the imagination.

Then I was overtaken by the dust-covered days on the backs of trucks so full there was nowhere to put your feet if you sat down, and if you stood up there was nothing to hold on to. Days where there were immediate consequences, and different worlds encountered on a whim. Shall I go west or east? Hop on this truck or that one? Help! There are just too many roads. Which one am I on? I traveled thousands of miles to get here, and whaddya know? I am bouncing about on a pothole-ridden road, trying to avoid sitting on overripe avocados. I was overtaken by a feeling that anything was possible and nothing was going to stop me — not that I knew what I was doing.

*

On top of Nyiragongo Crater, I couldn't imagine the route beyond the Zaire border. I had been in the country for five weeks, not that much time at all, and yet I felt so disconnected from the rest of the world that I was reluctant to leave, as if it meant risking all that I had gained. My mind and lungs had been stretched into shapes they had never known before, but now I was sure to remain loose, like a deflated balloon, and willing to be blown back up again.

I spent the last two weeks of my trip in Lamu, a Moslem fishing village on an island north of Mombasa, in the Indian Ocean. It was my first sight of an ocean since the Gulf of Guinea at Lomé, Togo, and seven months had passed since landing at Ceuta, where the torrential rain had almost swept our tents right back into the Strait of Gibraltar.

Having begun my trip in the Moslem countries of Morocco and Algeria, I ended it in a Moslem region, yet it might as well have been another religion, another continent, another Kate.

Lamu was a tourist trap, but a peaceful one where everyone knows you within your first day. I wrote in my journal during the cool early mornings and drank fresh mango juice. I watched children play hide-and-seek in Swahili as dhows sailed in and out of the bay. On Manda Island I ate freshly caught fish cooked over an open fire, eating with my fingers and sitting amid garbage and acacia trees. I walked on the empty beach, a three-mile walk along the shore, or took a ten-shilling ride in a dhow. There was no schedule; the boats left when full, as with all African transportation. The beach was clean and empty, and the sea was full of jellyfish. One afternoon, a Western couple walked hand in hand, buck naked. The next afternoon, several Lamuian women, completely covered in their *bui bui,* sat on the beach. There must have been a schedule for that sort of thing — naked couples on Tuesdays and Thursdays, women in *bui bui* on Mondays and Wednesdays.

I would wait for the afternoon heat to pass in Peponi's, a high-priced restaurant that sold canned mango juice. Mango season had just passed, and I had to search from one end of town to the other for a glass of freshly squeezed juice. On the lucky days, a few restaurants, Hapa Hapa, the Yogurt Inn, or the Coconut Juice Bar, were able to buy a few mangoes off the daily boat from the mainland. You had to be at the right place at the right time, ahead of all the other mango juice fanatics. There was no shortage of limes, coco-

nuts, and bananas, though. No matter where you go in the world, you can never escape from bananas.

At Peponi's I drank Bitter Lemon before walking the three miles back into town.

"Jambo, habari?" the young men called out to me. It was the Rasta boys' last three days with their dreadlocks before a police decree forced them to cut their hair.

"Mzuri," I mumbled, sweaty, salty, and tired. You always reply *"Mzuri,"* or "Fine," no matter how tough a day on the beach it had been. I didn't trust the boys. Were they coming on to me? I was soon exchanging safer greetings with the older men in traditional dress.

"Jambo, karibu," people called out as I walked down the streets. Swahili is a marvelous language. You can spend five minutes throwing one-word greetings to one another, making it easy to be polite.

It was Ramadan, so there wasn't much point in returning to town before six. Everything closed during the day, and the town came alive an hour before dinner when every child and adult male was out in the streets. The older men waited for the call to prayer; the children played under the care of their fathers. Women strode down the street like black clouds, *bui bui* billowing about them, flashes of bright colors underneath, and hurrying as only the women do. On the waterfront, travelers sat on the cement wall, waiting for the restaurants to open. Vendors set up their stands of big pots of iced passion fruit juice, *samosas, bhajias,* and pancakes. Prayers blasted out of the mosques' many loudspeakers. Men wearing *khanzus,* or long robes, and *kofia* caps flowed in and out of the mosques; some sat on the steps listening. At 6:28 or 6:30, according to exactly when the sun set, which you could find out in the daily newspaper, everyone disappeared. Dinnertime.

Streets that were teeming with people one moment emptied out the next until there were only the donkeys and cats left. The donkeys, free to wander, jogged down the main street or stood listlessly in the shade, heads in the doorways as if hoping for an invitation to dinner. (They say the cats are descendants of the royal cats of Egypt. Some are well cared for, most are starving.)

Many Lamuians stayed up all night for Ramadan, during which they are permitted to eat until 5:30 A.M., followed by another day of rest, prayer, and fasting. Nonetheless the market was always full

of women shopping. Non-Moslems ate indoors, away from fasting eyes. I ate my lunch, bread and peanut butter, in my bedroom, furtively, guiltily, with the door closed.

Africa changed my traveling ways. Here, spots of erosion, crumbled stones, and small trees sprouting from fissures appeared in the wall that was the image I had had of myself. Thoroughly stuck in the "I," I had flung myself out into Africa, and though I remained still firmly ensconced in that "I," it had become something less poverty-molded and something much more vast, much more awake, much more uncertain. But it was the sort of uncertainty that breeds courage and leads you to look more closely and calmly at those sorry bits of your own life, and at the scary bits of those around you.

Poverty can be a bitter, bitter way of moving through the world. It can be a life of reaction, of only coming from and never moving toward, no matter how far from it you come. Peace is rarely made with the past, for it is populated with too many ghosts, and with too much heartbreak.

I still look longingly through the windows of those whose lives seem full of impossibly ordered beauty, who live with immaculate carpets, unmarred walls, groomed gardens, and working televisions and toilets. I'm still drawn to the look of a person whose sofa doesn't sag. But thank God for my lessons in shame, for how else would I have learned to travel alone through Africa? There was no automatic commonality, for this was another continent, another world, but I had learned to see the details of people's lives a little more clearly than if I hadn't grown up poor. There wasn't as much to fear, and I didn't have as compelling an instinct to close my eyes. And yet it also made it all a little more raw. I knew too much. How close could I look?

Africa taught me to love glimpses of strange things that would never be explained, to love that sense of the secret life of the desert, of the rainforest canopy, and of those whom I met briefly. Love for the open road that helps the imagination flow, that breaks down the boundaries of thought and emotion with chance encounters and changing languages, customs, faces, and predicaments. My mind goes elsewhere on a road unhampered by what I think I know or expect to see.

I doubt, though, that I will ever get back on an overland truck.

From the terrace of my Lamuian guesthouse, I looked out to the east, to the Indian Ocean, toward Bombay, thinking of the Ugandan road sign that said SLOW FLYING STONES and feeling like a slow flying stone myself. But I had gotten things going. I was in the air. I had skimmed across Africa like a water spider shooting across a pond that was no pond at all but deep, dark, and unfathomable, like the flooded granite quarry we went swimming in as kids, nervously, for who knew how deep it was or what strange things you could find at the bottom. I flitted across this continent, sensing great pools of disaster lurking beneath, riptides and tidal waves about to destroy it all; sensing a fragility that made me want to weep. Humans and creatures, the Masai and the Turkana, the gorillas and the hyraxes, all going through hard times and poised on the razor's edge. Soon after I returned to the United States, Algeria descended into a brutal civil war. The Tuaregs revolted and scattered, losing their nomadic ways. Refugees from the Rwandan genocide flooded Goma. Five countries, including Zaire, were pulled into war. And I just missed it all, having perfectly timed my passage between droughts and genocide.

There was a saying that was making the rounds among backpackers in Nairobi: "You go to Latin America to learn politics, you go to Asia to learn philosophy, and you go to Africa to learn how to laugh."

I'm soft in the head about Africa, this land of still, moist twilight scented with jasmine and silhouettes of acacia trees and giraffe necks; this continent of endless, pothole-ridden roads; this land of shifting, golden Saharan sand and sticky, red Zairian mud, all pulling you into going nowhere yet sending you off to places you never imagined.

EDWARD HOAGLAND

Visiting Norah

FROM *Worth*

TWO PAIRS of marabou storks, each of them five feet tall and battleship gray with a pink neck and a wattle pouch, proudly posing and croaking, were raising chicks in bulky nests in the flame trees that overlooked the swimming pool at the Fairway Hotel in Kampala, Uganda. Probably because of the crowds of schoolkids learning how to swim every afternoon, they reminded me of the proverbial white and black European storks that flap over the thatched roofs of country cottages, bringing newborn human babes to each village. But marabou storks — unlike the storks of fairy-tale folklore — are carrion feeders and offal scavengers, similar to but huger than the most no-nonsense vulture, and in famine territory they of course will eat children who drop by the wayside. In the chaos of modern Africa, they have moved from the veldt and forests into the cities, wherever garbage and death and anarchy erupt. They are tolerated because, as they stalk around, gobbling refuse, rodents, fruit rinds, rotting vomit, dog carcasses, or what have you with their thick scary beaks (your eye would be a cherry tomato to them if you were lying shot), they fend off disease. But when I saw them roosting in the downtown parks, hunchbacked though formal-looking and humorless, as if watching for any homeless person who might be staggering or bleeding, they looked like undertakers to me.

Black kites and hooded vultures also circled over the city's seven hills — above its Catholic Hill, with the Rubaga Cathedral; its Moslem Hill, with the handsome Kibuli Mosque; its Anglican Hill, with the Namirembe Cathedral; and Makerere University's stately tree-

rimmed rise; and the separate central hill that President Yoweri Museveni governs from; the ceremonial palace hill of the Buganda kingdom; and the knobby water-tank hill, up which Kampala's drinking supply is pumped from Lake Victoria, to be distributed by gravity later on — and also the crossroads Clock Tower; the Parliament Building; the derelict railroad station; High Court; and Hindu and Bahai temples; and Nakivubo Stadium, by the odorous Owino Market, always a good place for a vulture to land. Hadada ibises, too, roosted at night in my hotel's courtyard trees, calling to one another like laughing peacocks in the evening and especially again when they flew away at dawn, crosswise — with their necks stretched out — against the sky, rising, scudding, or spiraling, and emitting the sound, *hada-da,* that lends them their name, in order to begin gleaning insects, amphibians, and mice from the marshes and fields. Poverty was their friend; abandoned land was best.

This was my third visit to Kampala and my fifth to Africa. After my flight from London had circled down, however, our British Airways pilot added a personal twist to the usual parting spiel. "God bless you," he said. Uganda was emerging from the worst siege of the Ebola virus that Africa has yet experienced, and most of the Europeans and Americans on the thrice-weekly flight were no doubt aid workers of various kinds. Yet the Africans aboard were returning to the torque of a continent beset by difficulties that dwarfed the Ebola outbreak. AIDS alone lurked in 25 million Africans (including an estimated 1 million Ugandans, not counting the many who had already died), though AIDS was not really any more problematic than the enigmas of governance.

My reason for traveling to this place was personal as well as journalistic. I am a writer and professor at Bennington College in Vermont, and, for a year and a half, I'd been sending money to a post office box in Kampala, tucking twenty- or fifty-dollar bills every couple of months into a greeting card so that they wouldn't show through the envelope if a larcenous clerk were looking for them. The grandmother and five orphans it was intended for had confirmed each safe arrival. Now I was coming to meet them, and know them if I could.

"Mother Norah Mugga" had begun the correspondence, out of the blue, in July 1999:

I am writting to introduce Myself to you on behalf of [my] young grand children. There are Samuel, Herbert, David, Betty and Nicholas. I am 72 years old lady and a widow. As you may be aware, in Africa we lead a hard life . . . Some of the parents died of accidents and others died of the deadly disease of Aids Scourge. As their grand Mother, I was put Under responsibility to look after them . . .

The following January, eighteen-year-old Samuel Ziwa Ssenyonjo took over the correspondence, sending report cards and the like because Norah's health had declined after a stroke. They owned a bungalow and two acres to grow food on, so their main expense was not for food or rent but (as with most Ugandan families now) school fees. Education isn't free; it costs between $25 and $500 each term, depending upon the age level of the child and quality of the school — which even at the low end of the range is an ulcerous worry in a country with so many orphans and waifs and where wages are typically a dollar or two a day.

Betty, age nine, was first in her class of 17 at the Tween-Age Educational Centre ("What Man Has Done, Man Can Do"), and in the next semester ranked second. Herbert, three years older than Betty, was fifth in a class of 24 at the Kitemu Parents' Primary School, and later ninth among 23. Herbert's cousin Allen (actually, eight orphans sometimes lived with Norah) was seventh in that same group, and in the next term, thirteenth. David, age ten, did not do as well, being eleventh out of a class of 14, and was described by his teachers as "Fair" more often than "Good." Samuel himself had recently finished what corresponds to the eleventh grade in an American high school. His performance at the Buddo Secondary School seemed to fluctuate a bit; one term he was fifth in a class of 139, another he was thirty-eighth in a class of 113.

Samuel next put me in touch with Nsubuga Mutebi, his uncle and guardian, and Norah's only surviving son. Nsubuga was thirty-eight, the father of two little girls, and lived with his wife (also a Norah) and her fifteen-year-old orphaned sister, Harriet, near a sports stadium in Nakawa, on the outskirts of the city. They had built the four-room house of bricks and cement after he had been released from the army, using his discharge money, though the site was malarial and the interior unfinished. During his military years, Nsubuga had marched a lot between towns near the Sudan border, from which a rebel group called the Lord's Resistance Army was

still staging raids occasionally. Now he worked as a driver, which meant that he owned a cell phone and therefore knew I was coming. He met me in a borrowed Toyota late that evening, accompanied by Samuel, a pleasant-looking, alert, limber teenager. Samuel was waiting to hear whether the results of the comprehensive exams he had just taken would afford him entry into the advanced phase of secondary school.

Nsubuga, round-faced and easygoing, was a conscientious son, a worrier in money matters but gregarious with his friends, a good husband — always advisable in an AIDS epidemic — and middle-of-the-road on the subject of ambition and education. I soon realized he wasn't going to ask me to try to finagle a scholarship abroad for Samuel, just to continue helping him locally. Indeed, I bought Samuel some chickens later on, for sixty-two cents apiece. The chicks — one hundred of them — would come by air freight from South Africa, and Samuel would be able to sell them for two dollars at the broiler stage (an old business of Nsubuga's, when he wasn't driving trucks eight hundred miles at a stretch for an importer). I liked their precarious eagerness, and they warmed to me too. With my kit slung over my shoulder and a green hat hiding my white hair, I looked in my fifties, they said, ten years younger than I am. I'd made the same twenty-mile night drive to Kampala before, with the erratic strings of cubicle shops and stalls fitfully lighted along the narrow road, bikes and pedestrians at constant risk — fifty of them to every car — and the smells of sewage under the stars, but of crops and foodstuffs too, and, above all, crowds of people. *Nearer my God to thee,* my mind murmured unexpectedly, which is the gist of what I always feel upon arriving in Africa. Not that Africa is "God" but that people, creatures, vegetation are, without the static of technology and machinery.

On a terrace at the Fairway Hotel, in the equatorial balminess, we had Cokes before Nsubuga and Samuel left me. It's a midlevel hostelry where many expatriate aid workers put up, about a twenty-minute walk from the center of this million-person capital city. I had stayed here before, on two trips with a Catholic Relief Services food-delivery group into a famine region of the civil-war zone in Sudan, on Uganda's northern boundary. Currently, 670,000 refugees are being fed by the World Food Program in camps within Uganda. So I assumed that the mystery of how Nsubuga's mother

had gotten my name was connected to those episodes. Norah was a retired kindergarten teacher with no present income, and had told me that a stranger at her church one Sunday had let her copy my address from a slip of paper that he kept in his glove compartment. The church, St. Apollo Kirebulaya in the town of Kitemu, ten miles outside Kampala, on the Congo and Rwanda Road, occasionally drew in a few long-haul truck drivers who wanted to pray. It must have been one of these who had responded to her need and who happened to have known me years ago while shuttling emergency relief to Sudanese refugees.

I rested the next day, watching the Senegal soccer team strut about the hallways in their yellow uniforms with numbers on the front, as they psyched themselves up to beat Uganda's hapless players, the Cranes, in an African Cup of Nations qualifying match at Nakivubo Stadium. Elsewhere in the hotel, Kampala's Rotarians held hands and sang in the dining room, at their monthly reception, while the Hormonal Contraceptive Society partied with a Luganda-language singer and an electronic band. Out on the lawn below, the Ministry of Public Services was awarding its annual citations, with big gift boxes in red wrapping paper, and office-party dancing, and finally a conga line.

I talked with a Zimbabwean consultant, as we watched all this, over glasses of *waragi* — banana gin — and tonic. His job involved visiting distant villages to check on how donor money for various projects was being spent. But since Zimbabwe's troops and Uganda's army were currently fighting on opposite sides in the Congolese civil war (which also included Rwanda, Angola, and Namibia, plus Kinshasa's ragtag forces and several rebel and tribal groups), I asked him teasingly if he was regarded as an "enemy alien." A booming-voiced, large man, he said no with a laugh and defended Robert Mugabe's twenty-one-year reign as Zimbabwe's caudillo; also the recent anarchic policy condoning violent seizures of white-owned land as a proper wind-down from colonialism. He said the tacit European boycott that had resulted was unfair. Instead, Europe should police the corporations that were stripping Zimbabwe of its gold and other natural resources. Meanwhile, Ugandan army generals were reported to be looting Congolese gold and diamonds. If applied to repairing Uganda's stumbling economy, the money might have justified the lives being lost —

sometimes in battles that were really over mining rights — but people in Kampala had become quite bitter over the corruption, even to the point of jeopardizing Museveni's reelection plans after a fourteen-year reign. (Museveni did eventually win, in the spring.)

Beyond the Oasis of Love

Next morning, Nsubuga picked me up in another borrowed Toyota — this one with a Japanese logo on the side — to bring me out to see his mother. He was trying to buy a car for his business, but the collapse of tourism, with the Ebola scare and the staggering economy and the country on a war footing, had caught him out. His day rate, about sixty dollars for the car and gas, was the same as my room rate and the equivalent of a month's wages for most of the hotel's employees. He was low-key and congenial, however, considering the breadwinning pressures he was under, with his mother's doctor bills and the kids' school fees. His wife worked six days a week selling rice and salt at a food mart to help. He said they had escaped the HIV plague by maintaining a good marriage and paying close attention to the earliest public warnings about "slim," as AIDS is often called in Uganda because of how it scours the body.

We rolled over several potholed, roller-coaster hills, passing a hundred walkers for every car, and sugarcane and pineapple juice stands, red termite mounds, the Obey the Thirst Pub, Half London Bar, Divine Gift Shop, Exotic Hotel, Success Nursery School, Didi's Amusement Park, Oasis of Love, and Noah's Ark School, then stopped to look at some children's wooden coffins for sale for fifteen dollars, though well polished and carved (adults' were sixty dollars). Transportation was mostly by *boda-boda*, Swahili for "motor scooter," which the customer rides on the back of for a few hundred shillings (1,600 to the dollar), or the fourteen-passenger vans called *matatus* that pull in and out of traffic constantly.

We turned off the two-lane international highway in a leafy outer suburb called Buddo, on a dirt road that climbed a fertile hill, past modest bungalows almost lost in banana plantations and elephant grass, with a scattering of goats trotting about and other domestic animals plus walkers and bicyclists, and impromptu-looking vegetable plots, and birdsong whenever the car slowed. People here

would hike down to the highway at dawn and catch a crowded *matatu* to a humdrum job in the city and maybe get home after dark, while the oldsters and schoolchildren kept the gardens going, boiled drinking water, and watched over the chickens so that no kid on a motorcycle could swoop past and grab one by the legs and sell it roasted to a trucker for a couple of bucks.

It was exciting to wind up the gentle hilltop and first catch sight of Norah's cement-and-stucco three-room house with a low-roofed porch under a grove of jackfruit, eucalyptus, and palm trees. She came out to greet me, leaning on a stick, in a yellow-flowered dress under a blue-patterned shawl. Intelligent and sweet, she looked like my own mild, kind, humorous grandmother had at about eighty-five (which turned out to be Norah's true age, when we figured it out), except for the width of her nose and the tint of her skin. Samuel was smiling beside her, again with the quicksilver quality that I liked, and shy, young Betty, who, once I was seated in the living room, knelt briefly on one knee in traditional obeisance to a visitor who had come so far. Behind this house — dark, to minimize the equatorial sun — was a mud hut that had been enlarged and cemented and was now used for storage and cooking but which Norah and her husband, Jovan, had originally built and lived in when they bought these two acres with his discharge money after World War II. They had come from Kalangala and Bubeke, two of the Ssese Islands, out in Lake Victoria (the world's second largest), marrying in 1937 and migrating to the mainland after the birth of the first of five children two years later. Jovan was drafted into the Seventh Regiment of the King's African Rifles and trained as a medic, which led to his work as a dispensary technician all over Uganda later. He established a second family in the city of Mbarara, in the west, with four other children, an African pattern not much frowned on here then, and the children visited each other till he died in 1994.

Norah couldn't walk far or talk English much because of the debilitation of the stroke, so Nsubuga led me in noticeable anguish through the plot of banana trees to the center of their little piece of property. Seven fresh, startling sarcophagi, heroic-size and starkly fashioned of cement, rested flat on the ground — the graves of Samuel's father and mother and other dear ones who had died of AIDS. He also showed me the mango trees, the beans and

yams and pawpaws and cassava, the chicken shack that he and Samuel would stock, and the hundred-gallon drum that gutters on their roof fed rainwater into. I'd brought Samuel a few books — *Things Fall Apart, Abyssinian Chronicles,* Wole Soyinka, Elechi Amadi, Ngugi wa Thiong'o, Okot p'Bitek, Peter Abrahams — and he showed me his best drawings from art class, especially a splendid fish, which Nsubuga joked was appropriate because they were descended from the Lungfish clan of the Baganda people.

The Baganda's king, the thirty-sixth *kabaka*, Ronald Muwenda Mutebi II, had been restored to his three traditional palaces on Kampala's hills by Museveni in 1993 — his father had been overthrown in 1966 — and Nsubuga, on our drives, always proudly pointed these out to me. The Baganda, like the Kikuyu of Kenya, are the dominant tribe in business and around the country's capital region, as well as the most populous ethnic group (a fifth of Ugandans), but differ from the Kikuyu in that they gained their head start before independence by cooperating with the British, not fighting against them, and generally seem more equable in their temperament.

Besides growing its famous coffee for export, Uganda ought to be a major trade center, lying as it does between northeastern Congo and the Indian Ocean as well as between Sudan and Africa's Great Lakes region. The spindly Gulu Road, running south from that border-district town a day's drive away from Kampala, should be roaring with commerce from Juba, on the White Nile — the unofficial capital of the southern Sudan — and all the natural resources there. Juba, however, has been under siege by a guerrilla army for most of the years since I visited it in 1977. To the west, Kisangani (Stanleyville), the fabled community at the great bend in the Congo River, has been racked by equally internecine warfare. So Kampala has a knot of hopeful new glass buildings, but its engines have stalled.

Yet this likable and loosely dirty-collared, steeply built minimetropolis centering on Nakasero Hill is endearing. The president's mansion and palace-guard quarters perch at the top, with the best hotels (the Sheraton, the Grand Imperial, the Nile, the Speke) shelved just under them. Banks and offices are at a middle level, and then come the indoor, middle-class sorts of stores for dry goods, housewares, and clothes. Near the bottom lurks the frenetic bedlam at rush hour of the enormous "taxi park" at Luwum Street,

where fifty, sixty, or more *matatus* and their hawkers are based, along with beggars, peddlers, pickpockets, and warehousemen. All the way down by the dank and fetid Nakivubo River seethes the vaster, tented babel of the Owino common market. Nairobi, in Kenya, of course has all of this chaos tripled, but Nairobi is encircled by the famished tragedy of squatters' camps, unmapped and amoeba-shaped. Ugandans, under Idi Amin's and Milton Obote's dictatorships in the early decades after independence, witnessed much crueler violence than Kenyans ever did, but because the violence emanated from the city, their impulse has been not to run to — rather, away from — Kampala in times of disaster. Kampala was so terrifying a crucible of mayhem, torture, and murder that it was not swamped with country folk, as Nairobi has been for half a century. Museveni has made the situation much better, even though his mid-March reelection was less than exemplary as a democratic exercise, and was preceded and followed by several fatal bombings. Indeed, his chief opponent, Dr. Kizza Besigye (who was favored by younger, educated voters), ran as a fresher version of Museveni. When you are in Kampala, you are not in a savage dictatorship like in Khartoum, nor in the hungry, gridlocked democratic tumult of Calcutta. Kampala is touching precisely because it is a city trembling between alternatives. Not starving, not a tyranny, and not yet choking with air pollution like Mexico City, because, except for a smoking soap factory, it hasn't a lot of industry.

The Angle of Conversation

Another day, Nsubuga drove me to his own home in the neighborhood of Bweyogerere on the Mombasa Road. Intermittent strips of one-story, plaster-and-cement businesses sped by: Nice Place Plastic Products, the Hot Fat Pork Joint, Maggie's Bar, and a drum maker, the Sunni Moslem hall, the Victory church. We turned off and bumped upward on a patch of trackless, slick red hardpan to a cluster of makeshift, small, mortared-over brick houses, close but catty-corner to each other, with gashed rain gullies nevertheless separating several of them, so that we were lucky that the car reached the door. We could hear other conversations and quarrels, and smell the communal privy, but Nsubuga's children, Sheila and Shakra, both breathed "Daddy!" joyfully when they saw him. (Two older ones were at his mother-in-law's farm, or *shamba,* sixty miles away

— she had had twelve children, many now dead of AIDS.) I was pleased to witness this because, although I knew Nsubuga was a good man and I had taken his wife and him out a couple of times for a drink in the evening, as well as his children swimming, our friendship never achieved much intimacy. Like many people I got to know in Uganda, he was so frantically short of money that our relationship was edged with angling requests for cash. Not just the orphans living with his mother, Norah, needed school tuition, but his mother-in-law's various orphaned grandchildren did also. To finish buying the Toyota, he needed the equivalent of another $2,500, which he had no way of acquiring. Yet as he neared forty, what he thought he maybe wanted more was a little *shamba* of his own, to make use of the agricultural sciences that he had studied in school, before he enlisted in the army. When I asked if he wouldn't inherit Norah's two acres, he told me a bit ruefully that if his father had outlived her that would be the case, but the Bagandan tribal custom specified that a woman should leave her property to her eldest brother's oldest daughter instead — and buying it would cost more than the car.

Even with both of them working, Nsubuga and his wife hadn't managed to finish the house. The bedroom, though uxoriously cozy, was the projected garage. The narrow yellow living room, with two sofas and two upholstered chairs, a blue rug, a TV with a Spike Lee video playing on it, a small coffee table, some calendar art, a refrigerator stocked with Pepsis, and a gold wall clock, was their future kitchen. They said they had met at a wedding party twelve years before, and still touched one another, side by side, so affectionately as they talked that it seemed like an inoculation against HIV. Harriet — Nsubuga's fifteen-year-old sister-in-law who baby-sat for them, liked biology in school, and wanted to be a nurse if they could afford to continue sending her — was as attractive as Samuel, out at Norah's in the country, and possibly smarter. Yet, living cheek by jowl with their neighbors, the family had malarial pools of rainwater just outside that the communal outhouse drained into.

The Two Josephines

So you may wonder why, as an American traveler, I didn't simply preoccupy myself with trying to help this particular family. Well,

there were malnourished street children roaming the town who had no adult relatives whatsoever left to help them. There were young Rwandan refugees, destitute and traumatized by the furnace of that next-door genocide. And the Congolese and Sudanese civil wars to the west and north, with maybe 5 million dead combined. On a milder note, there were the difficulties of the waitress whom I knew best at my hotel. Josephine Nantume was a single mother and — after the collapse of tourism in the wake of the Ebola epidemic and the recent kidnapping and murder of eight British, New Zealand, and American vacationers who had meant to observe gorillas in Bwindi National Park but were captured by guerrillas instead — was barely earning enough to cover her food and rent. I paid for Donald, her six-month-old son, to go to the doctor when he got feverish and started choking from bronchitis and she feared he might die of pneumonia, as well as for his regular supplementary milk. Then I hired Nsubuga to take me out along the Gulu Road to where she lived in two dark concrete rooms behind a groundnut, spice, and soda-pop store.

Donald still had a deep cough but was better, and we piled him and Josephine and Rosemary, Donald's twelve-year-old cousin who baby-sat when Josephine was working — all dressed in their Sunday best — into the car and drove about twenty miles for a surprise visit to Josephine's parents, in Buzzi. Her last visit had been alone on the back of a motorcycle for an AIDS funeral some time before, so this was a very special occasion. In fact, when we pulled up to the house, her parents, Kato and Nakawesa, thought the owner of the hotel must be bringing her home after an accident. But Josephine had bought sugar, rice, cornmeal, soap, and biscuits to load in our trunk to give them, and had saved about five dollars so that her father could buy kerosene for their lamps or clothes for himself. Unlike so many men, he had stuck with his wife for more than forty years, and now that he was rheumatic and deaf Josephine wanted to be as loyal to him. Ever since she, at seven, had walked two hours every weekday to St. Theresa's Primary School, on the opposite ridge, she could remember him biking the eight miles to his job planing boards at a sawmill in Kawuku Town. He ached from it now, and the trip was too dangerous, with the cars tearing up behind him at warp speed. She had eight brothers, but none of them had managed to obtain more education than she had. With her two dollars a day from the hotel, she couldn't pay for them to go to

school. So they were each earning maybe a dollar a day as pickup laborers or by collecting firewood to process into charcoal and sell in bags to passersby along the Entebbe Road and weren't good prospects for marriage — leaving Donald as the only grandchild. She herself, at twenty-seven, wanted no more, she said, after her disillusionment with the married pharmacist twenty years older than she, with five legitimate children, who had seduced her and fathered Donald. Then he had told her she was on her own because the AIDS epidemic had left him with so many relatives' orphans to feed, clothe, and educate. She kept her hair cropped short, like a country girl's, partly to show in the environs of the hotel as she served drinks that she was not for sale, and partly to save the four dollars a week that her longhaired friends spent on hairdressing.

We were in green, moist, spacious, rolling country, well cultivated yet not congested or lacking in handsome trees. And everywhere banana groves lent cover to the fields and the scattered houses built of cement, plaster, and iron sheets for roofing. Kato (the name is given to the second of male twins; he was of the Buffalo clan of the Baganda) and Nakawesa had begun their home in 1959, with bricks they'd baked, overlaid with mud and then cement when they could afford it, and an uncommon high, timbered ceiling and a proudly wooden-peaked, ceramic-tiled roof. The kitchen was a separate, open-faced structure of mud adhering to wooden poles, with mats on the earthen floor in front of the fireplace, and a pestle and mortar and a collection of cooking pots. A stack of clean banana leaves served as plates, and there were basins for washing your hands before and after eating. Josephine had quickly changed into the matronly dignity of a *gomesi* dress that made me think the pharmacist had missed the boat.

Her family was never going to starve. They had ten acres, wonderfully cared for and intricately planted with papayas, melons, and sweet potatoes, red peppers, peas, beans, pumpkins, avocados, tomatoes, eggplants, and yams, and mango, orange, lemon, large jackfruit, and little white-flowered coffee trees. The problem was that they had no vehicle to bring even their one cash crop — the banana liquor called *tonto* — to market. Cooked down, fermented, and distilled, twenty liters of tonto in a jerry can would sell for forty thousand shillings: nearly twenty-five dollars, if the trucker

didn't cheat them. (Distilled again to 80 proof and bottled at a factory, it becomes *waragi,* and three fourths of a liter sells for five dollars.) They had also had two cows, but rustlers had recently stolen these — probably transporting them straightaway to a slaughterhouse in Kampala. You couldn't get the police to come, even if you could afford a cell phone, because the police had no cars. And anyway, the rustlers had guns. If they came into your house, you lay face down on the floor without stirring except to give them whatever they wished (as Nsubuga, who had been through this, confirmed).

Josephine, when trying to arouse my sympathy for her father's plight, had told me that lions sometimes confronted him on his land and that he was too old for that. (Nsubuga similarly exaggerated his family's difficulties when he was asking for money, as if it were necessary.) But Kato said no, not for twenty years, and no leopards for ten, except that once a panicky cheetah displaced from a game reserve had dashed through. The wild pigs too were nearly gone; he had put his spear away. Only a few colobus monkeys, in a troop, might raid his fruit trees. Such a labor of love the place was: such variety he and Nakawesa had created in his spare time from the sawmill job.

They hugged Donald and Josephine good-bye and loaded our car with jackfruit, *bagoya* bananas, cabbages, eggs, eggplants and sweet potatoes, mangos, lemons, passion fruit, and coffee beans for our journey back to the city. It was touching how Josephine, too, given half a chance, had that ability to create a home, yet, always desperately behind on her rent, was not able to. At night, as she carried drinks to customers on the patio of the hotel, her mind was on Donald, who would have kicked off his blanket soon after young Rosemary fell deeply asleep, and might be crying unheard and coughing from the chill of having wet himself. She couldn't afford to hire a grown-up baby-sitter, and Rosemary stubbornly refused to take the baby into bed with her because then she would be wet and chilly too. Josephine, who was not allowed to sit down during her eight hours on duty, observed with chagrin the prostitutes who occasionally circulated and sat and drank at the tables with the *wazungu* (whites), speaking English or French or German so trippingly from long fluency at pillow talk, as well as of course Swahili and Kampala's own language, Lugandan, and perhaps their origi-

nal childhood tribal lingo. They earned in a lucky night what could be a whole month's wages for Josephine.

On the other hand, a cashier at the hotel, who was also named Josephine and earned barely enough to live on, and who was required to sit at a tiny desk for eight hours, counting change for beers and barbecue, had also had a child by a married man — a businessman who was now in Tanzania. This Josephine, however, had chosen to leave her four-year-old son, Ivor, with her mother on a three-cow farm in a far western village near the Congo border, an eight-hour bus ride away. Although he was safe, loved, and healthy, she saw him only once or twice a year. Josephine Mubera (Josephine II, as I called her) was a year older than Donald's mother and had been stuck at this hotel job for ten years instead of five. She was not Bagandan but from the more foothill-and-forest Banyankoro tribe. Her own father had deserted her family early on, so that Josephine II's heartstrings were tied instead to her mother — in the country with Ivor, an auntie's and a sister's orphans, and her three unmarried sisters — but also and particularly to her three brothers, who had followed her here to the city but, like her, had been unable to pay for more education. Thus, they seemed stranded, doomed to temporary laboring jobs or pickup hustles and tempted to fall in with one of the street gangs. She was bitter about it, as well as about her own thwarted state. Four nights a week she had to sleep on a mattress behind the bar to respond to room-service calls. Even so, with her mite of a savings account, she had just opened a beauty salon and was now dreaming of a way to go to the two-year program at the best beauty school in Africa, in Johannesburg (as it was, her assistant at the shop was teaching Josephine II whatever she knew). Or alternatively, if she could find someone like me to sponsor her visa and airplane fare to America, she might persuade her relatives there to loan her enough to get the business going properly (they weren't responding by mail) or else help the smartest of her brothers with the tuition to Makerere University, about $4,000 per semester.

Instead of the hotel uniform, Josephine II wore seductive Indian shawls over her Bombay blouse, a svelte skirt, and bracelets, and scented her hair. When she first met me, she squeezed my hand and asked if I wanted her to take me home. I didn't go the sugar daddy route — in such situations I always said that I was sixty-eight

and decrepit — but did gradually become her friend. I gave her money to ease her migraines and her ulcer pains, although she wasn't really seeking money for herself, and I hired Nsubuga to drive me out with Samuel to look at her salon, the Majo Unisex, in Nakawa, on the Jinja and Mombasa road, not too far from where Nsubuga himself lived.

With the garbage piled about the shopping area, kites and vultures wheeled overhead, but people walked from all directions in modest, constant numbers to buy necessities, more comfortable than in the jumbo markets downtown, where muggers sometimes stalked. Josephine's place of business was an open-fronted concrete cubicle ten feet square, with a tile-patterned linoleum floor and yellow plaster walls decorated with Dark & Lovely product posters (although the models were light-skinned). It was on the second floor of a two-story rectangle set on the hardpan and facing a wholesale maize-and-sugarcane depot, a groundnut warehouse, and a dressmaking school across the dirt alley. The cubicles near hers included a photocopy shop, a bicycle parts store, a bus ticket office, a pay-for-the-telephone stall, a dressmaker, a food takeaway, a Domestic Needs Market with china and cookware, and a Quez Boutique, which was her immediate competition. The roof was rusted corrugated iron, and there were other sheets of this, as well as bagged cement, for sale.

She had no hair dryers or other appliances that I could see, except two stools and plastic basins and a bucket for water, and shelving where the shampoo and oils and unguents were. The one customer during my visit, a zaftig, bored woman with a wealth of black, untidy hair, was sitting cross-legged on the floor while Josephine's assistant laboriously braided it — an eight-hour job that would last at least a couple of months and for which the charge would be ten or fifteen dollars, "or whatever she can pay," as Josephine later told me, having missed our appointment due to ongoing domestic melodramas. She was involved with an older man, a lawyer for the electricity board, who had succeeded in keeping his marriage secret from her for nine whole months and, now that she'd found out, seemed to be neglecting her. She was hurt and mad — she had only learned of his marriage because his oldest son had gotten gravely ill and, when they visited him in the hospital, had cried out "Daddy!" in his fever instead of "Uncle," as he was supposed to do.

Men lied everywhere, no doubt, she said, but in Uganda it was worse, because with AIDS, the truth or lie was life or death. Her lawyer hadn't done *that,* but AIDS meant he couldn't contribute to her family's needs because he too had a clutch of half a dozen or-phaned relatives to support. She'd finally met his wife — as would have been natural in the old, informally polygamous days — with-out much recrimination. But the tensions of survival in the saw-toothed complexity of this money economy, with so many prime-of-life deaths, had collapsed long-standing customs by which a pros-perous patriarch's progeny could live on millet, cassava, jackfruit, and bananas, on separate little plots of land, and run back and forth, welcomed in each household. I asked whether having been stung once, by the businessman who had fathered Ivor and then vanished to Tanzania, and now lied to by the lawyer, she was plan-ning — like the other Josephine, with her faithless pharmacist who was ignoring Donald — not to have another child. But she was bolder. Certainly she would, if she found a man who loved her. Children died in Africa — didn't they in the United States? — so you couldn't take the chance of bearing only one.

Rising from the Elephant Grass

I hired Nsubuga to drive me the ten or a dozen miles out of Kam-pala to visit Samuel's secondary school, on a hill near Kyengera Town that was half an hour's walk from Norah's house. It was raw and new, nine years old, although a sign on the gate doughtily pro-claimed THE STRUGGLE CONTINUES, and it had been started by the headmaster, Lawrence Muzoonga, and three partners (one al-ready dead of AIDS) as soon as he had obtained his master's de-gree from Makerere University. The few yellow stucco buildings, with blue metal roofs and a scattering of trees left about the stripped hillside, handled 42 staffers and 850 students, more than half of them girls, in the four O-level (for ordinary) and two A-level (advanced) grades that follow the seven primary-school years. Law-rence, an intense, emphatic, confident young man (though dis-armingly round-faced, as many Bagandans are), said that he takes about 75 percent of his applicants for an entering class of 160 and kicks out 10 percent a year for academic or disciplinary difficulties. If a student couldn't pay the $110 fee per three-month term, the

school truck was available to go to the parents' *shamba* and pick up the equivalent in bricks, firewood, yams, maize, or whatever. A student could also work off the tuition by helping to clear the swamp that Lawrence pointed at downhill, where he hoped eventually to get their drinking water. Most were boarders, and classes ran from 8:00 to 5:30, then an hour of sports, then supper and two hours of homework, and up again at 5:30 for early prep.

Samuel's favorite subjects were art, commerce, and biology. He liked history and English less, he said, though eventually he did better in history, English, and geography on the national examinations than in the others, and graduated at nineteen from the O-levels, twenty-seventh in his class of 108. There was nothing "slow" about Samuel — just the normal impoverishing disruption of a Ugandan orphan's life. Nsubuga's wife told me that she was the one who had found each of his parents dead in their beds of slim, four years apart.

Lawrence's manner was peremptory and somewhat off-putting as we talked in his small office, the way intellectuals in fragile, destitute Third World countries often act when talking to a rich visitor dropping in from the West, with a money belt on and a return ticket to London and New York City in the hotel safe. At thirty-three, with mostly orphans as students, he had wrung this institution out of the elephant grass, through the recent years of slim and Ebola and Congo wars and bomb blasts — fifty-six killed and two hundred injured in downtown Kampala alone in the four years preceding my visit — plus the cult immolation fires of a church or two, as the gloss went off the peace that President Museveni had finally brought after the holocaust of the Amin and Obote years, in which perhaps half a million Ugandans had died.

In my neophyte role, I asked him whether teachers and intellectuals like him were supporting Museveni's campaign for reelection, but he impatiently said no. They were grateful that the president had introduced the possibility of free discourse to the country and sent the army either back to its barracks or into the Congo instead of brutalizing the citizenry in arbitrary street sweeps and at roadblocks. But to pander to the Western "donor nations," he had also unlocked a rampant capitalism, permitted a drastic drain of the country's capital, and fostered a climate of greed and financial corruption that was destroying the traditional community spirit, of

village origin, that was Africa's virtue. So Lawrence, like many younger people I met whose idealism had not been as scalded by the violent years as that of older folks, was eager for the reforms promised by Museveni's former physician, Dr. Kizza Besigye, who was running against him and was said to be married to his opponent's former mistress. Besigye was also rumored to be suffering from AIDS, but the whispers didn't seem to hurt him in a country where that was commonplace.

The Kindness of Strangers

The Speke Hotel downtown is an old colonial building that originally served as office space for the British authorities. The lobby mural shows its namesake explorer, John Hanning Speke, rifle in hand, discovering the source of the Nile at Ripon Falls at the outlet of Lake Victoria, with his train of native bearers behind him, half naked, with boxes on their heads. Outside the hotel, vans parked at the curb were logoed OXFAM, DOCTORS WITHOUT BORDERS, SAVE THE CHILDREN, EUROPEAN UNION, UNICEF, BUDONGO INTEGRATED CONSERVATION AND REPRODUCTIVE HEALTH PROJECT, PAN-AFRICAN BEAN RESEARCH ALLIANCE, TOTAL QUALITY MANAGEMENT, LIVING EARTH, FAMILY PLANNING. Plus, there were so-called "briefcase NGOs" at its sidewalk café. These were the rumpled guys who flew in with a dozen gross of hearing aids or to operate on cataracts in Mbale, Mpigi, or Mbarara for twenty days, or to build a church or rent a storefront that oyster-eyed street children could flock to for a meal, and who benefited from knowing the Lord's ways: namely, that efficiency isn't actually an end in itself.

I spent several evenings at the café, mostly just eavesdropping. One day, in the opalescent dusk, I traded glances with Florence. She stared covertly and then, with a graceful, unsuggestive gesture, invited me to join her, which I did. She was a former model, now "fifty," and how painful it was "to grow old and lose your looks." I agreed, mentioning that I was sixty-eight, my mantra, and thus not in the market for sex, just stories. Of course I realized that stories would cost money too. Florence had been married to a German TV journalist, so she knew about that, she told me, and had two "half-caste" daughters, grown now and both interior decorators, one in Denmark, one in London. Her immediate problem was that al-

though she was living in a cousin's apartment to split the expenses, she didn't have enough money to reconnect her phone so that her daughters could call her, and she needed taxi fare to get home, which I gave her, after buying her a pack of Player's cigarettes and another drink.

Only twenty, and a student with a pittance of cash and a passport, Florence had gotten on a bus one terrifying day during the Amin regime — "Four of my brothers they killed!" she cried, drawing her finger across her throat — and passed safely through the exit controls at the Kenyan border, reaching Nairobi with a friend's address in her purse. Once there, she slept on a couch and ate little, until someone brightly thought to take her to see an American who ran a photo-shoot agency. She was a Batooro, severe in appearance, rather short, and as dark as the Congolese tribes near her hometown of Fort Portal, but with a posture of natural aplomb and straight, striking features. She still had that confident élan of a real beauty who could grab my hand imploringly like a woman who had never in her life known a turn-down and was only vamping.

The American booked her for ads in the East African newspapers and inserted her into Nairobi's nightclub scene, which in the 1970s was swinging without being carnivorous. She met her German TV man just as the fashion magazines in Europe and the States were going in for safari backgrounds or African models for a startling anchor in any setting, blanching the conventional anorexic or leggy supermodels with their ebony, obsidian, or eggplant colors, more primal than Harlem's. There was a boomlet for women like her from the very center of Africa, and her American agent and German husband (she was good with both languages) soon had her posing in Switzerland against the ski slopes, or on runways in Paris, Milan, London, and New York. In New Orleans she heard live Dixieland and liked Kenny Rogers. The dark continent was so à la mode that hotels put her up for free and couturiers paid her to strut their stuff as a clotheshorse in the public rooms. She wanted to show me her scrapbooks and clippings, but I believed her. The way she confided in me, listened to me, asked for favors in that great-beauty manner that brooks no opposition was sui generis. The German eventually left her, inevitably; went to West Africa and a younger woman. But her daughters were safe, with European passports.

I asked Florence why, with her savvy, she hadn't landed another

secure berth in a better time, while she was still lithe and mag-
netic. She liked white men and was still grateful to that American in
Nairobi.

"Oh, yes, yes — you see, but that was my mistake," she said, smil-
ing sadly. "I loved him. We would go to and fro, and I kept thinking
he was going to come back to me." Now, like a Tennessee Williams
character, peremptory but shipwrecked, she was mildly drunk and
extravagant in gesture but dependent upon the kindness of strang-
ers.

I wanted to move to another table, where a pair of Rwandan refu-
gees were sitting, also reluctant prostitutes, who had survived the
genocide and wanted only to get somehow to the peace and oppor-
tunity of London or New York and become dress designers. Flor-
ence latched on to my hand, however, imploring, in that great-
beauty manner again, and I whispered a promise to her that I
wasn't "going to go home with them either."

The Rwandans, Serena and her cousin Aisheba, both in their
middle twenties, had scalding memories, having lived through the
sneak 1994 genocide in which well over half a million people in
their tiny country had been hacked to death with machetes in
about three months. They had seen so much gore and dismember-
ment, scenes of begging and murder, impromptu amputations and
castrations, bleeding and horror, that Aisheba — who was the
tough one and a sort of Mother Courage, if you talked to her long
— confessed that she couldn't sleep with any Africans now. The
black skin produced hallucinations of wounds and stumps and
bodies in piteously severed piles that swamped her. Yet selling
themselves was the only livelihood Serena and Aisheba had as
marginals and foreigners — beginning in the refugee camps in Bu-
rundi (which had its own Hutu-Tutsi conflict), where, being from
different villages, they had fled the massacres separately, and where
food was at a premium. Then, as evacuees ferried to the sprawl-
ing, improvised, emergency tent cities at Goma, in the Congo,
their families virtually wiped out and both of them pregnant, they
had found each other. What a joy and relief! They'd leapt into each
other's arms and been inseparable ever since.

They were Hutus but had steered clear of the Hutu militias, the
Interahamwe, that were reorganizing in the Goma camps for retalia-
tory raids back into Rwanda against the Tutsis to continue the

civil war. The cousins had volunteered for repatriation by truck once the border was reopened and the opportunity occurred. And they insisted now on the patriotic, nontribal nomenclature of "Rwandans" for themselves as the only way to nullify the acid bath of hatred that had destroyed their country. After being resettled at home, living off bananas and cassava and keeping their heads down while the poisonous, vengeful intrigues of the aftermath bubbled around them, what they did, though, was hope for more. Leaving their children with Serena's mother and Aisheba's grandmother — the skeleton crew of survivors — they had set off as if they were sisters to try their luck in Kigali, Rwanda's capital, and make their way in the wider world. In the Goma camps they had received some medical care and basic language instruction from European aid workers, as well as regular food handouts, unless rain washed out the road. And this was when they seemed to have acquired the idea that white people were less berserk, sadistic, and treacherous (the Tutsis had previously brutalized the Hutus for years, though not on the same scale), and less inclined to turn all churches, schools, and villages into abattoirs.

Kigali didn't work out. It was still Victory City for the Tutsis (who had sheltered in Uganda too during their hard times), so Serena and Aisheba headed for Dar es Salaam, next door to the east on the Indian Ocean in Tanzania. But Tanzania at the time harbored half a million refugees in semipermanent encampments along its border with Rwanda and Burundi. So these two were threatened and robbed, got no foothold and few customers, couldn't afford a room for long, found no friends, and returned to Rwanda after a month or so. Dar wasn't a furnace like what they'd been through, but it was dangerously swarming with penniless young men and very disheartening.

Serena, softer, prettier, more vulnerably a worrier (and pouring Coca-Cola into her glass of beer to sweeten the taste), loved to chat with her friend in Rwandan in happy fashion while sharing a pizza, oblivious of me until they would "remember our manners." Now in Kampala they were finding business slow. The Ebola epidemic had chased most of the white men away, and AIDS was scaring off in particular the civilized, companionable, generous sort of person who was not bad to spend four or five hours with. By two or three in the morning they might be released to go home with maybe a hun-

dred-dollar bill if it had been two kindly friends employing them — expatriate construction supervisors or bush pilots or Red Cross staffers — sufficient to eke out a quiet recuperative week in their single room, cooking for themselves and swimming in a pool at a better hotel that was walking distance from their cinder-block place on a back street. When they could, they'd pay for three hours of daily group English lessons with other Rwandan and Congolese refugees. Their teacher, Aisheba said, an old Ugandan man, was becoming "like a father" to them when they talked to him after class. With no man left alive in their own families, she was frank to say they needed that. The one strong older woman was their staunch aunt, the intrepid pillar who had brought them to Kampala after the fiasco in Dar es Salaam and taught them how to appraise white men of all kinds.

This fortyish aunt, whom I never met, had just hit the jackpot. She had persuaded a Belgian not only to buy her new clothes and pay the rent but to take her to Europe. Maybe he'd marry her when her visa expired! She had given the girls her cell phone when she left and happened to call while they were sitting with me, to check how they were doing. They were about to leave for the more expensive Sheraton, where a band that might draw a crowd was going to play. They were apprehensive, delighted, but came up dry, as they told me later.

Florence introduced herself while we were still talking — she was leaving for home already — with a face that was so haunted by all she knew that Aisheba and Serena suddenly took pause. She simply asked them their names and looked at them — into them — and they shuddered a bit afterward as if envisioning the future, yet wishing too that they could know her from now on as a mentor, like the old Ugandan man, now that their auntie had flown away to Brussels. And sad because they were separated from their own children. When I mentioned that I had just become a grandfather, Aisheba told me she didn't expect to live to see her grandchildren, if she ever had any. Serena agreed. She had an unsettling habit of rolling her tongue in the front of her mouth when she didn't know what to say to me, as if she thought that fellatio was the only currency for barter she had left, after the decapitations that she had witnessed in Rwanda, the faces bashed in with a shovel, throats slit, ghastly mutilations, bound people begging for another hour of life or to be spared their eyesight or, in the agony of torture, sim-

ply for death — and then the bedlam of Goma and the brutality of Dar.

President Museveni had kept Uganda passably hospitable to Rwandans, they said, because he was from the border region himself, but if he lost this election, the lid would be off and persecution of foreigners like them would start. Although Rwanda and Uganda had been allies in the Congo war that had overthrown Sese Seko Mobutu, the two countries had lately been verging on battling each other over the diamond- and gold-mining areas they had captured. One such fight had leveled parts of Kisangani, and just now, on one of the days that we talked, Laurent Kabila — installed as ruler of the Congo after Mobutu's defeat — was assassinated in Kinshasa, the capital. Because he had turned against his former patrons in Kampala and Kigali and was fighting them both, if the Congo had had an air force, it would probably have bombed us on Nakasero Hill then and there. And like lava bubbling up, the Angolan civil war was reigniting; the suburbs of Bujumbura, the capital of Burundi, were being shelled by Hutu rebels; Sierra Leone, Liberia, Senegal, and Zimbabwe were in turmoil; and the leaders of Ethiopia and Eritrea — allies not long ago against the Mengistu dictatorship in Addis Ababa — had recently been locked in a war with each other. So when Aisheba and Serena looked to me to confirm that they should go to London or New York, I said sure, wishing I could wave a wand and whisk them off to fashion school.

A Ticket Out

Men fell into conversation with me too, with stories to tell — like the taxi driver Alphonse, who used to give me rides, and whose windshield was smashed right in front of the passenger seat, where one of my predecessors had nearly gone through. He wanted to be my chauffeur. The owner of my hotel, who was a leader in the Ismaili community, had escaped being killed by Idi Amin by a couple of hours in 1972, when all the Asians were expelled. Tipped off that agents of the "State Research Bureau" were coming for him, no doubt to torture him and then slowly pound a nail through his head — which was their preferred method of execution — he told everybody that he was going to a party, but drove instead to an outdoor movie theater and thence by byways to the airport. Like Hastings Banda of Malawi, who kept a crocodile pool, reputedly to

punish dissent, Amin liked to play mind games with dissidents. Another publicized method he used was to line up the prisoners and pass a sledgehammer down the file, each man killing the person immediately in front of him, on pain of a much worse death.

But I tended to pay closer attention to the women, as is natural when a man is traveling alone. I went to visit Norah again with Nsubuga and relaxed among her banana trees, with a fat pet goat nibbling a peel and Samuel cleaning the chicken coop before his hundred chicks arrived. The neighbors kept chickens too, and four or five cows, and had a black, gaunt saluki for a watchdog, like an ancient remnant from the British empire. Norah watched hospitably to see that I was comfortable, with two orphans around her skirts.

I was crestfallen several months later to hear by mail from Nsubuga that Norah had died of another stroke. And I was aghast to learn that Samuel, although he won entry into an advanced-placement boarding school, had caught typhoid and almost died. With these new friends, there always remained the tacit barrier that they were nearly destitute and I was not. So when I wanted a bit of conversational comradeship from Nsubuga or one of the Josephines, an urgent subtext of "money, money" intruded. How much would I leave behind with them when I left? Even my favorite person, the Josephine whose parents' house I'd gone to — and whose infant son, Donald, I had met — remarked, when I asked her whether she in turn might help a traveling American hippie if she saw one in trouble on her road, that she helped only white people who helped her. Otherwise, no, because she knew that they had a ticket for the airplane out or they couldn't have gotten a visa in the first place.

"We see two kinds of people here," she explained. "People who have an airplane ticket and people who don't."

I was reminded of this and other conversations I've had on trips to the Third World — to Yemen, India, Sudan — on September 11, when the World Trade Center towers in Manhattan were hit by two hijacked airplanes. Apart from the dismay and grief I felt, one of my reactions (like many travelers, I suspect) was that we as a nation should have foreseen it. Our amazing ignorance and monumental indifference about the developing world and its travails have corresponded, at least in my mind, to the callous and selfish

attitude so many white Americans displayed toward people of color in their own country until the 1960s — which provoked race riots and civil destruction. After the catharsis of military revenge, there will need to be a kind of earthquake in the seabed of our foreign relations. Our solipsism and narcissism must undergo a sea change, toward accepting other races and religions into what has been called "the family of man."

KATHLEEN LEE

The Scent of Two Cities

FROM *Condé Nast Traveler*

THE REUNIFICATION EXPRESS lurches through a Vietnamese landscape flat as a carpenter's level, in which solitary figures with baskets irrigate rice fields. Beneath a vast sky pale as a shroud, the cool, green land and the distant workers appear shrunken and serene. I think of a passage from Graham Greene's *The Quiet American,* which has just finished filming here, in which the narrator, the British journalist Thomas Fowler, details his love for Vietnam: "the gold of the rice fields under a flat late sun: the fishers' fragile cranes hovering over the fields like mosquitoes . . . the mollusc hats of the girls repairing the road where a mine had burst: the gold and the young green and the bright dresses of the south, and in the north the deep browns and the black clothes and the circle of enemy mountains and the drone of the planes." Although I'm traveling here some fifty years later — no droning planes, no roads recently blown apart by land mines — the quality of the country is unchanged: the north's somber grace, the south's wild energy, and the pastoral elegance of the countryside.

The Express, a shabby remnant of an earlier era, connects Hanoi in the north and Saigon in the south, eleven hundred miles and several decades apart. The two cities are in different stages of evolution. Hanoi, slowed earlier by the cautiousness of communism, grips the past tightly under its arm. Saigon, like a man with a get-rich-quick scheme, has vaulted into the twenty-first century without hesitation or nostalgia. In one city you see Vietnam's past, in the other its future.

*

The day's heat is an embrace — as sweet and damp, as reluctant to let go, as a child. A froth of pink clouds gleams in a corner of Hanoi's sky as I weave through the packed streets of the Old Quarter in search of a vendor who will allow me to hoist her shoulder pole. It's my second day here, and the women who carry baskets of fresh vegetables and fruit, plastic goods, or entire cafés from either end of a split bamboo pole are my heroes. At last I find a young peddler squatting beside her pyramids of produce. Reluctantly, she agrees to my gestured request. I bend to put my shoulder under the pole yoked with two baskets of enormous avocados and try to rise. She watches suspiciously, as if I might run off with her merchandise — which, since I can barely lift it, is unlikely. The baskets tilt awkwardly, my back hurts, the pole digs into my shoulder, and my incompetence makes her smile. Across Hanoi, these small women effortlessly carry loads that would flatten most people. This, I think, is the quality that enabled the Vietnamese to defeat both France and the United States, and to endure decades of difficulties.

The Old Quarter, called Thirty-six Pho Phuong ("Thirty-six Guild Streets") in Vietnamese, feels like an overstuffed suitcase. In it is packed what has been the soul of Hanoi's commercial life since the fifteenth century. Today, it is Vietnam's only remaining ancient merchant area. Old Quarter streets were originally organized around guilds: Hang Gai is Silk Street; Hang Tre, Bamboo Street; Hang Bac, Silversmith Street. Specialties still exist, but they don't always correlate with the original guilds. Now there are streets of shoes, towels, toys, and video game parlors, Internet depots, restaurants; nearly every inch of space calibrated to some financial purpose. In one block of Hang Bo, the sidewalk contains a man planing boards, boys peddling postcards, a woman yawning over her basket of baguettes; on one side someone repairs a bicycle tire, on another a woman chops meat. A rooster crows behind a confusion of conversation in algebraic Vietnamese, the ubiquitous motorbikes rev and honk, and Billie Holiday sings "God Bless the Child" from the doorway of a knockoff CD shop. Hanoi, resurrecting itself from the rubble of its recent history, is lighting the fires of its charm.

Vietnam's capital city is a delta town, wrung from the marshes and lagoons of the Red River: *ha noi*, "city within the river's bend."

Canals and sophisticated irrigation systems control the water-logged land and the exuberant rainy seasons, but the skies are soft and limpid with humidity, and lakes dot the city like well-placed beauty marks. The atmosphere has a languid, savory melancholy and a slight reserve and intellectual astuteness. Hanoians aren't rushed and scrambling; they stroll and linger, converse and reflect.

Hanoi's history matches its meteorology — wars like floods and trouble as regular as rainy seasons. The first capital on the city's site was established by invading Chinese in the seventh century; they called it Annam, "the pacified south." But nothing was pacified about the local population, who rebelled and ousted the Chinese. The city was neglected until 1010, when King Ly Thai To, imagining a great commercial center on the site, established his court beside the Red River. Over the next eight hundred years, dikes were built, marshes drained, artisans and merchants set up shop, and the first university was established. And the Vietnamese repeatedly lost and regained their independence, fighting the Chinese, fending off invasions from the Mongols, and weathering internal struggles for power.

In 1882, Hanoi became the capital of French Tonkin (from the Vietnamese *dong kinh,* or "eastern capital"), and in 1902, the capital of all French Indochina. The French constructed a lovely city with a sturdy infrastructure and fine buildings. This loveliness was clearly not meant for the Vietnamese, and the revolution blossomed. In August 1945, Ho Chi Minh called for an uprising, and Hanoians responded enthusiastically.

The Vietnamese fought the French for nine years before Hanoi finally became the capital of an independent Vietnam in 1954. Independent, but not peaceful. The American War followed (Americans call it the Vietnam War, Vietnamese call it the American War), and Hanoi sustained serious damage from air raids, particularly during the 1972 Christmas bombing campaign. Although the country was finally both independent and unified in 1975, life didn't become easier for Hanoians, since a decade of political isolation and economic deprivation ensued. It wasn't until 1986, when the government instigated *doi moi* — the open-door economic policy — that independence, reunification, and peace were matched with hope for prosperity.

*

I'm with my translator, Dao.

"Hanoi people eat breakfast outside," she says as we settle at one of the thousands of sidewalk cafés for a bowl of *pho* (pronounced something like *fur*), the national dish and a specialty. It's beef or chicken soup with rice vermicelli, cilantro, lime, and chili sauce. Dao is thirty years old, wearing clinging bell-bottom pants and a camouflage cap with the CIA logo on it. She looks embarrassed and says that the cap holds her hair in place when she drives her motorbike. As we slurp and chew, Dao says, "The government made a mistake by following the Russian-style economy. But they changed, and now people are happy because they can get rich." This is what people really desire — the freedom to get rich — never mind the freedom to choose their leaders. "The government is stable. Not every leader can be like Ho Chi Minh," she says philosophically.

Dao's memories of the postwar decade of deprivation are romantic, the way bad times can seem noble in retrospect. To save energy, there was no electricity in the evenings, and her mother would fan her in the dark, stroking her forehead with a cool cloth, telling stories. She is nostalgic for a time when everyone's purpose was clear and nearly identical, but she doesn't want that life back.

I look up where the cobbled history of the Old Quarter is visible: ancient Chinese doors and carved screens, sagging colonial shutters, chipped ocher walls, Art Deco styling. The Old Quarter is an architectural flea market.

On Hang Buom, Dao takes me into a tube house. Hanoi is one of only two cities in Vietnam where these still exist. Originally, taxes were levied on the basis of street frontage, so the houses were built narrow and long. I feel as if we're entering a dungeon; fifteen families — most occupying a single room — inhabit the rooms off this dark corridor. A communal kitchen and bathrooms are at the rear. Some families have a small courtyard with access to light and fresh air, but most breathe whatever secondhand air enters via the hallway.

Mr. Than wears a crushed felt fedora as he bounces up and down from a chair in the room he's shared with his family for forty-six years; there isn't enough space for him to pace. Decades of domesticity are piled together: A coffee table supports a bureau on which sits a vase of plastic birds of paradise, above which hangs a picture

of Ho Chi Minh. I understand why so much of life takes place on the streets of the Old Quarter: Inside is too cramped. Mr. Than frets about the size of his pension. He would like to move, but the rent is three dollars a month, one tenth of their income.

He ticks off the three best years of his life — 1945 (declaration of independence), 1975 (reunification), and 1986 (open-door economic policy). "If we are independent, we can be happy," Mr. Than says, echoing an oft-repeated quote of Ho Chi Minh ("Nothing is more precious than independence and freedom"). His sense of his own history is so entwined with that of his country that his best years aren't about personal successes and happiness. "The worst years were 1946 to 1975," Mr. Than says, referring to the decades of war with the French and the Americans. Still, he holds no grudge toward either. "We want to be friends with all countries," he says. "I worry sometimes that bad things will happen again." He looks anxiously at the picture of Ho, as if he could prevent future disasters.

At five-fifteen the next morning, the hour before purpose and longing take hold, Hoan Kiem Lake (Lake of the Restored Sword) is a still, delicate gray. It is not the largest of Hanoi's numerous lakes, but it is the heart of the city, an oasis between the packed frenzy of the Old Quarter and the sophistication of the French Quarter. I've risen in the dark to join hundreds of Hanoi residents in their daily activity, transforming the outdoors into a giant gymnasium. Here is the city in pajamas, shorts, and T-shirts. All around the lake's perimeter, ringed with tall, leafy trees, walkers and joggers bob; people do aerobics, practice tai chi, or play badminton.

Dao and I rendezvous beneath the looming trees as the sun flickers gold across the steely water. We meet a pair of women in their seventies on a bench with their pitcher of tea, traditional Vietnamese conical hats, and fans. Their hands are delicate, with mauve lacquered nails. They wear flowing black silk pants, pale blouses, and jade rings. I search for evidence of suffering, but their hair, pulled into buns, reveals serene, unlined faces.

They boast about their offspring, scattered around the world, until the war years are mentioned. "We lacked everything," they say, and smile at each other, as comrades who have survived to-

gether. "Close the past, go forward," one says. But the Americans, they add without rancor, should compensate people suffering from the effects of Agent Orange. This is the single critical comment I hear about America and its role in Vietnamese history.

Then they describe the decade after reunification: a harsh life, working in cooperatives, standing in line with coupons. Finally, they critique modern Hanoi, which they find noisy and crowded. Dao says that Hanoians regard themselves as elite: Their accent is the accent spoken on television, they are the intellectuals. "Hanoi is also known for its beautiful women," she says. Indeed, these women are beautiful; two who survived with jewelry intact and smooth hair.

Hanoians who were born post-independence have no interest in reviewing a past they didn't experience. One of the young people surfing the Internet in a tiny, stark room tells me, "There's a saying in Hanoi, 'No motorbike, no girlfriend.'" They care about romance and money; they negotiate the complicated terrain between Vietnamese traditions and a modern culture of materialism. Dao says, "As society develops, it must bend, but the family is still central and the ties between parents and children are strong." So far, she adds.

If the Old Quarter is Hanoi's heady *bia hoi* (the pungent, cheap local brew), then the French Quarter is the pure black coffee you drink to sober up. From the topiary to the croissants, what has felt like an Asian city — with low stools, chopsticks, and handleless teacups — now feels faintly French. Cramped streets open onto tree-lined boulevards and avenues. The atmosphere is suddenly serious and serene. Even the unrestored villas seem conscious of their decrepit, aging beauty. Joleaud-Barral, a French geographer who visited Hanoi in the 1890s, said, "In Singapore, at Saigon, one exists; at Hanoi, one lives." With its restaurants, cafés, and galleries, the French Quarter is a colonial set piece, its buildings redolent of the aura of another era.

We walk past the neoclassical Metropole, one of Asia's stately hotels, where Graham Greene wrote part of *The Quiet American* in a lovely, dark-floored, rattan-walled room. During the French war, the journalist Bernard Fall described the hotel as "the last really fashionable place in Hanoi to chat . . . the barman could produce a

reasonable facsimile of almost any civilized drink except water." We turn onto Trang Tien, to see the wedding cake on the French Quarter's architectural dessert platter: the Opera House. Slim Ionic columns match soaring palms in the gardens. Modeled after the Paris Opéra, this petite, magnificent building was completed in 1911 and has since been carefully restored.

"You aren't afraid to ride on the back of a motorbike?" Dao asks me early the following morning.

"No," I say.

"Most foreigners are," she says. Undoubtedly they have more sense than I.

With me perched behind Dao, we set out for the Ho Chi Minh Mausoleum on her Honda Dream.

From atop a motorbike, Hanoi traffic is a Nintendo game, less about getting where you want to go than about not getting wiped out by incoming fire: motorbikes, bicycles, cars, pedestrians. I can't decide which is more nerve-racking: the free-for-all intersections of the Old Quarter, sans traffic signals, or the wide boulevards of the French Quarter, which has lane lines and traffic lights but where you often find someone driving straight at you. Numbers say it all: Hanoi proper has a population of 2.6 million people and approximately 2 million motorbikes.

The man in front of me in line has wispy hair, thick glasses, and cheekbones like billiard balls. He's been to the Ho Chi Minh Mausoleum more than forty times. He used to be a soldier, he says, and "it's like visiting an old friend." This time, he's brought one of his grandsons to see Uncle Ho, the most beloved man in Vietnamese history. What is it about seeing him? I wonder. "It strengthens my belief. He led the Vietnamese people to independence and prosperity," he says.

It's just past 7:30 A.M. and hundreds of people have lined up to view the embalmed remains of a man who died in 1969. Who from American history would draw such crowds, six days a week? Anyway, democracies don't have the same fondness for embalming former leaders that Communist countries seem to have. Ho's nearly herculean dedication to independence and the Vietnamese people has resulted in a cult of reverence, sustained by the government's decision to ignore his request for cremation.

Mr. Nguyen, behind me in line, with dyed-black hair, joined the Communist party in 1940 because he believed that it was the best way to gain independence. "We, a small nation, have earned the honor of defeating through heroic struggle two big imperialisms — the French and the American," he says and looks at me expectantly. I wonder why. "That's a famous sentence from Ho Chi Minh's will. Have you read it?" he says. I shake my head no. Mr. Nguyen is surprised and clearly somewhat appalled. He ponders the implications of my ignorance. "The American government doesn't allow you to read Ho Chi Minh's will?" he asks. I tell him that I can read anything. I'm thinking of all the things Ho's will competes with in my reading life: Melville, Cather, Harry Potter . . .

The line pauses before the grand proportions of Ba Dinh Square, filled, on this early morning, with soldiers on their knees, weeding the grass that no one is allowed to walk on. It was here, on September 2, 1945, that Ho Chi Minh announced the creation of an independent nation with the sentence, familiar to Americans, "All men are created equal, they are endowed by their creator with certain unalienable rights, among these are life, liberty, and the pursuit of happiness." Ho is a symbol of international communism, and yet he was a fierce nationalist.

By the time we arrive at the rose-colored marble crypt, I, too, feel reverent. The interior is refrigerator cold, romantically lit with recessed lighting. Ho reclines in a glass coffin under red lights, as if he were in a rotisserie. His beard lies like a frayed gray pet on his chest; his hands are folded peacefully across his stomach. The Vietnamese are awed and wide-eyed, but I am dismayed on Ho's behalf. Perhaps, as a born and bred capitalist, I cannot appreciate the impact of Ho Chi Minh's embalmed body.

Soon after, I pass the statue of V. I. Lenin. Could it be? The leader who has been all but erased from even his own country's history? Dao quotes a Vietnamese proverb: "If you shoot a gun at the past, then future generations will shoot at you." And so the statue of Lenin still rises above Dien Bien Phu Street, named after the site where Vietnam decisively defeated the French.

The merging of communism and free-market economics is rich in irony, and perhaps this is best felt at Lenin's oversize feet. There, tourists have their photos taken, workers nap in the shade, and boys skateboard in the plaza. Lenin lives in the heart of the French

Quarter, with its wide sidewalks, straight roads, lush trees, and shops selling Coca-Cola, imitation Rolex watches, and perfume.

On a morning so humid I have an urge to wring the air, I visit the Army Museum, where Vietnam's extensive martial history advances and retreats through drab rooms ruled by wavering ceiling fans. I realize that all the tourists in the museum are from countries that were former enemies: China and Japan, France and America. I slog through the rooms, disheartened at the length and continuity of war in Vietnam. Watching scratchy film footage of bombing at Dien Bien Phu and of one of the battles in the American War, I find myself unable to connect this history to the vibrant life on Hanoi's streets. The present has the capacity, both soothing and disturbing, to obscure the past. The Americans bombed Hanoi so thoroughly that whole areas were destroyed. But even the crumpled remains of a B-52 in the museum's courtyard does not make this violent past more real. I recall Dao saying, "You can't forget the painful memories, but you can live in the present. If you live in peace, you can feel tranquillity."

A silent group of barefoot farmers sit on the floor watching a grainy black-and-white film. Their short, broad feet resemble spades, useful implements made for contact with the earth. Next door there's a glass case filled with captured Americans' boots, large and mysteriously clean, hefty objects made to prevent contact with the earth. For a moment, I understand everything in the context of feet and footwear.

I sit out an afternoon thunderstorm at Chua Quan Su, one of Hanoi's active Buddhist pagodas. The courtyard smells of cinnamon, guava, and frangipani blossoms crushed into the wet stone pavement. Couples flirt furtively beneath the portico. Good Communists are atheists, but since 1986, strictures against religious practice have eased, and many Vietnamese are again worshiping openly. The red-and-gold lacquered Buddhas meditating behind plumes of incense are figures of serenity and profound tolerance; I'm reminded of the kindness and warmth of the Vietnamese, their absence of resentment and anger about the past. The rain falls in straight lines onto leaves, rooftops, stairs; a fierce, steady thrumming.

*

"Hanoi is small. You can hold it in your arms," a waiter in a restaurant in a restored French villa tells me on my last night in the city. "The skies are green, the lakes make you feel fresh, and the people make you feel comfortable." In the Than Market in Saigon (a.k.a. Ho Chi Minh City), what you feel is the fury of buying and selling: Stalls crammed together peddle everything from conical hats to hardware, and the entire population seems to be out shopping. The summer heat is impressive, the air warm and moist as a dog's breath, thunderheads a boiling batch of laundry in the sky. I'm reassured to notice that everyone sweats, little beads sprayed like glitter beneath eyes and along upper lips. I duck into a stall for some respite. Mr. Tian, the calm proprietor, introduces himself in crisp English and offers coffee. I sit on a low stool. Heavy raindrops sputter into the alley, thick with shoppers. When Mr. Tian hears that I am from the United States, he becomes animated. During the American War, he worked for the U.S. military in intelligence. Wide smile. "Now I sell rice," he says. And his face folds itself into an expression of tolerant mourning. His mother squats before a kerosene flame, brewing coffee. It is peaceful in this room, dark, with sacks of rice and parked motorcycles. We watch the downpour and the ceaseless human traffic, sipping glasses of strong, fragrant coffee.

It is one of the few quiet moments in Saigon — most locals still use the old name — which is an energetic, clamorous city. If Hanoi is a woman permitting herself to age gracefully, then Saigon has opted for plastic surgery. And while the face seems youthful, scars are visible from certain angles. Colonial buildings crumble without fanfare, and sleek structures rise, leaving behind construction rubble and an air of dislocation. But Saigon is practical, concerned with the material world: beauty, of course; wealth and success above all. It is Vietnam's largest, most prosperous city, sprawling across what was once a mangrove swamp between three rivers and a bay. If you want to make your fortune in Vietnam, you go to Saigon.

I leave Mr. Tian, and two cyclo drivers, their smiles broad and zany, make a pitch for my business. Rickshaws seem so colonial, are such symbols of exploitation — and yet, it's a job and these guys need work. They joke and bounce around me, pull out photos of themselves surrounded by U.S. soldiers. Returning veterans? I can't tell, but it's evident that in the south, in Saigon particularly,

which benefited so materially during the American years, Americans trigger bursts of nostalgic emotion in some. It's not just the familiar "My cousin lives in Minneapolis; do you know her?" It's as if they once worked for my dad, and they possess an embarrassing longing to have their old jobs back. When the government in Hanoi decided to open the economy in 1986, it looked to Saigon, where entrepreneurship, the ability to turn *dong* into more *dong*, had been lying dormant. The bureaucratic capital, with its governmental departments and its cool-headed intellectuals, may be in Hanoi, but Saigon has flash and nerve, cash and passion.

I climb into a cyclo and the driver pedals into traffic. The streets are a whirling, frenzied spectacle, surpassing even the melee in Hanoi. Everyone is on a motorbike: girls in *ao dai,* matrons in black pumps, young toughs driving like Hollywood stuntmen. A monk rides shotgun, saffron robe flapping, shaved head shining with rain, talking on a cell phone. We pass dark, cool gardens, glinting fountains, chic shop windows, stalls selling photocopied books, and men idly squatting in the shade. At intersections, I hover somewhere between acute alertness, as if I might be capable of preventing a collision, and surrender, because the streets are a lesson in accepting one's fate. *The Quiet American,* set in Saigon, is filmed in Hanoi, which is more reminiscent of the Saigon of fifty years ago, because not even Hollywood has the power to cool the fever of these streets.

My hair redolent of exhaust, I'm dropped in Dong Khoi, the upscale downtown shopping area, with its famous hotels. Here is the white neoclassic Continental, where much of *The Quiet American* is set, and nearby the Rex, where, during the American War, journalists languished in the dark-paneled rooms. I eat a lunch of delicate banana-flower salad with grilled chicken, fresh mint, and basil, followed by chocolate crepes, and consider how extremity and contrast fuel Saigon: fresh white tablecloths, an orchid in a vase, and outside, the smell of fermenting fish sauce in narrow streets, mounds of purple and orange rice for sale, discarded syringes in the gutters, old women with betel nut–blackened teeth, and their granddaughters in heels and tight miniskirts.

Walking back to my small, neighborhood hotel, I pause to buy fruit: plump papayas, fuchsia dragonfruit, dusty-green custard apples. Pearl clouds rimmed in gold fill the sky — the kind of lumi-

nous sunset that makes you feel your life should be better. A girl beside me examines the wedding dresses in a shop (this street is devoted to bridal accessories). There are traditional Vietnamese and Western dresses, but she is transfixed by two mannequins, one wearing a brown-satin cowgirl outfit and the other a red lacy affair, the costume of a turn-of-the-century whore. A girl of fourteen, she's straddling her bicycle — traffic blasting behind her, people jostling past — unwavering in her awe, her unrequited longing. Here is the allure of Saigon: the sweetness of desire, the piercing quality of suffering.

LAWRENCE MILLMAN

In the Land of the White Rajahs

FROM *Islands*

ONE MORNING in Sarawak I found myself wandering through the jungly extravagance of Gunung Gading National Park. The heat was formidable, the humidity even more so. Working together, they made me feel like I was at once drying up and drowning.

In my discomfort, I almost wished I was back in Kuching, where I'd spent the past few days. Kuching, Sarawak's capital, is a charming town of wood-slatted Anglo-Malay buildings, ornate Chinese temples, and narrow labyrinthine lanes. It had a museum that housed a world-class exhibit of Iban *palangs* (penis pens) and another museum devoted exclusively to cats. For me, however, the town's main attraction was its McDonald's. There I would take refuge not because I was subject to Big Mac attacks — perish the thought — but because the building had air conditioning.

As the morning progressed, the heat grew steadily worse. I began thinking of it as vengeful; I felt it wanted to teach me, a sometime Arctic hand, an unpleasant lesson in climatology, or perhaps punish me for the expletives I'd been using at its expense. Meanwhile, the humidity had become nearly as thick as béchamel sauce.

At one point I noticed a dazzling indigo-colored bird hopping from tree to tree, but I couldn't identify it because the sweat was pouring off my brow in veritable cascades and blurring my vision. Then I saw something long and thin creeping across the path.

"Giant centipede," announced my Malay guide, Akhri. "One bite from him, and you die. But not right away. Maybe in about five minutes."

A heartening thought: If the sweltering conditions finally proved

too much for me, I could always caress one of these venomous arthropods, and then I'd at least go to my so-called reward quickly rather than in torturous increments.

But the local flora seemed to appreciate the hothouse conditions. Growth was almost visible, and its lushness made the sky almost invisible. From this sky, wherever it was, dangled lianas that a Tarzan would kill for.

Onward we trudged, stepping over masses of exposed roots that were like an ebony giant's fingers. Somewhere in the forest canopy a monkey cackled, presumably at the sight of two fellow hominoids demented enough to wander about in the midday heat. Suddenly I blinked. Blinked again. Wiped the sweat out of my eyes and blinked yet again. Directly in front of us was a vinaceous red flower three feet wide and boasting a deep spike-studded nectarium seemingly inspired by a medieval dungeon.

I tried to place the flower's distinctive odor. Ah, yes: dead caribou.

We'd happened upon a rafflesia, described by one of its discoverers, the nineteenth-century English botanist Joseph Arnold, as "the greatest prodigy of the vegetable world."

He was not mincing words. No flower in the world is bigger or heavier — rafflesias have been known to tip the scales at twenty pounds avoirdupois. Doubtless no flower is more bizarre in its habits or its physiognomy: It feeds only on the roots of the *Tetrastigma* vine, and has neither stalk nor leaves. Certainly, no other flower has such a rank odor.

Something curious happened as I was staring at this prodigy: I forgot all about my discomfort. For I'd been transported to a realm wholly different from the one I'd inhabited just a few minutes earlier, a realm so exotic that even its swelter was exotic. It was as if I'd somehow fallen into the flower's capacious opening and ended up, like Alice after her tumble down the rabbit hole, in Wonderland.

In my childhood imagination the island of Borneo occupied a privileged place. Especially in math and citizenship classes, I would journey to its distant jungles in search of hair-raising, pith-helmeted adventure. I would become chums with impenitent headhunters, idly shoo away poisonous snakes, and cross slippery log bridges with the aplomb of a ballet dancer. Stricken with malaria

and shaking like an aspen leaf, I would compose my face into a stoic smile; after all, malaria came with the territory.

If, in the midst of my daydreaming, I'd been asked to invent a history for Sarawak itself, I doubt that I could have come up with anything quite as romantic or improbable as the saga of the so-called White Rajahs.

James Brooke was an English gentleman-swashbuckler, maybe even a pirate, who arrived in Borneo in 1839 and promptly helped the Sultan of Brunei crush a local rebellion. In return, the grateful sultan gave him the northwest province of Sarawak. Brooke, now Rajah Brooke, proceeded to govern his newly acquired domain with no greater outside force than a shipwrecked Irishman, an English doctor, a translator, and his manservant.

In 1868 the aging rajah bequeathed his kingdom to his eccentric nephew, Charles, who ruled it for nearly fifty years. Charles had a glass eye originally made for a stuffed albatross (or so the rumor went) and, I'd heard, a habit of watering the plants at the Istana, his Kuching residence, by urinating on them. No less eccentric, in an age dedicated to shouldering the white man's burden, were his efforts to protect Sarawak's native people from harmful European influences.

The Brookes realized a colonialist's dream: to be at once potentate and proprietor of a large equatorial kingdom . . . and to have your subjects actually like you. Thus, when Vyner Brooke, the last of the White Rajahs, ceded Sarawak to the British crown in 1946, not a few of those subjects felt as if they'd been flung to the dogs. Even now, with Sarawak a state in eastern Malaysia, you can still find people who would gladly hand it back to a Brooke, whether he wanted it or not.

I can't help thinking that a century of relatively benevolent rule made Sarawak a kinder, gentler place. Its Bornean neighbor, the Indonesian territory of Kalimantan, is a periodic hotbed of religious and ethnic strife. In equally multiethnic (Malay, Chinese, and numerous native tribes) Sarawak, the only strife I encountered came on Bako Island, when a long-tailed macaque rushed me after I refused him a fried-noodle handout.

And in this supposedly dangerous part of the globe, the most dangerous behavior I ever encountered was, well, my own. Toward the beginning of the trip, I was chatting with some Bidayuh men

about the catholicity of their diet (python, various insects, fermented wild boar, and so on) when one of them asked me if I'd like to try some smoked cat. I shook my head vigorously and took an involuntary step backward, whereupon my leg slipped into a crack between the bamboo-slatted floorboards of their longhouse; it took the men several minutes to extricate me.

"This is a remote-control area," one of the Bidayuh men informed me, his slightly uncertain English being a testimony to the presence of television in his longhouse. But it wasn't really that remote; his longhouse, Anna Rais, was about an hour by road from the bustle of Kuching.

I wanted a genuine remote-control area, somewhere that would cater to my childhood jungle fantasies and perhaps even include a few impenitent headhunters. So that's why a day or so later Akhri and I found ourselves in a motorized dugout canoe on the Lemanak River, heading into Iban country.

"You are from the land of our old rajahs?" the boatman, an Iban, asked me, concluding that since I spoke English, I must also, therefore, be English myself.

"No, from America."

He uttered a few words in Malay to Akhri, who turned to me and said, "He's too polite to ask, but he wonders if you could introduce him to Rambo."

I wasn't surprised by this request, for the Iban have a reputation for being somewhat pugnacious themselves. Their most important god, Sengalang Burong, is a god of war, and from him all Iban trace their descent. For such people, Rambo would be a more likely celebrity than, say, Pee Wee Herman.

The river was an incessant series of rapids, snags, and oxbows, with the result that the boatman was constantly opening and closing the throttle of his antiquated, minimally horsepowered motor. But at last we pulled up alongside several other canoes. High above us loomed our destination, Nanga Kesit longhouse.

Now I heard howls of laughter and the stomping of feet. A *gawai* (festival) seemed to be in progress. I figured I might get to see a dusty skull brought out and a cigarette stuck in its mouth, or hear an Iban bard chant *mengap* (sacred poems), or at least observe the ritual sacrifice of a rooster.

No such luck. On the longhouse veranda, a group of lively, bibulous European visitors were performing what looked like an Iban war dance, while their hosts looked on with, I thought, commendable patience. One of the visitors seemed to be making a feature-length video of an Iban woman's bare breasts. Another was trying to show off his prowess with a ten-foot blowpipe, but his aim was so bad that he had everyone scurrying for cover.

The Iban knew a good thing when they saw it. Some of the women had spread out a mat and were doing a brisk trade in handicrafts. Not all the handicrafts were local, however. I picked up an exquisite carving of a rhinoceros hornbill and read "Made in Taiwan" written on the bottom.

As I was debating whether to buy this unusual cross-cultural artifact, an Iban man drunk on *tuak* (rice wine) approached me. Would I like to see his *palang*, he asked. (A *palang* is a traditional Bornean sex device inserted into the penis and designed to stimulate one's female partner.) For twenty Malaysian ringgit he offered to drop his loincloth and show it to me. Then another man offered to show me his *palang* for only ten ringgit, adding that it was made with a shear pin from an outboard motor.

"Evinrude or Mercury?" I asked.

"Yamaha," he said.

"This place seems to be full of exhibitionists," I told Akhri, who was doing the translating for me.

"Tourist longhouse," he observed rather tartly.

Before we left, I noticed a bundle of old skulls hanging in a rattan bag from the longhouse ceiling. The Iban believe that when a skull is displeased or offended, it will grind its teeth together. Was it my imagination, or did I hear the unmistakable sound of grinding teeth from inside the bag?

If at first you don't succeed, try, try again. A few days later Akhri and I were climbing up the notched log ladder to Nanga Ukon longhouse in the Batang Ai area. At the top, we took off our shoes and padded along the roofed veranda. Some Iban men mending a nylon fishing net smiled at us but did not offer to sell the net. I thought this a good sign.

Each of the thirty or so *bilik-bilik* (rooms) in the longhouse had a honeycomb tacked on its door to ward off *hantu-hantu* (evil spirits).

Hantu-hantu are mathematically challenged; they will stand at a door and try repeatedly to count the holes in the honeycomb before giving up in frustration.

"No honeycomb on your door, and you are — how you say it in English? — 'dead meat,'" Akhri told me.

The chief now appeared in front of his *bilik*. He was a lean, sinewy man in his mid-fifties; an extensive circuitry of blue-black tattoos made him look like a giant thumbprint.

"Welcome," he announced. "We were expecting you."

Apparently, someone had seen a magpie robin an hour or two earlier, which meant visitors, probably visitors from a distant place, would be coming.

"Bird omen," said Akhri. "Very important for the Iban. It's good they did not hear the little bird that sings, 'I will scratch your eyes out, I will scratch your eyes out . . .' Then maybe they would not be very nice to us."

Soon we were seated on a woven rattan mat beside the chief drinking tea so laden with sugar that it was almost viscous. Half the longhouse seemed to be gathered around us. There was an old woman with generously distended earlobes, a man with a Royal Malaysian Airlines logo tattooed on his upper chest, some wide-eyed children, the local *manang* (shaman), and girls so eloquently beautiful that any one of them would make a *Vogue* model seem like a toothless hag.

Akhri and the chief were talking rapidly in Malay.

"I told him you would like to stay here," Akhri said to me, "and he asks for how long, and I say only for a few days, and he says fine, but forever would be okay, too."

Although forever seemed a bit too long, I was, I confess, touched by the invitation. Here I was, a scruffy stranger scribbling God knows what absurdities in his notebook. If it had been me, I would have turned myself back at the door. But the magpie robin seemed to like me, and that was good enough for the chief.

Indeed, the bird must have been prodigal in its praise, for the Iban treated me like a White Rajah on an official visit. At dinner, a cicada with misguided ailerons crash-landed into my plate of glutinous rice, and half a dozen hands immediately reached down to remove it. The chief offered me a postprandial smoke — a large funnel-shaped cheroot made from local tobacco. Then someone

offered me a glass of *tuak*. Someone else noticed I was having prob-
lems with the heat and began fanning me with a *nipa* palm leaf.

If my skull ends up in a rattan bag here, I told myself, it will never
have cause to grind its teeth.

Actually, I was curious about the custom of taking heads, espe-
cially as I'd met a number of people in my travels — Parisian wait-
ers, for instance — far more inclined to whip off the occasional
head than my hosts. So I asked the chief if anyone in his longhouse
still did a bit of headhunting.

"The Iban have not hunted heads in many years."

"Not even to stay in practice?" I inquired.

"We have different trophies now."

In his grandfather's day, he said, an Iban man couldn't get a wife
unless he brought home an enemy's head as a trophy. But today
there were other, less sanguinary ways to get ahead (so to speak)
with a woman. One way was for a young man to take a job in
Brunei, Kuching, or peninsular Malaysia. He would bring back an
outboard motor or a sewing machine, and that would impress a
woman just as much as a head might have impressed her in the old
days.

I turned to the young woman seated next to me and asked her
which she would prefer, a sewing machine or a freshly plucked hu-
man head. She chose the sewing machine.

Evidently, the chief thought I had more than a researcher's inter-
est in the subject, because he asked whether I was married.

"No," I told him.

"Then perhaps you would like a wife?"

And before I could answer, a girl who couldn't have been more
than sixteen years old was brought forth for my inspection. I won't
say she looked at me imploringly, but neither will I say that she
wrinkled her nose in disgust.

Now the girl's father spoke. He would be willing to let me have
his daughter for either ten chickens or a new chain saw, whichever
would be easier on my budget. In addition to the daughter, he
would give me a share of his rice paddy and a *bilik* at the far end of
the longhouse.

It was a tempting offer, I admit: I could easily lose myself here,
forget about deadlines, forget about the IRS, and forget about un-
paid bills. Likewise, I could realize a refined vision of my youthful

Bornean fantasy, with genial ex-headhunters as my companions and an enviable domestic situation as well.

"Give me a day or two to think it over," I said.

That night I lay down on the veranda. The humidity was at least 100 percent. Dogs were barking, cocks crowing, and pigs rooting around noisily under the longhouse. Nightbirds screeched, and cicadas were exercising their typically strident vibratos. Doubtless there were a couple of *hantu-hantu* prowling about, too.

Even so, all night I slept the sleep of the blessed.

Certain images crowd my mind when I think of my visit to Nanga Ukon: the morning mist lifting to reveal the blue mountains of Kalimantan almost close enough to touch; a python falling through the longhouse roof, only to be dispatched by two small boys with sticks; children staring at me as I went about my evening ablutions ("Astonishing! He washes himself much the same way we do . . ."); and an elderly woman shaking my hand for a full minute, less a tribute to me, Akhri observed, than to my white-skinned predecessors, the Brookes.

One day I noticed a very nasty rash around my ankles (from a run-in with a *hantu*, I was told), but the *manang* applied a poultice of leaves from a larkspur-like plant to it, and lo! the rash went away in a few hours. I was so effusive in my gratitude that he gave me a tour of his pharmacy — i.e., the jungle.

He showed me a lanceolate leaf that he used for bladder problems and a shiny one that helped ease the pain of a toothache. This root would cure a hangover, this one was an antidote for snakebites, and a decoction from this plant was a tonic for diarrhea. With a rakish grin, he pointed to a plant called *tongkat ali,* "the Viagra of Borneo," in Akhri's words.

"Ask him what he recommends for writer's block," I said to Akhri.

It was obvious that the *manang* had never been asked about this occupational disease before. But he looked around and at last pointed to a small yellow-brown mushroom that I recognized as hallucinogenic.

"He say this *kulat* may be very helpful for such a block," said Akhri.

Now I asked the *manang* about edible fungi. Right away he

pointed to a split gill (*Schizophyllum commune*) and licked his lips, saying that it was highly prized by the Iban.

This was the first time I'd ever heard of anyone eating split gills, which have the consistency of leather and, I would have assumed, a flavor to match. But the Iban also considered monkey eyes a delicacy, and I found them somewhat unappetizing as well.

I ate several split gills that evening. They did have the flavor of leather. *Bad* leather. And in a flash, I knew I could never be a longhouse dweller. My own tastes, culinary and otherwise, were just too different from those of the Iban. Yet how to convey this without offending my would-be bride or her father, not to mention the matchmaking chief?

Akhri came to my rescue. "Mr. Larry lives in the Arctic," he declared, "and the heat here would kill him."

The chief gazed at me sympathetically, as did the girl and her father. That I was unwilling to spend the rest of my days in their longhouse did not seem to offend them. In fact, the girl's father looked relieved — for what self-respecting descendant of a war god would want an easily overheated wimp like me for a son-in-law?

As I was leaving, the chief shook my hand for at least a minute, then uttered this benediction: May all your omen birds be nice ones.

My fantasy jungle would be, if not wholly intact, at least logged so gently that no bird, beast, or human being would have cause for complaint. Here, particularly, Sarawak refused to conform to my idealization of it, for large swaths of rainforest have fallen to the chain saws and bulldozers of timber companies. In my flight from the oil boomtown of Miri to Gunung Mulu National Park, I saw countryside that seemed to have undergone an antibotanical blitzkrieg, and rivers so filled with runoff from the denuded land that they looked like soapy brown sludge.

Then the plane touched down in an opulence of green.

Remarkably lush in its vegetation and even more remarkably profuse in the variety of its wildlife (more than 20,000 bird, animal, and insect species), Mulu seemed a fitting place for me to conclude my journey into Borneo's wonderland.

The park did not disappoint me. On my inaugural hike I saw a snake no bigger than an earthworm, and a frog with webbed phalanges gliding elegantly from tree to tree. My Kelabit guide, Elis,

pointed to a lantern fly, an insect with a long snoutlike projection seemingly borrowed from Pinocchio. Here were orchids as delicate as origami and a tree, the *ipoh,* so indelicate as to exude a potentially lethal sap. And what made that odd noise? It was a black hornbill, perhaps the only bird in the world that sounds like a pig throwing up.

"Are there any poisonous snakes around here?" I asked Elis.

"Yes, but they are hiding from us," he replied. "You see, they believe people are poisonous."

One creature did eagerly seek us out. Leeches seemed to be everywhere — on twigs, leaves, and on the ground, not to mention affixed to our bodies. Some would actually jump onto us, those on the ground would loop toward us in graceful sinuosities, and others would rear up like miniature cobras at our approach. One species, the tiger leech, had stripes of yellow, red, and black, thus proving that in Borneo even the leeches are exotic.

"You know any good leech repellent?" I asked.

Elis shook his head and while doing so plucked a leech off it.

And then we were standing in front of an enormous hole in a limestone cliff. This was the opening to Great Deer Cave, which, according to one of my guidebooks, widened into a passage large enough to accommodate London's St. Paul's Cathedral five times over. Soon a few black specks emerged from the opening, then a few more, and then a virtual tornado of specks. The specks were wrinkle-lipped bats, millions of them, and they were going out to dinner.

"On a good night, they will eat six tons of insects," said Elis.

Twisting and turning, swiveling and undulating, the stream of bats appeared to be without end. Day turned to night, and still the stream continued, accompanied by an audible thrumming of wings.

On our walk back I listened to the nocturnal music of the jungle: the loud vibrato of cicadas, a frog whose croak sounded like the horn of an old Model T, and the soft reiterated *mm-pap* of the white-crested hornbill. A host of fireflies provided their version of a magic light show. Elis, too, produced a magic light show. At one point he focused the beam of his flashlight on an armor-plated gecko, and at another point on a pair of gently swaying branches — two giant stick insects mating.

So entranced was I by all these sights and sounds that when

we came to a log bridge, I stepped right onto it. Not having the aplomb of a ballet dancer, I tottered briefly and then slipped off, landing in the mud a few feet below. Another fantasy shattered.

But I didn't mind. I didn't mind at all.

Elis was busy with a group of German filmmakers, so on my last day in Mulu I went for a hike by myself. My destination was Clearwater stream, which, according to a local legend, makes a person a year younger every time he takes a dip in it. I planned to hop in and out of the stream's salubrious waters fifteen or twenty times.

All of a sudden a Penan man with rattan ringlets around his arms and legs appeared on the trail. He was short, maybe an inch or two above five feet, and he carried a blowpipe that towered above him. His feet were callused and spatulate from what was doubtless a lifetime of walking barefoot in the jungle.

"How are you?" the man said.

This turned out to be the extent of his English. And since my knowledge of Penan was even less extensive, I couldn't answer him. Nor could I ask him if he was one of the few remaining Penan who were still nomadic, or whether he'd settled in a longhouse like most of his fellow tribesmen.

The man gave me the barest of smiles, and then he vanished into the jungle. Well, he didn't entirely vanish. For this encounter, so haunting, so wholly mysterious, remained with me during my long flight home from Borneo. It remains with me even now, as I sit at my slightly boring desk. And as I write these words, I find myself with a peculiar craving for insufferable heat and slippery log bridges.

TONI MIROSEVICH

Lambs of God and the New Math

FROM *The San Francisco Chronicle*

MY GIRLFRIEND and I are junkies for the miraculous. We seek out testimonies from the faithful about spontaneous healings, hunt for lucky charms that work, carry back magical dirt from an adobe church in Chimayo, New Mexico, that caused the infirm to cast off their crutches and walk again. Last year, when it was reported that at a local cemetery the image of Our Lady of Guadalupe appeared on a sawed-off tree limb (formed by mold and fungus) we knew we had to go. Along with hundreds of followers, we made the pilgrimage every day and watched as people left flowers, prayer cards, dollar bills, and my favorite, a Reese's Peanut Butter Cup wrapper tacked to the tree, someone's most cherished item. It's clear each person wanted something miraculous to occur in their lives, freedom from sickness, from money woes, from awful in-laws. Everyone wanted to get out from under. We kept going each day until microbiology triumphed. The mold turned into more mold and finally, one day, the Virgin's face disappeared.

Maybe this desire to witness miracles all started when, like many of our middle-aged friends, we began looking for meaning in our lives. My girlfriend, Shotsy, started reading about the women saints of medieval time who went through all kinds of hell and back to experience transcendence. We traveled to Italy two summers ago to see the ultimate relic, the head of Saint Catherine of Siena on display in the Basilica di Santo Domenico. Thousands make the pilgrimage yearly. For a few lira, the altar where she is housed lights up, and her head — a mummified skull dressed in a white nun's habit, "dressed" as if she were on her way to lauds — takes on an electric glow.

The story goes that after a short life of performing numerous miracles, Saint Catherine died of the illness that would, years later, befall Karen Carpenter, anorexia nervosa. She was buried but wasn't allowed to rest for long. In hopes her daughter would win designation as an incorruptible, Catherine's mother let the church exhume the corpse to prove Catherine's body had not decayed. She then promptly gave Catherine's head to the church in Siena and her body to Rome.

So when we heard the relics of Saint Thérèse of Lisieux were going to be on display in the Bay Area we decided to make the journey to see them. Saint Thérèse, the saint they call "the little flower," spent her life always doing good and taught a simple way of confidence in God without limits. She died in 1897, and now, one hundred years later, they were taking her bones around the country in a little box for the faithful to see. When living she was reported to have said, "I would like to preach the Gospel on all five continents — until the consummation of the ages," so posthumously they were giving her her wish. Post grave, she was getting the grand tour.

On the day of the event we rise early and drive up to Napa, a drive that takes us past spring-green farmlands and new-growth vineyards. The spindly arms of each new grapevine branch out along the fence wires and look like the body of Christ on the cross, if you are in a spiritually associative frame of mind. Once we enter the city limits we follow our map and drive to the middle of town, where we find St. John the Baptist. I'm disappointed to see it is one of those monolithic church structures built to give the visual impression of a modern-day ark, a tall ship of a building rising to four square peaks. From a distance the roof looks like a giant washing-machine agitator.

Once inside the church everything is a little too cheery. There are banners hanging from the ceiling heralding this and that. The sun filters in through moderne stained-glass windows, depictions of the stations of the cross in vivid primary colors. The church architects seemed bent on stripping the space of any hint of darkness or mystery or blood on the cross, any suggestion that the trip on the River Styx was anything deeper and darker than a Disney ride.

The place is packed, so we find a pew in one of the side alcoves, behind a group of elders, their gray heads bent in prayer. Some folksy guitar music is playing — New Vatican meets Peter, Paul, and

Mary. On cue, the small schoolchildren from the Catholic school file in wearing the officially sanctioned school uniforms, bright-red cardigan sweaters over white blouses, with dark pants or skirts. On their heels come the true believers, the church's established status quo, their necks bowed low to suggest the proper supplicant position.

A priest appears from a side panel in the back of the church, a portly fellow in a cream-colored gown. He takes his place in front of the altar on the circular stage, a theater-in-the-round design to promote the new intimacy. It's soon apparent the purpose for this preceremonial address is to give us all a little instruction before the festivities begin.

"This is a glorious opportunity for all of us to reflect on the goodness of Saint Thérèse of Lisieux. We are truly blessed to have her visit." He directs his initial comments toward the school population. There is something punitive in his tone of voice, a drill-sergeant delivery he's using to enforce the reverential, just in case reverence isn't springing naturally from within. He wants to impress upon the teenagers that this is as big a deal as, say, 'N Sync come to call.

He shifts his target audience and addresses the rest of us gathered together.

"As there are so many of you, please, once you reach the relic, do not kneel and tarry. We're on a tight schedule today and this will slow the line. Please say your prayers and intentions on approach," he says, as if we are little planes lined up in the spiritual skies above SFO, wheels down, in a holding pattern. I whisper to Shotsy, "What a great idea! Express Prayer. Maybe we can get a cappuccino to go," and she tells me to shush, which draws a stern look from an old lady with a crucifix the size of a butter knife hanging upon her chest. When I look up I see people are already readying their thoughts and prayers, prioritizing, holding on to some intentions, turfing others, deciding which are nonessential prayers given the new limitations.

When everyone has a seat, the pomp and circumstance begins. The Knights of Columbus enter, six very old men dressed in red velveteen capes, swords drawn, *HMS Pinafore* caps on their heads. The swords are at the ready just in case someone bursts in and what? Makes a heist? Are there pirates who deal in the relic trade?

After the Knights come the altar boys and girls, then the priests and their various sidekicks, then finally, Saint Thérèse.

When the little box comes into view it is different than I imagined. I knew we wouldn't see the bones, but I expected to see a relic of a container that suggested its own kind of mystery, perhaps an old wooden box battered in its transcontinental shufflings. Instead, the Knights carry a small ornate building covered in gold filigree, a mini architectural wonder that looks like a miniature Versailles, with grand columns and cornices. It's as elaborate as a rich child's dollhouse that's been detailed, right down to the main ballroom's itsy-bitsy chandelier.

The small building sits under a large plastic dome, which covers the whole thing, like a football stadium Super Dome or a bell jar that covers an antique clock. (I once knew a man who worked in the AIDS Ward at San Francisco General Hospital who, after a visit by Elizabeth Taylor, grabbed her Styrofoam coffee cup from the desk with the half arc of her lipstick blotted on the rim, and had it ensconced under a glass dome for perpetuity.) The truth is this dome isn't made of glass, which has some physical integrity, but is Plexiglas, which seems to somehow cheapen the experience. The faithful must touch the Plexiglas that covers the box that covers the relic, somewhere deep inside, where a bone or two of Thérèse's lie. When I whisper to Shotsy that this wasn't what I hoped for, she quietly explains the significance of how what's removed from what illuminates the mathematics of the church, how religious power and meaning becomes an equation.

"A relic is a part of a person or a thing, a fragment of the true cross, or a fragment of a bone," she says. "A secondary relic is that which the original relic resides in or touches, when a piece of cloth touched the true cross or bone. A tertiary relic has touched something that's touched something. With each touch, each removal, there is an exponential decrease in power."

Based on this system, the plastic dome is a tertiary relic, three times removed from the original article, and removed from anything real is what I'm feeling at the present moment. I find all this as difficult to comprehend as the new math. If an object's power dilutes — like a weakened brew — the farther away you are from the object, does meaning dilute as well? Or what if instead there's an inverse relationship? What if the object's power becomes stronger, fueled by hope and imagination to even greater meaning?

There must be a sign I don't pick up on, a silent trumpet call heard by the pure of heart that signals it's time to honor the relic, for suddenly there's lots of movement, people shuffling about, adjusting their collars, straightening their clothes, putting themselves in order as if they're about to be on view. First, the children file forth, which is to be expected, as they are closer to holiness than we will ever be. They have yet to become embittered or cynical, haven't developed the capacity for making bad cappuccino jokes about a holy procession. Then in march more of the faithful, people with special dibs, powerful people in the church. The rest of the crowd, which is sizable, is instructed to file after row by row.

When it finally comes time for our pew to go, we first walk single file down the side aisles of the church and then make a U-turn to march down the center aisle. Given the length of the line there is lots of time to pre-pray.

Shotsy gives me a religious medal and a Kleenex to wipe across the dome, since somehow she still believes, though she has been through Buddhism, atheism, pantheism, and animism and has not as yet come to any definite conclusions.

There must still be a crumb, a shred of the original Catholic belief lodged in her from her twelve years in parochial schools. Some slim belief still resides in some part of her, under the stairway of the spine or in a secret alcove in the body, an elbow, a small toe. Prior to coming today she visited a religious supply store and bought the religious medal with the now defrocked Saint Christopher on the front and with a picture highlighting modes of transportation on the back. There's a train, a boat, and a plane. All we need is Dionne Warwick's strained, high voice, and her connection to the Psychic Network to transport us away.

On approach there's a backup. People aren't following the directions. Maybe there is an anarchistic uprising of sorts; people will not be rushed with their intentions, and this cheers me. A woman up at the podium microphone recites a long oration on Saint Thérèse's life story as we wait. "She died on September 30, 1897, loving with a heart as big as the world itself." A heart so big it surely couldn't have fit in that small box we are fast approaching.

As we near the relic we can see the ones just before us: a middle-aged woman with a pronounced limp who bows down with some difficulty, places a red rose on the floor in front of the relic, and needs help back up to standing, followed by an elderly husband

and wife, he with his hand protectively at the small of her back, guiding her, steering her forward. As if they have rehearsed for this at home, both, in one synchronized movement, kiss the top of the dome. Then there are some nondescript types, a man in a business suit, a woman in a pink scarf, another woman in a sweat suit with a mantilla covering her head. I think, my God, people need to believe. I look skyward, up at the ceiling, and for a moment think of the lost intention of this structure, like so many of our lost intentions, barely remembered. Gothic architecture was meant to provide the high ceilings necessary to accommodate all the prayers that fill the church cavity, every wish for a connection to something larger than this life that swells in each breast and ascends, floating upward toward the rafters, as heat rises. And maybe in each plea, each prayer in a bottle tossed out to sea, there's an unexpressed desire to go with, to follow the ones who have already departed and now only occasionally return in shards of bone. The truth of it is we are all here, every one of us, in the off chance these bones can bring some word back from the other side. Maybe word from our own dearly departed or from our modern kith and kin; the young men lost to the virus and the women who had left the earth without breasts and the little girls in ditches and so many more.

I watch a young man two people up from us who looks oddly out of place. He is wearing dirty faded jeans and a black Raiders jacket and has his ball cap pulled low across his brow. He looks to be about twenty-five, but it's hard to tell given his posture: His body is bent down like an old man's, hunched over, his hands stuffed deep in his jacket pockets. I can picture him at the ballpark or at the local tavern, but not here, in the middle of the day, with time on his hands. When he gets close, when it's his turn, he stops in front of the relic, stands there, and is unable to move. There's a nervous buzz in the line about the delay. Then, as if remembering his lost intention, he pulls two small blue knitted baby booties out of his jacket pocket, soft tiny booties, and slowly rubs the booties the length of the Plexiglas, in a loving arc, the gentlest of gestures, like when you put your hand upon a baby's face, as much to feel the softness as to shield that cheek from a world of harm. Everyone goes silent, all movement in the line stops, for it is too much, all of this is too much. We know the baby has already gone to God, made the journey, and here we are on this side, with no way to ford the

distance. And there is sorrow that has no depth and prayers that have no influence and before I know it it's my turn and I rub the medal, then the Kleenex along the length of the dome, press it firmly on the Plexiglas, I shine the dome and feel something, deep and heartfelt, a small crack, an opening, and almost cry but get a grip. If this is all projection or magic, intentional or not, at this moment I don't care, and I send a prayer up to the rafters for my loved ones. I feel it ascend.

"We all seem to have a need to go back to our earliest beginnings," Shotsy says as we drive away, which makes me think of paleontologists, archaeology, the necessity to go on some kind of dig, and I remember a line I wrote once: "She could read scat like there was no tomorrow." Or was it "She could sing scat like there was no tomorrow"? which makes me think of Ella, as holy as they come, closer to God than any priest in the church we've just left behind.

She continues. "We never seem to lose the desire. There's a need to connect to the unknown, and maybe, when we were very, very young, maybe we felt — and were — more connected. Remember, when we were small, how everything was large, landscapes were large, feelings were large, before memory interceded, before we ascribed things meaning? There weren't the layers of reasoning and analysis to get through. Remember when, as a kid, you would lie flat on your back in the grass and look up and you fell into the clouds or the intense blue of the sky? Or the first time your toes touched the lake's edge and the jolt was electric? There wasn't any distance between you and the world. Nothing got in the way."

It's true. I know so many friends who have taken treks to the places they inhabited as children, homeward-bound journeys to see the site of the early "miracles." But the places are never the same. Shotsy grew up in a little corner store in Louisville, Kentucky, Faust's Market, her father's place. I've seen pictures of it over the years, the small storefront windows advertising Nehi sodas and Meadow Gold ice cream, the striped awnings, the roof banner that read QUALITY MEATS — FOOD. The store looked like a Walker Evans photograph, a place that functioned as a way station, meeting place, counseling center, along with providing everyone's daily goods. We returned last year to the store, now a sad, sagging building with a fake new front, now just a shell. Where once the shelves were packed with pork and beans and the scale swayed under the

weight of ground round, where the bell on the screen door rang its little song and the penny candy stuck together in the glass jars, now there was nothing but batten and board.

"Take the church, for example," she continues. "When I return to the church, the site of some of my first memories, the Mass, the Latin and singing, the place seems like a husk, empty and strangely small. We go back to the place where meaning resided, but where did the meaning go? We return to a place where we were first introduced to things not of this world. And yet that world has changed beyond recognition."

We drive in silence after that. Before long we leave any semblance of city behind and farm fields appear with horses, then sheep. A long stretch of asphalt lies before us and we speed in an effort to get somewhere, to leave our disappointments behind. The highway is a gray ribbon that cuts through the center of the green hills and I notice that a car up ahead of us suddenly makes a sharp turn and swerves over to the side of the road. We slow down and I spot an arm reaching outside the passenger side window, as if signaling to us, pointing to the fields.

When we look to our right we see what they see: new lambs, just born, some barely standing on their new limbs, others racing in circles, kicking it up. Little black lambs and white ones frolicking, the word must have been invented for newborn lambs and I say, "Oh, Jesus, stop, stop," and Shotsy shouts, "Lambs of God, lambs of God," for if there is a divine hand it has been hard at work creating this scene.

"There's not a calculating bone in their bodies," Shotsy says, an odd comment, but true. We stand about and watch, then ascribe human characteristics to the lambs — they are guileless, innocent, generous in their play. We stay there and the wonder of this vision grows as surely as the vines are growing. Why would we find what we were looking for here, out in the open, a connection to something larger, to meaning, when we had just left the church, the designated place where meaning was supposed to reside? These lambs, removed from the logic and mathematics of the church, are closer to a real god than we'll ever get through the church. Out here nothing signals the arrival of wonder, no trumpet or ceremony, no official designation of this field as saintly or pure. Yet here is the unknown, the unexpected, and we can't help being altered from who we were a moment ago.

When it is time to go I glance back at the scene. If I widen my view the green rolling fields are active, fluid, and look like the sea. The lambs bob and crest, swimming in the bright green waves, their heads like little whitecaps, and happiness floods in like water through a busted pipe. Like Saint Thérèse we're released from all that once confined us and we are on the ocean, traveling the world again.

TOM MUELLER

Ancient Roads, Walled Cities

FROM *Hemispheres*

IT WAS the third century, and the walls of Rome rose swiftly in those dark times. The Persians had overrun Mesopotamia, the Palmyrenes had seized Roman Egypt and much of Asia Minor. To the north, wave upon wave of barbarians broke through the Rhine and Danube frontiers — Franks with their battle-axes, Sarmatian horsemen in bone-plate armor, fearsome Goths and Gepids and Vandals streaming into the heartland of the empire.

In 270, a war band of Alamanni and Iuthungi crossed the Alps and entered the sacred soil of what would become Italy. When they were only a few days' march from Rome, the emperor Aurelian intercepted and defeated them. Aurelian then decided to fortify Rome. (Rome had earlier circuit walls, but they were outgrown centuries before.) The line of walls was laid out according to precise religious ritual and was associated with the *pomerium,* the sacred boundary of the city that divided civilization from wilderness, the realm of peace from that of war.

Embedded in the twelve-mile circuit of brick and tufa walls are dozens of older structures — aqueducts, amphitheaters, mausoleums, and apartment buildings — that the builders incorporated into the ramparts to speed their work. Blocks of clean white travertine and shards of marble are frozen in the rough fabric of the walls like fossils of happier times, when mighty Rome needed no walls.

The only openings in this holy barrier were eighteen tall gateways, nine of which still stand, where the great Roman highways entered the city. All converged in the Forum at the *miliarium aureum,* or "golden milestone," set up by Augustus to mark the origin of all

Roman roadways and the center point of the empire. From here they radiated outward to the far corners of the known world, a fifty-thousand-mile network that covered what are now thirty-seven countries. Like the intricate system of arteries, veins, and capillaries in the human body, the roads made the Roman empire one organism. As one Roman put it, they "gave to all the world a shared law . . . and intertwined its peoples under a single name . . . in regions most diverse." Linking Scotland to Mesopotamia, the gloomy primordial forests of Germany to the sunbaked plains of North Africa, they made it possible for people in these far-flung lands to keep the same holidays, worship the same gods, respect the same laws, enjoy (or yearn for) the same foods, share similar tastes in sculpture and literature, and recognize the same supreme ruler. As long as goods and laws and leaders flowed smoothly through the vast web, the Roman empire thrived. So long as the legions traveled the frontiers, city walls were unnecessary in most places.

Yet in the grim years of the third century, the emphasis shifted from empirewide unity to local survival. All along the network of Roman roadways, stone rings sprouted like mushrooms, encircling cities in a firm embrace that would both protect against enemies and turn them in on themselves. Over the next two centuries, the heartbeat of the empire slowed, and then ceased; the long-distance flow of goods and ideas waned; the legions themselves disappeared. Each city learned to fend for itself.

The landscape of stone the Romans laid down is still with us. Roman roads underlie countless modern lanes, streets, and superhighways in the former empire. Roman walls, intact or modified in later centuries, still encircle many towns in Europe, North Africa, Turkey, and the Middle East. This landscape has shaped our history, molded our culture. Long after the fall of Rome, the Roman roads continued to guide the feet of merchants and prophets, farmers and kings. In their road system, the Romans made a blueprint for the future development of cities and towns, which tended to spring up along a roadway; lines drawn by a Roman surveyor still set the routes we drive through much of the former empire. And each stone circle of city walls became a crucible in which the identity of the community and its citizens would form. When today we marvel that two hill towns in Italy or Spain, only a half hour's walk apart, have different accents and dialects, distinctive breads and

sweets and pasta shapes, and diverse histories and myths, we see the work of the stone: The walls sheltered a cultural microclimate in which a unique way of life could evolve.

Roads

I have seen a perfect line of paving stones rise from the desert sands of Libya to become the main street of a ruined Roman town. I have ridden the same straight course through the patchwork fields of Somerset and along the brilliant blue Tyrrhenian Sea near Palermo. I have walked Roman roads through the Alpine snow-fields of the Gran San Bernardo Pass, in the damp, mosquito-ridden fields of Lazio beneath the umbrella pines, through the bone-dry hills of eastern Macedonia. Always the same huge, polygonal slabs of basalt or granite or limestone, smoothed by the passage of numberless feet, rutted by centuries of oxcarts. Always the same neat, sure trajectory. The same familiar friend.

Traveling Roman roads brings home the incredible achievement of the Roman empire. In this vast diversity of landscapes and peoples, the roads are the one common denominator. Ancient observers considered roads to be one of the Romans' supreme achievements, perhaps the supreme achievement. The Greek geographers Strabo and Dionysius of Helicarnassus agreed that roads, along with aqueducts and sewers, were the true sign of Rome's greatness; for the Roman natural historian Pliny the Elder the road system was a vital prerequisite for civilized life that he proudly contrasted with the "useless and stupid ostentation of the pyramids." Though earlier cultures had road networks, there was no precedent in the ancient world for the ambition, technology, and painstaking care that the Romans poured into their roads.

The Romans built their roads in a series of clearly defined steps. After the surveyor had determined the path of the new road, the workmen, often Roman soldiers, dug out the foundations down to solid rock or gravel, often to considerable depth. This roadbed was then filled with successive strata of increasingly fine-grained rock and gravel, to ensure stability and good drainage. Finally the surface layer of stone was set in place, blocks fitting seamlessly together in a perfectly cambered surface that shed water and could be traveled in all weather. On wet ground, roads were built on

raised embankments or causeways of timber pilings; they crossed watercourses on bridges, sometimes hundreds of feet long; in the mountains they might pass through tunnels in the solid rock. The amount of work involved staggers the imagination. The verb the Romans commonly used for road-building was *munire*, which also meant "to build a wall around." In fact, a Roman road resembles a stone wall fifteen feet tall and four feet thick — lying on its side. Consider building such a wall fifty thousand miles long — the equivalent of twice around the earth, or about the same length as the U.S. interstate highway system.

The bold conception and execution of Roman roads, their fearless, head-on challenge to Nature, have an epic quality. When in 312 B.C. the censor Appius Claudius Caecus set out to build the first great Roman road, the Via Appia, he drew a perfectly straight line across rivers, hills, and malaria-ridden marshes and bade his road-builders follow it, seeming to delight in subduing each natural barrier that lay in the course. Near the bridge at Alcántara, which carries the Roman road over the Tagus River on six broad arches, the architect Caius Julius Lacer left his epitaph: PONTEM PERPETUI MANSURUM IN SAECULA MUNDI ("I have built a bridge that will last the ages"). These were more than roads. They were art, built to last forever.

As so they have. Flying low over Europe one can easily pick out the Roman roads, those clean straight vectors among the chaotic medieval checkerboard of lanes and farmers' fields. The Fosse Way in Somerset, the autoroute from Calais to Dijon, long stretches of the Via Aemilia and Via Flaminia — all follow the original Roman route. Where I live near the Mediterranean in northwest Italy, not far from the French border, the main coastal highway is the Via Aurelia, on the Roman road of the same name. Driving home along its supple, efficient curves, it is reassuring to know that, under the thin, potholed crust of asphalt, a solid path of original Roman paving stones leads on ahead.

I turn inland at Finale Ligure, the closest town of any size to my house. Here another Roman road, the Via Julia Augusta minor, joins the Aurelia. It is not used for motor traffic — only farmers and a few intrepid mountain bikers travel it now — but it is the most direct line to my house, and I walk it regularly. The road climbs steeply between cliffs of pink limestone, for which Finale is

famous, through a thick fringe of laurel and hornbeam and occasional stands of chestnut touching green leaf tips in a canopy overhead. It fords five watercourses on original Roman bridges, squat structures that seem to have grown up from the soil. Along the way is an occasional poor farmstead, where a farmer can be seen tending his olive trees and his Lumassina vines, hoeing the thin soil. On the cliff tops, cypresses wave in the stiff sea breeze that seems never to reach the valley floor. The view from the road is much as the Roman traveler would have seen it.

The original stone road surface is visible most of the way, an invitation to remove your shoes and walk barefoot; the stones are sunwarmed even in the rain. Walking this warm roadway through the green trees, ideas come that don't come elsewhere. Sometimes I stop, kneel down, and touch the stone with my hand, tracing the ruts worn by two thousand years of carts. Or I stand motionless on a bridge, in forest silence. At such moments, walking an old Roman road comes close to time travel.

Walls

For millennia — perhaps for as long as people have built in stone — an ancient wall has evoked powerful images of past lives. The Anglo-Saxon bard who composed "The Ruin" sometime around A.D. 700, three centuries after the passing of the Romans and three more before the Norman Conquest, clearly felt this pull of the past. Looking up at the massive stonework of the Roman town of Aquae Sulis, modern-day Bath, he saw what we still see: proud people and bright celebrations and collective triumphs, as well as the inexorable glacial crawl of time (which he calls Weird, or Fate) and the sadness brought by its passage:

> Well-wrought this wall: Weirds broke it.
> The stronghold burst . . .
> Snapped rooftrees, towers fallen,
> the work of the Giants, the stonesmiths,
> mouldereth . . .
>
> And the wielders and wrights?
> Earthgrip holds them — gone, long gone
> fast in gravesgrasp while fifty fathers
> and sons have passed . . .

> Bright were the buildings, halls where springs ran,
> high, horngabled, much throng-noise;
> these many meadhalls men filled
> with loud cheerfulness: Weird changed that . . .

An ancient city wall, scarred by battles and patched by lichens, is history made visible. Walking the ramparts of Dubrovnik or the battered land wall of Constantinople, it is easy to imagine the Saracen hosts ranged out below in a glint of sunlight on iron, a whiff of Greek fire. Arriving at sunset beneath the mighty ramparts of Ávila in central Spain or the Welsh walled town of Conwy, one has a passing sense of what it must have been to arrive too late, after the great gates had closed for the night, and be alone in darkness outside. Striding across the thirteenth-century city walls of Rothenburg, the well-preserved medieval German city lies encircled before you just as it did six centuries earlier. Standing on the walls, or below them, the Roman concept of *pomerium* has instinctive appeal: You feel the aggressive line between *us* and *them* that city walls create, between inside (the sphere of peace and culture) and outside (chaos, the enemy, death). They mark off the city as a place apart, separate from the rest of the world.

The equation of fortifications and cityhood is more than poetic fancy. In many cultures, a city is a city because it has walls. In classical Chinese, for example, a single character (*cheng*) could mean both "city" and "wall." The link was just as close in medieval Europe. The seventh-century scholar Isidore of Seville wrote, "The city is constituted by its defensive walls." The pairing runs deep in our conception of human society: The root of our word *community*, the Latin *communis*, may well have derived from *cum* + *moenia*, "with + fortifications."

Yet walls were not always the acid test of cityhood. At the height of the Roman empire, as the historian Robert Lopez has pointed out, a city was defined by very different attributes: a forum where people could gather and laws could be given, public baths for the pleasure of the body, theaters and arenas for the delight of the mind. Beginning with the crisis of the third century, when defense became the overriding concern, walls grew in stature in people's imagination: Law, bodily pleasure, and intellectual delight were supplanted by the simple will to survive. In fact, as the walls of Rome itself prove, many town fortifications were built at least in

part with stone from the town forum, baths, and amphitheater. City walls graphically depict the transition from the classical world to the Middle Ages.

Each wall is an enduring record of the history and local traditions of the city it protects. It was built by the townspeople from local stone, quarried nearby and frequently characteristic of regional architecture: the luminous white limestone of Dubrovnik and York, the caramel-colored *pietra dura* of Florence, the blackened sandstone of Trier, the brick and blue granite of Marrakesh. Even if the existing wall is no older than the Renaissance, it often rests on Roman or pre-Roman structures: The walls of Perugia, Volterra, Todi, and many other towns of central Italy contain imposing Etruscan stonework and are connected with the earliest origins of these places. Walls celebrate in heroic terms some of the most dramatic history of their city. Michelangelo helped design the walls of Florence to withstand the 1529 siege of the Medici, bent on subjecting the proud Florentine state. The walls of Constantinople, the ancient world's most awe-inspiring fortifications, withstood centuries of sieges before succumbing to Sultan Mehmed the Conqueror in 1453.

The walls themselves changed shape to meet the changing technology of war. Aurelian's walls were raised and substantially modified only forty years after he built them and again in the early fifth century. Double rings of walls, impressive gatehouses, new profiles and placement for defensive towers, platforms known as machicolation built out from the parapets with "murder holes" in the floor through which defenders could bombard the enemy: Each was a step in the age-old arms race of besiegers and besieged. Gunpowder revolutionized the art of fortification. When a cannon could fire a projectile in a flat trajectory directly at the foot of a wall — the one point where it was vulnerable to collapse — the tall, vertical ramparts that had protected townspeople for nine thousand years suddenly became obsolete. Using his state-of-the-art mobile field artillery, King Charles VII of France cracked open sixty English castles in a single campaign season (1449). Italian architects countered the French threat with a new fortification style known as the bastioned trace, which had low, broad ramparts that could absorb the shock of cannon balls, and gun platforms shaped like arrowheads projecting from the main wall, where defenders could rake the enemy with artillery fire.

Since fortifications were in steady evolution, the style of a surviving wall tells much about the town's history. First, of course, a wall proves that when it was raised, the townspeople had the independence and considerable wealth necessary to build it. Yet an extant wall also frequently records like a snapshot the town's fall from grace. Florence, for example, fell in the siege of 1529 and lost its independence forever. The city walls remain just as Michelangelo built them: They were not dismantled, because the Florentines no longer posed a threat to their new masters, nor did they evolve, because the Florentines lacked the authority. Nearby Lucca maintained its independence almost three centuries longer and boasts the ramparts and gun platforms of an up-to-date bastioned trace.

Even when a town remained free, a surviving city wall suggests that it had lost economic prominence by the nineteenth century. Thriving cities soon outgrew their early circuits of walls, which remained as useless relics in the center of town. During the Industrial Revolution, with the emergence of new models of urban design and modes of transportation, most major cities dismantled their old fortifications. Rome is the only European capital with an intact circuit of city walls, largely because Rome did not outgrow them until the twentieth century: Aurelian built his walls around a metropolis of a million people, but the city rapidly dwindled to a tenth of that size and did not regain its classical population until the 1930s.

Today, city walls still cause traffic problems, as anyone will attest who has watched a rush-hour line of cars crawl along ancient ramparts. Walled cities are out of step with the times, for old fortifications are a barrier to modernity. But as you cast your eyes on these wonders, you can only say, "Long may they stand."

Old stone structures have regularly evoked vivid thoughts of time — from the proud words of Caius Julius Lacer by the bridge at Alcántara to the melancholy strains of "The Ruin," from Thomas Gray's "Elegy Written in a Country Churchyard" to this slim, rocky article. Set up piece by piece and block on block, they build a personal link with the past. You sense not only the greatness of Aurelian, who raised the walls of Rome, but the sound judgment of his surveyors, who set its course; both the daring of Appius Claudius Caecus to imagine the Via Appia and the deft hands of the soldiers and slaves who laid it down yard by yard. Come very close, lay

your hand on the stone, and you sense telltale signs of past lives: quarry marks, sharp chisel scores and careful graffiti, neatly laid lines of mortar. You stand just where the nameless builder once stood, your hands where his hands were, as he shaped each stone and set it in place. The stones still stand for the people who built them.

Ancient walls and roadways embody our history, give it tangible shape. Resting one course atop another like a human geology, and resting ultimately on the bedrock of earth itself, they root us directly in the past, give the present a grounding and perspective that we need. They are the weatherworn bodies of our myths.

ELIZABETH NICKSON

Where the Bee Sucks

FROM *Harper's Magazine*

Prologue

JUST OFF the southern tip of Vancouver Island, twenty sea miles and an entire dimensional journey from Seattle, lies an island known as Salt Spring. It is the largest of an archipelago of several dozen such islands that reaches from Seattle toward Alaska. In the United States these islands are called the San Juans; in Canada they are called the Gulf Islands. The archipelago travels up through the fabled Inside Passage between Vancouver and Vancouver Island, where Captain Cook marked the first Anglo landfall in 1778.

The climate is northern Mediterranean, and nature, far from being red in tooth and claw, is titanic, breathtaking, inviting worship. Salt Spring, the largest of these islands, is seventy-four square miles. Three mountains mark natural boundaries between farmland and forest reserve. Mt. Baker hangs in the sky to the south, buttressed by clouds. All around is navy-blue sea.

Today, ten thousand residents call Salt Spring their home. Some of them are farmers, loggers, and fishermen, beleaguered resource workers all. Other, more recent arrivals are retired professors and bureaucrats, of which Canada has an unconscionable number. Although the true proportion has never been determined, we might say that half want to preserve the "rural character" of the island, while the other half are the rural character and would like, therefore, to cash in on it. The dilemma was not always so easily described.

Act I

In the dark backward and abysm of time that was, to be precise, the early 1970s, storm-tossed escapees arrived on the island, looking at

first for an escape from the war, and then from the perfidy of a world that poured down stinking pitch on the offerings of the counterculture. They wanted, at peril of their souls, an acre of barren ground, long heath, brown furze, anything they could tend, a place bereft of any normal society, a place where they could read, tend their secret gardens, get high.

And so the island's beneficence grew in reputation. Broken and running, women were heaved there all through the eighties and into the nineties, children in arms, without men usually or, if with, the males generally shucked in a year or so as the women acclimatized and grew strong. By the early nineties, Salt Spring was considered a female island: eight women to each single man, went the rumored stats. Many were victims of cocaine binges in the cities; cheated of their lives by drunkards; wrecked by yuppie greed, or by foul play, or by infidelity, or by that catchall malaise: stress. Here on this island they arrived, looking for a safe place to bring up their children. Myths were unearthed that the natives had fished, collected psilocybin mushrooms, clams, and oysters, but had not wintered on the island, because their women became too powerful and the men less warlike. In fact, said a popular local book, *Daughters of Copper Woman,* pre-contact natives in the area were matriarchal and matrilineal and, furthermore, believed that menstrual blood connected Woman to the divine.

These were just a few of the mythic verities that grew up around what swiftly became known as a sacred island. It was even discovered, and whispered about to the elect, that the Lion, Mary, and Michael lines, the three major ley lines of the world, passed through, lines of sacred energy that identified the island as having the same distinct pull and weight as the ancient city of Lhasa, the North Island of New Zealand, Machu Picchu. Women in the middle of the prairie were woken in the night by disembodied voices and told to come here. Women said that they were dropped here on their backs, arms and legs waving in the air, turtles dropped by a careless child, a tale suspiciously like a First Nations myth of origin. On these ley lines, vortices were discovered, and some were said to be portals to other worlds. Labyrinths were built on these portals. Self-identified as neopagans, and dedicated to reviving the ancient nature religions, the women agreed to agree on almost nothing but that the first witch was black, bisexual, a warrior, a wise and strong woman, a midwife, and a leader of the tribe.

Standing on its head, therefore, the notion of the original evil witch Sycorax, or Morgaine, or the Wicked Witch of the West, it also was found that the original settlers in the 1850s were freed African-American slaves and Hawaiians, and this history gave resonance, depth, meaning, and power to this matrilineal island of outcasts.

The women, jealous of their place, commanded the elements to silence, wrapped the island in a fog, like Avalon, so that very few people, unbidden by the convergences, would come, and so that those who came, stayed, and did not fit in would be spit out by the goddess, as the island Wizard and limousine driver would have it. Even those whom the island loved were wrapped in sleepy clouds, their spirits bound up, lulled by the beauty of the trees, the ocean, the mountains, the birds, the rivers, and the nature spirits. The women studied the deep and abstruse texts of witchcraft and early tribal religions. Their states grew strange. They were transported, rapt in secret studies. And neglecting worldly ends, all dedicated themselves to closeness and the bettering of their minds, with that which, but by being so retired, o'er prized all popular rate; they lived on the social assistance. They developed their own rituals and calendars, held celebrations at the solstices and cross-quarters, and raised beautiful pagan children who believed in environmentally sound principles of living and who actively promoted a way of life that would not damage the Great Mother or any of her spirit or fleshly children.

There were many white middle-class people on the island as well, descendants of the original farming families. Among these was our Ariel, who in the spirit of deliberate confusion and for the sake of standing all patriarchal archetypes on their heads, shall be a short, squat, ecofeminist, celibate lesbian in late middle age, retired early from the education business. Brigid, we shall call her, ran the Tir Nan Og Light Centre on the south end of the island and communed in solitary splendor in her straw-bale house with a host of nature spirits, including fairies, gnomes, sprites, zephyrs, salamanders, and the Green Man, Pan. She worked with the spirits, healing the earth and teaching people how to live without money. Brigid knew the island, knew the spirits and what they wanted from us. If she could be accused of an excess of imagination, equally she accused others of a too rich fantasy life. Neopagans, as we have established, agree on nothing.

Other members of the old farming families watched in some amazement as their land values rose and their forests were protected by those who did not own them. Many of the families saw the island as a future resort destination, a Carmel-by-the-Sea, a waterskiing, hiking, kayaking, yachting kind of place. And they were angered by the notion that a bunch of hippie mothers living on the social welfare, dressing in long skirts, their children in dreadlocks and grime, did not want this. The old families had been kind. They had been generous. When the mothers first arrived, they showed them where the best places were, where to fish, where and what to plant, where to buy honey, what goats to keep, and the mothers had been grateful, full of praise. The mothers had joined the farmers' institute, lauded the school, undertaken to improve it, and taken booths at the Fall Fair. Now, as the honeyman Dave Harris put it, the families felt that there were "far too many people on Salt Spring who have no intention of ever making a living."

The mothers met in a circle under the waxing moon, best for the banishing of evil forces. Ariel was called, and the request was made to the gnomes and the trolls:

> Run upon the sharp wind of the north
> To do me business in the veins o' th' earth
> When it is baked with frost.

The convergences were drawing others, less worthy others. The world was intruding. The magic island needed some magic.

Act II

There are many candidates for Prospero on Salt Spring. A self-described warlock, Bristol Foster, a former director of the Royal British Columbia Museum, for instance, a wolfish man with multiple Ph.D.s, or Maureen Milburn, former president of the Island Conservancy, who holds her doctorate in art history, their libraries (and activism) dukedom (or tenured professorship) enough for them. Or Nina Raginsky, coordinator of the Waterbird Watch Collective, a self-described minor-league heiress, former *Time* magazine photographer, and lecturer in metaphysics. They are merely representatives, behind them a flock of a few dozen highly educated, committed environmental activists, what our Caliban, a

craggy, handsome former forestry CEO named Tom Toynbee, owner of much of the commercial real estate in the main village of Ganges, calls (in public) the most educated, articulate, formidable, and committed opposition around.

Many island people cross the street when they see Tom Toynbee; he is a villain they do not love to look on. But Toynbee makes the hardware store, the galleries, the restaurants, and the shops possible. Even the most pagan mother accepts that the island cannot do without him. Does Toynbee think he's a slave? Indeed he does, for the island is so beautiful that no one wants to work, except, he thinks, him. And they will not let him develop the property so that he can stop working. If he does not say in private, "All the infections that the sun sucks up from bogs, fens, flats, on Prosper fall, and make him by inch-meal a disease," then he is a saint, and despite the spiritual nature of all on the island, well, it is unlikely.

Along with the witches who arrived in the late eighties and early nineties came a more successful sort. Gonzalos to a woman or man, they came with professions that required floatplanes and high-speed telephone cables, and they conceived of the island as a boomer utopia and rejoiced:

> . . . no kind of traffic
> Would I admit; no name of magistrate
> Letters should not be known; riches, poverty
> And use of service, none; contract, succession
> Bourn, bound of land, tilth, vineyard, none;
> No use of metal, corn, wine, or oil;
> No occupation; all men idle, all;
> And women too, but innocent and pure;
> No sovereignty —

The Gonzalos announced that they would with such perfection govern t'excel the Golden Age. They threw their collective weight behind the Islands Trust, a government agency designed to preserve and protect, and proceeded to strike committees to consider zoning bylaws that restricted development.

Noble creatures, thought the witches and single mothers, and they joined the rich boomers with the Pathfinders and off-island incomes in ignoring the meeting at the Harbour House of gentlemen of such brave mettle that would lift the moon out of her

sphere if she would continue in it five weeks without changing, who contrariwise cried that they'd rather

> . . . sow't with nettle-seed.
> Or docks, or mallows.
> And were the king on't what would I do?
> Scape being drunk for want of wine.

For developers from Asia and the States had been drawn by the beauty of the place and the wasted space. Fishermen from Norway who had fished out the North Sea lusted after the Pacific salmon, and loggers who had exhausted the New Zealand forests arrived eager to exploit the last, biggest, cheapest forest in the world.

Making common cause, they laughed at the mothers. Here, they said, is everything to life, save means to live, and began to plot.

Act III

> Spiritual earth mother into yoga, wheatgrass, fasting, cleansing, herbal masks, soy-milk douches, and simple life. Seeking to share her yurt with Island nature boy. Dreadlocks, didgeridoo, drum, multi-patched jeans, various dogs, '71 purple VW van. Maximum 8-word vocabulary and deep far-away look a necessity.
> — classified ad,
> *Salt Spring Island Thyme*

In 1989, in a fit of despair at city life, I bought thirty acres in the country my paternal family had settled a hundred years before. Over the years spent in London and New York, I had heard rumors about Salt Spring. The witches danced naked under the full moon, rowed out into the sea to cast flower petals on the water to honor the Great Mother. There were women on the island whom it behooved you not to cross. I would have laughed at these warnings, except that when I was in my first year of college I had persuaded a gypsy friend, who boasted that she was from a family of Bohemian witches, to cast a love spell on my philosophy professor. Jovita protested that her family couldn't cast spells anymore because a curse had been laid on them: When they practiced witchcraft their houses would burn down. I teased, challenged, and dared her until, on the night of the full moon, she drew a pentacle on her kitchen floor. Five days later my professor called, professing eternal

passion, and ten days later Jovita's apartment building burned to the ground.

I am cleaning up the remains of a hash-oil factory on my land and the detritus of a party house run by hippie settlers. I collect dozens of old beer bottles, car parts, hunks of an old refrigerator, slabs of roofing, and add them to my slash pile. I, like Ferdinand, and all new residents, carry logs, back and forth, for years.

While I plod, I puzzle. Who are these witches? What do they want? They are not casting love spells, for romance on the island is considered best left to the very young. Many women are gay, or committed to the pursuit of cronedom, making middle-age, heterosexual love sporadic in incidence at best. Besides, given pagan morality, just about every combination has been tried, and the combatants have retired early from the field, with bruised hearts and exhausted bodies, leaving the joust to their children. Pagan teenage girls are perfect and peerless, created of every creature's best, clean and healthy, nature girls all, usually ambitionless, since ambition is violence to the Great Mother. Young pagan island men, says Maureen Milburn's husband, Sam, travel from woman to woman, with gardening tools in the back of their pickup trucks, often leaving a child behind in each camp. Mainland boys pour onto the island, leaving the world (and cross parents) behind, attracted by the hippie chicks of Salt Spring, who are not, shall we say, overburdened by the desire for material possessions or even the knowledge that Dolce & Gabbana exists.

Loggers, fishermen, and developers, perhaps piqued by the fact that none of their blandishments had any effect on these gorgeous young creatures, who saw them as abhorred monsters, which any print of goodness would not take, capable of all ill, savage, brutish, and so forth, methodically sent the word of the island abroad. With the help and moral support of some members of the old families, the Trust was besieged by applications for casinos, resort-destination hotels, and walled retirement complexes. The Trust planner had appointments lined up for months on end with developers from Asia and the States. Men walked about the island as if in a trance, marveling at their future,

> . . . and then, in dreaming,
> The clouds methought would open and show riches

> Ready to drop on me; that, when I wak'd
> I cried to dream again.

Gunslinging developers hired high-priced lawyers to inspect the island bylaws. Legal challenges to the zoning restrictions were mounted. Secret allies were found, Gonzalos interested in selling their land for five or ten times what they had paid for it. The developers and loggers proclaimed their victory over

> . . . this Sir Prudence, who
> Should not upbraid our course. For all the rest,
> They'll take suggestion as a cat laps milk;
> They'll tell the clock to any business that
> We say befits the hour.

Clear-cuts appeared on the pristine and sacred South End. A communal farm, one of the last hippie utopias, blew up, and the survivors put their few hundred acres of the last old-growth Garry Oak meadow on the island up for sale. A consortium of loggers from Washington State made an offer of $800,000. Three condominium developments sprouted in the town. A strip mall appeared, as if by magic, overnight, and two more were planned.

For despite the island's beauty, the loggers, fishermen, and developers were right: there was no local economy to support the pagan women and their children, and the social welfare was becoming suspicious and impatient.

Circles were held under the full moon, and Prospero consulted his books.

In addition to studying the White Goddess, the Welsh Mabinogion, the collected works of Starhawk, Lady Gregory's *Fairy Book*, and various ecological texts, Prospero had been reading Machiavelli, *The Art of War*, and Tony Robbins. This effort was delivered of an Official Community Plan that expanded the original eight-page document to more than three hundred pages, providing the island of ten thousand souls with more bylaws than the nearby provincial capital of Victoria. Accusations of sin were made against men deemed not fit to live. Suggestions were made that the developers, loggers, and fishermen should hang and drown their proper selves and take up garlic farming.

War broke out. Ecoterrorists filled the gas tanks of logging trucks

with sand. A witch struck a member of Parliament. The loggers burned down the Community Centre on a neighboring island that the witches had declared to be the gateway to the elven kingdom.

Stephano, who slid under the wire a sleazy time-share complex on a fragile water table, announced with foolish bravado, "Who cares about the local residents — they're just a bunch of goofers." Next door to the time-share, Goofer's Pig Farm raised a giant sign, and the island sprouted GOOFER'S PIG FARM T-shirts and bumper stickers.

"The plan makes *1984* look like laissez-faire capitalism," argued Trinculo, local poet and pig farmer. People here, he said, "are always figuring out what to do with other people's property."

But no matter how Caliban declared the island full of noises, sounds, and sweet airs that give delight and hurt not, many developers gave up, for it appeared that every river, stream, marsh, and wetland had its protectors. There were two hundred pagans on the Waterbird Watch alone. No tree was to be felled without a permit or an arborist in attendance. View corridors were to be protected. Farmers were not to cut down their trees for fences or barns without a permit. The water table was deemed sacrosanct. No streams were to be dammed. No lakes were to be drained for the watering of packaged tourists dressed in unenvironmentally sound polyester. No hotels or golf courses or gated communities were to be built by those who would doubtless spend their profits in the sinkholes of the off-island world.

And still people flowed onto the island, though now it seemed that each new arrival came with a disorder: chronic fatigue, fibromyalgia, multiple allergies. The island mothers, recognizing that the social welfare was impatient and that abundance (if not ambition) was desirable, proceeded to start many businesses to feed and heal the newcomers. Bounty descended in floods of organic produce, unbioengineered vegetables, unfarmed fish, free-range chicken. The witch mothers hung out shingles, and every conceivable kind of treatment became available. Infusions were struck on the eve of the new moon, and people spoke of the sacred geometric grid of abundance: When properly lit up, there would be money enough for all without the degradations of commerce.

The island's enemies were all knit up in their distraction. They skulked in the bar at the Harbour House and swore, O, it is mon-

strous! Monstrous! But one fiend at a time, I'll fight their legions o'er.

All were desperate. Their great guilt like poison bit the spirit.

Act IV

> This is the charge of the goddess: sing, feast, dance, make music and love, all in My presence, for Mine is the ecstasy of the spirit, and Mine also is joy on earth.
> — Reclaiming Collective's "Invocation of Goddess"

The battle joined, Patricia Brown, Maureen Milburn, and Marcia Craig, members of the coven called the Gaia Collective, summoned leading ecofeminist witches Starhawk and Tisch from the Reclaiming Collective in San Francisco, and rituals and circles were held all over Salt Spring to raise the cone of power and bring it down to heal the earth. They embarked on such tasks as "moving energy around corners," singing, "Take off your head/Put it on the ground/That's how you enter the house of love."

The elements were called in, and praised, creating sacred space. Celebrating the body, food, love, song, wine, dance, drumming, the witches felt their years of abuse fade into insignificance. They went adventuring in the astral world. Their chakras opened, and going into trance and moving energy became easy and plausible, as if they were Celtic priestesses. They called in healthy male energy, power *with* rather than power *over,* an energy the world had never experienced. They performed the spiral dance, and by the end of it they had created their own private world, filled with mummers, fairies, elves, gnomes, and powerful spirits, called from their confines to enact the witches' present fancies.

Dr. Bristol Foster ascended and declared that each acre of forest held billions of microorganisms whose usefulness had not yet been identified; we must therefore protect as much forest as we can for

> Earth's increase, foison plenty,
> Barns and garners never empty:
> Vines, with clust'ring bunches bowing; . . .
> Spring come to you at the farthest
> In the very end of harvest!
> Scarcity and want shall shun you;
> Ceres' blessing so is on you.

Dr. Marilyn Walker, ethnobotanist, former director of the Prince of Wales Northern Heritage Centre in Yellowknife, and author of *Harvesting the Northern Wild,* ascended and declared that whereas Westerners talk about owning property, traditional cultures talk about stewardship. Walker spoke of the need to go beyond that, to cultures that have never lost the harmony among emotional and mental and spiritual. Traditional cultures, she said, all hold that plants have their own sound, their own song, and that they each have a lesson to teach and that therefore

> . . . the queen o' the sky
> Whose watery arch and messenger am I,
> Bids thee leave these; and with her sovereign grace,
> Here on this grass-plot, in this very place,
> To come and sport; her peacocks fly amain:
> Approach, rich Ceres, her to entertain.

Ceres had woken Angelique and Christianna in Saskatchewan and recommended that Christianna, a new fully realized being, move to Salt Spring and invite Amaterasu, a Japanese goddess buried in the earth for millennia, to the surface so that she might bring with her the devic kingdom, the spirits that weave energy into matter, and teach the people how to care for the land as sacred space. In the garden of their new house, Angelique and Christianna built a labyrinth on a ley-line vortex, and Amaterasu emerged through this portal and scattered many jewels of Vitality and Energy and Aliveness across the island, and she called out:

> You nymphs call'd Naiades of the windring brooks,
> With your sedg'd crowns, and ever-harmless looks,
> Leave your crisp channels, and on this green land
> Answer your summons: Juno does command.

The goddesses had ascended (that goddesses *de*scend is a patriarchal construction), and the healing of the land had begun. Prospero bid Ariel fetch the rabble to commence the referendum on the Official Community Plan, and before you can say "come" and "go," and breathe twice and cry, "so, so," each one, tripping on his toe, was here with mop and mow — and video camera, torch, and plan in hand to hurl at the island trustees, then (retrieved) to burn on bonfires in village riots in Centennial Park. Fights began in the bar at Harbour House:

> . . . red-hot with drinking;
> So full of valour they smote the air . . .
> For kissing of their feet; yet always bending
> Towards their project.

A witch spoke up and claimed that the island had prosperity enough. Had not a shopping mall of religious practices arisen: wicca, tarot, dream analysis, transformational massage, astrology, astral projection, precognition, psychic and homeopathic healing, meditation and yoga? Some of the resource-industry workers themselves had left their professions and opened shops to sell spiritual tat. In vain did Caliban decry the products of the forest:

> The dropsy drown this fool! What do you mean
> To dote thus on such luggage? Let's along,
> And do the murder first . . .

Regulations hunted the developers, loggers, and fishermen like hungry, angry dogs.

Act V

> Now does my project gather to a head:
> My charms crack not; my spirits obey, and time
> Goes upright with his carriage.

All business on the island was spell-stopped, confined until the referendum. All the developers were distracted, and those with large properties they wished to subdivide were mourning, brimful of sorrow and dismay. Tears ran down their beards like winter's drops from eaves of reeds.

But Prospero's affections had grown tender. He decided that the rarer action is in virtue than in vengeance and rewrote the Official Community Plan in order to allow some development but not that much. Pace and proportion were to be the guidelines. Policies were written that deliberately excluded outside investors in situations where economic benefits went only to absentee landlords. If developers were to come to the Islands Trust with plans that gave back Green Space, then some growth was possible. The marketplace would be delinked from the land. Collective rules would be

held higher than individual values. The Official Community Plan
was culled and simplified. Then Prospero called out:

> Ye elves of hills, brooks, standing lakes, and groves;
> And ye, that on the sands with printless foot
> Do chase the ebbing Neptune and do fly him
> When he comes back; you demi-puppets, that
> By moonshine do the green sour ringlets make
> Whereof the ewe not bites; and you, whose pastime
> Is to make midnight mushrooms; that rejoice
> To hear the solemn curfew; by whose aid —
> Weak masters though ye be — I have bedimm'd
> The noontide sun . . .

Out of the forest, streaming toward the voting booth, emerged
three or four thousands (the numbers are hotly contested) of
squatters with no stake in the land, who lived off the grid in school
buses, tents, yurts, tepees, and shacks. Some were shamans, who
could transform both the seen and the unseen, who could journey
to other realms, who experienced trances and visions and could
predict the future, and who could move between this world and
a less substantial — though ultimately more real — world for the
benefit of others as well as the self. Inside sweat lodges they had
contacted other worlds and made their requests, and the spirits
said that Salt Spring was to be held sacred. And so the tribe who
worshiped the Magic Mushroom came out of the forest, along with
their Fane, and all the people marveled at Prospero's magic, for
this tribe had not been seen for years.

And out of their houses, streaming for the voting booth, came
the newest arrivals, too, with autoimmune diseases that only a
clean, pure island with food products that were not bioengineered
or farmed with multiple pesticides could cure. And from these
illnesses had come forth Tofu Debbie, Barb's Buns, Dan Jason's
Organic Seed and Garlic Farm, David Wood's Salt Spring Island
Sheep and Goat Cheese, Green's Plus — an entire economy of
wellness, just as the witches had said. It was not for nothing that the
principal mountain was called Mount Maxwell.

All torment, trouble, wonder, and amazement inhabit here,
cried the developers as they watched the island saved for the nature
spirits. Gonzalo himself saved the Mill Farm from a consortium of

Washington State loggers by purchasing the land. Seven covenants were put in place to protect this plot in perpetuity, and Ariel, representing all those who weave the ether into matter, sang:

> Where the bee sucks, there suck I
> In a cowslip's bell I lie;
> There I crouch when owls do cry.
> On the bat's back I do fly
> After summer merrily:
> Merrily . . . under the blossom that hangs on the bough.

Entire matrices of vortices opened after the new Official Community Plan was accepted and the developers restrained. Trees began to talk, and all the plants were discovered to have an opinion as to where they should be planted. Radishes in magic gardens grew to the size of grapefruits, and raspberry plants reached ten feet tall. Ariel suggested that Salt Spring should become like the old mystery schools of Egypt and teach people how to heal, how to find and manifest visions, how to become elders, how to lead the Shift of Ages.

Unsuspecting tourists came and marveled and spent money. And it was discovered after all that displaying and marketing the products of a magic island indeed produced profits — not large profits, but profits nonetheless. And the businessmen finally agreed,

> . . . do entreat
> Thou pardon me my wrongs.
> This is as strange a maze as e'er men trod;
> And there is in this business more than nature
> Was ever conduct of . . .

And they threw in their lot with Prospero, deciding not to infest their minds with beating on the strangeness of this business.

And still the convergences pulled others — not just tourists but artists and musicians and movie stars, all wandering the island with eyes full of beauty, blind with wonder. It was not for nothing, therefore, that the many Mirandas exclaimed,

> How many goodly creatures are there here!
> How beauteous mankind is! O brave new world,
> That has such people in't!

Epilogue

But this is the twenty-first century, or almost so, and in this world we have Karl Lagerfeld, whose pet in the eighties was a young woman named Gloria, the Princess von Thurn und Taxis, a onetime Düsseldorf nightclub punk introduced by Karl, after her marriage to an antique cousin, to the thrills of the very rich, such thrills including couture, gambling, over-the-top decorating, and the pleasures of Area, Les Bains, and the Palace. A few years after her ancient husband's death, Gloria realized that her debts were insurmountable but that she had an old-fashioned forest estate way the hell and gone in western Canada. She promptly sold it to a couple of development fiends.

Greenbaiting and greenmail are honorable businesses in the Northwest; for there is money in them. While waiting for their opposition to organize, the fiends made loud plans to strip the Princess's erstwhile forest estate of "every scrap of merchantable timber."

The witches had withdrawn, buried their books, and were growing gardens filled with not-magic indigenous plants that jibed with the tenets of bioregionalism. They had stopped going to community meetings, because they did not like being shouted at. They had started a new circle of elders, called the Transformation Group, that would work toward a civil community, without the violence and polarization of the past. They begged leave to retire:

> *Now my charms are all o'erthrown,*
> *And what strength I have's mine own;*
> *Which is most faint . . .*

But on the magic island lived others now, and a new Prospero, Andrea Collins, the former wife of the crushingly famous rock star Phil Collins, made sure that people the world over knew of the magic island and its dilemma. The witches took off their clothes and posed on their treasured island, and the calendar was blessed with many sales. Money was raised, pots of it, first in the amount of $800,000 from the community itself, more from a consortium of anonymous donors, NGOs, and government agencies. Thousands helped this time. There were blockades, and street people came from all over the world to live in the Peace Camp. People were arrested. People were slapped with nuisance suits. Community newspapers were sued for libel, as were columnists and editors. Dossiers and writs flooded the courts, until the government grew weary and pled for mercy, too.

Gentle breath of yours my sails
Must fill, or else my project fails

Then people with doctorates and bureaucratic expertise raised $3.9 million and placed it on the table. They then raised $7.7 million and placed it on the table. And finally they raised $20 million and placed that on the table. Then Prospero amazed the greenmailers by demanding that the land be frozen in time, left to its true owners, the fairies.

The witches rejoiced, for there had been parties, and dances, and fairs, and barbecues, and TV shows, and documentaries, and poems, and more parties, just as the Goddess required. And at one of the last, David Suzuki, who some saw as the greatest warlock of all, came to the island, and everyone who had been arrested or slapped or sued was his guest of honor.

The Princess's lands were proposed as a national park. And Prospero, by your indulgence, was set free.

MOLLY O'NEILL

Home for Dinner

FROM *The New Yorker*

ONE MORNING last winter, Sottha Khunn — the chef whose four-teen-year reign at Le Cirque earned him international fame and a four-star rating from the *Times* — sat on his mother's terrace in Cambodia, wearing Yves St.-Laurent boxer shorts and peeling man-goes. It was not yet 5 A.M., the temperature was already ninety de-grees, and the landscape was silent and still, as if swept by a hurri-cane that had long since moved on. Below, in the predawn light, was a jungle of a garden and a high locked gate; the trees that fringed the scrubby field across the road were violet silhouettes.

In each mango, Sottha made a shallow incision and pulled up-ward, lifting rather than slicing away the blushing green skin. Over the years, as Sottha has evolved from a staunch French classicist to one of the leading architects of East-meets-West cuisine, I've watched him hacking and mincing meat, fish, vegetables, and fruit for hundreds of hours. Even so, the sound of the mango skin rip-ping away from the fruit's flesh was unsettling. Every few moments, he would glance at me over the top of his graphite-framed half-glasses, and I wondered what he was thinking.

I had interviewed Sottha dozens of times for stories about food and culture, but it took a decade before he allowed a careful, famil-ial sort of friendship to take root between us. He likes to communi-cate by innuendo and metaphor, especially food metaphor, and his French-accented English rushes along in Khmer cadence. I have developed the habit of first deciphering the words, considering the context, and then repeating back to him what I think he's saying. Once, he told me that I was like his "see-key-a-tree," or "psychia-trist." "You say what I think," he said.

Several months earlier, facing his fiftieth birthday, Sottha had abruptly resigned from Le Cirque, and turned down book deals, television opportunities, and job offers that would have tripled his income. He announced that, after twenty-seven years in the diaspora, he was going home — back to Siem Reap, the town in Cambodia where he had grown up. "Maybe for three months," he'd told me, "maybe for good." Every time I asked him to explain his plans, he offered a different scenario. At first, he thought he might open a school to train chefs, or a restaurant to attract tourists: "Before I die, I wish to make something for Cambodia." Later he said, "I want to give my mother some happiness before she dies, help her finish the house, maybe cook for her one perfect meal. Better than sending orchids to the funeral." He also said that he'd reached a creative impasse in the kitchen. "I can play any note that anyone has ever played, and I can play it perfectly, but still I am missing a note," he said. "Maybe I know it and I forget. Maybe I never know it."

One particular dish — sea bass steamed over a broth of lemongrass and *galangal* (a gingerlike root), thickened with butter and enlivened with chopped tomatoes, chives, and basil — had become the emblem of his frustration. He worked and reworked the dish, and it earned him critical praise, but he felt that some minute calibration between sweet and sour continued to elude him. "Not yet the perfect balance, the sensation that lets the customer taste the world as I taste it," he said.

Sottha never told me that he was going home for himself. Instead, he turned to me the night before he left Manhattan and said, "I am going home for mango season. How can I explain it to you unless you come and taste?"

Sottha's bearing, his manners, and his acute sense of society's appetites had long distinguished him in professional kitchens, but his origins have always been mysterious. People assumed that he was wellborn and escaped by luck the nightmare that had befallen his country — that he had spent decades working sixteen-hour days to avoid looking back. But he has always discouraged direct questions about his past. "There are seven million Cambodian stories," he once told me. "I am only one, and not such an interesting one."

In 1998, Sottha returned to Cambodia for the dedication of his

father's *stupa*, a burial monument, and saw his mother briefly, but he was so undone by the disappearance of the country he had known that he took the next available flight back. I thought he was crazy when he started talking about going home for an extended stay — maybe even forever. I also thought his invitation, which had sounded almost like a challenge, was really a plea: He wanted a witness.

By the time I joined him in Siem Reap for my mango lesson, Sottha had been home for several weeks, long enough to feel exposed. "You will taste each one — more sweet, less sweet, and more less sweet," he said, cutting fat slices from each of the three mangoes. "That way, you know the whole story, always by contrast." There are, he explained, three kinds of mangoes in Cambodia. The flesh of the cheapest and most common is gaudy orange, fibrous, and cloyingly sweet. A midrange mango is the color of monks' robes — a dusty orange-gold. It is sweet, too, but there are slivers of sour running through it, like ice. In the rarest, most expensive mango, sweetness is balanced by spicy, musky, and tart flavors, and its flesh is smooth and creamy, the color of the gold moon. Here, sweetness is a respite from sour — a concept that looms large in the Cambodian imagination.

"You see?" he said, staring at me. "Once you taste the perfect taste, just once you taste it. And you spend your whole life looking for it again. But you can never find it, never. The chef, he works like an animal to make one perfect taste, and when he does it break his heart, because he no can make it again, ever. But the chef, he can't stop himself, he keeps looking and looking, he will do anything to find that one perfect taste again."

Most mornings, I sat on the second-floor terrace of Sottha's family home and watched signs of Cambodia's past and its future slide by. Peasants pedaled toward the market on wobbly old bicycles loaded with foraged firewood, roots, and greens. Entire families were crammed onto Honda Dream motorcycles, ferrying children to school. Men who'd lost their legs in land-mine explosions scooted by on wheeled wooden platforms, heading to the center of town, where they would beg, like the skinny barefoot children who ambled along the apron of the road. Tour buses zoomed by, chasing sunrise to the ruins at Angkor Wat.

As many as a hundred thousand people live in Siem Reap, which is situated in northwestern Cambodia. The town is anchored at its southerly tip by the Tonle Sap, one of the largest freshwater lakes in the world, and at its northeastern end by Angkor, the ruins of a vast temple complex built between the ninth and the thirteenth centuries, when the Khmer empire encompassed Myanmar, Thailand, and much of Laos, Vietnam, and the Malay Peninsula. Since then, Cambodia has shrunk from being the cultural center of Southeast Asia to its Poland: a buffer state between its more powerful neighbors Thailand and Vietnam.

The Khunn family accumulated rice fields for five generations before Sottha was born, in 1951. During his childhood, he said, "past glory still justified everything, the very existence of the country, the way things were done." The division between rich and poor was severe, and, like other children of privilege in the nineteen-sixties, Sottha spent as much of his adolescence railing against the inequities of Cambodian society as he did absorbing the ornate mores and closely circumscribed expectations that he was born to. He was a graduate student in Paris in 1975, when the Khmer Rouge — originally led by a band of educated and privileged idealists — succeeded in toppling Cambodia's royalist government. Like most Cambodians, the few members of Sottha's extended family who survived Pol Pot's regime spent the next two decades attempting to rebuild their lives. The family home, a spare two-story white stucco house that is a replica of the one that was destroyed in the war, sits on the small square of land that was restored to the family in 1995. Sottha's savings helped rebuild the house; his mother, Long Sovann Khunn, supports herself by running it as a bed-and-breakfast (by invitation only).

In a month of traveling throughout the country and interviewing diplomats, international relief workers, and Cambodians from the diaspora who have returned, I found that the élite class had not disappeared with the war; its composition had simply changed. Today, government officials control the bulk of the country's wealth. Most Cambodians are subsistence farmers, and widespread corruption — from the greedy bureaucrats to the woefully underpaid teachers who sell test answers to their students in order to feed their own children — is hobbling the economy. At the same time, a new middle class and a vibrant tourism industry have taken root:

Hotels are altering the skylines; restaurants are crowded; and the roads are clogged with small motorbikes and old Toyotas. In the evening, new televisions blue the windows of private homes. Many Cambodians were eager to discuss these changes, but Sottha was not. "I am a cook, not a politician," he said. Instead, he sought to make sense of Cambodia's changes through the idiom of taste.

Sottha and I spent as much time as his mother would allow in her kitchen, a long breezeway that flanks one end of her home. There he studied the ingredients that shape the sweet, sour, salty, and bitter notes in Khmer cuisine. He parsed the various sweet tones in curry, banana, sugar, and mango; he contemplated the difference between salt, soy, the fish sauce called *tik trei*, the more intense fermented paste called *prahok*, and the distinct sorts of bitter heat from herbs and wild greens. The sourness of lemongrass as opposed to that of tamarind, young pineapple, lime, vinegar, green mango, and papaya occupied him for hours. Cambodian cooking is the subtlest cuisine in Southeast Asia: less sweet and spicy than Thai cuisine, less bitter and salty than Vietnamese. The Khmer dishes his mother cooked were brighter, sourer than he'd remembered.

For lunch and dinner every day, Mme. Khunn prepared a multicourse meal, alternating, in accordance with Cambodian tradition, solid and liquid, cooked and raw. She made tiny spring rolls stuffed with crab, frogs stuffed with minced pork and lemongrass, curried fish, stir-fried fish with bamboo and water lilies. She made pork stewed in caramelized palm sugar, peppered beef with peanuts, and stir-fried chicken with pea-size eggplants. She made vegetable broth with banana blossoms and fish balls, and pork broth soured with tamarind, thickened slightly with rice starch, and chock full of tiny shrimp and greens. She viewed the food she cooked for her firstborn as a mother's conversation with an amnesiac. She often spoke about Sottha — usually within his hearing. "I wonder if food tastes like he remembers," she said to me one day, "or if he doesn't remember, or if the cooking changes because we change."

Mme. Khunn is sixty-eight years old, short and plump. She wears a housedress in the kitchen, quickly wrapping a sarong around her waist when anyone enters. She keeps her hair black, and wears it short. Her face is angular, ruddy, typically Khmer; Sottha, like his late father, looks more Chinese — paler, smoother, rounder. Like

many Cambodians, Mme. Khunn sees her life in three frames: be-
fore Pol Pot, during Pol Pot, and after Pol Pot. Before Pol Pot, she
had married well, and — like all women of her status — she'd be-
come a connoisseur of high Khmer culture: its ballet, its music, its
traditional palace cuisine. But instead of attending her mother-in-
law, as tradition dictated, she devoted herself to public service and
the arts, learning French, English, Russian, and Vietnamese along
the way. Sottha's mother was glamorous; she was also a distant and
distracted parent, entrusting her children to nannies, relatives,
and French private schools.

By 1974, when she sent Sottha to graduate school in Paris, the
ranks of the Khmer Rouge had been growing for more than a dec-
ade. The rebels, who lived in training camps in the jungle, were be-
coming increasingly violent and difficult to ignore. That year, they
had taken over dozens of provincial villages throughout the coun-
try, and were poised to march on Phnom Penh. But the Khunns,
like many Cambodians, never imagined that a revolution led by
children of privilege could end up destroying their world. Then, in
the spring of 1975, a few months after Sottha's father died, of a
heart attack, the Khmer Rouge invaded Siem Reap. Along with the
rest of the town's inhabitants, Sottha's mother, brothers, and sister
were ordered from their home and marched north into the jungle.
Mme. Khunn's parents and brothers died along the road. At the
end of the march, her eighteen-year-old son was caught eating a
foraged yam, and to avoid the punishment — typically evisceration
— for "greed," he committed suicide. Her two youngest sons and
her seven-year-old daughter were sent to the countryside to herd
cattle. Mme. Khunn spent the next four years clearing land, build-
ing huts, and tending to bands of other people's children.

Now, twenty-six years later, she was swaying in the hammock in
her kitchen, peeling shallots, looking more like a peasant than a
former grande dame. She lost a second son in an accident in 1998,
but her son Thony and his wife live with her and help maintain the
house; her daughter, Mum, visits regularly from Phnom Penh; and
her firstborn son has finally come home.

Like Sottha, Mme. Khunn frequently communicates in meta-
phor, stories, and innuendo. Before taking up her shallots, for in-
stance, she showed me photographs of Angkor Wat, pointed out
how Buddhist characteristics had been applied to earlier Hindu

images, and then, with a meaningful glance, asked me to taste the soup she was making. In the nineteenth century, the Sanskritist Émile Senart wrote about Cambodia's tendency to "submerge deep differences inside surface similarities," and noted that even the evolution of its religion was a process of layering. Likewise, in the Khmer kitchen, elements from Java, Malaysia, China, Thailand, and Vietnam were added to the Indian foundation, deepening, rather than changing, the basic balance of sweet, salty, sour, and bitter. The daily pounding of lemongrass, *galangal,* turmeric, garlic, and shallots in a mortar and pestle to create *kroeung,* the spice paste that is the foundation of most dishes, is an indication of how seriously melding and fusing continue to be taken in Cambodia.

Sottha argues that the fact that *kroeung* is made for each meal, instead of in large weekly batches, reflects another Cambodian characteristic. The Cambodian, he said, "doesn't think ahead. He never had to. When he is hungry, he reaches up to the tree for fruit, into the water for fish, and he eats what he gets." Sottha was standing over a box of huge hard-shell crabs on the ceramic tile floor of the kitchen.

"Not true, Sottha," said his mother, who, having finished the shallots, had moved from the hammock to a grass mat on the floor to begin pounding the paste for lunch. She argued that the paste was made fresh because one dish might need more lemongrass while another might need more shallots or garlic. Sottha didn't point out that small portions from a large batch could be tailored for each dish. He smiled at his mother, and shook his head at me.

"He's been away too long," Mme. Khunn muttered. "He doesn't remember." She rose to stir the *kroeung* into a pork broth with tamarind and *prahok.*

The kitchen smelled like the muddy banks of the Tonle Sap when the day's catch is drying and women are squatting around small three-legged stoves, simmering what they've caught and foraged. Most Cambodians live on a diet of rice with modest amounts of fish and vegetables, whereas Mme. Khunn cooked high Khmer cuisine for her visiting son. Even so, her kitchen smelled like everyone else's, and she was proud of it. "Since Pol Pot, I don't cook French," she said.

French cuisine is, perhaps, the only cuisine introduced to Cambodia that has never fused with Khmer cooking. It remained sepa-

rate and was, until recently, a gold standard — the food of the élite. Now, however, after a war that all but destroyed Cambodian high culture, knowledge of the ornate traditions of Khmer cuisine has become more precious. King Norodom Sihanouk is still proud of his French cooking, but Mme. Khunn and her two best friends, Luk Mei Tioulong and Paula Prem, are as obsessed with Khmer cuisine as conservation groups have become with Cambodia's vanishing forests. For Mme. Khunn, cooking is not simply making a meal; it is a way of passing along an endangered tradition. Frowning at the crabs on her kitchen floor, she said that it was already too late to reverse some of the ways that Khmer customs had changed in her lifetime.

Cambodian Buddhists are not prohibited from eating flesh; they just aren't supposed to kill for it — which created a tradition of hypocrisy in the markets. For instance, before Pol Pot, a Buddhist Cambodian woman might admire a fish in the market by saying "Too bad it is still alive," and continue walking until the fishmonger, who was invariably Vietnamese, caught up with her and announced that the fish had just died. During Pol Pot, when people survived on insects, snakes, paddy rats, and birds, the prohibition against slaughter largely disappeared. But some, like Mme. Khunn, would no more kill a crab for dinner than they would forget to make morning offerings. Her son assured her that he would execute the crabs. "Don't worry," he said. "I already killed a million lobsters. What's twelve more crabs?"

His war had been different.

Sottha was planning to earn his doctorate in economics when he left Siem Reap for Paris on September 6, 1974. He'd grown up on Evian water, *pommes de terre dauphinoise,* and *filet de sole à la bonne femme,* he said, and he felt at home in France. When his father died, it was already too dangerous for Sottha to return for the funeral. In April of 1975, Phnom Penh fell to the Khmer Rouge. "At first I thought it was a joke, or they made a mistake," Sottha recalled. "How could the Communists come to Cambodia when all our lives we pray to the Buddha?" Unable to pay for school, Sottha rented a tiny studio in the Twelfth Arrondissement, and a family friend in Paris helped him secure an apprenticeship at Maison Prunier, then a fashionable restaurant with two Michelin stars. He'd never

cooked a thing. "When I was little, I watched my mother's parties. Watching, watching. Always I was asking for a taste, but never, ever could I have that," he said. "I figured I could learn cooking, and, besides, what other job is a Chinese going to get in Paris?"

Sottha hunted for news of home — reading four newspapers a day, trading scraps of information with other members of the large expatriate Cambodian community, and frequently visiting a distant cousin who owned a television. He assumed that his family was dead, and lost himself in the sweaty trenches of restaurant kitchens, where the unceasing demands of the moment obscured the past. Every day, Sottha said, was like a war. "The orders attack you, the chef attacks you, you sweat, and you fear one mistake. You must become a machine or you are dead."

It takes about ten years to become a chef — to master the ways of a knife, the inner life of ingredients, and the vicissitudes of heat, and then to hone this knowledge until it lives in the hands, like a musician's response to notes on a page. Sottha spent four of those years at Maison Prunier, working twelve-hour days, except on Mondays, when he slept and read cookbooks. He also made a weekly pilgrimage to Fauchon, the exclusive grocery store in Paris, to look in the window.

"I stared and stared at the mangoes, so expensive I could not buy them, so I try to imagine them, but soon I forget," he said. "My happiness became cooking. I put my life there." In that period, he began listening to Mozart and Beethoven. "I understood that the meal is a symphony and that I was young, just learning the notes." He continued his apprenticeship with Alain Senderens, who helped create nouvelle cuisine, spending a year at his restaurant L'Archestrate, which had three Michelin stars. He spent the next year at Troisgros, another Michelin three-star restaurant, in Roanne. Then, in 1980, Sottha received a letter that his mother had slipped to an American journalist. A Vietnamese-backed invasion had toppled Pol Pot, and she'd been sent home to Siem Reap and made the general manager of the Grand Hôtel d'Angkor; she did all the cooking, cleaning, and laundry in the luxury establishment where she'd once entertained. Sottha's three surviving siblings were in a group home nearby.

There was still no mail service in Cambodia, so Sottha couldn't respond. But by 1981 hints of Southeast Asia were surfacing in

his cooking. Named executive sous-chef to Alain Passard at Duc d'Enghien, a restaurant eight miles north of Paris, he began to use wonton wrappers to make crabmeat ravioli, which he served in a ginger broth. He also began to use exotic fruits and to infuse sweet syrups with lemongrass for desserts. The restaurant earned two Michelin stars in 1983. The following year, Sottha was recruited by Daniel Boulud, another prodigy of French cooking, to help open the dining room at the Hôtel Plaza Athénée, in Manhattan. "I put the salt, and Daniel put the pepper," Sottha recalled. "We are like one mind, one person, one taste." Two years later, the French chef and his Cambodian sous-chef took over the kitchen at Le Cirque and began creating modern classics: sea bass wrapped in parchment-thin potatoes, scallops "black tie" (studded with black truffles). By the time I met Sottha, in 1991, he was midway through his second decade, the time when a chef's personal style usually begins to emerge. In Sottha's case, I could taste the East in his Western cooking, but just barely; his effort to create a distinct signature was still tentative. But he had become a master at pleasing people.

During every meal at Le Cirque, Sottha would stand in the kitchen in his well-starched white jacket, as compact as a major-league catcher directing the game from behind home plate. As the waiters rushed in to report on the personages seated in the dining room, Sottha would instantly connect the names with what he had read or heard of each diner's tastes, dietary concerns, and self-image, and signal his staff to cook accordingly. Intuitively, he knew to order deeper exotic seasoning and a vivid, spare presentation for the self-consciously hip, and then, imagining the same dish for a self-made mogul, to order subdued seasoning, a more bountiful look, and the addition of obvious luxury — a hillock of beluga, for instance, or a palisade of shaved white truffle.

He lived a monastic life in New York, working twelve to fourteen hours almost every day. In 1994, he bought a tiny co-op on the Upper East Side, where he listened to Beethoven, polished his small collection of Cambodian silver boxes, tended orchids, and doted on Ted, his Bichon Havanais. Then Sottha was given an opportunity to define his cuisine. Boulud had resigned from Le Cirque, in 1993, to open Daniel, and Sottha initially declined to take his place, preferring to remain a sous-chef. But in 1996, when Le Cirque closed at its original location, the owner, Sirio Maccioni, persuaded Sottha to accept the position of executive chef, offering

him a year to help design the restaurant's new kitchen and menu. Sottha continued to talk about his job as if it were a war, but, instead of fearing death at the hands of an exacting chef, now he was terrified of food critics.

A week before Le Cirque was scheduled to reopen, Sottha's dishes tasted perfect to me but not to him. His frustration was apparent as he sat with two assistants in the restaurant's lower level, behind the glass wall of its humidor room, making the final selection of dishes that would appear on his first menu. "They're going to kill me," he muttered. "Just waiting to kill me." I'd written "Losing it" in my notebook when there was a thundering explosion, and the four of us dove under the table amid a cascade of glass. The wall behind us, improperly installed, had shattered. "What I tell you?" Sottha said to me.

After that, Sottha started talking less about aesthetics and more about himself, although always indirectly. He first alluded to his nationality by telling me his response upon hearing that Henry Kissinger had been seated in the restaurant. "I couldn't cook," he said. (Kissinger's extensive bombing of Cambodia in 1973 had helped pave the way for Pol Pot.) "But after the first time," he continued, "no problem. Mr. Kissinger is a man of taste."

At Le Cirque, Sottha was fascinated by the pathos of his wealthy customers' lives — the woman who wore a crown to lunch ("Poor thing, I feel so bad, she want to be the queen, and America can give her everything but a throne"), the man who could eat only soft food ("Can you imagine? He have everything, all the money in the world, but no teeth"). "I learned the limits of society, and for me it is the human condition that is more interesting," he said. "I read Molière, so what? What is more interesting is what people have in common — appetite. And, if they are lucky, taste."

He also confessed his weakness for *The King and I,* one of the few movies he owns on tape. "I can't help it," he said. "Maybe I watch this video one hundred times." One evening last year, after cajoling me into watching it with him, he described his own background and his deep ambivalence about the world of his parents: "When I was little, my mother had two little white dogs and she loved them more than her children and gave them always steak tartare and Evian and gold collars," he recalled, gasping with laughter. "Then came Pol Pot. And like that, the dogs, they lost everything."

*

The war's toll on lives and places — and, perhaps equally disturbing, the steady trickling away of the country's resources — was apparent everywhere I went in Cambodia. The hillsides are scarred by illegal logging, and gems and ancient artifacts get spirited out of the country to Thailand, where they are sold, covertly, to Westerners. Sottha, however, showed little reaction to these trangressions and offered little comment. His jaw tightened as we stood in front of a pantheon of headless statuary at Angkor, but when I asked him about the relics trade he did his best to deflect my questions. He encouraged me to consider where Cambodia's treasures might surface: "Garden walls, birdbaths, planters in the Hamptons?"

Sottha's friend Lim had joined us for a week of traveling through Cambodia. A robust man with white hair, high energy, and equal measures of joy and righteous indignation, Lim was as direct as Sottha was discreet. One of the few Cambodian friends Sottha had made during his years in exile, Lim hadn't seen his homeland since the nineteen-sixties, when he left for graduate school in the United States. A highly respected chemist who earned his reputation parsing and synthesizing flavors for the food industry, Lim had retired just before accepting Sottha's invitation to visit Siem Reap. The two men spent hours analyzing the ways in which their country's recent history was reflected in its cuisine. One day, we drove from Phnom Penh through the province of Kompot to Kep, a famous old resort town on the Gulf of Thailand. The road was all but impassable, and when Lim wasn't complaining about the lack of clean running water in the impoverished villages, or the freshly lumbered swaths that zigzagged across the Cardamom Mountains, he cheered himself with memories of Kep, a place that both he and Sottha had visited as children, when it was a bustling resort with white villas perched on the hillsides and beaches dense with parasols.

But we arrived in a ghost town. Moss grew on the rubble of once grand homes along the wide boulevards. There were no stores. Two policemen, two scrawny children begging, and a man inexplicably selling stuffed banana leaves were the only signs of life on the crumbling promenade along the beach. Lim collapsed on the first bench he reached. Sottha walked off, returning a few minutes later with a stack of the thin banana-leaf squares.

"Remember *noum sloeuk chek*? We ate so many," Sottha said, sit-

ting down next to Lim. Inside each folded leaf was a thin barbe-
cued rice pancake with coconut cream and black sesame seeds.

"A world disappears," Lim said. "Its snack remains."

"Isn't it amazing," Sottha said, glancing around at the seaside ru-
ins, "how the sweet thing tastes sweeter next to the sour?"

On the way back to Phnom Penh, the two men discussed the dif-
ference between bitterness, which eventually numbs one's tongue,
and sourness, which lingers in the mouth, changing the way other
things taste. We'd planned to stop at a black-pepper plantation af-
ter visiting Kep, but Sottha changed the plan. "Too dangerous," he
said — a frequent refrain. Although travel in Cambodia can be ar-
duous, tourists are courted and travel is relatively safe. Returning
after so many years, however, Sottha experienced his country as a
vast unknown, and became obsessed with the comfort and security
of his guests. He discouraged a picnic to the sacred mountain
Kulen ("land mines and snakes") and vetoed a proposed trip to the
cashew and fruit plantations outside Battambang, citing the possi-
bility of being attacked by bandits. His family laughed at him; after
several days, so did his guests. Nevertheless, if someone was five
minutes late returning home from an outing, Sottha would pace
the terrace of his family's house, chain-smoking menthol Benson &
Hedges. On the way back to Phnom Penh as evening fell, he asked
each of us, for the fourth time that day, if we had our passports.
"You need a passport for Phnom Penh?" I asked. "If something
happens, we go directly to Vietnam, directly out of this country," he
replied. "My family already learned this lesson."

For many French people, a perfect omelette symbolizes the re-
strained force and impeccable taste of a self-assured society. *A-mok*
represents something similar to Cambodians: the curried-fish cus-
tard steamed in banana leaves is testimony to the power of gentle-
ness. The squabbling hot, sweet, salty, and bitter tones in the cur-
ried fish are softened and suspended in a harmonious coexistence
by the fragile custard.

Lim swooned for Mme. Khunn's *a-mok,* and was not shy about
hugging the cook. Every time he ate a meal, he remembered
things, he said. This pleased Madame; her own son was courteous
and attentive but much more aloof. The memories stirred in Lim,
however, were not always comforting. After dinner, as we sat on the

terrace in the dimming heat and light, he might praise a meal and then suddenly remember a childhood friend whose parents couldn't afford to send him to school watching Lim troupe off with his book bag. "It enraged me. I blamed my parents and their world," he said. "It wasn't that we had much, but I hated the society that had anything when most people had nothing — the injustice."

The damp air was sweet with the scent of jasmine and mimosa. Sottha's laugh was a cough in the dark. "We all hated it, a whole generation born rebelling. When the parents send us to the lycée, we study the French Revolution and we think that's the answer — we must cut off the heads of the rich!"

"Some of us who left never changed," Lim replied softly. "If I'd stayed, I'd be dead. I was such a bigmouth, it scares me to think what I might have done." He continued, "And I come back, can't remember the language, but that anger, my God — I see the poverty, the corruption, and I'm nineteen years old, still raging."

After Lim left the Khunn household, Sottha ventured from home only to accompany his mother to the market in the morning. In his polo shirt, well-creased Bermuda shorts, and flip-flops, he looked like a foreigner among the squatting vendors. Until he spoke Khmer, they quoted him tourist prices.

"I don't belong here anymore," he said one morning as we rode the mile home from the market in a rickshaw pulled by a motorcycle. He told me about visiting the countryside, and how overwhelmed he'd been by the poverty. "I asked one woman why does she not get a pig — that way, you feed it for six months and you have a lot of food," Sottha recalled. "She tell me, 'I have to feed my children before I can feed a pig,' and I was so ashamed. I was grateful my father died before he hear me say something so stupid." His father had always told him that people had to have food before art. "I am thinking that a restaurant or a cooking school is not right for Cambodia now. People must eat and read before they learn to work in restaurants."

Sottha devoted most of his time to helping his mother in the garden. They spent several days repotting fifty-nine orchids into coconut shells and hanging them on a shaded arbor. From my room on the second floor, I often heard them laughing, slipping from Khmer to French to English as they discussed unfinished details in the house — the drapes needed here, the furniture needed there.

One evening, as we walked through the garden, he named the trees and plants for me: frangipani, yellow oleander, sea hibiscus, queen of the night, gardenia, bird of paradise, Malay apple, lime, guava, longan, durian, jackfruit, and litchi trees. "Can you imagine?" he asked. "In New York, I live on Tylenol for the headache, but here I never take one." He continued, "I think the most important thing is I give some happiness to my mother." He had begun planning a feast for Mme. Khunn and her friends. "I've cooked for kings and presidents and the Pope but never for my family. Can you imagine that?"

Whatever had begun to melt inside Sottha seized up again when Mme. Khunn's friends Luk Mei Tioulong and Paula Prem arrived, along with her brother-in-law Chau Sen Cocsal, for the weekend. They set up their table for *bair tong* — a betting game played with ticket-size cards — in the living room as Sottha began his lengthy preparations for the grand meal. Their cackles and shrieks rose above the slapping sound of the cards and drifted into the kitchen as the gamblers competed to see who could tell the most outrageous stories. Sottha poured them coconut water and Evian, smiling politely, and then returned to the kitchen, raising his eyebrows and shaking his head like an impatient adolescent.

"Like my grandmother," he said, "all day long, play *bair tong*, talking, getting massages, one maid doing all the work." And yet there was nothing indolent about the elders, nothing parochial or self-reverential. Having survived their history, they had earned the right to laugh at it. "We learned, we changed," Mme. Khunn said. "So the past seems very far away."

Mme. Tioulong had regularly been asked to advise the king on Cambodian traditions and protocol; between vintage tales of philandering husbands and polygamy, she was given to satirizing the manners, style, and personal foibles of Cambodia's current and former élite. Paula Prem had recently begun teaching the classic Khmer palace cuisine in Phnom Penh; her descriptions of educating the culinary illiterate made the others laugh until they cried. Cocsal was also a joker. At ninety-five, he is still the minister of Cambodia's constitution. "If they don't like what I say, what are they going to do?" he said. "Shoot me? Why waste the bullet? I'm going to die soon anyway."

When the conversation drifted from the past to Cambodia's current state of affairs, the four of them would cluck about living in an upside-down world, where royalists are populists and the Communists are making all the money. Occasionally, Mme. Khunn would glance toward the kitchen door and her friends would lower their voices. "Sottha does not understand," she told me. "He's been away too long."

Something was shaking the chef's usually infallible instinct for the tastes of his diners. The menu he'd planned harked back to the past that his mother and her friends congratulated themselves on having transcended. There was foie gras that he'd carried with him from Manhattan; roasted chickens stuffed with black truffles; roasted beef tenderloin with an old-fashioned Bordelaise sauce; a *gâteau au chocolat;* a fruit tart. "It is what they want," Sottha insisted. He compared it to the way in which the public tends to prefer a composer's early work over his mature art. "None of this I have cooked in twenty years, but what do I care, if it makes them happy?" He allowed only one dish to veer from the old-fashioned French idiom: the sea bass that had confounded him at Le Cirque. "But very subtle," he said. "It has to taste French. If they taste the Asian seasoning, they will think it is not elegant."

In addition to cooking for an audience that existed only in his memory, Sottha was not cooking at the top of his game. His menu was too ambitious for one set of hands, and since early morning he had been grimly efficient, yet his trademark attention to detail was missing. As I helped prepare the tomatoes for the sea bass, for instance, carefully carving the flesh into the minute diamonds I'd seen him create hundreds of times, he said, "Forget the diamonds, what they know? Just rough chop."

His obsessive finesse continued to evaporate as the sun got meaner and the amused anticipation at the *bair tong* table grew. The beef, which was tough, should have been marinated, but Sottha shrugged it off. He'd insisted that the bass seasoning be mild yet couldn't stop himself from adding more and more garlic and lemongrass to his olive-oil marinade. He neglected to baste the chickens sufficiently, so that they dried out as they roasted, and he proceeded to overcook most of the vegetables.

Even so, a distinctly French aroma filled the house. The elders

kept tiptoeing to the kitchen door for a deeper whiff, beckoning each other to peek at Sottha as he set the dinner table. He used a white linen tablecloth, and wrapped each napkin in a ring of mimosa flowers. The effect was lovely, in a very proper Sixteenth Arrondissement sort of way. As we looked at it together, Mme. Khunn smiled sadly. "Sottha was not here," she whispered. "He is there," and she nodded toward the open door to the next room, where a painting of a young boy with well-combed hair, a bow tie, and an obedient expression hung on the wall. For Sottha, it was as if time had stopped the day he left the country.

"I hear Le Cirque is as expensive as Robuchon," Mme. Tioulong said, settling into her seat across from me at the table as Sottha began pouring champagne. "Big bucks," whispered Cocsal, who had also lived in Paris, and was seated to my left. The old man joined the collective *ooh!* when Sottha served the terrine de foie gras with a tiny salad, but then he beckoned for me to lean down so that he could speak into my ear. "Can you eat this for me?" he said. "I'd rather have rice. Rich food keeps me awake." Like everyone at the table, however, he smiled broadly and said "Thank you, just delicious" to the chef when he cleared the plates, with their gently nibbled portions.

"What I tell you," Sottha whispered as he bent to take away my plate, the only empty one at the table. "They love what they remember. They're not going to like the bass — too spicy, too bold. I got carried away."

The dish didn't look bold; it looked innocent. Sottha hadn't added the tomatoes. The butter sauce was light, and its lemony hue, combined with the pale minced chives and wild greens, was almost translucent against the white fish fillets, like refracted sunlight. Without the tomatoes, the sauce was tart and sour, the fish gentle and sweet. The scent of lemongrass erupted like a cheer over the distant, poignant memory of *galangal* and garlic. Sottha had done it: he had found a new balance between East and West.

The room became very quiet. The elders looked at each other as if one of their children had just won the Nobel Prize. Within three minutes, every plate on the table looked as if it had been licked clean. When Sottha saw the empty plates, he understood that he'd seriously misread the crowd. Cocsal lifted his Scotch glass and said,

"Bravo!" The three Mesdames raised champagne glasses in a bab-
ble of *"Cin cin!"* "Cheers!" *"Salut!"* Sottha later told me, "It was at
this precise moment that I realize exactly how stupid I am, a slave,
all my life, to perfection, and for what? To be always alone? The
perfect thing comes like a fortune or a war. You prepare but you
never know exactly the day, and only a stupid man stands and
waits."

The rest of the meal — by Sottha's standards, anyway — was anti-
climactic ("Like the history of Cambodia since the ninth century,"
Cocsal cheerfully whispered to me). Nobody cared. Sottha brought
it to the table, sat down, and ate with us. His fantasy of a formal eve-
ning became a family dinner. "What the hell," he said. "Everybody
having a good time." Later, when I asked Sottha what had inspired
him to leave the tomatoes out of the fish dish, he replied that it had
simply been an oversight. But his mother did not agree. "Sottha did
not forget the tomatoes," she said as we cleared the table. "He re-
membered that he did not need them."

After dinner, we sat on the second-floor terrace, and Sottha
blasted a recording of Beethoven's Sixth into the navy-blue night.
Beneath the music, we could hear the water lapping in an orna-
mental pool below us as the fish nipped mosquitoes from its sur-
face. Tiny iridescent frogs glowed in the dark, hopping from one
lotus leaf to another. "Like that, I feel like I'm finally free," Sottha
said softly. "I do everything I should, everybody has some happi-
ness. Now I can do whatever I want."

As to what that might be, the chef didn't have a clue. He thought
he'd return to New York, he said, maybe open a sandwich shop: "A
good price, a good sandwich — that way I give a little piece of hap-
piness to the maximum number of people, wash my hands, and go
home and have a life." But several minutes later he started laugh-
ing. "Maybe there is one problem for me about the sandwich
shop," he said. "My father always tells me the one born a swan can-
not become a duck. Like that, maybe one guy who helps shape the
cuisine, he cannot make a sandwich."

P. J. O'ROURKE

Zion's Vital Signs

FROM *The Atlantic Monthly*

PASSOVER IS MY IDEA of a perfect holiday. Dear God, when you're handing out plagues of darkness, locusts, hail, boils, flies, lice, frogs, and cattle murrain, and turning the Nile to blood and smiting the firstborn, give me a pass. And tell me when it's over.

The Lord did well by me this Passover — brilliant sunshine on the beaches of Tel Aviv, pellucid waters, no flies in my room at the Hilton, and certainly no lice. I am a firstborn myself, but I was not the least smitten, not even by the cute waitress at the Hilton's kosher sushi restaurant. I am a happily married man. And by the way, Leviticus 11:10 says, "Of any living thing which is in the waters, they shall be an abomination unto you" — an apt description of sushi as far as I'm concerned. But gentiles aren't expected to understand the intricacies of dietary law, although extra complications thereof lead to Passover's main drawback: food and — more important to gentiles — drink.

"I'll have a Scotch," I said to the Hilton's bartender.

"Scotch isn't kosher," he said. "It's made with leaven."

"Gin and tonic," I said.

"Gin isn't kosher."

"What can I have?"

"You can have a screwdriver — Israeli vodka and orange juice."

"What's Israeli vodka like?" I asked.

"The orange juice is very good."

There was no plague of tourists in Israel. It should have been a period of hectic visitation, with Passover beginning April 7 and the

Eastern Orthodox and Western Easters coinciding a week later. But Israel's income from tourism dropped by 58 percent in the last quarter of 2000, and to judge by the queue-less ticket counters at Ben-Gurion Airport and the empty-seated aisles of El Al, the drop had continued. The marble lobby of the Hilton echoed, when at all, with the chatter of idle desk clerks and bellhops. The din of strife had rendered Israel quiet.

Quiet without portentous hush — traffic hum, air-conditioning buzz, and cell-phone beeps indicated ordinary life in an ordinary place. Tourism wasn't the only thing there was no sign of in Israel. No demonstrations blocked intersections; public-address systems failed to crackle with imperatives; exigent posters weren't stuck to walls except to advertise raves. There was no sign of crisis, international or bilateral or domestic political, although all news reports agreed that a crisis raged here, and an economic crisis besides. A 12 percent quarterly decline in gross domestic product was unevident in boarded-up shops and empty cafés, which didn't exist, and beggars and the homeless, who weren't on the streets.

There was no sign of terrorism's effects. The Carmel Market was crowded with people either wholly unafraid or indifferent to whether they were blown up singly or in bunches. If police security was pervasive, it was invisible. Israel, I've heard, is hated fanatically by millions of Muslims around the world, whereas Congress is loathed only by a small number of well-informed people who follow politics closely. But a walk around anything in Israel is less impeded by barriers and armed guards than a walk around the Capitol building in Washington.

There was no sign of war. Plenty of soldiers were to be seen, carrying their weapons, but this is no shock to the frequent traveler. For all that the world looks askance at America's lack of gun control, foreigners love to wave guns around. Nothing about the Israeli Defense Forces is as odd as Italian carabinieri brandishing their machine pistols while grimly patrolling that flashpoint Venice.

There was, in fact, no sign of anything in Tel Aviv. In particular there was no sign of Israel's vital strategic importance to world peace — except, of course, those signs of vital strategic importance to world peace one sees everywhere, the lettering here in Hebrew but the trademark logos recognizable enough.

*

Tel Aviv is new, built on the sand dunes north of Jaffa in the 1890s, about the same time Miami was founded. The cities bear a resemblance in size, site, climate, and architecture, which ranges from the bland to the fancifully bland. In Miami the striving, somewhat troublesome immigrant population is the result of Russia's meddling with Cuba. In Tel Aviv the striving, somewhat troublesome immigrant population is the result of Russia's meddling with itself. I found a Russian restaurant where they couldn't have cared less what was made with leaven, where they had Scotch, and where, over one Scotch too many, I contemplated the absurdity of Israel's being an ordinary place.

What if people who had been away for ages, out and on their own, suddenly showed up at their old home and decided to move back in? My friends with grown-up children tell me this happens all the time. What if the countless ancient tribal groups that are now defeated, dispersed, and stateless contrived to reestablish themselves in their ancestral lands in such a way as to dominate everyone around them? The Mashantucket Pequots are doing so this minute at their Foxwoods casino, in southeastern Connecticut. What if a religious group sought a homeland never minding how multifarious its religion had become or how divergent its adherents were in principles and practices? A homeland for Protestants would have to satisfy the aspirations of born-again literalists holding forth about creationism in their concrete-block tabernacles and also to fulfill the hopes and dreams of vaguely churched latitudinarians praising God's creation by boating on Sundays. Protestant Zion would need to be perfect both for sniping at abortion doctors in North Carolina and for marrying lesbians in Vermont. As an American, I already live in that country.

Maybe there's nothing absurd about Israel. I wandered out into the ordinary nighttime, down Jabotinsky Street, named for the founder of Revisionist Zionism, Ze'ev Jabotinsky, who wrote in 1923, "A voluntary agreement between us and the Arabs of Palestine is inconceivable now or in the foreseeable future." Thus Jabotinsky broke with the father of Zionism, Theodor Herzl, who, in *Altneuland* (1902), had a fictional future Arab character in a fictional future Israel saying, "The Jews have made us prosperous, why should we be angry with them?" And now the Carmel Market was full of goods from Egypt.

From Jabotinsky Street I meandered into Weizmann Street, named for the first president of Israel, Chaim Weizmann, who in 1919 met with Emir Faisal, the future king of Iraq and a son of the sherif of Mecca, and concluded an agreement that "all necessary measures shall be taken to encourage and stimulate immigration of Jews into Palestine on a large scale." Faisal sent a letter to the American Zionist delegates at the Versailles peace conference wishing Jews "a most hearty welcome home."

Turning off Weizmann Street, I got lost for a while among signpost monikers I didn't recognize but that probably commemorated people who became at least as embattled as Jabotinsky, Herzl, Weizmann, and Faisal. I emerged on Ben-Gurion Avenue. The first prime minister of Israel was a ferocious battler. He fought the British mandate, the war of liberation, Palestinian guerrillas, and the Sinai campaign. He even won, most of the time, in the Israeli Knesset. And still he was on the lookout for peace. In the months leading up to the Suez crisis, in 1956, President Dwight Eisenhower had a secret emissary shuttling between Jerusalem and Cairo. Egypt's president, Gamal Abdel Nasser, told the emissary (in words that Yasir Arafat could use and, for all I know, does), "If the initiative [Nasser] was now taking in these talks was known in public he would be faced not only with a political problem, but — possibly — with a bullet."

A bullet was what Yitzhak Rabin got, at the end of Ben-Gurion Avenue, from a Jewish extremist, during a peace rally in the square that now bears Rabin's name. A bullet was also what Emir Faisal's brother, King Abdullah of Jordan, got, from a Muslim extremist, for advocating peace with Israel. Nasser's successor, Anwar Sadat, got a bullet too.

If bullets were the going price for moderation hereabouts, then I needed another drink. I walked west along Gordon Street — named, I hope, for Judah Leib Gordon, the nineteenth-century Russian novelist who wrote in classical Hebrew, and not for Lord George Gordon, the fanatical anti-Catholic and leader of the 1780 Gordon riots, who converted to Judaism late in life and died in Newgate Prison praising the French Revolution. This brought me to a stretch of nightclubs along the beach promenade. Here, two months later, a suicide bomber would kill twenty-one people outside the Dolphi disco. Most of the victims were teenage Russian

girls, no doubt very moderate about everything other than clothes, makeup, and the proper selection of dance-mix albums.

My tour guide arrived the next morning. His name was a long collection of aspirates, glottal stops, and gutturals with, like printed Hebrew, no evident vowels. "Americans can never pronounce it," he said. "Just call me T'zchv."

I called him Z. I was Z's only customer. He drove a minibus of the kind that in the United States always seems to be filled with a church group. And so was Z's, until recently. "Most of my clients," he said, "are the fundamentalists. They want to go everywhere in the Bible. But now . . ." The people who talk incessantly about Last Days have, owing to violence in the region, quit visiting the place where the world will end.

Z was seventy-five, a retired colonel in the Israeli Defense Forces, a veteran of every war from liberation to the invasion of Lebanon. "Our worst enemy is CNN," he said. His parents came from Russia in 1908 and settled on the first kibbutz in Palestine. Z was full of anger about the fighting in Israel — the fighting with the ultra-Orthodox Jews. "They don't serve in the army. They don't pay taxes. The government gives them money. I call them Pharisees."

As we walked around, Z would greet by name people of perfectly secular appearance, adding, "you Pharisee, you," or would introduce me to someone in a T-shirt and jeans who had maybe voted for Ariel Sharon in the most recent election by saying, "I want you to meet Moshe, a real Pharisee, this one."

Z said, over and over, "The problem is with the Pharisees." About Arabs I couldn't get him to say much. He seemed to regard Arabs as he did weather. Weather is important. Weather is good. We enjoy weather. We respect weather. Nobody likes to be out in weather when it gets dramatic. "My wife won't let me go to the Palestinian areas," Z said.

"Let's go to an ultra-Orthodox neighborhood," I said.

"You don't want to go there," he said. "They're dumps. You want to see where Jesus walked by the Sea of Galilee."

"No, I don't."

"And Jesus, walking by the Sea of Galilee, saw two brethren, Simon called Peter, and Andrew his brother, casting a net into the sea . . ." For a man at loggerheads with religious orthodoxy, Z re-

cited a lot of Scripture, albeit mostly from the New Testament, where Pharisees come off looking pretty bad. When quoting he would shift to the trochaic foot — familiar to him, perhaps, from the preaching of his evangelical tourists; familiar to me from my mom's yelling through the screen door, "*You* get *in* here *right* this *min*ute!"

As a compromise we went to Jaffa and had Saint Peter's fish from the Sea of Galilee for lunch. Jaffa is the old port city for Jerusalem, a quaint jumble of Arab architecture out of which the Arabs ran or were run (depending on who's writing history) during the war of liberation. Like most quaint jumbles adjacent to quaintness-free cities, Jaffa is full of galleries and studios. Israel is an admirably artsy place. And, as in other artsy places of the modern world, admiration had to be aimed principally at the effort. The output indicated that Israelis should have listened the first time when God said, "Thou shalt not make unto thee any graven image, or any likeness of any thing." Some of the abstract stuff was good.

I wanted to look at art. Z wanted me to look at the house of Simon the Tanner, on the Jaffa waterfront. This, according to Acts 10:10–15, is where Saint Peter went into a trance and foresaw a universal Christian church and, also, fitted sheets. Peter had a vision of "a great sheet knit at the four corners, and let down to the earth: Wherein were all manner of four-footed beasts of the earth, and wild beasts, and creeping things." God told Peter to kill them and eat them. Peter thought this didn't look kosher — or, probably, in the case of the creeping things, appetizing. And God said that what He had cleansed should not be called unclean.

"Then is when Peter knew Christianity was for everyone, not just the Jews!" Z said, with vicarious pride in another religion's generous thought.

A little too generous. To Peter's idea we owe ideology, the notion that the wonderful visions we have involve not only ourselves but the whole world, whether the world wants to get involved or not. Until that moment of Peter's in Jaffa, the killing of heretics and infidels was a local business. Take, for example, the case of John the Baptist: With Herodias, Herod Antipas, and his stepdaughter Salome running the store, it was a mom-and-pop operation. But by the middle of the first century theological persecution had gone global in the known world. Eventually the slaughter would outgrow

the limited market in religious differences. During our era millions of people have been murdered on purely intellectual grounds.

"Can we go in?" I asked.

"No," Z said. "The Muslims put a mosque in there, which made the Orthodox angry. They rioted, which kept the Christians out. So the police closed the place."

For those who dislike ideology, the great thing about kibbutzim is that they're such a lousy idea. Take an Eastern European intelligentsia and make the desert bloom. One would sooner take Mormons and start a rap label. But Kibbutz Yad-Mordechai, three quarters of a mile north of the Gaza Strip, passed the test of ideology. It worked — something no fully elaborated, universally applied ideology ever does.

I'd never been to a kibbutz. I don't know what I expected — Grossinger's with guns? A bar mitzvah with tractors? Some of my friends went to kibbutzim in the 1960s and came back with tales of sex and socialism. But you could get that at Oberlin, without the circle dancing. I'm sure my poli-sci–major pals were very little help with the avocado crop. Anyway, what I wasn't expecting was a cluster of JFK-era summer cottages with haphazard flower beds, sagging badminton nets, and Big Wheel tricycles on the grass — Lake Missaukee, Michigan, without Lake Missaukee.

A miniature Michigan of shrubbery and trees covered the low hills of the settlement, but with a network of drip-irrigation lines weaving among the stems and trunks. Here were the fiber-optic connections of a previous and more substantive generation of modernists, who meant to treat a troubled world with water rather than information. Scattered in the greenery were the blank metal-sided workshops and warehouses of contemporary agriculture, suggestive more of light industry than of peasanthood. And Yad-Mordechai has light industry, too, producing housewares and decorative ceramics. Plus it has the largest apiary in Israel, an educational center devoted to honey and bees, a gift shop, a kosher restaurant, and, of all things 1,300 yards from the Gaza Strip, a petting zoo.

Yad-Mordechai was founded in 1943 on an untilled, sandy patch of the Negev. The land was bought from the sheik of a neighboring village. And there, in the common little verb of the preceding sen-

tence, is the moral genius of Zionism. Theodor Herzl, when he set down the design of Zionism in *The Jewish State* (1896), wrote, "The land . . . must, of course, be privately acquired." The Zionists intended to buy a nation rather than conquer one. This had never been tried. Albeit various colonists, such as the American ones, had foisted purchase-and-sale agreements on peoples who had no concept of fee-simple tenure or of geography as anything but a free good. But Zionists wanted an honest title search.

More than a hundred years ago the Zionists realized what nobody else has realized yet — nobody but a few cranky Austrian economists and some very rich people skimming the earth in Gulfstream jets. Nothing is zero-sum, not even statehood. Man can make more of everything, including the very thing he sets his feet on, as the fellow getting to his feet and heading to the bar on the GV can tell you. "If we wish to found a State to-day," Herzl wrote, "we shall not do it in the way which would have been the only possible one a thousand years ago."

Whether the early Zionists realized what they'd realized is another matter. Palestinian Arabs realized, very quickly, that along with the purchased polity came politics. In politics, as opposed to reality, everything is zero-sum.

Considering how things are going politically in Zion these days, the foregoing quotation from Herzl should be continued and completed.

> Supposing, for example, we were obliged to clear a country of wild beasts, we should not set about the task in the fashion of Europeans of the fifth century. We should not take spear and lance and go out singly in pursuit of bears; we should organise a large and lively hunting party, drive the animals together, and throw a melinite bomb into their midst.

On May 19, 1948, Yad-Mordechai was attacked by an Egyptian armored column with air and artillery support. The kibbutz was guarded by 130 men and women, some of them teenagers, most without military training. They had fifty-five light weapons, one machine gun, and a two-inch mortar. Yad-Mordechai held out for six days — long enough for the Israeli army to secure the coast road to Tel Aviv. Twenty-six of the defenders were killed, and about three hundred Egyptians.

A slit trench has been left along the Yad-Mordechai hilltop, with

the original fifty-five weapons fastened to boards and preserved with tar. Under the viscous coatings a nineteenth-century British rifle is discernible, and the sink-trap plumbing of two primitive Bren guns. The rest of the firearms look like the birds and cats that were once mummified — by Egyptians, appropriately enough. Below the trench is a lace negligee of barbed wire, all the barbed wire the kibbutz had in 1948, and beyond that are Egyptian tanks, just where they stopped when they could go no farther. Between the tanks dozens of charging Egyptian soldiers are represented by life-size, black-painted two-dimensional cutouts — Gumby commandos, lawn ornaments on attack.

It is the only war memorial I've seen that was frightening and silly — things all war memorials should be. Most war memorials are sad or awful — things, come to think of it, war memorials should also be. And this war memorial has a price of admission — which, considering the cost of war, is another good idea.

There was a crabby old guy at the ticket booth, whom Z greeted with warm complaining, grouch to grouch. Then Z took me to Yad-Mordechai's Holocaust museum, which skips pity and goes immediately to Jewish resistance during World War II and Jewish fighting in Palestine and Israel. Yad-Mordechai is named for Mordechai Anielewicz, the commander of the Warsaw ghetto uprising. The message of the Yad-Mordechai museum is that the Holocaust memorial is in the trench at the other end of the kibbutz.

This is the second wonderful thing about Zionism: It was right. Every other "ism" of the modern world has been wrong about the nature of civilized man — Marxism, mesmerism, surrealism, pacifism, existentialism, nudism. But civilized man did want to kill Jews, and was going to do more of it. And Zionism was specific. While other systems of thought blundered around in the universal, looking for general solutions to comprehensive problems, Zionism stuck to its guns, or — in the beginning, anyway — to its hoes, mattocks, and irrigation pipes.

True, Zionism has a utopian-socialist aspect that is thoroughly nutty as far as I'm concerned. But it isn't my concern. No one knocks on my door during dinner and asks me to join a kibbutz or calls me on the weekend to persuade me to drop my current long-distance carrier and make all my phone calls by way of Israel. And given my last name, they won't.

My last name is, coincidentally, similar to the maiden name of the Holocaust-museum docent, who was Baltimore Irish and had married a young man from the kibbutz and moved there in the 1970s. "I converted," she said, "which the Orthodox make it hard to do, but I went through with it. There's a crabby old guy here who sort of took me under his wing. The first Yom Kippur after I converted, he asked me, 'Did you fast?' I said yes. He said, 'Stupid!' You probably saw him on the way in, behind the ticket counter. He's a veteran of the fight for Yad-Mordechai. There's a photo of him here, when they liberated the kibbutz, in November '48." And there was the photo of the young, heroic, crabby old guy. And now he was behind the ticket counter at the war memorial — not making a political career in Jerusalem or writing a book about the young, heroic days or flogging his story to the History Channel.

"How cool is that?" said the Baltimore Irish woman running the Holocaust museum.

Z and I had lunch at the kibbutz's self-serve restaurant, where Z took his plate of meat and sat in the middle of the dairy section. In the sky to the south we could see smoke rising from the Gaza Strip — tires burning at an intifada barricade, or just trash being incinerated. Public services aren't what they might be in the Palestinian Authority at the moment. Or maybe it was one of the Jewish settlements in Gaza being attacked, although we hadn't heard gunfire.

These settlements aren't farms but, mostly, apartment clusters. "Are the settlements in the West Bank and Gaza some kind of postagricultural, postindustrial, high-rise Zionism?" I asked Z. "Or are they a government-funded, mondo-condo, live-dangerously parody of nation building?"

"Pharisees!" Z said, and he went back to eating.

After lunch we drove to Ben-Gurion's house in Tel Aviv, a modest, foursquare, utterly unadorned structure. But the inside was cozy with twenty thousand books, in Hebrew, English, French, German, Russian, Latin, Spanish, Turkish, and ancient Greek. No fiction, however: A man who devoted his life to making a profound change in society was uninterested in the encyclopedia of society that fiction provides.

Looking at the thick walls and heavy shutters, I wondered if the house had been built to be defended. Then I twigged to the pur-

pose of the design and gained true respect for the courage of the Zionist pioneers. Ben-Gurion came to the Middle East before air conditioning was invented — and from Plonsk, at that.

We spent the next day, at my insistence and to Z's mystification, driving around the most ordinary parts of Israel, which look so ordinary to an American that I'm rendered useless for describing them to other Americans. American highway strip-mall development hasn't quite reached Israel, however, so there's even less of the nondescript to not describe.

Z and I stood in a garden-apartment complex in Ashdod, in the garden part, a patch of trampled grass. "Here is the ugliest living in Israel," he said. We went to a hill on the Ashdod shore, a tell actually, a mound of ancient ruins, an ash heap of history from which we had a view of — ash heaps, and the power plant that goes with them, which supplies half of Israel's electricity. Ashdod, incidentally, is a Philistine place name, not a pun. We could also see the container port, Israel's principal deep-water harbor. "This is the place where the whale threw Jonah up," Z said.

We went to the best suburbs of Tel Aviv, which look like the second-best suburbs of San Diego. We spent a lot of time stuck in traffic. Violence in the West Bank has forced traffic into bottlenecks on Routes 2 and 4 along the coast, in a pattern familiar to anyone negotiating Washington, D.C.'s Beltway — living in a place where you're scared to go to half of it and the other half you can't get to.

Israel is slightly smaller than New Jersey. Moses in effect led the tribes of Israel out of the District of Columbia, parted Chesapeake Bay near Annapolis, and wandered for forty years in Delaware. From the top of Mount Nebo, in the equivalent of Pennsylvania, the Lord showed Moses all of Canaan. New Canaan is in Connecticut — but close enough. And there is a Mount Nebo in Pennsylvania, although it overlooks the Susquehanna rather than the Promised Land of, say, Paramus. Joshua blew the trumpet and the malls of Paramus came tumbling down. Israel also has beaches that are at least as nice as New Jersey's.

An old friend of mine, Dave Garcia, flew in from Hong Kong to spend Easter in Jerusalem. "I like to go places when the tourists

aren't there," he said. Dave spent two years in Vietnam before the tourists arrived, as a prisoner of the Viet Cong. "Let's see where the Prince of Peace was born," he said. "It's in the middle of the intifada."

Z took us from Ben-Gurion Airport to the roadblock between Jerusalem and Bethlehem. The highway was strewn with broken bottles, as if in the aftermath not of war but of a very bad party. Israeli soldiers and Palestinian Authority policemen stood around warily. Z handed us over to an Arab tour-guide friend of his who drove a twenty-five-year-old Mercedes and looked glum. Israel had lost half its tourism, but hotels in Palestinian areas were reporting occupancy rates of 4 percent.

The Arab guide parked at random in the middle of empty Manger Square, outside the Church of the Nativity. "There is normally a three-and-a-half-hour wait," he said, as we walked straight into the Manger Grotto. The little cave has been rendered a soot hole by millennia of offertory candles. It's hung with damp-stained tapestries and tarnished lamps and festoons of grimy ornamentation elaborate enough for a Byzantine emperor if the Byzantine emperor lived in a basement. I imagine the Virgin Mary had the place done up more cheerfully, with little homey touches, when it was a barn.

The only other visitors were in a tour group from El Salvador, wearing bright-yellow T-shirts and acting cheerfully pious. Dave asked them in Spanish if, after all that El Salvador had been through with earthquakes and civil war, the fuss about violence and danger around here puzzled them. They shrugged and looked puzzled, but that may have been because no one in the Garcia family has been able to speak Spanish for three generations, including Dave.

According to our tour guide, all the dead babies from the Massacre of the Innocents are conveniently buried one grotto over, under the same church. Sites of Christian devotion around Jerusalem tend to be convenient. In the Church of the Holy Sepulcher the piece of ground where Jesus' cross was erected, the stone where he was laid out for burial, and the tomb in which he was resurrected — plus where Adam's skull was allegedly buried and, according to early Christian cartographers, the center of the world — are within a few arthritic steps of one another. Saint Helena, the mother of

the emperor Constantine, was over seventy-five when she traveled to the Holy Land, in 326, looking for sacred locations. Arriving with a full imperial retinue and a deep purse, Saint Helena discovered that her tour guides were able to take her to every place she wanted to go; each turned out to be nearby and, as luck would have it, for sale. The attack of real estate agents in Palestine long predates Zionism.

The Church of the Nativity is a shabby mess, the result of quarreling religious orders. Greek Orthodox, Armenian Orthodox, and Roman Catholic priests have staked out Nativity turf with the acrimonious precision of teenage brothers sharing a bedroom. A locked steel door prevents direct access from the Roman Catholic chapel to the Grotto of the Nativity, which has to be reached through the Greek Orthodox monastery, where there is a particular "Armenian beam" that Greek Orthodox monks stand on to sweep the area above the Grotto entrance, making the Armenians so angry that, according to my guidebook, "in 1984 there were violent clashes as Greek and Armenian clergy fought running battles with staves and chains that had been hidden beneath their robes." What would Jesus have thought? He might have thought, *Hand me a stave,* per Mark 11:15: "Jesus went into the temple, and began to cast out them that sold and bought in the temple, and overthrew the tables of the moneychangers."

It's left to the Muslims to keep the peace at the Church of the Nativity in Bethlehem, just as it's left to the Jews to keep a similar peace at the likewise divided Church of the Holy Sepulcher in Jerusalem. Who will be a Muslim and a Jew to the Muslims and the Jews? Hindus, maybe. That is more or less the idea behind putting UN peacekeeping troops in Israel. This may or may not work. The *Bhagavad Gita* opens with the hero Arjuna trying to be a pacifist: "Woe!" Arjuna says. "We have resolved to commit a great crime as we stand ready to kill family out of greed for kingship and pleasures!" But the Lord Krishna tells Arjuna to quit whining and fight. "Either you are killed and will then attain to heaven," Krishna says, "or you triumph and will enjoy the earth."

Our guide took us to several large gift stores with no other customers, aisles stacked with unsold souvenirs of Jesus' birth. Part of the Israeli strategy in the intifada has been to put economic pressure on the Arabs of the West Bank and Gaza. Fear of death hasn't

stopped the Arabs. Maybe fear of Chapter 11 will do the trick. The entire hope of peace on earth rests with badly carved olive-wood crèche sets. Dave and I bought several.

Then our guide took us up a hill to the Christian Arab village of Beit Jala, which the Israelis had been shelling (and later would occupy). Large chunks were gone from the tall, previously comfortable-looking limestone villas. Shuttered housefronts were full of what looked like bullet holes but were large enough to put a Popsicle in. "Ooh, fifty-caliber," Dave said with professional appreciation.

"These people," our guide said, "have no part in the violence." Dave and I made noises of condolence and agreement in that shift of sympathy to the nearest immediate victim that is the hallmark of modern morality.

"Here a man was sleeping in his bed," our guide said, showing us a three-story pile of rubble. "And they couldn't find him for days later. The Israelis shell here for no reason."

"Um," Dave said, "*why* for no reason?" And our guide, speaking in diplomatic circumlocution, allowed as how every now and then, all the time, Palestinian gunmen would occasionally, very often, use the Beit Jala hilltop to shoot with rifles at Israeli tanks guarding a highway tunnel in the valley. They did it the next night.

"It's kind of a rule of military tactics," Dave said to me, sotto voce, as we walked back to the car, "not to shoot a rifle at a tank when the tank knows where you are." Unless, of course, scanty olive-wood crèche-set sales are spoiling your enjoyment of earth and you've decided to attain to heaven.

The owner of an upscale antiquities shop back in Bethlehem did not look as if he meant to attain any sooner than necessary, even though his store's air-conditioning unit had been knocked out by Israelis firing on nearby rioters. He arrived in a new Mercedes with three assistants to open his business especially for Dave, his first customer in a month.

The antiquities dealer was another friend of Z's. Z told us that this was the man whose grandfather was the Palestinian cobbler to whom the Dead Sea Scrolls were offered as scrap leather by the Bedouin shepherd who found them — a story too good to subject to the discourtesies of investigative journalism.

The emporium was new, built in the soon-dashed hopes of mil-

lennium traffic. The antiquities were displayed in the stark, track-lit modernity necessary to make them look like something other than the pots and pans and jars and bottles of people who had, one way or another, given up on this place long ago.

Dave collects antiques, but by profession he's an iron-and-steel commodities trader. He has also lived in Asia for years. I sat on a pile of rugs and drank little cups of coffee while Levantine bargaining met Oriental dickering and the cold-eyed brokerage of the market floor. The three great world traditions of haggle flowered into confrontation for two and a half hours. Folks from the Oslo talks and the Camp David meetings should have been there for benefit of instruction. Everyone ended up happy. No fatal zero-sum thinking was seen as bank notes and ceramics changed hands at last. Dave could make more money. And the Arabs could make more antiquities.

Why can't everybody just get along? No reasonably detached person goes to Israel without being reduced in philosophical discourse to the level of Rodney King — or, for that matter, to the level of George Santayana. "Those who cannot remember the past are condemned to repeat it," Santayana said, in one of those moments of fatuousness that come to even the most detached of philosophers. It goes double for those who can't remember anything else. And they *do* get along, after their fashion. Muslims and Christians and Jews have lived together in the Holy Land for centuries — hating one another's guts, cutting one another's throats, and touching off wars of various magnitudes.

The whole melodrama of the Middle East would be improved if amnesia were as common here as it is in melodramatic plots. I was thinking this as I looked at the Dead Sea Scrolls in the solemn underground Shrine of the Book, inside the vast precincts of the Israel Museum. Maybe all the world's hoary tracts ought to wind up as loafer soles or be auctioned at Sotheby's to a greedy high-tech billionaire for display in his otherwise bookless four-thousand-square-foot cyber-den. Then I noticed that Z was reading the scrolls, muttering aloud at speed, perusing an ancient text with more ease than I can read Henry James. What's past is past, perhaps, but when it passed, this was where it went.

*

Z dropped us at the King David Hotel, the headquarters of the Palestinian mandate administration when the British were trying to keep the peace. In 1946 the hotel was blown up by the radical wing of the Jewish Resistance Movement, the Irgun. Some of every group were killed — forty-one Arabs, twenty-eight British, seventeen Jews, and five reasonably detached persons of miscellaneous designation. The Irgun was led by the future prime minister Menachem Begin, who would make peace with Egypt in the 1970s but, then again, war with Lebanon in the 1980s.

On the way to the hotel Z explained why there will always be war in the region. "Israel is strategic," he said in his most New Testamental tone. "It is the strategic land bridge between Africa and Asia. For five thousand years there has been fighting in Israel. It is the strategic land bridge." And the fighting continues, a sort of geopolitical muscle memory, as though airplanes and supertankers hadn't been invented. The English and the French might as well be fighting over the beaver-pelt trade in Quebec today, and from what I understand of Canadian politics, they are.

We were meeting Israeli friends of Dave's at the hotel, a married couple. He voted for Sharon; she voted for Ehud Barak. Dave and I marked our lintels and doorposts with the blood of the lamb, metaphorically speaking, and drank Israeli vodka and orange juice.

"There will always be war," the husband said, "because with war Arafat is a hero and without war he's just an unimportant guy in charge of an unimportant place with a lot of political and economic problems."

"There will always be war," the wife said, "because with war Sharon is a hero and without war he's just an unimportant guy in charge of an unimportant place with . . ."

Also, war is fun — from a distance. Late the next night Dave and I were walking back to our hotel in Arab East Jerusalem. Dave was wearing a Hawaiian shirt and I was in a blazer and chinos. We couldn't have looked less Israeli if we'd been dressed like Lawrence of Arabia (who, incidentally, was a third party to the cordial meeting between Chaim Weizmann and Emir Faisal). Fifty yards down a side street a couple of Palestinian teenagers jumped out of the shadows. Using the girly overhand throw of nations that mostly play soccer, one kid threw a bottle at us. It landed forty yards away.

*

On Good Friday, Dave and Z and I walked from the Garden of Gethsemane to the Lions Gate, where Israeli paratroopers fought their way into the Old City during the Six-Day War. We traveled the Via Dolorosa in an uncrowded quiet that Jesus Christ and those paratroopers were not able to enjoy. We owed our peace in Jerusalem to an enormous police presence. There have always been a lot of policemen in Jerusalem, but they did Jesus no good. Nor did the Jordanian police give Israeli soldiers helpful directions to the Ecce Homo Arch. And our Savior and the heroes of 1967 didn't have a chance to stop along the way and bargain with Arab rug merchants.

Z and the rug merchants exchanged pessimisms, Z grousing about Sharon and the Arabs complaining about Arafat. "The Israeli army tells Arafat where the strikes will come," one shopkeeper said. "They tell him, 'Don't be here. Don't be there.' No one tells me."

I visited the fourteen Stations of the Cross and said my prayers — for peace, of course, although, as a Zionist friend of mine puts it, "Victory would be okay too." Jesus said, "Love your enemies." He didn't say not to have any. In fact, he said, "I came not to send peace but a sword." Or at least staves and chains.

Then we went to the Wailing Wall, the remnant of the Second Temple, built by the same Herod the Great who killed all the babies buried near the manger in Bethlehem. Atop the Wailing Wall stands the Haram ash-Sarif, with the Dome of the Rock enclosing Mount Moriah, where Abraham was ready to kill Isaac and where, at that moment, Muslims gathered for Friday prayers were surrounded by Israeli soldiers, some of both no doubt ready to kill too. (The Dome of the Rock also marks the center of the world for those who don't believe that the center of the world is down the street, in the Church of the Holy Sepulcher.)

In the plaza in front of the Wailing Wall religious volunteers were lending yarmulkes to Jews who had arrived bareheaded. "Well," Dave said, "my mother was Jewish, so I guess that makes me Jewish. I'd better get a rent-a-beanie and go over to the Wailing Wall and . . . wail, or something."

The yarmulkes being handed out were, unaccountably, made of silver reflective fabric. "I look like an outer-space Jew," Dave said.

"I always thought you were Catholic," I said.

"Because of Garcia," Dave said, "like O'Rourke."

"I'm not Catholic either. My mother was Presbyterian, my father was Lutheran, and I'm Methodist. I came home from Methodist confirmation class in a big huff and told my mother there were huge differences between Presbyterians and Lutherans and Methodists. And my mother said, 'We sent you to the Methodist church because all the nice people in the neighborhood go there.'"

"They could use that church here," Dave said. He swayed in front of the wall, like the Orthodox surrounding him, although, frankly, in a manner more aging-pop-fan than Hasidic.

What could cause more hatred and bloodshed than religion? This is the Israel question. Except it isn't rhetorical; it has an answer. We went to Yad Vashem, the Jerusalem Holocaust memorial, and saw what the godless get up to.

There are worse things than war, if the intifada is indeed a war. As of this writing, 513 Palestinians and 124 Israelis have been killed in what is called the second intifada. About forty thousand people perished in the 1992–1996 civil war in Tajikistan that nobody's heard of. From one and a half to two million are dead in Sudan. There are parts of the world where the situation Dave and I were in is too ordinary to have a name.

Late Saturday night the particular place where we were in that situation was the American Colony Hotel, in East Jerusalem, sometimes called the PLO Hotel for the supposed connections the staff has. It is the preferred residence of intifada-covering journalists, especially those who are indignant about Israeli behavior. The American Colony Hotel was once the mansion of an Ottoman pasha. Dave and I sat among palms in the peristyle courtyard, surrounded by arabesques carved in Jerusalem's golden limestone. The bedroom-temperature air was scented with Easter lilies, and in the distance, now and then, gunfire could be heard.

"This country is hopeless," Dave said, pouring a Palestinian Taybeh beer to complement a number of Israeli Maccabee beers we'd had earlier in West Jerusalem. "And as hopeless places go, it's not bad." We discussed another Israel question. Why are Israeli girls so fetching in their army uniforms, whereas the women in the U.S. military are less so? It may have something to do with carrying guns all the time. But Freud was a lukewarm Zionist, and let's not think about it.

After the first Zionist Congress, in 1897, the rabbis of Vienna sent a delegation to Palestine on a fact-finding mission. The delegation cabled Vienna saying, "The bride is beautiful, but she is married to another man." However, the twentieth century, with all its Freudianism, was about to dawn, and we know what having the beautiful bride married to another man means in a modern story line. No fair using amnesia as a device for tidy plot resolution.

"Do we have to choose sides?" Dave said. But it's like dating sisters. Better make a decision or head for the Global Village limits. And speaking of sisters, I opened the *Jerusalem Post* on Easter morning and discovered that my sister's neighborhood in Cincinnati was under curfew, overrun with race riots.

TONY PERROTTET

Spain in a Minor Key

FROM *Islands*

IT WAS MIDNIGHT in Menorca when a young cheese maker told
me to seek out "the place" — a traditional fisherman's hangout
where guitarists played and sang until dawn.

"Tomorrow is a holiday for the Virgin," he confided. "So tonight
should be . . . *lively.*"

On this genteel Spanish island such vague suggestions can seem
like urgent directives — at least if you've just indulged in a second
bottle of rioja with your sautéed anchovies. Sadly, my late-night
quest for "the place" did not go immediately as planned. I found
myself wandering the dark, cobbled lanes of a colonial port called
Es Castell, where every window was firmly shuttered and the only
signs of life were the black cats that persisted in crossing my path.
When I finally identified the correct lane, it led sharply down to
the waterfront of Cala Corb, where there were nothing but empty
fishing skiffs bobbing in the breeze.

I was about to give up, when I noticed a soft glow emanating
from the base of the cliff wall. It was coming from one of the old
Menorcan boathouses that had been carved out of the rock. Cau-
tiously, I slipped toward the light.

I didn't hear a sound until I was almost inside — but then I
found myself blinking with disbelief. Suddenly, I was enveloped by
a veil of cigarette smoke and a rich, voluptuous cascade of notes
from a Spanish guitar. The cave walls yawned open into a bright
cellar, which was packed shoulder to shoulder with Menorcans
dressed in their Sunday best and heartily singing, with moist eyes, a
soulful *habanera*. The center of attention was a wizened musician

with inch-thick spectacles, head bent over his guitar, plucking the strings with intense concentration; by his side, a trio of male singers — one rotund and bearded, the other two lean and dripping with jewelry — began belting out the chorus like the Three Spanish Tenors.

There was no doubt that this was Es Cau — Catalan for, literally enough, "the place." Every few minutes more islanders appeared within the cave — many of them frail elderly women, immaculate and adorned with their finest gold brooches, out for a late-night song and a snifter of sherry.

Reeling from the close atmosphere, I ordered a *pomada* — gin and lemonade — from the barman, who looked like a taller, leaner Picasso in his fisherman's shirt and cropped white hair. He turned out to be Gabriel, the bar's owner of thirty-five years. I had just decided he was the retiring type, when the next song began and he put one leg up on a stool and erupted into a full-throated *menorquino* — local verse, as dramatic as a tango. The crowd roared approval. Gents whistled. Matrons waved their miniature fans in delight.

When I finally staggered out into the night air at 3 A.M., the music vanished instantly behind me, as if the bar and its singers had been swallowed up by the stone itself. For a second, staring up at the same bobbing boats, I felt as if I'd dreamed the whole thing — until another pair of elegant grandmothers barreled past, arranging their silk scarves and necklaces, looking for some late-night entertainment. One woman paused at a shrine carved into the rock and kissed the silver crucifix around her neck — perhaps apologizing to the Holy Virgin — before disappearing like a ghost into the glowing entrance.

Next morning I groggily faced my first *café con leche* of the day and considered that I'd learned two valuable lessons: First, the afternoon siesta exists in Spain for good reason. And second: On Menorca, a touch of persistence can reveal a flamboyant secret world.

Not many people — even on mainland Spain — have more than a shadowy image of Menorca. The "little island" of the Balearic archipelago is often defined by what it is *not*. For a start, Menorca is not to be confused with Mallorca — holiday resort for generations of Britons. Nor is it even remotely like its other notorious island

sibling, Ibiza — the flashy party capital of the western Med. Still, Menorca remains something of a cipher.

Which is, I soon discovered, just the way Menorcans prefer it — and so do the devoted cadres of international Menorca lovers, who return to the island, quietly, year after year.

The truth is, being forgotten was the best thing that ever happened to Menorca. The island got just a small share of the rampaging tourism boom of the 1970s, so that today, Menorca has been left with one of the most pristine coastlines in all of Spain. In 1993 UNESCO declared the island a biosphere reserve, protecting its wetlands and remoter beaches forever. By staying out of the limelight, Menorca has, in fact, become one of the Mediterranean's ultimate nature trips.

This cucumber-shaped island is like a sampler of unspoiled European landscapes. Start with rolling green hills straight out of the Irish countryside, complete with medieval villages and crossed with timeless stone fences. Add to that quiet beach coves fringed by pine forests, and cliff-top lighthouses reminiscent of the coast of Brittany. Deserts of lava appear as austere as the expanses of Iceland. And framing it all, like a pair of bookends, are its two ports, Mahón and Ciutadella, crowded with fine architecture, but as different in their outlooks as New York and Los Angeles.

And yet, in contrast to Menorca's current low profile, the island was for most of its history cursed with far too much outside attention from a string of world conquerors, beginning with the Phoenicians. In the Middle Ages, as one of the key battlegrounds between Christendom and Islam, Menorca violently swapped hands several times and became a favorite prey of the Mediterranean's pirate kings, who descended on the island's green shores with entire corsair navies.

Thanks to the bloody revolving door of invaders, Menorca's history has meandered along a different track from that of the rest of Spain. For a start, the place is riddled with the ruins of a mysterious prehistoric culture, making it one of the richest archaeological sites in Western Europe. On the poetic level, Menorcans speak a unique dialect of Catalan, which is itself a distinct language closer to French than Spanish. Museums devote lavish galleries to such arcana as *Myostragus balearicus,* an antelope once indigenous to the island, or to Menorca's truly obscure painters. And as far as the gour-

met is concerned, there is a unique Menorcan cheese, a peculiar herbed aperitif, and fat Menorcan toadstools, called *grigolas,* that are fried and served as tapas. Before long, you might start agreeing that Menorcans are as exotic as Zanzibaris.

My own journey to Menorca began in what must be the most eccentric of the island's enclaves; I found myself taking tea with the ghosts of the British Royal Navy.

A Georgian mansion that once belonged to Admiral Lord Collingwood, perched on a headland above the harbor of Port Mahón, has been turned into a pension, complete with vivid shades of the 1790s: The parlor is heavy with plush carpets, silver candlesticks, and antique etchings — even an original oil painting by Titian, which is said to be the most valuable object on the entire island. Embossed leather on the surface of the doors dulls all noise from the parlor to the guest rooms — an original feature, intended to deter eavesdroppers, from the days when the admiral hosted strategic meetings here for sixty smartly turned-out naval captains, all bracing for battle with the devilish Bonaparte.

On that first evening a storm was lashing at the windows — an unseasonal taste of the dreaded north wind called the *tramontana.* Rain was pelting down in sheets.

The house is an improbable relic of an improbable era. For much of the eighteenth century the island was ruled by the British, making Mahón — which happens to have one of the finest natural harbors in the entire Mediterranean — one of the biggest Royal Navy bases south of Plymouth. Those days left a lasting mark on Menorcans. It explains why the islanders brew their own aromatic gin, bid one another "Bye-bye" instead of *"Adiós,"* call an aristocratic woman *"una lady"* — and maintain an abiding passion for the seventies crooner Tom Jones.

There in those rooms, it felt as if mad King George III was still ruling the island. I retreated to the security of the bar, with its vaulted stone ceiling, where silver-haired Scottish gentlemen were playing a round of bridge, while their elderly wives sipped sherry and knitted.

The next day, as I puffed up and down Mahón's steep streets, mostly so narrow that only foot traffic could enter, the design sense of the British seemed to be everywhere — in the many elegant

Georgian public buildings, whose graceful lines and coolly rational facades evoked Bath more than Barcelona; in the private town-houses whose magnificently expansive curves of glass are still called by Menorcans *boinders,* a corruption of "bow windows"; and, most of all, in the archaic nautical atmosphere itself.

As the squawk of gulls was carried through the streets with the salt breeze, I was transported back to the great sea novels of Patrick O'Brian, which run some twenty volumes and have their very first scene here in Port Mahón. That chapter re-creates a time when British naval officers listened to chamber concerts; stayed in water-front inns that smelled of "olive oil, sardines and wine"; and savored the delectable *mahonesa* sauce that would become one of the world's most popular condiments, mayonnaise. On the way to the docks I followed a slippery winding staircase once known as Pigtail Steps, bane of drunken sailors, and arrived at the fortified inlet that used to be thick with men-of-war, as well as a bewildering array of "feluccas, tartans, xebecs, pinks, polacres, polacre-settees, houarios and barca-longas," not to mention "bean-cods, cats [and] herring-buses" from beyond the Mediterranean.

Back at my own sardine-scented inn, I opened my shutters over a tangled cactus garden and looked out across that extraordinary harbor to another red British mansion directly opposite. That was Golden Farm, a private house where Nelson stayed in 1799 — trysting, legend has it, with his mistress, Lady Emma Hamilton. (That unshakable tale is based purely on the discovery of graffiti etched into a desk in the study: *Remember of me E.*) But when I mentioned the appealing story to Francisco Montanari — owner of the Collingwood mansion (and easily identified by the red macaw usually following him about) — his brow knitted.

"I would rather not talk about Lord Nelson," he said, smiling politely, bowing, and turning away.

I discovered the reason a little later, at one of the weekly lecture tours he gave to groups of British naval history buffs. It appeared that since he bought the house in 1961, Señor Montanari had been conducting a one-man campaign to raise Admiral Collingwood into the pantheon of British war heroes.

"I wish to say nothing against Lord Nelson," Montanari declared to the group, "but it seems to me Lord Collingwood is not well known enough in England."

The naval huffs murmured politely, and the macaw let out a squawk of agreement.

"Nelson's name is known everywhere! He was a very romantic figure — the one-armed, one-eyed commodore. He was more of a lady's man. But who really won the Battle of Trafalgar? Nelson expired in the middle of the encounter. Collingwood took command. He was the actual victor. But news of the victory and of Nelson's death arrived at the same time in London. People assumed Nelson was in command to the very last!"

What's more, Montanari opined, Lord Collingwood was "honest and gentle," and deeply beloved by Menorcans for transporting a giant pipe organ from the mainland for the Church of Santa Maria. Surely he deserved to be a household name in England?

Next morning the last remains of the storm were still hovering over the island, with cool blustery winds and brooding Gaelic skies — ideal conditions for delving into Menorca's barbarous past. The only difficult question was which slice of the past I should start with.

Pick a century — any century. The story of Menorca has always been written in stone, and the island has a relic for every taste: There are Greek fragments, Phoenician caves, Roman engravings and mosaics, a medieval footpath that once ringed the island, Moorish fortresses, Byzantine cathedrals. And every hill is crowned with watchtowers that were built to spot invading pirate fleets.

I decided, logically enough, to start at the beginning. In fact, Menorca's most distinctive moment in history took place around 1200 B.C.

In antiquity Menorca was inhabited by an enigmatic and hirsute people known today as the Talayots. Don't be swayed by drawings on display in Menorcan museums, which make them look disconcertingly like California hippies — the men with long wild beards and ponytails, the women in flowing robes and adorned with hefty bronze jewelry. The Talayots lived a brutal, spartan existence. Their greatest talent, on this stone-covered island, was the art of the slingshot. From an early age boys were trained by their mothers to use one: At mealtimes, pieces of bread were strung up fifty paces away, and the boys could eat only what they hit. Their aim became so deadly that Hannibal took teams of Talayots with him across the Alps when he marched against Rome. (The name Balearics, which

refers to the whole archipelago, is actually Latin for "sling throwers.")

As adults, the Talayots became ingenious stonemasons, creating grandiose ritual structures that still litter the island — intriguing monuments such as burial chambers that look like overturned boat hulls. These timeworn edifices are made even more atmospheric by their spectacular locations: At Cales Coves, on the south coast, I hiked up stone steps to see more than one hundred burial caves riddling a cliff, while below, the ocean boiled like a cauldron. At Cala Morell, in the northwest, a necropolis hid above the most picturesque beaches, with the ancient doorways of the tombs gazing out to sea.

But the Talayots' crowning creations were without doubt the *taulas* — cyclopean T-shaped blocks as large as segments of Stonehenge, raised across the landscape. So I set my sites on the remotest, named after the farm where it was found, La Taula de Sa Torreta de Tramuntana.

A road led me out of Mahón into the rich farmland of the north, where fields were cushioned like the green felt of a billiard table. The turnoffs became more obscure as I zigzagged down ever-narrower roads until I was squeezed on either side by powerful stone fences. This thirty-mile-long island is stitched together with miles of those walls, some of which date back to the Crusades. Finally, an unmarked wooden gate led into a private farm. I stepped out in the warm afternoon air and walked through the gate, half expecting an outraged cry in Catalan: "Smithers, release the hounds."

I had gone about a hundred paces when the chirping of birds was interrupted by a distant farmer yelling at me and waving his arms like a madman. Here we go, I thought — some cantankerous local was going to invoke his ancient property rights and charge a toll. But no, he informed me pleasantly, he was about to drive a herd of cows along this very path, and I was in danger of being stampeded. ("They get very nervous if there are strangers about. One of the herd has a new calf.") I hung back beside an olive tree as the farmer moved the herd along — singing *woop, woop, woop* behind them.

All that remained for me to do was climb two more fences, and before I knew it, I was standing in a prehistoric Talayot village. Scattered all about like giant Lego blocks were limestone chunks aflame with orange lichen.

I pressed on to the crest of the hill to seek out the Taula de Sa Torreta de Tramuntana. The T-shaped column may once have helped support a vast ceremonial hut. But as I reached the top of the hill, I had to admit those crusty Talayots also had a fine sense of location. From the peak there was a view that encompassed a vast curving coastline out to a horizon of polished silver. As I stood there, the setting sun made the giant T glow an ever more virulent shade of scarlet, and the *taula* began to seem less like a relic from the unimaginable past and more like a spiritually charged monolith from *2001: A Space Odyssey*.

By that afternoon there wasn't a cloud in the pale-blue sky. It was as if the gods had flicked a switch on to summer. Every restaurant had tables set out on the sidewalks, flesh was bared — tourist flesh, at least — and my own thoughts, inevitably, turned to the sea. It was time to see those "untouched beaches" Menorcans spoke about with such pride.

Of all the different terrains squeezed into the tiny island, the dry southwest seemed most archetypically Spanish. I drove into a landscape of pale, sunburned earth and ancient olive trees.

The road halted near Cala en Turqueta, Turks' Beach, a cozy patch of white sand enclosed by limestone bluffs. Hidden just around the cliff was a natural cave that had metal bars installed on its opening — not to mention potted plants, a picnic table, and deck chairs. The domestic scene was completed by a small fishing boat tied up in front. I'd heard that many ancient caves were now inhabited by hippies — latter-day troglodytes, or cave dwellers, peculiar to Menorca. Instead, I found a wiry, weather-beaten fisherman in a knit cap, stitching up his nets.

"I am Rafael," he croaked sagaciously and immediately motioned me inside his cave. House-proud, he showed off his narrow bed and gas burner; the ingredients for a fish lunch were laid out, along with a bottle of white wine. The decor included about twenty glass vials of finely layered sand taken from each of the Menorcan beaches; the palette ranged from pink to black, and each bottle was carefully labeled.

"What do you think? Comfortable enough?" he asked. "It's been in my family since before *La Guerra.*"

By "The War" he meant the Spanish Civil War of 1936–1939, when Menorca supported the good guys — the Republicans —

against the Fascists. (Menorca was actually the last holdout in all of Spain against Generalissimo Franco.)

"It used to be a military bunker," he smiled, pointing down a tunnel lit by fluorescent lamps. "Now I store my wines down there, in the cool."

Cala en Turqueta was a fine beach, Rafael went on — but Menorca's most beautiful coves were the ones you could reach only on foot.

"You should take the Horse Path," Rafael said, pointing east along the cliff face, where there was an old trail. "You'll come to Macarelleta, Little Macarella."

"Is it far?" I asked.

He shrugged. "Five minutes. Or maybe an hour."

I set off into the forest behind the beach, trying not to worry about the fact that the trail ran directly away from the water. Soon I emerged from the trees and found myself on a high plain above the sea cliffs — a salt-sprayed Mediterranean heath, baking in the sun, sprinkled with yellow and purple wildflowers. Trudging along for what might have been five minutes or an hour, I realized I'd brought no water. Suddenly the trail dropped into a ravine. Where had Rafael sent me?

But then I finally glimpsed it through the pine trees: a glittering jewel of ocean — the promised sand, Little Macarella — and all doubts evaporated.

I emerged at a little inlet penetrating the coast, hidden from the eyes of the world by towering cliffs. But the most astonishing thing was the color of the water: less the familiar turquoise of the eastern Mediterranean and more a piercing lime green. As I dived beneath its serene surface, the tint seemed to turn to the color of emeralds. It made me think, stroking out to sea, of Byzantine glassware, of Cointreau on ice, of peacock tails and the northern lights. The water was so utterly transparent that I could watch my shadow as it followed along the ocean floor twenty feet down, rippling over the white sand bed.

Floating there, I knew I was starting to get the measure of Menorca.

There's a rule of thumb in the Mediterranean: The smaller an island is, the more epic in scale its internal feuds. On Menorca, the

ancient port of Ciutadella has always stood against Mahón as the opposite pole of the Menorcan soul. While Mahón, ever since the arrival of the British, has opened itself to the outside world, Ciutadella — "the little city" — has withdrawn into monastic self-denial, maintaining its Catalan purity. Today, Mahón remains the beachhead of foreign influence, Ciutadella the custodian of the island's florid Hispanic traditions — a perfectly intact sixteenth-century port, rising from the sea.

It was a Sunday morning when I arrived, and not a citizen could be found in Ciutadella's labyrinth of lanes. At every turn the old city revealed a new architectural tableau — a Moorish plaza with its stately palm trees, a Gothic cathedral as intimidating as any castle fortress, monstrous wooden doorways of ancestral palaces laden with coats of arms. By midmorning the residents began to emerge, many carrying octagonal boxes of *ensaimadas,* large flat pastries similar to New Orleans beignets. I watched as the Menorcans met, bowed, and stopped to chat. The graciousness of Ciutadella was matched by the chivalrous Old World manners of its people. It made Mahón, despite its long past, seem oddly rootless.

That night I repeated this observation to a raven-haired museum attendant in the fortress of Sant Nicolau. I'd dropped by during a sunset *paseo* — the traditional Mediterranean promenade and fashion parade, which Ciutadellans pursue with vigor — and unwittingly provoked a breathless tirade against the pernicious Mahonesas.

"I don't like Mahón," she began. "It's far too big. And the people are so cold and distant. We're so much warmer here in Ciutadella. Everyone talks to everyone else."

It wasn't just that the island's capital was moved to Mahón in 1721, condemning Ciutadella to provincial status, or even that Mahón has ended up with the island's only airport, which means that most foreign visitors choose to stay there. No, the rivalry began much earlier.

"It was in the time of Barbarossa, really," she sighed.

"Redbeard?" I tried not to sound incredulous.

In the 1500s — so I was patiently advised — both Ciutadella and Mahón were the targets of attacks by Turkish pirate fleets. Mahón was the first victim in 1535, when Barbarossa, the pirate king of Algiers, swept down on the island with a force of crack Turkish

troops. The citizens of Ciutadella sent three hundred men to help in defense, but the cowardly Mahón officials negotiated a secret surrender — saving themselves but dooming the Ciutadellan volunteers to slaughter.

Twenty years later it was Ciutadella's turn to be attacked, this time by a vast navy led by the corsair Piali. But the lowly Mahón folk sent only fifty men to her aid — and only "seven or eight" actually arrived. Unlike the pitiful Mahonesas, the Ciutadellans fought with extraordinary bravery against impossible odds before succumbing to the infidels. Every citizen in Ciutadella was either butchered or taken away in shackles.

"We still remember July 9 as the Day of the Disaster," she concluded.

Nobody can accuse the Ciutadellans of having short memories.

I had explored the cities, I had discovered the best beaches, I was a connoisseur of *taulas* — all that remained to complete my education on the island was to unlock the mysteries of Menorca's rural world. To that end, I took a room in the Sant Ignasi, a converted Spanish farmhouse that operated as a small hotel. Secluded among an aristocratic family's age-old pastures, it was perhaps the most atmospheric escape in the Balearics.

From there I drove along remote back roads and ate in underground cellars in dusty villages, where farmhands gathered for pork chops and carafes of wine poured from eight-gallon drums. And I hiked up a Roman road to the remains of an Arab fortress on the mountain of Santa Agueda, for commanding views of the entire verdant island.

But there was something about the gentility of Menorca that made me want to keep exploring until I'd touched its extremes. And that meant heading into the volcanic wasteland whipped by the *tramontana* wind.

On the car radio, as ever, Tom Jones was crooning "She's a lady . . . woah woah woah, she's a lady," a curious favorite with the populace. I turned off the main road and watched the manicured green farmland of Menorca slowly fray and disappear. The pastures became dotted with rocks — as if it had been raining stones. Soon there were no farms to be seen at all, just fields of sharp lava glinting like coals in the afternoon sun. Finally, a solitary lighthouse stood guard on sheer cliffs.

But that wasn't quite the end of the road. A brittle trail continued, as if into the sea itself. The perfect lava flow — not a sign of life — looked as if it had appeared yesterday. Nobody ventured out onto this jagged peninsula. Yet I picked my way across a river of rock that changed from bone-white shards to solid-gray elephant hide. Jurassic lichens clung to jagged overhangs. Clumps of agate burst from the earth. The wind roared like a wild animal.

I marched until I could go no farther. The lava itself had finally given up and sunk into the crashing sea. The same Mediterranean that had been so seductive on the south coast now boiled with unexpected fury, black as ink.

But Menorca wasn't about to let me finish on such a ferocious note: It was as if, proud as it may be of its unspoiled landscapes, the island just can't help but soften its wilder side with the refinements of Spanish civilization. After all that lunar emptiness, I decided to make a beeline to Fornells, a whitewashed fishing village whose waterfront restaurants are renowned for a single amazing dish, *caldereta de langoste,* lobster stew.

I found a table right on the dock; minnows darted in the green water beneath my feet. My silver-haired waiter — one of the aristocratic professionals who regard their trade as the noblest of careers — assured me that I was about to savor the very same dish that Juan Carlos, king of Spain, insists on every time he moors off Menorca in his yacht.

"And this Catalonian chardonnay has a hint of spice, to relax the well-exercised limbs," he confided, like a doctor prescribing a medicine.

What could I say? I sat back and succumbed to the Menorcan relaxation regime. If it was good enough for Juan Carlos, it was good enough for me.

KIRA SALAK

Making Rain

FROM *Quarterly West*

AMBUNTI IS the St. Louis of Papua New Guinea. Sitting on the
Sepik River, it is where the missionaries come to "get a break from
the bush," while foreign backpackers find it a convenient place to
head in. Tribal people pass through: women with their faces tat-
tooed; men with the septa of their noses hollowed out, light passing
through when they turn their heads. Ambunti is the gateway to all
points west, the town where travelers converge to refuel and stock
up before heading upriver. Here one can catch up on news, make a
phone call, mail letters, even cash a traveler's check. A small police
station exists to administer law and order the old-fashioned way:
with fear and a big stick. The town was settled by the Australians in
1924 in an attempt to subdue the headhunting populations of the
area so exploratory missions could safely venture into the interior
in search of gold. There hadn't been much gold around to make it
worth their efforts, but Ambunti became the most important out-
post in the Sepik River region — a reputation it still holds today. It
is the Last Stop. After Ambunti, the river can go on for days without
offering the respite of human presence. Just jungle, I'm told. River
and the endless green.

It is in Ambunti that I first hear about a famous Apowasi witch
doctor living upriver. He has uncanny powers. He can heal the sick,
curse the wicked. He speaks to the animals of the jungle, cajoling
them until they walk into a hunter's hands. But more than any-
thing, he's renowned for his ability to connect with the gods. He
knows the proper spells, and how to lift his prayers higher than the
stars, until they rest at last in the right ears. The gods hear him.

They answer his prayers. The lost become found; the dying, saved. He can create miracles, I'm told, and I want to find him and ask him whether the gods are watching me, helping me. I want to know what I'm doing here in New Guinea, always on the move, always traveling to one dangerous place after the next. When will I be able to stop? When will I end the searching?

Given its unique outpost status, Ambunti isn't a very big place. It's a pleasant town of about 1,300 people, and the centrally located airstrip is its only main attraction. The village itself consists mostly of traditional and Western-style houses spread out along the Sepik River, people peacefully going about their affairs of fishing, running small stores. A missionary compound and a couple of simple guesthouses face the airstrip, and I head over to see about a room. I stop off at a simple-looking shack with a corrugated iron roof — one of the town stores. Inside is the usual food of PNG, the mainstays of Australian bush cuisine: packets of Maggi instant noodles, great tins of margarine with a smiling New Guinean boy on the label holding out a piece of buttered bread, whole milk powder from France, gargantuan bottles of cooking oil, Milo bars, rice, Cadbury's chocolate. I pick up a jar of the Australian black yeast spread called Vegemite, the most revolting substance ever designed for human consumption.

"It'll grow hair on your toes," someone behind me says in an Australian accent.

I turn around to see a tall, lanky, redheaded man in olive army surplus pants and broad-rimmed straw hat, smiling at me. "Rob Hodge," he says, extending his hand.

Beside him is a man with curly blond hair, wearing a sun visor. Though of slight frame, he's all muscle and sinew. "Yens," he says with a German accent.

He spells it for me: Jens. He's from Germany, is taking his "holiday" in Papua New Guinea. He says his girlfriend hadn't wanted to accompany him here so he has to settle for Rob. I find it odd that one would choose PNG as a vacation spot; I seem to have chosen this country for every other reason — for the raw challenge of the place, for the lack of comfort and guarantees. Jens is reminding me of the trip I might have had: going to a place merely to enjoy myself, to languish on a beach, to swim in turquoise waters. Nothing to prove to myself or the world. It seems a somewhat quixotic idea.

I introduce myself. Rob inspects me, beaming like a proud father.

"Looks like you've seen hell," he concludes.

"Do I look that bad?"

"Ya, well, your legs are not so good." Jens points at them with a serious expression. "All the scratches here."

I shrug. No beauty contests out here. This is what you look like after hacking yourself out of a jungle for a week, getting heat stroke, almost dying in the process. My legs are like war zones, covered in scratches, punctures, rips.

"How'd you get like this?" Rob asks.

I tell them about my hike from Fiak to Hotmin: the heat exhaustion, the ninety-degree mountains of jungle, and the never-ending rain. I describe the small villages I'd seen after leaving Hotmin for the May River mission, and how the missionaries must be pulling their hair out because the women were still bare-breasted and wearing bark-string skirts.

Jens shakes his head wistfully. "I am jealous," he says. "I want to see that." His disappointment is what safari-goers in the Serengeti might have when told they'd missed a leopard sighting.

Rob slaps me on the back.

"You've got the blood in you," he says. "I'm impressed."

I'm glad he's impressed; it's like receiving an acknowledgment that I, a woman, also belong in this place — a place that has traditionally been the playground of male travelers and adventurers. I've passed the test. I *can* do what the boys can do.

"'The blood'?" I ask Rob.

"You've got balls," he says. "I'm going to call you *bush meri*."

I smile. A Bush Mary with balls — the male anatomy bestowed upon me to explain the phenomenon of what I've done.

I start to feel better when Rob tells me that Jens is a German Navy SEAL officer, of high rank, a "killing machine." (Jens blushes.) His skills are in such high demand that he's often brought over to the States to help train American Special Forces units. No wonder he is so strong, appears so physically fit. I want to know why he's chosen to commit his life to the Navy SEALs. What does it give him that he can't get anywhere else?

"Do you enjoy it?" I ask him.

"Of course," he says.

"What do you enjoy about it?"

He sputters his lips. "It's not an office job, this kind of thing."

"Do you like the adventure of it?"

"Yes, of course."

He sighs and looks away. I consider telling him about my childhood fantasy of becoming a female Green Beret, but I don't want to frighten him with the idea.

Rob tells me that he met Jens in a guesthouse in the coastal town of Wewak, and that they flew here to Ambunti to hire a canoe and guide for their very own trip up the Sepik River. Jens doesn't have much time, but their plan is to go up some rarely traveled tributaries, seek out tribes that have had little or no contact with travelers. He asks if I'd like to join them.

It doesn't take me long to decide. We'll try to find the Apowasi witch doctor.

As we leave the store, I ask Jens what he teaches his American Special Forces students.

"It depends, you know."

"Bombs and stuff? Explosives?"

He sighs. "Ya, ya. I teach some of that."

"Teaches 'em how to blow the enemy to smithereens," Robert offers.

Jens is blushing again. "Ya. That kind of thing."

"Do you teach them how to conduct secret training missions?" I remember the books about the Special Forces and Navy SEALS I used to read as a kid. "You know — scuba-diving to enemy ships and planting explosives on the hull?"

Jens looks at me curiously. "I can't talk about it, you know."

But we don't give up asking; Jens's reality is so surreal to us.

"One thing I'm wondering," Rob says. "Do you know how to strangle people with wire?"

We follow the course of the airstrip, waiting for Jens to reply. We want him to tell us that yes, he's been taught to do that, has even done it once in a covert operation in some forgotten corner of the world like Papua New Guinea.

A pilot loads some screeching piglets in *billum* bags next to a coffin in the back of a small plane. Jens pulls out his camera and takes a few pictures — this is the world Jens considers bizarre. Rob reiterates his question. Wires. Strangulation.

"I'm on holiday," Jens says simply.

Rob slaps Jens on the back again. "We'll just get you pissed, mate. Loosen the tongue." He grins devilishly at me.

We head over to the hut of a well-known guide in town. This man, Joseph Kona, knows immediately about the Apowasi witch doctor known as "the Chief," who is the *bigman* of his tribe. We three are invited into Joseph's hut to work out the details and expenses for visiting the man. It turns out that the Apowasi are far up a branch of the Wogamush River, a western tributary of the Sepik. Their village isn't on any of our maps, the people themselves living inland from the river in a remote area. Joseph says they're visited by Westerners maybe once every few years.

We make final arrangements, and Joseph invites us to spend the night in his hut. I feel a lightness of mind because I'm not traveling alone anymore and don't have to rely on myself if anything dangerous should happen. I'm with two men, one of them a Navy SEAL. Not bad. Better than carrying a machete.

And it turns out that Rob has been everywhere. He's been attacked by hippos in the Serengeti, has made daring leaps from cliffs onto trucks in the Australian Outback. He's canoed down the Klondike River, every last mile of it, and has seen the sun rise on the Alps, the Himalayas, the Andes. Rob has seen it all, and none of it was ever enough for him — until now. Now, he's content. We eat Sepik River catfish with rice before the glow of a kerosene lamp, and he sits back against the palm-bark wall of Joseph's hut, smiling a big Irish grin.

"This has got to be the one place I would most want to be in this moment," he says. "Here it is."

Jens glances at him, amused. He won't be caught with Rob's moist eyes or goofy smiles. Not a word out of his mouth sails beyond the present and the practical. Jens, a warrior by profession, a specialist who teaches others how to kill, must find sentimentality a sign of weakness. A liability.

But does he hear the sound of children playing outside in the night? The soft conversations in the native *tok ples* language from Joseph's family in the back room? The banter of the frogs? There is a sense of our being told a secret now — right now. We're being let in on what should, *must,* always matter in life. The intimate sounds of life go on around us as if they have no intention of ever stop-

ping. I wonder if Jens hears. I sit down near Rob, who is grinning mysteriously, and we smile at each other. We know. We share this night.

When we all finish eating, we head into a spare room of the hut to set up our mosquito nets. I choose a place between Jens and Rob, enjoying the safety of their proximity and relishing their company. They change out of their clothes in front of me as if I weren't here. I sit and watch them, their chests, the beautiful male bodies. Why not? I watch them until they slip into their mosquito nets — Jens in boxer shorts, Rob naked. Then I slip off my own shirt. I catch them watching me, and it's as if we belong to each other.

We three sit in wicker chairs in a large dugout canoe. "The lazy way," Rob calls it. Joseph sits up front, sleeping, his younger cousin, Alphonso, piloting us along. Jens is also asleep in front of me. Though fair-complexioned with his blond hair and blue eyes, and wearing only a thin T-shirt and shorts, Jens is convinced that sunscreen is a useless gimmick of the West, and he refuses to wear any. His skin is red and crispy all over, his curly blond locks bleaching in the sun. Rob makes up for Jens's intransigence by wearing a long-sleeved army shirt, straw hat, pants, and boots. I fall somewhere in between, in T-shirt and Australian bush hat.

For the first time since arriving in PNG, I'm feeling as if I might just be "on holiday," like Jens. I'm just enjoying the world, postponing all tests. It always amazes me how intrusive beauty becomes when the mind allows itself to rest. The body relaxes, the senses turn on. Perfection imposes itself upon the earth, and I am gorging myself on the spread of river that twists and glides to the west, to some space seemingly beyond the horizon. This feeling is the same as looking at a night sky — all the immensity, the grandeur — only here it is a feasting of color. Clouds sweep broadly across the blue sky, rising in pillars and arcs of gray and white. I can almost feel distant rain pounding down on some immutable shore. The river waters catch and rattle the stands of wild sugarcane bordering the river. Sunlight falls haphazardly upon the inland jungle, lighting the tops of trees in one place while another group falls into darkness. Crocodiles, the kings of the PNG waterways, slip into the water as we motor by. Joseph points at them with reverence. They're big out here, he says. As numerous as the very stars them-

selves. He tells us that the crocodile is a special creature. In the beginning there was nothing but water, but then a giant crocodile swam down to the bottom of the sea and returned with mud on its back, creating the world.

We exit the Sepik River for a small river that heads south, toward one of the largest lagoons in the country. Rob wants to see a bird of paradise, PNG's national bird and a species famous for its spectacular plumage, so we're taking a side trip to a village called Wagu located at the bottom of the lagoon.

Joseph has his reservations about taking us, though, because my female presence might emit "poison," which could chase the birds away. He tells me that females in PNG are believed to give off poison much more often than the men ever do, their menstrual cycles and genitals causing sickness, injury, death. Even worldly Joseph, missionary-schooled, English-speaking, a prominent man in Ambunti, firmly accepts this. He's seen it happen, he says. Couples who "don't take the tradition seriously" will pay the price for not bewaring of the female poison: The men grow weak and die young.

Just as a town would want to separate infectious typhoid patients from the general population, women in these villages are whisked away to menstruation huts — *haus meri* — at the first sign of their monthly evil because Joseph says they're "full of mischief" and can spread poison. Poison is spread in the most unassuming ways. Maybe a woman sits down on her husband's chair while she's menstruating, and he sits there after her — well, he's just caught her evil and has infected himself, and chances are his health will begin to deteriorate. Food preparation and cooking must be done by another female during this time, to avoid having menstruating women infecting the meals and causing the man's body to "rot" from the inside out. But what the men fear most is the vindictive wife who, wanting to get back at her husband, practices "sorcery." Maybe she leaves some menstrual blood where he'll walk on it, or — God forbid! — is intent on spreading her poisonous sex fluids on him during intercourse. From the man's point of view, the hazards must be many, the risks great, in order to lie with a woman to perpetuate his clan.

I don't tell Joseph or anyone else that I'm currently having my period, and revel in the thought of all the poison I'm unleashing onto the world. Joseph says that one of the worst things a woman can do is to step over a man during her "blood time." Feeling

mighty and wrathful, I make an effort to step over Joseph several times as I get in and out of the canoe during the day. The poor man suspects nothing.

After slipping across the lagoon's wide, black waters, we reach Wagu at dusk. It's a small village comprised of a few stilt huts spread along the water. Mosquitoes are mysteriously absent, and I walk casually along the lagoon's shore, staring up at the ever-brightening stars. The night air is cool and pleasant here, and I'm surprised that the Bahinomo people of Wagu village are the only ones to have chosen to settle beside this lagoon; it may be that fierce tribal fighting allowed them to keep this paradisiacal part of the country all for themselves.

We wake up at dawn to seek out the birds of paradise. Our guide, a local man, leads us up a steep slope into the neighboring jungle. We chop ourselves a path, sweating and cursing our way through the thick foliage until our guide stops us. He points at the branches of a large red *klinkii*.

Two birds of paradise with bright-red feathers taunt each other and fly into the air, their long, frilly plumage flaring about them. Rob and Jens take their cameras out and start to take pictures, as our guide lets out a high-pitched call, hoping to call over more. The two birds fly off. We sit down and wait, flicking off the little wormlike leeches that jump onto us from the foliage and inch up our arms and legs. No birds are returning. Nothing.

Joseph is becoming increasingly furious. "It's no good. That man" — he points to our guide — "was with his wife last night. She put smell on him. The birds smell her poison and they don't come."

Joseph repeats this to the guide in pidgin, and the Wagu man looks at his feet like a guilty child. Joseph is spitting and frothing in anger now, berating the silent man. Rob raises his eyebrows at me, and we try not to laugh, waiting for Joseph's tirade to end.

With the birds staying clear of us, we have no other alternative but to return to Wagu. Joseph, still piqued, tells me that if a man sleeps with a woman then goes on a big fishing trip, he won't catch anything. She leaves her evil on him, jinxes him. The animals and fish can smell her and they stay away. "Our guide knows this," he says to me. "Stupid man."

Rob nudges me, but I'm not laughing anymore. I'm starting to

get really sick of women being blamed for everything. When we get back to Wagu village, I'm determined to step over both Joseph *and* the guide a few times. And maybe Rob and Jens, too.

We're on a small tributary of the Wogamush called Piyowai Creek, trying to reach the Apowasi people, and I don't even know if I could get the days and dates right now. The arching of branches and vines overhead obscures the movement of the sun so that life feels timeless here. Enormous butterflies with wings of blue and green satin flutter and cavort with each other in the patches of sunlight streaming down. Bright-red and blue damselflies skim the water's surface, rising in abrupt swirls to settle daintily on plants lining the shore.

The bird life here would please even the most discerning ornithologist. Parrots announce our canoe's approach in a flash of green and red wings. Black-and-white cockatoos, creatures I've only seen inside cages, watch us fearlessly from their perches. Joseph points out a large bird with black body, white head, and an enormous yellow beak — a hornbill. As it takes off, it makes a loud, propeller-like sound, as if it were a chopper flying off in retreat. Crown pigeons with red eyes, bluish-gray bodies, and large tufts of feathers on their crowns study us from the trees. Alphonso shoots a four-pronged bamboo arrow at one, misses, and the bird flies away over the treetops with a loud *whoosh-whoosh-whoosh.*

The creek narrows to no more than fifteen feet across. With the water so shallow and cluttered with rainforest debris, it's becoming hazardous using the outboard and we're forced to pole ourselves along. Our progress slows. Dead trees block our passage, and we're constantly getting out of the canoe to drag it over them. When we encounter large tangles of tree trunks, our only recourse is to chop them apart so we can make a corridor for our canoe. This is Jens's and Rob's idea of adventure, and they eagerly shed their shirts and take up an ax. I offer my own services, but Joseph and Alphonso shake their heads and grin at the idea. Men only.

Fine with me — it's full sun and 90 percent humidity.

"Move that ax a little faster," I tell Rob from my seat in the wicker chair.

Joseph is concerned about the time it's taking us: It's not only the dry season, but there's been very little rain this year. Our canoe

is now starting to drag along the bottom of the creek, making him wonder if we should forget about trying to reach the Apowasi people. He's worried there won't be any creek water left when we're making our return to Biaga. What do we want to do?

Rob is unperturbed. He doesn't mind dragging the canoe back to Biaga if he has to. Jens wants to get to these Apowasi people, see "people who wear traditional clothing." My opinion isn't solicited. I'm starting to miss traveling by myself.

"I'd still like to see the Apowasi chief," I announce.

That settles it. We'll continue.

It's the late afternoon when Joseph says we've reached the spot where we'll be leaving the canoe behind for a hike through the jungle. The water is so low that we have to pull ourselves up a six-foot-high, muddy embankment just to reach the shore. A ramshackle hunter's hut sits in the midst of an overgrown clearing, birds streaming from the structure as we approach. The sun barely reaches us here, the jungle crouching over the hut, crowding out light so that everything appears in dim, greenish hues. Insects screech and fidget from the reeds near the creek shore. Birds high up in the canopy let out sharp calls. This place feels haunted, as if ghostly eyes of the ancestors stare at us.

We put all of our things in the hut and prepare for the hike to the Apowasi village. We follow a faint, muddy path through primeval jungle, trees towering at least a hundred feet above us, vines creeping from limb to limb, hugging trunks and hanging from boughs like gigantic tentacles. Tall, skinny aruka palms compete for light with large red *klinkiis*, renowned for their strong wood, which is used by the locals for making canoes. The competing black *klinkiis* have wood so heavy and durable that it sinks in water, being used primarily for paddles. Every jungle plant must have its utility in the lives of the local tribes, from the food-giving sago palm to the wild sugarcane used for making mats.

Our pace is unusually fast, as if this were a bushwalking competition. Rob, Jens, and Joseph are directly ahead of me, Rob slipping from time to time on muddy tree roots because he wears his boots, refusing to go barefoot like the rest of us. Jens, though, seems to be back in Navy SEAL training. He's as adept at this kind of travel as Joseph is, and easily twists and breaks off branches with a flick of his hand.

It's been an hour of this fast-paced jungle hiking until the path opens up and we see a small village sitting on the edge of a large stream. Mountains of rainforest rise to the south, clouds languishing about them, the departing sun already warming the sky and jungle with an orange glow. Everything looks softened, as if a god were resting a gentle hand on the earth, quieting it, preparing it for rest. The stream travels over stones that catch the sun's light and cause it to glitter. Naked children chase each other through the water, laughing. They haven't seen us yet. No one has. The village is completely undisturbed; it is one of the most serene places I have ever seen.

Joseph calls out. The kids playing in the stream look over at us, freeze, then run off in terror.

"They never see white people," Joseph explains.

Jens has his camera out and is snapping pictures of the retreating children.

A man in a dingy, unbuttoned white shirt, wearing a breechcloth and pandanus leaves around his waist, comes out to greet us. Cassowary claws erupt from the tops of each of his nostrils, and large hoop earrings made from bird quills graze his shoulders. A band of bright red and yellow beads encircles his head. A half-moon *kina* shell is tied around his neck — surely his prized possession as this shiny, abalone-like shell had been traded all the way from the ocean. These *kina* shells themselves are so highly prized that the PNG monetary unit is called by the same name.

"This is the Chief," Joseph says.

"Does he have any other name?" I ask. I'm reminded of a denigrating Western out of the fifties.

"Everyone calls him the Chief."

The Chief's face is stern as he examines us. Rob points to a necklace he's wearing, made of tulip-tree fibers woven about a round piece of wood.

"Mourning necklace," Joseph explains.

He tells us that the Apowasi people wear a necklace whenever one of their family members dies. The necklaces contain the soul of the deceased, and only once the necklace falls off will the mourning period end and the soul pass on to the spirit world.

Joseph and the Chief chat in a tribal language, presumably about us *waitman na wait meri,* and what we're doing here. They're both laughing heartily.

The Chief says something, and Joseph translates.

"He asks if you want to take photo."

The Chief holds out his hand. He demands one *kina* for every picture we want to take of him. Jens has already taken several and pays up. I look at Rob. Neither one of us wants to seem like some ridiculous, camera-toting tourist, paying for a photo beside the guy in the Mickey Mouse suit. Yet we are tourists. Silly tourists fascinated by the man before us. And this has become a business venture for the Apowasi. It's curious that this isolated tribe knows to collect money from us, as there's nothing to spend it on, the nearest stores in distant Ambunti. I'm witnessing one of the surest signs of the power of Western influence.

We all pay up. Rob stands beside the Chief as Jens focuses the camera, the Apowasi *bigman* looking off in a different direction, not wanting to make eye contact with the lens.

Another man, dressed like the Chief with large cassowary talons sticking out of the top of each of nostril, comes forward, asks for a *kina* from each of us, and poses next to his friend for pictures. Rob uses his Polaroid, giving them both instant shots, and they pass these along to family members who start to emerge from the nearby huts. Jens must be disappointed: none of the gathering Apowasi women are wearing bark-string skirts, having converted to a cloth *laplap* around their waists and a T-shirt worn threadbare over their breasts. A single old woman appears in the distance, though, wearing only a bark skirt, and Jens charges toward her with his camera. I'm embarrassed. I want to apologize to everyone for breaking into the routine of their lives, for not having anything meaningful to contribute except, perhaps, my wad of *kina* bills.

The Chief and his friend disappear, and about ten minutes later we hear a low-pitched, ominous whooping coming from the nearby jungle. Suddenly the two men burst forward with spears held aloft. Bright-yellow paint covers their bodies. Pandanus leaves are tied about their arms and legs. They charge toward us with a sharp holler and I find myself running for my life. I retreat toward the village but am quickly cut off, the Chief's spear only inches from my face.

He smiles. I try to smile back. Thirty years ago, I may have actually been speared. Now he lowers the spear and shows it to me. Though I'm not in the mood, he insists I run my fingers down the length of its shaft, touch the sharp bamboo point. Jens comes

over and tries it out, pretending to be a javelin thrower. He calls Joseph over to translate, and thus begins a heated discussion about whether the spear is for sale and how much it costs. Rob wants a spear, too, and so the Chief's friend runs off to his hut to get some more. It's the Home Shopping Network, PNG style, spears, bows, and arrows laid out for our *kina*. Jens pulls off his T-shirt and exchanges it for several arrows. The T-shirt I'm wearing could buy me two spears, but I'm not interested.

I wander off along the stream, watching the mountains growing increasingly pink in the declining light. If I could, I would walk off to those mountains, but with none of the rush and exertion of past travels. This time I would do it slowly, taking weeks, perhaps months, stopping to learn the names of all the plants and insects — the local names, the names that have special meaning to the people. I'd learn how one plant relies on another, how a single seed sprouts and a tree comes into being. I'd start from the beginning, learn about life all over again, if only, by the end of it, I would be able to understand why I'm here in PNG, what quakes of the soul had sent me adrift.

Children hide behind the posts of the stilt huts, watching me silently. I'm the perpetual stranger. I hear Rob saying that this place is his idea of "utopia," yet I don't know what a utopia is supposed to be, or where one could be found. I sometimes think that it is the place where fear and doubt end with the realization that around you is everything you need, and there is nothing else to find.

The old woman with the grass skirt comes toward me and hands me a few of the mourning necklaces she's made. She pats my hand, says something to me, and smiles a toothless grin. Thinking she's trying to sell them to me, I reach for some *kina* to pay her, but she shakes her head and speaks softly to me in her *tok ples* language. She pats my hand again and I watch her shuffle off, back bent, bare feet following the ground's well-worn path. I am beginning to understand.

"Is she selling those necklaces?" Jens calls over, his arms full of arrows.

"No," I say.

I walk over to the Chief, and have Joseph ask him about the gods. He may find my question strange: I want to know if the gods are kind.

Joseph translates. "They are full of mischief," the Chief says.

"Why?"

"People want many things," the Chief says. "The gods hear and give them big gifts, but people don't give a payback. The gods are angry."

"Can the gods hear us now?"

The Chief points at a bird flying across the stream. "There. He hears."

I have Joseph explain to the Chief that I know he has great magic, and I'd like to make a wish and have the gods hear.

The Chief tells me to wait. He suddenly points to a large crown pigeon that has alighted on a nearby tree, and nods. I look at it, make my wish. *I want to find a way to end my crazy searching.* The Chief is smiling slightly. Jens comes over, wanting to see the mourning necklaces I've "bought," and I hand them over, my eyes still on the spot where the bird was. Here in Apowasi village, life is inseparable from magic. The hunter who catches a large cassowary in the jungle has been favored by a god's magic; the little girl who grows sick and dies is the victim of evildoing. But it's not easy for me to believe. I find myself wanting evidence, proof.

It's getting late, and all of our things are back with Alphonso at the hunter's hut beside Piyowai Creek. Joseph wants us to get going, but the Apowasi chief stops us. He will do us a favor. He said he's heard from Joseph about how difficult our travel was up Piyowai Creek. He wants us to have easy travel back to the Wogamush River in our canoe, so he says he will make us rain.

Jens sputters his lips and ties his arrows together with a strip of bark. I'm looking at the sky. A few distant clouds. No sign of a storm. The jungle announces night in the dark-red hues of dusk. We've got a jungle to get through, and I'm feeling nervous. I don't want to hike when it's dark out; the jungle makes me feel claustrophobic enough as it is.

The Chief goes and gets a newly cut sago palm branch, closes his eyes, and says some words in a deep voice to evoke the spirit of the water. He opens his eyes and breaks the branch over the river, the pieces floating away in the current. We all watch as they knock against rocks and bob through rapids. The Chief smiles placidly: We will have our rain.

He points at me to tell me the gods have heard — I will have my wish.

*

We are nearly to the hunter's hut. Traveling through the dark jungle, I've been waiting for the Chief's promise of rain, and it begins now, like a benediction. Suddenly the wind tears at the trees and lightning flashes. The dark sky wants to drown us. The path below our feet disappears with water and I fumble along a trail I can't see, stepping where the person ahead of me steps, feeling for footholds with my toes. The night cracks and booms as we slosh through mud, never knowing what we're about to step on.

We fumble up to the hut. The rain gushes upon us, and Joseph is telling us to hurry, hurry. Alphonso stares out of the doorway at us, eyes wide. The magnitude of this storm is like nothing any of us has seen, and the night tears at the hut's thatch roof, water streaming in from myriad places. The thunder shakes the wooden foundations and pounds away across the jungle. Alphonso sits with his knees pulled in against him. Rob gives him a friendly pat on the back, but the man isn't comforted. He shakes his head, mumbles something in a language we don't understand. Joseph tells us that Alphonso knew this storm was magic — the Chief's magic. The gods are everywhere, he says to us, shaking.

We all go to bed, rain soaking us through our mosquito nets. If I should be scared, I'm not. Rather, I find myself comforted by the determination of the storm.

Dawn. The rain has ended and sunlight streams through slits in the palm-bark walls. I hear Alphonso exclaiming, and crawl out of my mosquito net to see what he's pointing at. Directly outside of the hut is Piyowai Creek. Where there was once a six-foot slope down to its waters, muddy water now surges past.

Joseph hurries us. "This is special for us," he says. "The Chief make water for us. Normally, the water stay like this for two, three days, but this water is just for us. Chief said we must leave early because the water will go down."

Our canoe, having risen with the water, floats beneath the stilt legs of the hut. We pull it over and load our things into it. Rob has his video camera out to record this creek turned river.

"Should have asked the Chief to make us some cold Fosters," he says.

We get into the canoe and shove off. Our work is minimal; we merely let the current take us back to the Wogamush. I'm surprised

to discover how swift this current is. How determined. We travel so quickly that even the outboard is unnecessary, and the giant logs that had blocked our way on the approach are now deeply submerged, only the very tips of their branches poking through the top of the water. The sun glares down on us from a cloudless sky, the heat becoming intense, yet we're speeding along as if a great wind were behind us — or a god's hand pushing us along. I'm ecstatic with the feeling of speed.

Slowly, the water returns to where it was the day before. The nearer we get to the end of the Piyowai, the more the bloated creek recedes, until finally, like a gift, the current graciously releases us into the great, black spread of the Wogamush River.

"That was special for us," Joseph reminds us.

Jens adjusts his wicker chair and leans back, eyes closed, face to the sun.

"We could use a little rain-making back in the Outback," Rob says, beaming.

I sit in the prow, watching the tip of our canoe break the black waters. Reflections of the jungle appear on the river's surface — trees, a bird swooping across a screen of blank sky. The passage of our canoe pulls and distorts the images until they're taken by the waves. Last night's rain might have been a complete fluke. I know this. Yet, I still believe.

DAVID SEDARIS

The Man Upstairs

FROM *Esquire*

WHEN I WAS TOLD that they'd canceled the two o'clock flight from Boston to Portland, Maine, my first instinct was to lie down on the floor and cry. Timewise, the delay was hardly the end of the world: My business wouldn't begin until the following morning, but still, the news was crushing. The cancellation was a reminder that I do not govern the activities of major airports, which seems obvious enough but always comes as a terrible shock when stated out loud.

Like most people, I've constructed an elaborate house of cards based on the concept that I control the world around me. The hotels in which I stay do not catch fire because I do not want them to, and my planes stay aloft for the same reason. What religious people call fate, I call luck, and what they call God's will, I call bad luck. Accept a canceled flight and suddenly you're on a roll, opening yourself to the possibilities of tax audits and spinal-cord injuries. Anything can happen once the precedent's been set.

The news was disappointing, but I might have sulked a lot harder had my earlier flight not included a bald five-year-old traveling with a couple I guessed to be his parents. Boys that age do not generally shave their heads, and so I, along with everyone else, naturally assumed he had cancer. When adults get sick, it's commonly decided that they brought it upon themselves — Constance held grudges; Marty destroyed his heart with buttered popcorn. It's our pathetic way of insisting that the same thing could never happen to us. But it's sort of hard to blame a child. I mean, what, did he teethe too hard?

It was a hot, crowded flight, and we spent an hour on the runway, waiting to take off. The beverage service was canceled due to turbulence, but rather than complain, we looked at the bald five-year-old, realizing that a free Dr. Pepper doesn't mean very much when held against a sick and possibly dying child. No one said anything, but you could tell we were all thinking the same thing:

No beverage service? Oh, that's okay, but can't you round up a bag of pretzels for our little friend in 11-B?

It was one of those rare moments when a group of strangers comes together in a spirit of quiet benevolence. Had the pilot announced a request for bone marrow, we would have given it. Had he thrown in a few thousand bonus miles, the flight attendants could have walked away with a sackful of warm kidneys.

Logan Airport isn't terribly lively on a Sunday afternoon. My rescheduled plane was supposed to leave at three-thirty, and I returned to the gate a half hour early to find that it, too, had been canceled, this time due to "bad weather." At this point, I started wondering if the bald child hadn't been a plant, a professional Tiny Tim shuttled from city to city in order to keep the customers quiet and reflective. I'm normally not that suspicious, but this was an airline that tended to schedule regular, hourly flights and then systematically cancel them until they'd collected enough victims to fill an entire plane.

The ticket agent's nametag identified her as Pamela D. She was a pale, redheaded woman who'd framed her stained teeth with an unflattering coat of thick, liver-colored lipstick. Even her voice was rusty, worn ragged from barking identical orders to seemingly identical passengers.

It was warm and sunny in Boston, and when I asked if conditions were truly *that* different 110 miles to the north, she cut me off, saying that neither she nor her associates were personally responsible for the weather.

Though she seemed entirely capable of brewing a storm, I hadn't actually accused her of anything. "Listen," I said, "I just wanted to know if —"

Again she cut me off, saying there was no reason to raise my voice. I'd been speaking in my normal, conversational tone, and when I repeated the question at half my regular volume, she in-

structed me to step away from the counter and return when I was ready to behave like an adult. Which meant never.

There's really nothing to be done in such situations, but I'm always happy to latch on to someone who thinks otherwise. On this particular occasion, that someone was a self-proclaimed scholar who looked to be in her mid-fifties. The woman was scheduled to deliver a speech at a Portland-area college and informed the ticket agent that her time was extremely valuable.

"You people exist from one coffee break to the next," she said, "but that's not how things work in academia. This trip was arranged months ago. Notices have been sent, and come eight o'clock this evening, an auditorium full of people will be waiting to hear what I have to say."

This failed to impress Pamela D., who categorized the alleged foul weather as an unfortunate "act of God."

"Don't spout your tripe to me," the scholar said. "The others might buy it, but I'm an educator and can sniff a lie from a mile away."

I wasn't sure what this woman taught but guessed that it might have something to do with really big jewelry. She wore a ring on every finger, a huge pair of boxy copper earrings, and, around her neck, a coaster-sized medallion embossed with the figures of wrestling Athenians. With the possible exception of an armor-suited knight, she was a metal detector's worst nightmare.

"I'm on to you, missy," she said, walking toward the bank of pay phones. "You and your whole stinking organization."

At four o'clock, I heard a rumor that we might be boarding at four-thirty. Come five, word on the street was that we'd get moving just as soon as the baggage was loaded. At around six, Pamela D. and her associates herded us onto a bus we assumed would carry us to our plane. Twenty minutes later, as we sat stalled on the dark tarmac, we were informed that our flight attendant had called in sick and that we would be unable to proceed without her. No one was happy, but the scholar took it harder than most.

"What the hell!" she shouted. "If you're looking for volunteers, I'll stand at the door and tell everyone to have a nice goddamned day."

Oh, I thought, I *like* you.

This is a mistake I happen to make with depressing regularity.

Given the choice of dozens of sane and perfectly decent candidates, I always attach myself to the loudmouths seconds before they reveal themselves to be psychotic. It's the price I pay for being both a natural-born follower and an overly enthusiastic listener. The scholar had been talking for hours, but unless she was crabbing at the airline personnel, her comments had not been directed at anyone in particular. Rather, she just spoke, hoping that sooner or later someone would meet her eye and agree to play the role of her listener. I accepted the challenge, and by the time we left the bus, I was carrying her luggage.

Ours was a relatively undemanding relationship, as I wasn't expected to have opinions and conspiracy theories of my own. My role was to take up the rear, occasionally stoking the fire with a well-placed "You've got *that* right" or "I couldn't agree more." I liked her, in part, because it was easy.

Back in the terminal, she cornered Pamela D., who claimed that because her illness was weather related, the missing flight attendant was yet another act of God. "Therefore," she said, "we cannot be held accountable for her absence."

This did not sit well with the scholar, who pounded the countertop and demanded to hear the airline's official definition of God.

Pamela D. offered that He was, you know, Jesus' dad, and the scholar shouted that this wasn't good enough. "The Romans *defined* their gods," she yelled. "The Jews, even the Aztecs, but your people can't quite put their finger on Him, can they? Oh, you'll use His name when one of your girls calls in sick, but when the time comes to get specific, you're no better than the goddamned Unitarians."

Pamela D. was not trained to discuss theology. She asked what the Unitarians had to with anything, but the scholar ignored the question.

"You're telling me that God plays an active role in your organization, that He basically works here and makes all the important decisions. And I'm telling you that as an extremely dissatisfied customer, I want to talk to Him. Right now."

Pamela D. mentioned an interdenominational chapel at the far end of the United terminal, and the scholar rolled her eyes, saying, "Where do they find you people, in a cave?" She then demanded to speak to a supervisor, saying, "Hurry along, now. Chop-chop."

Pamela D. left her station, and in her absence I was treated to a dramatic reenactment of their conversation. "She said it was an 'act of God,' so I said, 'Define God!' That got her, all right. I mean, what if some of us don't believe in Him? What then? This isn't a church, so why bring religion into it? I said, 'If God works here, let me have a word with Him!' Ha! That put a cork in her faucet. I said, 'Where do they find you people, in a cave?'"

A white-haired man looked up from his paper and turned his head in our direction. "Oh, give it a rest," he said. "We're not going anywhere until they find a flight attendant, so why don't the two of you just shut up?"

The two of you. In the minds of our fellow passengers, the woman and I were now a team — the Sid and Nancy of interfaith love and tolerance.

Back away slowly, I thought. *Just keep moving and no one will get hurt.* I inched toward the departure gate, and the scholar grabbed my shoulder.

"They're all sheep," she told me. "Happy to sit on their haunches until someone opens the gates and shoos them to pasture. Joe Schmo misses his Sunday dinner, and fine, it's ultimately no big deal, but I have a lecture to deliver." She rooted through her purse for a throat lozenge, and then, squinting at the figures approaching in the distance, she turned to me, shouting, "Well, wouldn't you know it. I asked to speak to the guy in charge and they send me the biggest, fattest bull dyke in the entire city of Boston."

This was a mistake, as technically the biggest, fattest bull dyke in the entire city of Boston was not the approaching supervisor but rather the titanic female rugby player sprawled before us on the carpet. The second-, third-, and fourth-biggest bull dykes were undoubtedly her three teammates, who leaned against the nearby wall, exhaling what appeared to be steam.

It suddenly seemed wise to break rank and express my considerable interest in all-state female rugby.

"It's a great sport," I told my new friends. "*Definitely* more exciting than old what's-her-name. God, don't you just hate women like her?"

It took them a while to accept me, but when the rugby players eventually got to talking, my only wish was that they'd shut up. The supervisor had entered the waiting area, and the confrontation be-

tween her and the scholar was much more interesting than a de-
tailed account of last season's losing streak. I heard snippets of the
previous argument laced with accusations against the airline per-
sonnel, whom the scholar referred to alternately as either "nitwits"
or "your girls," as in, "I didn't expect to find any brain trusts, but
you've hired some first-class nitwits, haven't you? I ask a question
and your girls just stand there, giving me lip."

The supervisor was a remarkably patient woman who exuded an
air of genuine concern. She stood as if for sentencing, her eyes low-
ered and one hand folded over the other, occasionally interrupting
to offer an apology. No, God was *not* on the official airline payroll,
and yes, it *was* wrong of the ticket agent to suggest otherwise. "Like
everyone, they sometimes forget themselves and say things they
don't mean. If they've offended you in any way . . ." She absorbed
the scholar's anger much as a plant takes in the sunlight, gradually
raising her head and growing visibly heartier with each dose. This
liveliness was reflected in a series of cheerful platitudes dedicated
to the theme of overcoming adversity and punctuated by the
phrase *"Que será, será."*

"When life hands me a lemon, I give it a squeeze, add some
sugar, and hey, *Que será, será!*"

Did she even know what it meant?

The peppier she was, the louder and more self-important the
scholar became, inciting laughter rather than the respect she had
demanded. An audience gathered, sitting on trash cans and identi-
cal rolling suitcases. Conversation stopped, heads snapped to atten-
tion, and storm clouds raced south from the city of Portland, where
a crowd of learned people faced an empty podium, wondering
what had become of tonight's featured speaker.

Stolen Blessings

FROM *The South Florida Sun-Sentinel*

THE BAMIYAN BUDDHA. The World Trade Center. The *Mississippi Queen.*

The story of the year — prelude, climax, aftermath — is written in the names of lost tourist landmarks.

It began in March (the year, not the story, which has much older origins) when a group called the Taliban first insinuated itself into the consciousness of millions by destroying a 170-foot-tall Buddha — said to have been the world's tallest — that had stood philosophically in an Afghanistan mountainside for a millennium and a half. The Taliban, which also took out a smaller, equally ancient statue, had been in power in Afghanistan since the late 1990s.

These erasures earned universal condemnation — in Germany the acts were compared to Nazi book burning — and even calls to action. The columnist Ellen Goodman wrote, with unimagined and only slightly misplaced prescience: "Imagine the outrage if the Statue of Liberty were torn down like the Buddhas."

But Afghanistan was a murky, remote, benighted place, of no conceivable significance to us.

So spring came and we embraced the world as if it were not short two Buddhas. A California financier with the evocative name of Dennis Tito paid the Russians $20 million for the privilege of spending eight days in space, and thus becoming history's first space tourist. And like that, the always intoxicating possibilities of travel entered a new dimension.

Meanwhile, the rest of us continued moving about at more affordable altitudes. Overbooked planes, their baggage holds stuffed

like cornucopias, fought for gates at overburdened airports. The talk was all of expansion, more runways, the untapped potential of the non-hubs. For we had become an aerial nation, a giddily earth-freed citizenry, needing to fly to see the country, close a deal, visit the family, catch a game. "You can't hop a jet plane," Gordon Lightfoot lamented in the seventies, "like you can a freight train." But we had come awfully close.

A novel appeared just in time to capture the doomed zeitgeist, *Up in the Air*, in which a corporate consultant from Denver by the name of Ryan Bingham (a trifecta of ordinariness) spends his days in pursuit of a million frequent flyer miles. For Bingham is at his happiest in an airplane or at an airport, anonymous in that uniform and seemingly ever-burgeoning realm that he dubs "Air-world" and that his creator, Walter Kirn, clearly saw as the new America.

Then one morning in September we woke up to find airplanes flying headlong into buildings. Our national facilitators had been transmogrified into foreign missiles and directed at our most potent symbols. With the World Trade Center we had the double horror (squared) of watching first the crashes and then the disintegration of both the towers. We knew, as John Updike wrote in *The New Yorker*, "we had just witnessed thousands of deaths." Heaped onto the sorrow for all the lost lives came the thought of all the young widows and one-parent children and snuffed-out companies, which was followed by a trivial but equally unfathomable reckoning of all the equipment — computers, copiers, fax machines, coffee makers — now lying in rubble as a shower of paper, the flimsiest, least indestructible of materials, floated lazily over the city, a small and unappreciated reminder of the saving graces of flight.

All planes were immediately grounded, and stayed that way for the next few days. The nation that couldn't stop soaring now could not take off.

Which was fine, for we were in no condition to fly. The decision to halt air traffic had been made with regard to safety, but it was important from a psychological standpoint; we needed time to grieve, and assimilate what had happened. Still, it was a strange few days, the empty skies giving to all Americans the awareness of a void that New Yorkers and thousands of families around the world were just beginning to learn to live with.

When the planes returned, it was not the same. It was with a new fragility. Those first flights, bringing people home who had been stranded in Canada, were like our earliest space launches, commanding awe and apprehension. We held our breath. Our capacity for imagining disaster had been brutally enlarged.

And so we entered, as all the media informed us, a changed world. As Americans we had always associated change with progress (the great World's Fair message of a better tomorrow); now we experienced it as a grim regression. Technological advances had made travel a pleasure, or at least a comparative breeze; atavistic barbarity had turned it back into an ordeal. Increased security, while reassuring, added hours of tedium to the process, and the once easygoing banter was replaced with a grave suspicion. It is difficult to get excited about a trip when you see a man in camouflage clutching an M-16.

People who had a fear of flying before September 11 now vowed never to board a plane, and those who still didn't think twice about the danger stayed away because of the hassle. Americans, never world travelers (only 15 percent of the population possesses a passport), became proud homebodies.

The quiescence hurt. Airlines needed a bailout from the federal government, while two cruise lines filed for bankruptcy (midnight buffets being less vital to the national interest). This was less surprising in the case of a company like Renaissance, which covered the globe, than it was in that of American Classic Voyages, whose most famous vessels plied the rivers of the placid Midwest. The historic *Delta Queen* will remain in service, but other vessels, like the *Mississippi Queen,* are out of commission, felled by the murderers of innocents.

Travel, a subject generally associated with family vacations (and relegated to a Sunday section stuck somewhere between the comics and the car ads), became a pressing issue, a matter of economic and political importance. Within days of the attacks, Mayor Giuliani told us that if we wanted to help New York City we should come spend our money in its hotels and restaurants. Another famous Manhattanite, Susan Sontag, wrote in a critical and much-criticized commentary in *The New Yorker* that "a few shreds of historical awareness might help us understand what has just happened and what might continue to happen." An appeal not necessarily for travel, but for the worldly knowledge that is often its offspring.

Travel editors, traditionally the most envied and least respected people in the newsroom, saw the tables turned, as the job of getting on planes and flying to distant places no longer seemed such a plum, and the once frivolous domain crept into the limelight through the sudden acquisition (belated outside acknowledgment) of wider implications. Some sections concentrated on deals, greasing an ongoing theme of helpfulness (now not just toward readers, but toward the ailing travel industry and, by extension, the economy), while others found the new climate conducive to reflection and unconventional sallies. Joe Sharkey, the business travel writer for the *New York Times,* began one of his columns (before the crash of Flight 587) with the question a dour Dorothy Parker would ask on picking up the phone: "What fresh hell is this?"

No one could travel lightly anymore. In the old days (this past summer) people discussed where to go; now they first had to ask themselves if they should. Like heightened airport security, it was a necessary measure that slowed down the process. It was another step back. We used to start with the atlas; now we had to consult the front page and probe our hearts.

The major concern was safety, but there were related issues: the propriety of going on vacation when your country is in mourning or, a few weeks later, at war. And there was also the question of affordability, now that stocks were falling and jobs being lost. We had been shown the importance of travel to the economy; now we had to examine its importance to our lives.

If we found it still vital, we faced new criteria for choosing a destination. The usual enticements — sights, culture, food, shopping — became secondary to our perception of serenity and even, in some cases, our sense of loyalty. The antiquities of Egypt had a hard time competing with the innocuousness of Australia (even though one had to spend a disquieting amount of time in a plane to get to it). And the four-star restaurants of France did not appeal to some of us, replete with gratitude and wartime camaraderie, the way the homey pubs of England suddenly did.

Of course, the true travelers among us weren't fazed; if anything, they found their wanderlust strengthened, partly because it had been briefly constricted. Other Americans took to the road, packing the car and discovering the country. Such trips answered the need for security — feet on the (familiar) ground — while feeding

a dormant patriotism — heart in the (wounded) homeland — that was buttressed by all the American flags now rippling the roadways, many of them having been mounted, one couldn't help but notice, by the irony-immune owners of gas-guzzling SUVs.

But these restless souls were in the minority. The lumpen masses stayed at home, talking of Tora Bora and Mazar-i-Sharif.

ISABELLA TREE

Spétses, Greece

FROM *Islands*

TODAY IS LIKE YESTERDAY and tomorrow. There is nothing to ruffle the waters of the mind, no cloud on the horizon. The cicadas have made a nest deep inside my temporal lobe, and they rasp there incessantly, soothingly, an entomological lullaby shutting off all forms of conscious thought. The air is alive and warm and suffused with the intoxicating smell of pine needles. Nothing stirs. Only the breeze and the ripples of water sucking idly at pebbles on the beach.

We are moored in a bay on the eastern side of the Aegean island of Spétses. Our boat is a traditional caïque built of pinewood by local craftsmen who have worked it by eye, without plans, with the blueprint in their genes. It bobs on the sea like a cradle.

Beneath me the water is gin clear, and light twinkles through it as if the sun is rising from its depths. Diving in — which I will do in a minute or two, when I can stir some action into my limbs — is like bursting a bubble.

I will swim to the shore and join the others. And soon Panos — electrician in winter, boatman in summer — will emerge from the water, snorkel and mask in one hand, plastic bag bursting with sea urchins in the other. A little ouzo; the sweet-salt taste of urchin eggs; a squeeze of tart lemon.

It's a common notion among visitors here that spending summer in Spétses is like taking a colossal sleeping pill, that it makes you comatose for a couple of weeks. But I'm convinced the opposite is true. To be sure, one part of you — the clock-watching, cuticle-chewing, frenetic workaholic — shuts down. But another, ne-

glected part — the carefree euphoric sensualist — springs to life. Spétses works like smelling salts; it's a corpse reviver, a spiritually renewing slap on the bottom. And every year, as the hydrofoil from Athens approaches the island and that first whiff of Aleppo pines comes blasting across the sea, some deep part of me starts to stretch and yawn and shake itself awake, happy to find itself back home.

I first arrived on the island in a basket — something I'm constantly reminded of by doting *yayas,* the Spétses "grannies." They seemed older than God then; now they're even more whiskered and toothless, and their ranks have been replenished by another generation of women in black. My earliest memories are of being squeezed to an endless round of bosoms, my head stroked, my cheeks pinched, my knees squeezed — until, mercifully, my sister came along. With her fair hair and big blue eyes, she was like honey to the bees. It was the *yayas* who instructed my mother to tie a sprig of basil and a blue glass amulet painted with a white and yellow eye to my cot: one to repel mosquitoes; the other, the evil eye.

My parents had fallen in love with Spétses a decade before I was born. Every summer they rented the same house: a beautiful villa in the oldest part of town, near the mouth of the old harbor, right on the sea, overlooking the monastery of Agios Nicholaos — St. Nicholas.

Like all the villas in the neighborhood, it was originally built by a merchant sea captain who'd earned his fortune blockade-running in the mid-nineteenth century. The house had walls several feet thick (whitewashed on the outside, so it was blessedly cool in the August heat); bare, painted floors inside; and stenciled borders round the ceilings, Venetian style. Off the sitting room there was a wrought-iron balcony that overhung the road and proved the perfect place from which my sister and I could flick pistachio shells onto passing carriage drivers when no one was looking. (Spétses then, as now, has no cars, only a bus, a couple of taxis, bikes and motorbikes, the odd donkey, and ranks of elegant horse-drawn carriages.)

The plumbing in the villa was a noisy, temperamental, twentieth-century addition — one single lavatory that failed spectacularly to live up to the trade name emblazoned on the inside of its bowl: Best Niagara.

My sister and I slept in the basement storeroom where the merchant would have kept his sacks of grain, casks of oil, and bolts of expensive cloth. The floor was uneven, of beaten earth; and light showers of dust fell from between the boards of the ceiling when the grown-ups walked around upstairs. At night the lighthouse at the entrance to the harbor would poke its beam through the bars of the window at the end of the room in three-second bursts, hypnotically — one hippopotamus, two hippopotamus, three hippopotamus, flash! One hippopotamus, two hippopotamus . . . I was asleep long before the rats ventured out to continue their gnawing on the legs of my bed.

When my bed finally collapsed one night, landing with a resounding crash on the floor, the *yayas* in the household were triumphant. Never keen on the unconventional idea of children sleeping in the basement, they'd scored a moral victory, and my mother lost considerable ground in her battle against their old wives' tales about things that go bump in the night.

The house belonged to the Bouboulis family, descendants of the great Spetsiot heroine, Laskarina Bouboulina. She it was who captained the Spetsiot fleet in 1821, so the story goes, when Spétses won the first naval victory for the Greeks against the Turks in the war for independence. Bouboulina loomed large in my childhood repertoire of myths and legends, an Amazonian figure in felt skirt, brocade bodice, and bare feet, as fierce and dashing and romantic as Boadicea or Joan of Arc.

Charging around the garden between the plumbago and the pots of basil, with fly swatters in the waistband of my shorts, I was Bouboulina marshaling my troops, boarding battleships, firing cannons, drawing cutlasses and pistols from my cummerbund. Pushing my sister into the geraniums, I launched my fire ships at the Ottoman galleons, and leapt with breathtaking bravado onto the garden wall, shouting, *"Eleftheria e thanatos!"* — Freedom or death! — the only words, apart from "please" and "thank you" and "good morning," that our patriotic cook had thought essential for my sister and me to learn.

Bouboulina's sea battle was a victory that was celebrated every year with bunting and fireworks and Greek dancers in traditional costumes (including pom-poms on their shoes), and the burning of a mock Turkish galleon in the sea in front of the Dapia — the high defensive wall overlooking the new harbor in the commercial

part of town. Those Armata, or "Burning the Turk," celebrations fell in the second week of September, so, until secondary school rudely intruded and we had to return home earlier for the start of the autumn term, our holidays always ended with a bang, the thud of cannons.

I like to think that some of that Mediterranean fervor, that love of rebellion, was scored into my soul at an early age, the Armata lighting a little bonfire that even the interminable English winters and a thousand school dinners would fail to dampen. I didn't think directly of Bouboulina when I got myself expelled from school, but I remember pledging "Freedom or death" rather melodramatically as my best friend and I broke out down the fire escape and headed off for an ill-fated rendezvous with our boyfriends and a bottle of Southern Comfort.

The influence of Spétses on my education was not all negative. It compelled me to pursue the challenging subject of ancient Greek. My fellow classicists chose the subject for a variety of highbrow and commendable reasons: for the discipline of tackling a difficult ancient grammar, for a better command of the English language, to study the tongue of the birthplace of Western civilization, to read Herodotus (the grandfather of history) and Aristotle and Plato, for a better understanding of the politics and philosophy of the modern world, or at the very least because it gave even the dimmest of us a fighting chance of getting into a good university.

But I chose it flippantly and self-indulgently — because it allowed me to dream myself back to the halcyon days of summer. While my classmates were furrowing their brows over aorist optatives, I felt myself skimming like a flying fish across the waves, invoking "Goddess of Song, teach me the story of a hero . . ." I knew how Odysseus felt when he stood on the bow of his ship heading for home. I'd seen dawn come up with its rosy fingers. I was intimate with that wine-dark sea. As I gazed at the blackboard I could smell the pine resin from Circe's wooded isle, and hear the waves turning over the pebbles on the beach in Ithaca, the adzes knocking in the boatbuilders' yards, the cicadas rasping in the silvery, long-leafed olive trees.

By the time I got to Sappho's teasing fragments of erotic, bisexual love poems, there was no holding me back. I was in my late teens, and the isles of Greece were synonymous with sex. Accus-

tomed to propping up the wall at the local disco back at home, or endlessly reapplying eyeliner in the ladies', I knew Spétses would work unimaginable miracles on my love life. Provided I could bribe, cajole, or coerce my heartthrob onto the airplane at Heathrow, I would be assured of an amazing transformation at the other end. Spétses would make him as pliable and powerless as Menelaus, and I, throwing caution to the winds, would be able to indulge myself, for a few precious weeks, as Helen of Troy.

I was too conscious of Spétses' charms to become swollenheaded. I knew it was the cocktail of sunsets and retsina; the sensual overload of sounds and tastes and smells; the arching, impossibly blue canopy of sky; the aching, glittering depths of the sea — all that was irresistible, not me. But my husband seems still spellbound. He fell in love with Spétses when he fell in love with me, so with luck he'll never disassociate the two.

A couple of summers after we got together, he bought a house here — another Venetian-style villa right on the sea, just a few doors away from the Bouboulis house. "Spiti Charlie" has traditional painted floors, high stenciled ceilings, shuttered windows and thick walls, and a sitting room the most perfect powder blue.

Our first summer in the house we were so consumed with restoration that we almost failed to notice that a gem had fallen into our hands. We turned the tiles on the roof, repaired doors and windows, replaced hinges and panes of glass, buried electric cables, and battled with characteristically rebellious plumbing. The furniture we inherited — bedsteads and armoires, brass spice grinders and samovars, porcelain pitchers for water, the odd musket — were from the time of Bouboulina. In the storeroom under the house we found a Spetsiot war of independence flag emblazoned with ELEFTHERIA E THANATOS and a snake entwined around an anchor; the banner flew from the terrace as the fireworks burst on our first Armata party.

The following summer we came back to find that a squadron of bees had built a home in a niche above the bathroom window and the walls were dripping with honey. We set bowls on the floor, and dribbled the nectar onto our bread and yogurt at breakfast. Irini, our housekeeper, pronounced it a wonderful omen, a blessing.

Not everyone was so optimistic. The *yayas* (the new generation of them, that is) were horrified when we planted a fig tree just meters

from the house. "It's no good for babies," they said, shaking their heads, ruefully warning that fig trees make men sterile.

Two babies later, I'm glad to have proved them wrong — though they would never bring themselves to concede it. But every year I brace myself, just as my mother did, for a torrent of matriarchal advice and more trinkets to ward off the evil eye. My son and daughter are pinched and squeezed and petted and teased and transported off for secret treats — honeyed pastries and moped rides and visits to newborn lambs — just as my sister and I were.

And at night, when I tuck them into their — thank goodness, rat-free — beds upstairs, we listen to the sound of the sea on the pebbles and the *ding-ding* of the carriage bells, and count "one hippopotamus, two hippopotamus, three hippopotamus, flash!" as the beam from the lighthouse floods the room and fills their dreams with the mesmeric, permeating sorcery of the island.

KATE WHEELER

The Fist of God

FROM *Outside*

SEVERO GUZMÁN is strikingly handsome, well dressed in a red
jacket, white felt hat, and white wool pants. He says he thinks he is
sixty, but he can't be over forty-five. I'm meeting him in an onion
patch, escorted here by an intermediary, because it is the only way I
can talk to him.

He is a campesino, a peasant. In this remote river valley, cut deep
into the Bolivian altiplano, he works white people's land. And
every year he walks into their town — San Pedro de Buenavista —
to pay off his *patrones* in sacks of corn and fresh-killed meat, to en-
joy its Catholic feast day, and to beat other campesinos bloody.

Severo fights the ritual battle called *tinku*. It is full-force combat;
sometimes people die. Although it takes place alongside Catholic
celebrations, *tinku* is an ancient festival, one that no outsider has
come to understand. For days, I've been trying to get someone — a
fighter, someone who *knows* — to explain it. But the campesinos in
the market, the indigenous Quechuas and Aymaras, stare right
through me. Lots of them don't speak Spanish, and I don't know
Quechua or Aymara. And on top of language is history, a history of
conquest and mistrust. But now Saúl, a white man, has arranged
this meeting with Severo, who works his family's land. Saúl calls
him "my peasant"; Severo calls Saúl *tatay*, Quechua for "my father."
But Severo says Saúl treats him fairly, unlike many *patrones*. And so
he is honored to explain *tinku* to a gringa.

"I fight every year, *sagrado*, sacred," he begins, with Saúl translat-
ing into Spanish. "I can never break my promise, for that which is
sacred is sacred always. *Tinku* is perfect, like the lightning. When it

kills you, it kills you; when you have to die, you die. There is no justice or law. He who lets himself fall, let the earth be the one to complain.

"And it is pleasant always to be a little drunk, because when you're sober it is not as much fun. It's a euphoria, a gift of the festival, to hit one another. I feel more of a man when I hit someone.

"To prepare, some have ceremonies; they dedicate themselves to the mountains. In our house we always have something sacred where we make offerings. But there are mountains that are sacred and great, much greater than what we have in the house.

"There has been *tinku* ever since I had a memory. From our great-great-grandfathers, it is always there. Before the Spanish there was always this. In our veins we carry the custom of fighting. No matter what, each year I want to do it. It sears me. I think, 'It's not just others who can fight, I too can fight.' My father, he beat hundreds, he was famous, renowned. My brothers, Lorenzo, Gregorio. My brother Eusebio, he cannot be beaten.

"*Tata* San Pedro, *Tata* San Pedro," he concludes, invoking the town's patron saint. "May he guide us and keep us always together. We are his campesinos, brave enough to offer ourselves up."

Severo promises to dedicate a fight to me. To honor him in return, I say I'll dress in campesina's clothes. As it happens, I never see him again, but my change of costume will propel me straight into the heart of the *tinku*.

There are worlds of marvel in Bolivia. Doors that open onto other ways of seeing, trails that lead across solitary landscapes and end in unexpected places, and inner and outer wildernesses where no trails yet exist. A couple of German filmmakers told me in a pizza joint in La Paz last year how they'd come off a salt flat into a village whose annual festival had just started, and they went wild for this drunken feast, its totem poles and stuffed condors.

With only 9 million people in an area not much smaller than Alaska, travelers here enter the uncrowded space of an ancient population balance. More and more people have discovered this, and now La Paz sometimes seems overrun with loping, fleece-clad, sunglassed refugees from ourselves, all beating a path to the next untrampled adventure destination. But hours outside the capital, the gringo trail peters out, and vast, acute terrain takes over. You

can scale five-thousand-meter snowpeaks, trek around them, or machete through rainforests. You can cross the lands of the Kallawaya healers, the magicians of the Inca empire.

But it's never safe to hike alone. Fatal accidents have occurred on the popular trekking route from La Paz to the resort of Coroico, where a Swiss blonde disappeared last April. Most of the country-side is peaceful, but there are places where tourists are not welcomed. Years ago my friend Peter had a fantasy that he and I would get some llamas and trek around the northern shores of Lake Titicaca. Our map showed a dirt road and the town of Achacachi. We imagined ourselves strolling between golden fields of quinoa and the thrilling blue waters of the highest lake. Living in Bolivia for part of each year, I asked about Achacachi. Don't go there, people said; Achacacheños were mean and *fuertes*. A friend in La Paz happened to come from there, as I learned one night, drinking, when he suddenly commanded me to fear him: He was from Achacachi — he ate babies. It turned out to be a common rumor, this baby eating. Eventually I asked a Bolivian anthropologist. He said there were a lot of strange things in the backcountry. He'd never seen baby eating, but he was sure it had happened in secret, because, he explained, a myth that has never been disproved must contain some truth. Another visitor told of a black dog howling like a woman in the haunted plaza. I decided not to go.

I've been a festival dancer in La Paz, even president of one of its *diabladas*, its groups of masked devil dancers, but I was afraid *tinku* was one festival I shouldn't attend. *Tinku* was brutal, forbidden, for campesinos only. In 1999, at Bolivia's biggest *tinku*, in the town of Macha, a French photographer was seriously injured, beaten over the head with his own camera. The gesture was hard to misinterpret. Beyond endangering myself, I didn't want my presence to make the fighters feel like animals in the tourists' zoo. And yet the pull was deep. I grew up in South America, feeling a complicated mix of separation, identification, responsibility, and desire. At age ten, in Peru, I found a woman's skull in a pre-Inca burial ground. I used to sit and stare into her eye sockets, wondering who she'd been.

And I'd wanted to see a *tinku* ever since a friend evoked a haunting, Kurosawa-like scene of campesinos converging across an arid altiplano amid the howling of giant panpipes and the fluttering

of flags. The Quechua word *tinku* means "encounter"; weddings and fistfights happen at the same celebration. Somehow the conjunction made sense to me, as if a festival of life and death, excluding no type of human contact, might offer a glimpse of wholeness.

I decided to go, but quietly, responsibly. I dug up most of what's in books, on film — not much. I tracked down experts in La Paz. I learned that the southern Andes are dotted with violent festivals, where people fight with fists, whips, rocks, farm tools, on horseback, or sling dried apricots at one another. Bloodshed, even death, are overt objectives as extended Andean families, called *ayllus,* square off in slugfests that can last from a few minutes to nearly a week. Most such battles (and the deaths that occur in them) are undocumented, but the *tinku* tradition, based in the altiplano *departamentos* of Oruro and Potosí, is coming out of oblivion. A dozen or so are held annually, defying efforts to ban them; the Macha *tinku* makes the TV news. Two thousand campesinos fought there last year under the pacifying influence of police armed with bullwhips and tear gas. One death was reported — a man beaten so badly that he couldn't be identified. At least one other man died without making the news. A stylized *tinku* dance was even in vogue among educated, roots-oriented young people, but before joining a real *tinku* most urban Bolivians would rather visit Miami, or maybe rot in hell.

Editorials echoed the words of Spanish observers four hundred years ago — savage, subhuman. Resisting such portrayals, an Aymara pundit told me that soccer was more brutal — and didn't *norte-americanos* have their boxing? Clearly *tinku* was being obscured by the very sensationalism that had brought it to light. I had to see for myself. La Paz friends urged me not to go. There was also a war going on for much of last year on the border of Potosí and Oruro, a feud between two of the *ayllus* that compete most ferociously at *tinkus.* The army had gone in. The news was full of burning hamlets, corpses, poked-out eyes. Fifty people had died, but it was hard to believe that all of *tinku* country — some sixty thousand square miles — was aflame with danger. "Ay, Katy!" my Bolivian *tocaya,* or same-name friend, Katy Camacho, said. "Why don't you go to Cochabamba instead? There's a Christ there. He cries real tears!"

I know now that I was failing to imagine what real violence would be like.

It took two days to get to San Pedro by four-wheel drive. My friend Wolfgang Schüler, a German photographer who's lived in La Paz for sixteen years and seen more *tinkus* than just about any nonfighter, thought there still might be a *tinku* there. Ten years ago he'd seen a thriving festival with mass campesino weddings and thrilling fights. Whether it still existed was anybody's guess. And so one day in early winter Wolf and I and my anthropologist boyfriend, David Guss, along with Wolf's driver-sidekick, Don René Irahola, a retired mechanic whose stated age ranges from seventy-two to ninety, loaded Wolf's aging Nissan with seventy-five liters of extra gasoline and left La Paz to find out.

The first night we crossed a boiling river, its steam eerily brilliant in our headlights. Dead people's clothes were washed here, a funeral custom. We chose not to stop. The next day we lurched out of the last depressed mining town, past mountains of slag dug into hideous goblin-warrens by *palliris*, workers who rinse tin ore from crushed rock for as little as one boliviano, about fifteen cents, a day. We ate dust, climbing in and out of valleys where the earth swirled violet, rust, black, gray, white, green. In one hamlet, every person was stone-drunk. They stood swaying blankly as we passed, like victims of some enchantment.

I'd never come so far into the altiplano as to taste its bitterness. Windowless hovels hunched against the frigid wind. A raddled, barefoot family trampled frozen potatoes into the black and vaguely oily staple, *chuño*. Billboards blaring the names of politicians and foreign-aid projects only added to the sense of desolation. All you could see were mountains upon mountains, an ocean of ranges rippling. Ears roaring with altitude and light, I began to wonder about my notion that all distances could be covered.

We saw no signs of a war. Instead, on lonely curves, we'd pass a young man in a tall, conical knitted hat and a bright embroidered jacket, walking along playing a tiny guitar, a *charango,* to himself. No village in sight. Once he would have been a warrior for the Incas; now he was a subsistence farmer, with a life expectancy of forty-six. We drove all day, until San Pedro rose from the confluence — the *tinku* — of three rivers. We arrived just after dark to find its

main plaza full of excited vendors preparing to sleep in places they'd staked out. The fountain's silver-painted swan glinted in the moonlight; the air, at a mere 2,400 meters — less than 8,000 feet — felt edible compared to the altiplano's, more than a kilometer above the town. Alas, Wolf's friend, one of the two local priests, had other guests, but he steered us to a UNICEF dormitory at the far end of town.

The electricity went off for the night, leaving us to the music of *charangos* and to a crawling and nipping in my bed — which I hoped was fleas, not vinchuca beetles, carriers of fatal Chagas' disease. I lay awake, listening to the shimmering music that would drift through all our *tinku* days and nights.

I thought of the words of Marcelo Fernández, an Aymara writer in La Paz. He'd said *tinku* was the last ferocious expression of the *ayllus* — an education in courage. The need for courage here seemed great.

At dawn, I went out alone. Beyond a stubbled field was the vast riverbed; then stark, pale, folded mountains. This end of town was filling up with trucks disgorging *tinku*-goers and livestock. People were driving loaded donkeys up from the river and cooking by the roadside. Passed-out drunks lay where they'd fallen.

Men wore bits of traditional clothing, knitted hats and tight, bright jackets mixed with T-shirts and jeans. Women were more conservative, in full skirts and beribboned white felt hats. Black skirts were *altiplánico;* printed or synthetic ones, *valluno*. Later I'd hear that Aymaras from the highlands would fight Quechuas from the river, but also that in the contest of *tinku,* the rules of engagement between *ayllus* were far too intricate to summarize.

White people didn't fight. Their outfits wouldn't be out of place in Boston. To make things even more complex, nearly everyone in Bolivia has indigenous ancestry, so most "whites" are actually mestizo — as are many *indígenas*. And of course all foreign tourists are "white," in our uniforms of pants and sunglasses.

Trudging uphill, I fell in beside two campesinos carrying two-hundred-liter earthen jars. "What are those?" I asked one of the men. I was pretty sure they were for *chicha,* Andean corn beer.

"Chicken coops," he sourly lied.

I climbed past the clinic and a jail out of a spaghetti Western.

The jail was empty. I'd learn that its former jailer was now an inmate, convicted (to everyone's amazement) of beating another mestizo's campesino to death — but that he and the other two prisoners had been freed for the festival.

Past the market, where hundreds of liters of grain alcohol stood for sale in big pink cans, I came to the small plaza where the fights would take place. It was remarkably unremarkable, a rocky, tilted, piss-stained triangle rimmed by house fronts and raw adobe walls. I was standing there, depressed, when a man in his later forties with a reddish complexion and a neat mustache, dressed in khaki pants and shirt, came strolling up. Taking him for an official, I offered a tentative hello. He introduced himself as Saúl Villagómez. "Come with me!" he cried, and led me through a patio and upstairs to a room where eight men lay on straw mattresses.

They sat up and immediately produced a bucket of *chicha,* and we began toasting. Over my protests that I had a "husband" down the hill, Saúl introduced me as his love, called for a *charango,* and began improvising, singing lewdly of his golden *"pingo,"* and (since I had a husband) begging to be hired as my gardener. "Oh, let me labor in your garden," he crooned, "to dig your earth will make me — Ah, the roses and the lilies!"

He was really good. The men clapped along; Saúl played behind his head, gazing into my eyes. All along, a fox-faced fellow sat sharpening a table knife to a deadly point. He slipped out to slaughter cattle for the upcoming feasts.

More guitars appeared; new men sang. I turned down a gourd of *chicha,* on grounds that it was not yet 8 A.M. "The fiesta knows no day or night!" Saúl insisted.

Most of San Pedro's mestizo upper crust was assembled in that room. Their lands, nearby, were worked by campesino sharecroppers. Only two lived in town; the rest had emigrated to cities as children, after the uprising of 1958 when thousands of campesinos had besieged the town, vowing to drink blood from the skulls of its inhabitants. Saúl told me that his aunt, Erlinda, had foretold the rebellion. Asked how she knew, she said, "I sleep with the devil, and he gives me money." Her husband had scoffed until, Saúl said, *"el diablo lo violó per detrás"* ("the devil fucked him in the ass") one night. The uprising was put down, its leader's severed head hung on the pacay tree in front of the church. Nonetheless it was fear —

along with the lack of schools, roads, mail, telephones, electricity
— that led San Pedro's gentry to decide there was no future here.

Still, there is a past, and each year the town's mestizo sons and
daughters return for this festival, reoccupying crumbling ancestral
homes. This year's celebrations were sponsored by one of Saúl's
friends, Joél Murillo, *patrón* of the valley's biggest hacienda and son
of the town's great patriarch, Don Ángel Murillo. A quiet man of
thirty-five, Joél had ordered the making of thirty thousand liters of
chicha and brought in a brass band from Oruro; tomorrow he'd
sponsor a mass animal sacrifice, the *uywañakaku,* and then
cockfights, a bonfire, fireworks, Masses, two saints' processions — a
weeklong party. (Campesinos had separate festivities, culminating
in the *tinku* itself, which would begin in four days.) The extrava-
ganza stood to cost Joél the equivalent of five thousand dollars,
more than a decade's average income around here. He planned to
take advantage of the occasion to marry Prima, his pregnant wife
(they'd had a civil ceremony years ago), in a church ceremony. The
priests forbade campesino weddings in San Pedro, citing *tinku*-
goers' drunkenness among their reasons, but apparently preg-
nancy was no problem.

"This town," Saúl whispered to me, "outwardly, it looks like pig's
urine. But inwardly, it's our souls' home. People travel days and
days to get here."

The *uywañakaku* was deeply upsetting, not least to the heifer. She
struggled against her fate, but they tied her by the horns to the
1930s amphibious vehicle — a relic of the Chaco War and of a not-
so-far-off time when the only access to San Pedro was up the
riverbed — that was rusting in front of Joél's house.

Joél and Prima splashed the heifer with *chicha,* and then a beefy
dude named Marco Antonio Casano pushed a knife into her spine.
She took forever to die, kicking and gasping through her severed
windpipe while her head was being sawed off. A man smeared
blood on our cheeks, where it hardened into bright-red scabs. The
cow was pregnant, so they took out the pink fetus and draped it's
membrane over Prima's head like a veil (so David told me; by then
I'd fled). Eighteen sheep and goats were slaughtered next, laid out
in a pond of blood. All day the street was blocked by tubs of guts,
women butchering.

And the town kept filling. We counted eighteen impromptu *chicherías* in one block. New four-hundred-liter *chicha* barrels rolled off trucks at all hours. Campesinos crowded the market, buying everything from sheep to sweatpants, cassettes to colanders. Men swaggered with leather gloves or helmets dangling from their belts. Wooden saints were paraded up and down, preceded by schoolgirls dancing the *tinku* dance I'd learned in La Paz.

Thanks to Joél and Saúl, no mestizo's door was closed to us. Joél's mother taught me to peel potatoes. His twenty-seven-year-old half sister, Fanny Murillo, fed us in her pension. The notary, Serafín Taborga, filled us in on San Pedro's foundation in 1570, its various sieges, its glorious past when it boasted twenty-two lawyers and twenty-four-hour electricity. This surreal backwater, San Pedro, was like a nonfictional Macondo, the town in *One Hundred Years of Solitude*. It was said that old Don Ángel had fathered more than sixteen children, if you counted in campesinos' huts. Saúl's sister Gilma had been gifted with second sight after a terrible car accident. Then there was Dr. Gabino Andrade, a retired judge, self-taught dentist (he'd recently botched an extraction), and former violin virtuoso who confided that Satan once played the violin through him.

A dozen of Saúl's relatives were camped in the Villagómez ancestral house. They didn't know how old it was — they showed me where silver coins had rained from the decaying ceiling twice when they were children. The place stood locked most of the year; the family was sleeping in one room and cooking out back. Saúl came and went elusively, indulged and deplored in turns by his sisters. They cooked and washed, men drank and played *charangos*, older kids whined about the rustic boredom, and Fabrizio, age five, made a first disastrous experiment with *chicha*. Invariably, one of "their" campesinos labored silently nearby.

But none of the campesinos, the ones who would fight, would talk to me. Having seen serfdom in action, I couldn't blame them. Fanny said country people wouldn't talk to her, either. She'd been told she'd bring evil winds, hail, drought, or that all non-Indians were *kharasiris*, a type of vampire that lives on human fat. Again, Saúl came to my rescue. "Why didn't you tell me?" he said. "Come tomorrow, my campesino is bringing a sack of corn."

And so the next day, David and Saúl and his wife, Crecencia, and

I stood with Severo Guzmán in the garden at sunrise, and Saúl called for *chicha* and Severo spoke: "Once a year, I get to drink with my *patrón* . . . *Tinku* is perfect, like the lightning. When it kills you, it kills you; when you have to die, you die." Every so often, Saúl interrupted his own translation to exclaim with pride, "Hear how he talks! He's my campesino! He's my little man!"

My promise to Severo changed everything. The next morning, on the day the *tinku* was to start, I put on a campesina's skirt and instantly ceased to be invisible. Gales of laughter followed me everywhere. "Looking good!" the campesinas cried. Guys would say, "Hey, *cholita*, country girl! Watch out tonight, we'll kidnap you!"

The *chicherías* were full of stomping, dancing drinkers, gearing up. As I passed a doorway, someone grabbed me by the elbow and dragged me inside, commanding, "Buy *chicha!*" It was Siriaco González, a kid of seventeen or so, eager to fight in his first *tinku*. Soon I was stomping in a circle, arms linked with Siriaco and his friends.

"Try my *montera!*" Siriaco showed me how to pry apart his *tinku* helmet's stiffened cowhide to shove my head inside. It was tight, hard as metal. Giving myself a playful tap, I pierced my palm on a spike I hadn't seen. As I inspected the tiny purple wound, Siriaco whacked the helmet from behind, making my head ring like a bell.

It was almost four in the afternoon when two oldsters faced off in the dusty *tinku* plaza, shuffling their feet almost shyly. Then they went at it, swinging their arms wide in the traditional punches called *waracazos*. "Too old to do any damage," a fellow bystander remarked. After a few haymakers, the antagonists waddled off arm in arm to get a little drunker.

But they'd started it. Seconds later, two fights broke out at once; the crowd closed instantly around each one, forming a tight ring. *"Tiracarajo! Tiracarajo!"* women shrieked. "Hittimgoddammit!" Dust rose from the holes in the crowd. We could see jerky motion, and ostrich plumes bobbing atop the helmets. As we tried to get closer to one fight, the knot of the crowd broke open, spilling out a man in a yellow jacket. Several guys came after him, kicking and punching; bystanders took the opportunity to land a few blows of

their own. As the action surged toward us, David, Wolf, and I scuttled off to the safety of a balcony.

Getting to the heart of the *tinku* no longer felt compelling. Male or female, anyone close enough to follow the action stood a chance of getting punched, kicked, or otherwise caught up in the contagious, violent glee. In the first hour alone we saw broken teeth and noses, not to mention full-force kicks to the head and kidneys of a cowering loser, administered by teams of booted hearties deaf to the victim's pleas for mercy until women hauled them off from behind. Occasionally there were flash points: A duel would erupt into a plazawide riot, a seething chaos of flailing limbs and screaming that lasted for several minutes until the defeated faction vanished down an alley as if blown there by a gust of wind — a deceptive lull, during which the women's voices dropped to an ominous blubbering ("Brr! Brr!") and everyone ran for doorways, cover against the rain of stones soon to fly from the alley's mouth.

From the balcony I watched my seventeen-year-old friend Siriaco take beating after beating. He left his chest exposed, swinging his arms wildly. His shirt got torn off. He fell. Half naked, covered with dust and blood, he eventually disappeared.

I found him sitting on a curb, crying like a baby. His face was crusted with freshly scabbing blood. "They killed me," he sobbed. "They ganged up on me. I got too drunk. I didn't win even one!"

"You were brave!" I told him. "You were never afraid to fight."

"Really?" he said after a while. He smiled. "Buy me *chicha!*"

That day San Pedro reached fever pitch. Five people died in a road accident trying to reach the fiesta. Drunken couples screamed at each other outside the *chicherías*. Behind the church was a massive campesino orgy of drinking, dancing, flirting, singing, brawling, yodeling, and stamping the ground, all in a haze of dust, with occasional hails of stones and shouts of "We are men!"

I wandered all around, my campesina skirt earning me the privilege of buying drinks and talking to *tinku* fighters. It caused a new stir among the gentry at Joél and Prima's wedding dance that night. Men threatened to abduct me. Women begged to try it on. It caught the eye of the town's most prominent living son, General Alfredo Loayza, who'd returned for the first time in forty-four years. "I see you are a woman who knows how to dress herself," he

purred as we danced a tasty cumbia. Though he hadn't watched to-day's fights (he'd once been hit in the eyebrow by a stone, requir-ing over a thousand dollars in medical work), the general had a sympathetic theory: "Somehow the people have to express their re-sentment."

And after dark the roar from the campesino party was terrifying. All night, squads of dressed-up campesinos trotted through town, the men strumming *charangos,* the women shrilling praise songs to whichever roadless hamlet they'd walked from. When they passed the UNICEF dorm, the earth shook slightly.

The next day's fights were ugly but conclusive. Two giants ap-peared from a nearby army barracks in camouflage and studded helmets. But even they lost to four young men who stood in a row and put away all comers. The four fought dirty, ignoring the ref-eree, an old campesina who hit at them with her stick. I hated them, especially the thin one in black, steel-studded sadist's gloves. Hours later, though, I met them behind the church — village boys toasting their victory, eager to practice English.

The next morning was the festival's last; truck and bus drivers lined up in the plaza, calling out their destinations. When they had the requisite overload, they heaved into motion, jamming Saúl's street and filling the *tinku* plaza with a gridlock of idling engines and die-sel fumes. It took hours to inch our way out of town. Yesterday's winners were loitering about, looking hopeful, but the *chicha* had given us bellyaches, and it was time to go.

As the Nissan lurched toward the pastry shops of Cochabamba, I considered all the worlds we'd traveled in and out of in this one small place, San Pedro. And the moment when I'd gone as far as I could go, and knew I wanted to turn back.

On the first day of the *tinku,* I'd gotten up the courage to ap-proach a women's fight. A young campesina in a red cardigan was winning, grabbing two fistfuls of her opponent's hair and slowly, slowly — enduring an identical grip on her own hair — shoving her enemy face down into the dirt. She stood panting, fiercely vic-torious, in a tight, deep ring of delighted onlookers.

I pressed closer, trying to see. Suddenly, the campesina spotted me through the crowd and began screeching in Quechua. From a stream of insults, I picked out the Hispanicized *putay,* "whore."

Who, me? Her black eyes drilled into mine, glittering unmistakably. By the unwritten rules of ritual battle, we were appropriate opponents: from different communities yet of the same sex, approximate age, size, and degree of intoxication.

I ducked and turned, taking cover in the human jam. As if through a mass of cotton I heard everybody laughing. The campesina berated me louder, clearly enjoying herself.

"She has won," a bystander informed me. And then, luckily, everyone was distracted by a sound like baseball bats hitting sacks of grain. New fight. Men.

For hours I chided myself. I'd failed to defend the honor of the United States against that of northern Potosí. I should have poked that woman in the eye! How dare she call me a whore?

But no, it would have been intrusive, obscene. The following afternoon, I saw my enemy again. She still wore her red cardigan, but she wasn't gloating now. Weeping drunkenly, she struggled with two young men who gripped her arms as they steered her down a slope littered with old plastic bags and human turds.

Weeks later, I was dismayed when a sociologist in La Paz told me that they could have been dragging her off to rape her. He'd visited San Pedro many times and was a confidant of Joél's brother, Samuel Murillo. Gang rapes were common at the *tinku,* he said. Though all *tinku* rumors can be inflated, I easily found an eyewitness to an attempted gang rape at another *tinku.* Clearly a *tinku's* sexual aspects cover the same range as the fighting — from terror to beauty, from brutality to entertainment. I'd experienced some of that range myself, from Saúl's flirtations to the taunts that followed my skirt — and to the excruciating drunk in a *chichería* who had lifted my skirt, talked filth in Quechua, and grabbed my hands hard, bringing me to tears of rage and pain. No one stopped him; David and Wolf were not around. I berated him in Spanish, and he'd laughed and crushed my hands, saying that gringos had no respect, until he decided, all on his own, to head for the bathroom, to puke and pass out.

Tinku had been appalling all along. The bloody teeth, the piss-slick alleyways, the damage and the posturing. Yet its ugliness proved how real it was, real beyond measure, beyond imagining. And for that, I loved it. Weeks later, at another *tinku,* I'd hear the particular silence that came when a man fell and did not get up. I

bent over him, thinking to use my rusty EMT skills, but his wife cursed me away. Ten minutes later, he was still unconscious; I left, ashamed. What was I doing here?

I cannot forget the campesina, she who was willing to be my enemy. I'd used everything I knew to reach the frontier between our worlds. Of course, if I'd been from one of those villages, I'd have taken her up on her challenge. I'd have gained some injury or scar, surely, but I might also have a permanent friend. I can still feel her eyes burning, like the lightning, through all the distances between us.

Contributors' Notes

Notable Travel Writing of 2001

Contributors' Notes

André Aciman is the author of *Out of Egypt: A Memoir* and *False Papers: Essays on Exile and Memory,* and the coauthor and editor of *Letters of Transit.* He was born in Alexandria and has lived in Egypt, Italy, and France. Educated at Harvard, he has taught at Princeton and Bard College and teaches at the CUNY Graduate Center. A contributor to the *New York Times, The New Yorker,* the *New Republic,* and the *New York Review of Books,* he is the recipient of a Whiting Writers' Award, a Guggenheim Fellowship, and a fellowship from the New York Public Library's Center for Scholars and Writers.

Scott Anderson is a journalist and novelist who lives — at least some of the time — in New York. A contributing editor of *Harper's Magazine,* he also writes frequently for the *New York Times Magazine* and *Esquire,* usually on foreign, war-related themes. His most recent books are *Triage,* a novel, and *The Man Who Tried to Save the World,* a nonfiction investigation of the mysterious disappearance of an American relief worker in Chechnya. His story "As Long As We Were Together, Nothing Bad Could Happen to Us" appeared in *The Best American Travel Writing 2001.*

Stephen Bodio is a naturalist and writer whose books include *Querencia* and *On the Edge of the Wild.* When not traveling he lives in a small town in southwestern New Mexico. He has just finished a book about his experiences with the Kazakhs of Mongolia.

William Booth covers the West for the *Washington Post* as bureau chief based in Los Angeles. His work has also appeared in numerous magazines. He is working on a book about the California islands.

Kevin Canty has written four books: *A Stranger in This World* (stories), *Into the Great Wide Open* and *Nine Below Zero* (novels), and, most recently, *Honeymoon*, another book of short stories. His fiction and nonfiction have appeared in *The New Yorker, Esquire, Vogue, GQ, Details,* and elsewhere. He lives in Missoula, Montana, and teaches in the writing program at the University of Montana.

Rod Davis is an award-winning writer and editor whose work has appeared in numerous publications. He is the author of *American Voudou: Journey into a Hidden World,* a study of West African religion in the United States. A novel about voudou, politics, and Jazzfest, *Corina's Way,* will be published in fall 2003. Davis is currently the travel editor of the *San Antonio Express-News* and previously served as executive editor at *Cooking Light,* and he is a former editor of the critically acclaimed *Texas Observer* and *American Way.*

Michael Finkel is a contributing editor at *National Geographic Adventure.* He has been on assignment in more than forty nations for such publications as the *Atlantic Monthly, Sports Illustrated,* and the *New York Times Magazine.* His stories have also appeared in *The Best American Travel Writing 2001* and *The Best American Sports Writing 2000.* He spends about half the year poking about the planet and half the year in western Montana.

Devin Friedman was born in Cleveland, Ohio, and though he lives in New York City, he tells anyone who will listen that his heart resides on Lake Erie. This is only partially disingenuous. He was a staff writer at *GQ* and is now senior writer at *Men's Journal.* His work has appeared in *Esquire,* the *New York Times Magazine, The New Yorker,* and *FOUND.* He would like to tell you that he is at work on a novel, but it would be a lie. He thanks his grandfather.

Laurence Gonzales won the 2001 National Magazine Award for "The Rules of Adventure" in *National Geographic Adventure,* where he is currently a contributing editor. His essays have appeared in such periodicals as *Harper's Magazine, Rolling Stone, Men's Journal, Playboy, Penthouse, Smithsonian Air and Space, Chicago Magazine,* and *San Francisco Magazine.* Gonzales has published a dozen books, including two award-winning collections of essays, three novels, and the book-length essay *One Zero Charlie.* His work has been translated into seven languages and has won numerous awards, including an Emmy Award for the HBO series *From the Earth to the Moon.* He is currently at work on a book about survival.

Adam Gopnik has been writing for *The New Yorker* since 1986. His work for the magazine has twice won the National Magazine Award for essays, as

well as the George Polk Award for magazine reporting. From 1995 to 2000 he wrote "Paris Journal," which, collected and amplified, became the best-selling memoir *Paris to the Moon.* He now writes the magazine's "New York Journal."

Jim Harrison is the author of four collections of novellas, seven novels, seven collections of poetry, and a collection of nonfiction. He has been awarded a National Endowment for the Arts grant and a Guggenheim Fellowship. His work has been published in twenty-two languages.

Kate Hennessy is a native Vermonter who, after two decades of traveling, is just beginning to write about her experiences. *Slow Flying Stones* is an excerpt from a collection of essays, yet to be published, describing lessons learned on the road. She currently divides her time between Ireland, Guatemala, and Vermont.

Edward Hoagland began writing professionally in 1952 and has written seventeen books of fiction and nonfiction. His first novel was *Cat Man;* his most recent book is a memoir, *Compass Points: How I Lived.* He has been nominated for the National Book Award, the National Book Critics Circle Award, and the American Book Award. He lives in Bennington, Vermont.

Kathleen Lee is the author of *Travel Among Men,* a collection of short stories. She writes for *Condé Nast Traveler,* and her work appeared in *The Best American Travel Writing 2001.* She lives in Pittsburgh.

Lawrence Millman is the author of eleven books, including *Our Like Will Not Be There Again, A Kayak Full of Ghosts, Last Places, An Evening Among Headhunters, Northern Latitudes,* and *Lost in the Arctic: Explorations on the Edge,* forthcoming this fall. He is a fellow of the Explorers Club and has a mountain named after him in East Greenland. He keeps a post office box in Cambridge, Massachusetts.

Toni Mirosevich is a poet, fiction writer, and essayist whose work has appeared in the *Kenyon Review,* the *Progressive,* the *Seattle Review, ZYZZYVA,* and other literary magazines. She is the author of two books of poetry and prose, *The Rooms We Make Our Own* and *Trio,* and has taught creative writing at San Francisco State University for the past ten years. In 1999 she received the national Astraea Foundation Emerging Lesbian Writer in Fiction Award. Raised in a fishing family in Everett, Washington, a scenic coastal town in the Pacific Northwest, she now lives with her partner in Pacifica, California, a scenic coastal town in the San Francisco Bay area.

Tom Mueller lives in an ancient stone farmhouse in the Ligurian hills, halfway between Genoa and Nice. He has written for the *Atlantic Monthly*, the *New Republic*, the *New York Times*, *Travel & Leisure*, *Business Week*, and other publications and is a contributing editor at *Hemispheres*. Currently he is completing his first novel, a historical thriller set in (and under) Rome.

Elizabeth Nickson is a writer and journalist who has been published all over the world. She initiated and coordinated the acquisition of Nelson Mandela's autobiography for Little, Brown, smuggling letters to Mandela in prison before he was released. She has served as a reporter for *Time*, as the European bureau chief of *Life*, and as a columnist and contributing book reviewer for the *Toronto Globe and Mail*, and is now a "Comment Page" columnist for the *National Post*. In 1994 she published the *The Monkey Puzzle Tree*, a novel, which is now being made into a film.

Molly O'Neill was a reporter for the *New York Times* and the food columnist for the *New York Times Magazine* for ten years. She is the author of three award-winning cookbooks and the host of the PBS show *Great Food*, which also won a James Beard Award. Her work has appeared in all major food magazines as well as many general interest magazines. Early in her career she taught cooking to Indo-Chinese refugees, and she has maintained a lifetime interest in Vietnam and Cambodia, which informed her experience of traveling back to Cambodia with one of its prodigal sons. O'Neill's memoir of growing up in a midwestern baseball family will be published in 2004.

P. J. O'Rourke is a correspondent for the *Atlantic Monthly*. A journalist for thirty-one years, he has covered news events in more than forty countries. He is the author of ten books, four of which have been *New York Times* bestsellers: *Parliament of Whores*, *Give War a Chance*, *All the Trouble in the World*, and *Eat the Rich*. He was editor in chief of the *National Lampoon* from 1978 to 1981 and international affairs correspondent for *Rolling Stone* magazine from 1985 to 2001.

Tony Perrottet is the author, most recently, *of Route 66 A.D.: On the Trail of Ancient Roman Tourists*, published in April, which follows the little-known Grand Tour of Antiquity across the Mediterranean. Born in Australia, he studied history at Sydney University before traveling widely in Asia and working in South America for several years as a foreign correspondent. For the past decade he has been based in Manhattan, commuting from Zanzibar to Iceland and Tierra del Fuego while contributing to such magazines as *Esquire*, *Outside*, *National Geographic Adventure*, the *New York Times Magazine*, and *Islands*, where he is a contributing editor.

Kira Salak is the author of *Four Corners: Into the Heart of New Guinea, One Woman's Solo Journey*, which was selected by the *New York Times* as a Notable Travel Book of the Year; it details her crossing of Papua New Guinea along the route that the British explorer Ivan Champion took in 1927. She is a contributing writer for *National Geographic Adventure* and is pursuing a Ph.D. in English at the University of Missouri at Columbia. Her fiction is featured in *Best New American Voices 2001* and has been nominated for a Pushcart Prize.

David Sedaris is the author of the bestsellers *Barrel Fever, Naked,* and *Me Talk Pretty One Day*. His other book, a collection of Christmas-related stories, is entitled *Holiday on Ice*. He and his sister, Amy Sedaris, have collaborated under the name The Talent Family and written several plays, including *Stump the Host, Stitches, One Woman Shoe* (which received an Obie Award), *Incident at Cobbler's Knob,* and *The Book of Liz*. Sedaris's essays appear regularly in *Esquire,* and his original pieces can often be heard on *This American Life,* on National Public Radio. In 2001 he was named Humorist of the Year by *Time* and became the third recipient of the Thurber Prize for American Humor. Sedaris currently lives in Paris.

Thomas Swick is the travel editor of the *South Florida Sun-Sentinel* and the author of a travel memoir, *Unquiet Days: At Home in Poland*. His work has appeared in the *American Scholar,* the *Oxford American,* the *North American Review, Ploughshares, Boulevard, Commonweal,* and *The Best American Travel Writing 2001*.

Isabella Tree's latest book, *Sliced Iguana: Travels in Mexico,* was published in paperback in July. Her previous book, *Islands in the Clouds: Travels in the Highlands of New Guinea,* was shortlisted for the Thomas Cook Award. Tree was overall winner of the Travelex Travel Writers' Awards 1999.

Kate Wheeler is the author of a novel, *When Mountains Walked,* and a collection of short stories, *Not Where I Started From*. She also has written about travel for several publications. When not in the air or on the road, she lives in Somerville, Massachusetts.

Notable Travel Writing of 2001

SELECTED BY JASON WILSON

JAN MORRIS
 The Meaning of Nowhere. *Preservation,* October.

LELA NARGI
 Into the Thar. *Natural Bridge,* Number 6.
CATHY NEWMAN
 Welcome to Monhegan Island, Maine. Now Please Go Away. *National Geographic,*
 July.

DAVID OWEN
 Swinging in Morocco. *The New Yorker,* May 21.

BOB PAYNE
 Faces of the Past. *Islands,* September/October.
ROBERT YOUNG PELTON
 The Sound and the Fury. *Blue,* August/September.
EVGENIA PERETZ
 La Dolce Capri. *Vanity Fair,* May.
RICHARD PEVEAR
 Letter from Paris. *Hudson Review,* Autumn.
KATHLENE POSTMA
 Becoming Foreign. *Natural Bridge,* Number 6.
ROLF POTTS
 Islam's Bloody Celebration. *WorldHum,* October 2.

CHRISTOPHER REYNOLDS
 Guitar Central. *LA Times Magazine,* October 14.
JOHN H. RICHARDSON
 The Long Way Home (Part 1). *Esquire,* November.
JOE ROBINSON
 Real Travel. *Utne Reader,* July/August.

KIRA SALAK
 Long Way Too Much. *National Geographic Adventure,* November/December.
DAVID SAMUELS
 My Descent into Decadence. *GQ,* February.
JOHN SEABROOK
 Soldiers and Spice. *The New Yorker,* August 13.
PEGGY SHUMAKER
 Shark. *Ascent,* Spring.
PETER SKINNER
 Papua New Guinea. *Islands,* April.
SHIRLEY STRESHINSKY
 Return to Midway. *American Heritage,* April.
THOMAS SWICK
 Charmed Lives. *Oxford American,* March/April.

PATRICK SYMMES
The Last Days of the Mountain Kingdom. *Outside,* September.
Romancing the River. *Condé Nast Traveler,* September.

MARGARET TALBOT
Nip, Tuck, and Frequent-Flier Miles. *New York Times Magazine,* May 6.
JEFFREY TAYLER
Flushing Out the Shlaki. *Atlantic Monthly,* January.
MARCEL THEROUX
Alive in the Dead Zone. *Travel & Leisure,* May.
Brighton Rocks. *Travel & Leisure,* July.
The Rock of Ages. *Travel & Leisure,* August.
GLENN THRUSH
The La Guardia Syndrome. *New York Times Magazine,* January 21.
GUY TREBAY
The Next Hot Spot. *Travel & Leisure,* September.
CALVIN TRILLIN
The Frying Game. *Gourmet,* November.
New Grub Streets. *The New Yorker,* September 3.

KEN WELLS
From Zaire with Love. *Oxford American,* March/April.
JULIA WHITTY
Shoals of Time. *Harper's Magazine,* January.
JOY WILLIAMS
One Acre. *Harper's Magazine,* February.
SIMON WINCHESTER
Islands Forever. *Islands,* July/August.

TRACY YOUNG
The Tao of Folding. *Condé Nast Traveler,* March.

THE B·E·S·T AMERICAN SERIES ™

THE BEST AMERICAN SHORT STORIES® 2002
Sue Miller, guest editor • Katrina Kenison, series editor

"Story for story, readers can't beat the *Best American Short Stories* series" (*Chicago Tribune*). This year's most beloved short fiction anthology is edited by the best-selling novelist Sue Miller and includes stories by Edwidge Danticat, Jill McCorkle, E. L. Doctorow, and Akhil Sharma, among others.

0-618-13173-6 PA $13.00 / 0-618-11749-0 CL $27.50
0-618-13172-8 CASS $26.00 / 0-618-25816-7 CD $35.00

THE BEST AMERICAN ESSAYS® 2002
Stephen Jay Gould, guest editor • Robert Atwan, series editor

Since 1986, the *Best American Essays* series has gathered the best nonfiction writing of the year. Edited by Stephen Jay Gould, the eminent scientist and distinguished writer, this year's volume features writing by Jonathan Franzen, Sebastian Junger, Gore Vidal, Mario Vargas Llosa, and others.

0-618-04932-0 PA $13.00 / 0-618-21388-0 CL $27.50

THE BEST AMERICAN MYSTERY STORIES™ 2002
James Ellroy, guest editor • Otto Penzler, series editor

Our perennially popular anthology is a favorite of mystery buffs and general readers alike. This year's volume is edited by the internationally acclaimed author James Ellroy and offers pieces by Robert B. Parker, Joyce Carol Oates, Michael Connelly, Stuart M. Kaminsky, and others.

0-618-12493-4 PA $13.00 / 0-618-12494-2 CL $27.50
0-618-25807-8 CASS $26.00 / 0-618-25806-X CD $35.00

THE BEST AMERICAN SPORTS WRITING™ 2002
Rick Reilly, guest editor • Glenn Stout, series editor

This series has garnered wide acclaim for its stellar sports writing and top-notch editors. Now Rick Reilly, the best-selling author and "Life of Reilly" columnist for *Sports Illustrated,* continues that tradition with pieces by Frank Deford, Steve Rushin, Jeanne Marie Laskas, Mark Kram, Jr., and others.

0-618-08628-5 PA $13.00 / 0-618-08627-7 CL $27.50

THE B·E·S·T AMERICAN SERIES™

THE BEST AMERICAN TRAVEL WRITING 2002
Frances Mayes, guest editor • Jason Wilson, series editor

The Best American Travel Writing 2002 is edited by Frances Mayes, the author of the enormously popular *Under the Tuscan Sun* and *Bella Tuscany*. Giving new life to armchair travel for 2002 are David Sedaris, Kate Wheeler, André Aciman, and many others.

0-618-11880-2 PA $13.00 / 0-618-11879-9 CL $27.50
0-618-19719-2 CASS $26.00 / 0-618-19720-6 CD $35.00

THE BEST AMERICAN SCIENCE AND NATURE WRITING 2002
Natalie Angier, guest editor • Tim Folger, series editor

This year's edition promises to be another "eclectic, provocative collection" (*Entertainment Weekly*). Edited by Natalie Angier, the Pulitzer Prize–winning author of *Woman: An Intimate Geography,* it features work by Malcolm Gladwell, Joy Williams, Barbara Ehrenreich, Dennis Overbye, and others.

0-618-13478-6 PA $13.00 / 0-618-08297-2 CL $27.50

THE BEST AMERICAN RECIPES 2002–2003
Edited by Fran McCullough with Molly Stevens

"The cream of the crop . . . McCullough's selections form an eclectic, unfussy mix" (*People*). Offering the best of what America's cooking, as well as the latest trends, time-saving tips, and techniques, this year's edition includes a foreword by Anthony Bourdain, the best-selling author of *Kitchen Confidential* and *A Cook's Tour.*

0-618-19137-2 CL $26.00

THE BEST AMERICAN NONREQUIRED READING 2002
Dave Eggers, guest editor • Michael Cart, series editor

The Best American Nonrequired Reading is the newest addition to the series — and the first annual of its kind for readers fifteen and up. Edited by Dave Eggers, the author of the phenomenal bestseller *A Heartbreaking Work of Staggering Genius,* this genre-busting volume draws from mainstream and alternative American periodicals and features writing by Eric Schlosser, David Sedaris, Sam Lipsyte, Michael Finkel, and others.

0-618-24694-0 PA $13.00 / 0-618-24693-2 CL $27.50 / 0-618-25810-8 CD $35.00

HOUGHTON MIFFLIN COMPANY www.houghtonmifflinbooks.com